CONTEMPORARY ARTISTS AND THEIR CRITICS

Series Editor:

Donald Kuspit
State University of New York, Stony Brook

Advisory Board:

Matthew Baigell, *Rutgers University*
Lynn Gamwell, *State University of New York, Binghamton*
Richard Hertz, *Art Center College of Design, Pasadena*
Udo Kulturmann, *Washington University*
Judith Russi Kirshner, *University of Illinois, Chicago*

This series presents a broad range of writings on contemporary art by some of the most astute critics at work today. Combining the methods of art criticism and art history, their essays, published here in anthologized form, are at once scholarly and timely, analytic and evaluative, a record and critique of art events. Books in this series are on the "cutting edge" of thinking about contemporary art. Deliberately pluralistic in approach, the series represents a wide variety of approaches. Collectively, books published in this series will deal with the complexity of contemporary art from a wide perspective, in terms of both point of view and writing.

Other Books in the Series:

Beyond the Mainstream, by Peter Selz
Building-Art, by Joseph Masheck
The Education of the Surrealists: The Gold of Time,
 by Jack J. Spector
*The Exile's Return: Toward a Redefinition of Painting for the
 Post-Modern Era,* by Thomas McEvilley
*Looking at Art from the Inside Out: The Psychoiconographic
 Approach to Modern Art,* by Mary Mathews Gedo
Signs of Psyche in Modern and Postmodern Art,
 by Donald Kuspit

Signifying Art

Essays on Art after 1960

MARJORIE WELISH
Pratt Institute

CAMBRIDGE
UNIVERSITY PRESS

PUBLISHED BY THE PRESS SYNDICATE OF THE UNIVERSITY OF CAMBRIDGE
The Pitt Building, Trumpington Street, Cambridge, United Kingdom

CAMBRIDGE UNIVERSITY PRESS
The Edinburgh Building, Cambridge CB2 2RU, UK www.cup.cam.ac.uk
40 West 20th Street, New York, NY 10011–4211, USA www.cup.org
10 Stamford Road, Oakleigh, Melbourne 3166, Australia
Ruiz de Alarcón 13, 28014 Madrid, Spain

First published 1999

Printed in the United States of America

Typeface Sabon *System* DeskTopPro$_{/UX}$® [BV]

*A catalog record for this book is available from
the British Library.*

Library of Congress Cataloging-in-Publication Data

Welish, Marjorie, 1944–
 Signifying art : essays on art after 1960 / Marjorie Welish.
 p. cm. – (Contemporary artists and their critics)
 Includes bibliographical references and index.
 ISBN 0-521-63301-X. – ISBN 0-521-63393-1 (pbk.)
 1. Art, American. 2. Art, Modern – 20th century – United States.
 I. Title. II. Series.
 N6512.W39 1999
 709'.73'09045 – dc21 99–14189
 CIP

ISBN 0 521 63301 X hardback
ISBN 0 521 63393 1 paperback

Contents

List of Illustrations

Sources of Previously Published Essays

These conference papers, articles, and reviews, or slightly modified versions of them, have appeared in the following publications acknowledged here.

1. "Pail for Ganymede" was written on the occasion of the exhibition organized by Julia Brown Turrell, and it was published in the catalogue *Rauschenberg Sculpture* (Fort Worth, TX: Modern Art Museum, 1995), pp. 85–127.

2. "Texas, Japan, Etc.: Robert Rauschenberg's Sense of Place" appeared in *Arts Magazine* 60 (March 1986), pp. 52–4.

3. "Early Paintings" accompanied the catalogue *Cy Twombly: Paintings* (New York: Stephen Mazoh Gallery, 1983), for an exhibition of the same name. "A Discourse on Twombly" first appeared in *Art in America* 67 (September 1979), pp. 80–3.

4. Written for the conference "After Roland Barthes" organized by Jean-Michel Rabaté and held at the University of Pennsylvania in 1994, "The Art of Being Sparse, Porous, Scattered" appears with the papers collected in Jean-Michel Rabaté, ed., *Writing the Image After Roland Barthes* (Philadelphia: University of Pennsylvania Press, 1997), pp. 201–16.

5. Written for the conference "Assembling Alternatives" that was organized by Romana Huk for the University of New Hampshire in 1997, "Narrating the Hand" was to be published in *Annals of Scholarship* 13 (forthcoming).

6. "When Is a Door Not a Door?" is an abbreviated version of a lecture given first at Fondation Royaumont, Asnères-sur-Oise, France, in 1990 and subsequently published in this form in *Art Journal: The Constructed Painting Issue*, which was guest edited by Curt Barnes (Spring 1991), pp. 48–51.

7. "Jasper's Patterns" appeared in *Salmagundi* 87 (Summer 1990), pp. 281–302.

8. "Frame of Mind: Interpreting Jasper Johns" was published in *Art Criticism* 3 (May 1987), pp. 71–87.

9. "The Specter of Art Hype and the Ghost of Yves Klein" was previously published in *Sulfur* 12 (Fall 1985), pp. 22–8. This was written on the occasion of "Yves Klein 1928–1962: A Retrospective," originating at The Institute for the Arts, Rice Museum, Houston, Texas, 1982.

10. "Harold Rosenberg: Transforming the Earth" first appeared in *Art Criticism* 2 (Fall 1985), pp. 77–87.

11. "Underworld Overcoat" originally appeared in *Sulfur* 23 (1988), pp. 146–50. "I Confess" first appeared in *Arts Magazine* (November 1988), pp. 46–50. Both were occasioned by the retrospective "The Drawings of Philip Guston" organized by Magdalena Dabrowski at the Museum of Modern Art in New York, 1988.

12. This chapter of short reviews and articles includes: "Worrying Man: Jonathan Borofsky," published in *ACM: The Journal of the Artists' Choice Museum* (Fall 1984), pp. 17–20; "Food for Centaurs," *Arts Magazine* (December 1991), pp. 46–7; "Jonathan Lasker," *New York Painters* (Munich: Sammlung Goetz, 1994), p. 36; "Body's Surplus: David Reed," *Sulfur* 27 (1990, the Fall issue), pp. 115–22.

13. "Contesting Leisure: Alex Katz and Eric Fischl" first appeared in *Artscribe* (London) (July 1986), pp. 45–7. It was occasioned by the exhibitions coincidentally held at the Whitney Museum of American Art in New York in 1986.

14. "Indeterminacy Meets Encyclopedia" is an unpublished essay commissioned by Kestutis Zapkus and the Lithuania Cultural Ministry.

15. "A Greenberg Retrospective" was published by *Partisan Review* 56 (Spring 1989), pp. 301–5.

16. "Abstractions: Barnett Newman and James Turrell" appeared in *Partisan Review* 59 (Spring 1992), pp. 328–32.

17. "A Literature of Silence" is a catalogue essay for *Nancy Haynes*, which was written on the occasion of an exhibition at the John Good Gallery in New York in 1993.

18. "Boulders from Flatland" was written for the catalogue of drawings by Jene Highstein on the occasion of an exhibition at the Southeastern Center for Contemporary Art in Winston-Salem, North Carolina, in 1996.

19. "Box, Aspects of: Donald Judd" has not been published previously.

20. "Quality Through Quantity: Donald Judd" has not been published previously.

21. The catalogue essay "Maquettes and Models: Siah Armajani and Hannes Brunner" originally appeared in The Swiss Institute's *Common Houses: Siah Armajani and Hannes Brunner* (New York: Swiss Institute, 1993), pp. 5–25.

22. Originally published in *Artstudio* 6 (Paris: Fall 1987), pp. 84–101, "Ideas of Order" then appeared in Adachiara Zevi, ed., *Sol LeWitt Testi Critici* (Rome: A.E.I.U.O., 1995), pp. 365–79.

23. "Contextualizing 'The Open Work,'" published in *Sulfur* 32 (Spring 1993), pp. 225–69, is a reworked critical statement that originally augmented "The Open Work," an exhibition organized by me for the John Good Gallery in New York in 1992.

Introduction

This is a collection of essays on art which variously engage the aesthetics of responses to Abstract Expressionism and the New York School. The essays were written over a twenty-year span beginning in the late 1970s. Having been published previously as reviews, catalogue essays, and conference papers, they reflect the vicissitudes of the times. Even so, under a rubric of art during the period following Abstract Expressionism, there do coalesce certain givens which these essays respect.

The art criticism gathered in *Signifying Art* does in part investigate the fate of the concept of the brushstroke, which became the focus of sense and significance in painting after 1945 – that is, from the 1950s through the 1980s. The brushstroke as *matière*, a material intuition prior to thought, was the sense conveyed through raw pigment on canvas that was often left unworked. (In sculpture the analogue would be found as materials left "as themselves" in assemblages.) At an opposite extreme the brushstroke, together with other formal elements of painting and sculpture, presented itself as a way to theorize about art within the artwork itself: The brushstroke became a sign of its own conventionality. Yet another sense, one derived from the brushstroke's being taken for granted as an appropriate instrumentality for expressivities of all kinds, may be said to have revisited Abstract Expressionism. No radical reexamination of the brushstroke, this last variety continued in the wake of Abstract Expressionism, consolidating Abstract Expressionism's gains.

Although the essays gathered in *Signifying Art* take for granted an art biased toward the brushstroke as the minimal unit of visual and cultural meaning, they also take for granted an art that is self-conscious of compositional structure and the idea of order as such, and they rely on the modern notion that to adopt an order of some kind is to propose a style and mentality. As a result of the profound nonobjective strategies conceived by Wassily Kandinsky, by Kasimir Malevich in Suprematism, by Vladimir Tatlin in Constructivism, and by the competitive partnership of Pablo Picasso and Georges Braque

in Cubism, unprecedented attention came to be paid to the creative organization of the available spatial field. In Analytic Cubism figure and ground conspicuously interpenetrate and disclose an even-handed formal logic wherein insides and outsides, fronts and backs, and far and near constitute a structure of relations. Thanks to these and other investigations into the ordering of space, art after World War II might measure its own achievement against these pioneering paradigms. By the 1950s, kinds of distributed order ranging from scatter to series – whether improvised or totally predetermined – carried the burden of meaning in music, dance, poetry, and visual art.

Indeed, the semantics of syntax that had determined style during the early twentieth century grew into a cultural preoccupation by the 1960s and 1970s, because by then constitutive orders had become identifiably signs of modern art.

<p style="text-align:center">✳</p>

The immediate historical touchstone for our present purposes is that of the miraculous year of 1948, when Jackson Pollock, following a longstanding tradition in the arts, declared his stylistic maturity by titling a painting by a kind of opus number: *Number 1*. In that same year Barnett Newman likewise staked his claim to style by naming a work *Onement 1*. These aesthetic declarations put the art world on notice, giving these artists both a form and a style to defend; at the same time, they were inciting others to answer with a style at least as necessary to art history as their own. Under one mode of description, the crux of Pollock's painting is a gesture made endless; under another description, it is a line made to incorporate space. Under either one – the expressive or formal description – Pollock's constitutive synthesis of stroke and all-over organization is seen to be a definitive form of modern art, if not its very signature, and it was soon to become a standard and stereotype. At the same time Newman's rending of space by line – organizing space with a single stroke – also codified a modern form. These stylistic manifestoes by both Pollock and Newman constituted a major aesthetic challenge for artists in the United States after World War II.

Without Europeans and others who had been displaced from their home countries in the 1930s and the 1940s by totalitarian regimes and by World War II, however, so-called American art would not have come about. This is a truism that the term New York School tends to disguise because, after all, the term New York

School designates a place not where artists crucial to the era were born but where they ended up. Since the 1930s, they had convened in New York as the diaspora of culture in Europe brought cosmo-politan artists from everywhere. A sophisticated intelligentsia – or at least a conspicuous sampling of that culture, one that might have been found in Berlin or Paris or Moscow – concentrated in New York and transformed the scene, so that American art came into maturity thanks to the cultural pressure put on the provincial culture in the United States from abroad. What this development entailed was the education of American artists in the forms of European modern art that developed in Germany, France, the Netherlands, and the Soviet Union. But it further entailed educating Americans in fundamental visual literacy: The language of form common to an understanding of abstract art and indeed of art in general – and one presupposed by Russian and Eastern European artists in formalism and structuralism by the second decade of the century – was trans-mitted from East to West as artists made their way from abroad. At any rate this critical mass of foreign art-world sophistication was indispensable to the creation of American art then and to its pres-ence on the world stage thereafter.

Strong affinities and antipathies to Abstract Expressionism, in particular, and within the New York School, in general, still gained momentum throughout the 1960s. First, the formal preoccupations of the New York School continued to provide a frame of reference for art strategies. It was not only the brushstroke and its aftermath that were continually at issue. The very definition of the art object and its significant history became the target of self-reference. Then the assumption that modernity is an ongoing project – or at least the topic to which the generations challenging it must refer – was evi-denced in the several vivid responses of color-field abstraction, Min-imalism, and Pop Art (or, by another description, in assemblages, installations, and events), all emerging at the time. Finally, the New York School set the standard for art that was proposing to over-throw or meet the challenge of significant cultural statement. With styles, modes, and genres of strong definition, the art of the 1960s emerged victorious in the contest against the normative artifacts which the New York School had brought forth.

A retrospective glance at the period underscores the fact that the New York School provoked several compelling antagonistic art strategies that formed in response to its influence. Although other narratives may be told, it may still be argued that throughout the

1970s, the influence of the New York School continued to develop –
as, for instance, both in the fact that the calligraphy designed by
Pollock may be said to be reenergized recursively in the drawings of
Philip Guston and in the codified style of mark in the paintings of
David Reed and (later) of Jonathan Lasker, as well as in the fact
that a palpable space optically conveyed gives Newman an heir not
only in the light installations of Dan Flavin but also in those liminal
environments of James Turrell.

<div align="center">*</div>

This book presupposes that the strong challenge to the New York
School is met with at least an intuited sense of strong narratives that
compel what's at stake for modern art history. For this reason, as
well as for the author's own situation (I was a student trained in art
history at Columbia University during the late 1960s), the essays
found in *Signifying Art* approach the art through issues internal to
the discipline. Stylistic analysis, one that presupposes an historical
sense of style as embedded cultural expression, is advanced to clar-
ify, interpret, and explain the art being considered.

Despite the postmodern dogma of philosophy without epistemol-
ogy, in its cultural relativism modern art history also acknowledges
its own hypothetical status as knowledge. By advocating the systems
of thought, values, and beliefs of proximate and remote cultures,
those that provide access to an organically derived cultural relativ-
ism, an art historian remains aware of his or her tastes; yet such
historians overrule these other systems of belief on behalf of the
aesthetics advanced by the inherited culture under discussion. Mean-
while, the fact that pure objectivity is impossible is not a source of
disillusionment.

As a critic, what I hope to contribute is the sense that art-
historically grounded judgment is an engaged mode of thought
rather than a holding pattern in archival practices. Again, because
to assert something is to hypothesize knowledge that (at least while
it is entertained) has the status of plausibility, art history provides
frames of reference that act as a check on an infinite regress of
interpretation as much as on the mood swings of opinion. Mean-
while, the hypothetical knowledge proposed by art history to be true
allows for much leeway in interpreting facts. A cultural perspective
on style, together with ideological analyses of empirical chronicles
as well as other objectifying perspectives that are at work in tradi-
tional art history, continues to be useful for art criticism; such per-

spectives remain useful even as experiments in phenomenological, hermeneutic, or (very different) semiotic interpretations render art-historically informed criticism receptive to creative readings of the art object. These are some of the assumptions of my own practice.

Signifying Art includes the frequent use of a stereoscopic perspective on art: Two or more essays on an artist's work appear in the book to show not only that ongoing engagement with significant work is worthwhile but also that language and thought play a role by subjecting knowledge to the creative process inherent in writing and signification. Instead of being based on an authorized sense of the art object – authorized, indeed, through the artist's intention, told again and again in profiles in magazines and official biographies – an essay that proffers a deviant classification may reveal the cultural codes of the artwork neglected in prior accounts. So when Julia Brown Turrell organized an exhibition of Robert Rauschenberg's art and proposed that I write the catalogue essay, what interested me critically was the perversity of her designation "sculpture," particularly since Rauschenberg had all along and without embarrassment advanced the notion of "combines," assemblages that trashed the distinctions between and mixed the categories of painting and sculpture. "What happens to change the meaning of the artifacts we call 'assemblages,' " I wondered, "if they are restored to the type named 'sculpture'?" "Pail for Ganymede" was the result. It appears together with "Texas, Japan, Etc.: Rauschenberg's Sense of Place," criticism written on the occasion of one of Rauschenberg's many mid-career exhibitions. Then again, in thinking about Judd's work, I noticed that the imputed signification altered considerably depending upon whether I considered his work to be "cubic" or "boxy" – to assume, in the first instance, the intention of geometric form and, in the second, the vernacular idiom. Thus, an essay emerged from a meditation on the description "box," one that explored how such a description embeds interpretation. "Box, Aspects of" appears along with "Quality Through Quantity," an essay which evaluates Judd's objects in the face of the presupposition about Minimalist art that whatever remains of content is uniformly present throughout its severely reductive form.

Meaning, then, establishes itself as a convention in part owing to the role language plays in the critical process. The selective, ideologically plotted account known as history is itself a description embedding an interpretation (and explanation) of events, one that relies on the artifacts privileged in such a set of linguistic choices even as the

critic at the same time advances open-ended "writerly" texts for discussion. Moreover, the critic's retelling of such a narrative in the reception of cultural history puts into play a narrative from a time distinct from that of the artifact. Whether or not a causal explanation of the state of affairs is forthcoming, the critic's language may well register cultural codes in the community of his or her contemporaries. There is no telling in advance whether a critic is conscious of this fact and will work the language advantageously.

Catalogue essays may frequently occasion such creative experiment and, ranging from the meditation to the prose poem, may suggest a creative role for criticism that engages the art object under scrutiny. Beyond this is a sociological point to be made concerning professional criticism. Adopting a belletristic style when writing catalogue essays reveals a certain professional constraint; in contrast to independent criticism, criticism in which the art critic is allowed intellectual freedom, the catalogue essay is, with rare exceptions, an occasion for advocacy – art appreciation rather than art criticism is what is mandated.

Critics well known for cultivating a rhetoric of style ranging from the metaphorical activism of Harold Rosenberg and John Berger to the literary structuralist and perpetually self-repudiating poststructuralist Roland Barthes (to name critics brought up for discussion in these pages) propose that language provides a necessarily subversive instrumentality that mediates between art and the viewer in the staged resistance to merchandising. Sometimes seen as an intervention, sometimes as an intrusion, literary discourse has come to lend strategies and tactics to art criticism in the closing decades of this century. In the 1950s the editor Tom Hess conceived *Art News* as a forum in which writing on art comprehended the scholarly and the poetic without slighting either area, and for the most part this was a vision of criticism that worked. From the late 1960s onward and at the expense of formal criticism, writing in art magazines received the imprint of the critic as creative author for whom, as suggested by semiologist Umberto Eco, the labyrinth provides a model for proliferating interpretations that are irreducible to a single explanatory or ideological viewpoint. It was this that I had in mind when publishing the text in the last chapter which was originally written to accompany an exhibition that I organized in a gallery, a text that argued in support of an alternative thesis to the essential definition of modernity. Now the closing piece in this book, "Contextualizing 'The

Open Work,' " amalgamates the once parallel account of the exhibition statement after the show had received critical reception.

In any event, reinterpreting artwork over time helps instill the sense that knowledge is hypothetical and in formation, however it may present itself through ideology and culture.

It is this last point I want to stress in relation to the contribution of art criticism to culture now. Rather than submitting to the opportunistic pluralism that passes for progressive thought, art criticism has a role to play in mediating between both sensibility and intellect – and with scruple, not convenience, in investigating the cultural content of style and matters of form, as well as in utilizing speculative instruments worthy of the task. It should be possible for description, interpretation, and evaluation to adjust to a shift in the cultural hierarchy of values and beliefs without imploding altogether. Art criticism may provide a mode of thought whereby speculative instruments – tools that are analytic and empirical, formal and stylistic, linguistic and philosophical – continue to test the received ideas of modern (and postmodern) culture.

<p style="text-align:center">✳</p>

I would like to acknowledge Pratt Institute for a grant given through the Faculty Development Fund to complete this book. I would further extend gratitude to my intellectual confidants, primarily Samuel Katz, Joseph Masheck, William S. Wilson, and the late Kathleen Hamel Peifer.

Narrating the
Hand

1

Pail for Ganymede
Rauschenberg's Sculpture

To consider Robert Rauschenberg a sculptor may seem self-defeating. First and last, Rauschenberg is not a sculptor – and perhaps not a painter, for that matter. For the central fiction prompted by him – and which readily became a signature – is that of an incorrigible talent working between categories: neither painting nor sculpture exactly, but painting with sculptural elements fabricated of and yet between both. As Rauschenberg put it, it is neither art exactly nor life – yet in between. Notoriously unruly in academic settings during his early period, Rauschenberg still goes about learning unconventionally. His activity is less about submitting to the disciplined craft of making objects studiously or even grappling with tradition and issues; it is rather more about urging materials to behave inventively. It would seem, therefore, that the category "sculpture" would be precisely the sort of genre from which Rauschenberg might most like to escape.

But precisely because the activity of this "escape artist" rests uneasily among categories of painting, sculpture, and performance, it becomes all the more interesting to suppose Rauschenberg a sculptor. What the current exhibition [*Rauschenberg: Sculpture*, at the Modern Art Museum of Fort Worth, Texas, October 1995] does not propose is that we have been working under a misconception all along and that he is now proved to be the sculptor we had been too preoccupied to see. Rather it presents the opportunity to hypothesize what would happen to our understanding of the work if it were considered as sculpture. Traditionally, the art of three dimensions has brought into being dense masses that take up space and dwell on the floor. How have the ABCs of the genre fared under Rauschenberg and what sort of art objects have resulted? Given this question, how might our subsequent interpretation of these objects' sculptural condition change?

Traditionally indispensable to the idea of sculpture is mass. Thus, when the enduring story of sculpture is told, it tends to seize on the modern conversion from mass to volume as one defining moment.

Because it is considered to be synonymous with working with stone, sculpture retains a close affiliation with massiveness even in translation to other substances. Weight, gravity, and other physical evidence of mass announce the presence of sculpture, but mass is the primary quality sufficient to the archaic idea.

At any rate, once construction muscled in on the ancient methods of carving and modeling, the nature of modern sculpture changed irrevocably. Although with the Industrial Revolution had come the nineteenth-century perforated masses of cast iron and skeins of cable made of steel thread, there also came even in workaday manufacture the material possibility for incorporating space into the mass that had been so stalwart. Volume – three-dimensionality without mass – emerges, then, as the necessary and sufficient sculptural expression; and for much of the twentieth century, it remains uncontested as such.

In this regard, Rauschenberg's early work, incorporating both mass and volume from the outset, would seem to be a cultural throwback to an energized industrial modernism; but it is in perfect accord with mid–twentieth-century archaism that is investigated experimentally. Moreover, his objects are mindful of certain key issues. The box tethering a rock, for instance, fulfills the requirements of being hollow and massive at once (*Untitled* [Elemental Sculpture], 1953): So unprepossessing as to not seem a sculpture at all, it also challenges European sensibility by flaunting a duality as though a unity. Culturally Zen, the early works by Rauschenberg proffer sculptural koans. Or as Walter Hopps says of another work, "In the plank with tethered stones, the traditional Japanese, Zenlike polycentric composition recalls important concerns of Rauschenberg's close friend [John] Cage."[1]

As a sculptor of masses and volumes, Rauschenberg assembled no better early example than a box into which he had sneaked a balsa cube sealed inside a translucent skin (*Untitled* [2] [Elemental Sculpture], 1953). Here is abstract sculptural thinking accomplished in the most rigorous terms; all we need to know about modern attitudes toward sculpture is being literally encapsulated in this material statement. This object further hypothesizes that this box, which might formerly have stored a variety of fetishes inside it, in the end contains more of itself. The interior, no less interesting for being about the space of which it is made, presents itself in palpable form in order to manifest itself as idea, and this paradox seems sufficient. After all, sculpture comprises space even as it takes up

space.[2] This work of Rauschenberg thus also admits to a subtle interrogation of matter.

The early sculptures are interesting because they draw our attention to their being bodies extended in space without having to resort to massiveness to do so. In fact, their very modesty helps articulate the fact that they are merely a piece of the world in which they exist. Made of planks and stones, these things resting on the floor of Rauschenberg's studio might be said to have caught the Kantian insight of things being intrinsically a part of the world's surrounding manifold and, in effect, accustoming us to the fact of this condition.

But extension in another sense is a trademark of the objects done early and late throughout this artist's career (see Figure 1). Not only *of* space, but *across* or *through* space, Rauschenberg's works actually link domains of space. With a length of rope between them,

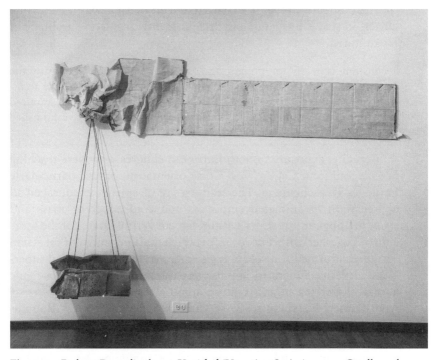

Figure 1. Robert Rauschenberg, *Untitled* (Venetian Series). 1973. Cardboard on plywood with objects, 62 × 97½ × 17 inches. Collection of the artist. © Robert Rauschenberg/Licensed by VAGA, New York. Photograph by Eric Pollitzer.

rock and wood are made into one thing materially extended along the floor. Observers have noted that this flexible reach favors matters alien to sculpture's fixed dimensions, and Rauschenberg will indeed exploit the palpable fluidity that chance composition and accidental viewer intervention lend to sculptural size. A late work illustrating this insight is the lightweight although architectonically extended *Sant'Agnese* (1973), which typically brings together contrary sculptural expectations. With an ethereal sensibility exuding from the least likely – because gawky – vehicle for such expression, the chair, which is seemingly in spatial translation, seems to be readying itself for the Surrealist domain of the marvelous. Remarkable is the blunt means Rauschenberg has of extending a thing: To get from point A to point B, connect the points – just do it.

Long before Rauschenberg emerged as an artist, floor plans of sequential or meandering volumes had well infiltrated American art from Europe and elsewhere; floor plans alternative to those of Europe are already integral to an American artist's way of creating objects in space. Early modern architects attentive to the aesthetic of Japan noted

a constant concern for human scale and an unfailing respect for the materials used, according to their nature. Above all, however, the architects of the organic movement (notably, Frank Lloyd Wright) admired the extensibility of the buildings and the permanent exchange established inside them between "inside" and "outside."[3]

Actually, exposure to both European emigrés who were teaching in exile and John Cage's West Coast orientalism proved particularly fertile for Rauschenberg. The aesthetics of receptivity encouraged an appreciation of animated emptiness and void, whereby mass and space are not contradictory entities but convertible states of the same entity. Together with European experimentation, traces of an Asian aesthetic informed Rauschenberg's early art; indeed, they had superseded a Native American impulse to explore personal fetishes made a year earlier (to note a culture admired by contemporary artists from Barnett Newman to Betty Parsons, in whose gallery Rauschenberg had a show in 1951). The artistic climate of the 1950s invited forays into non-European sculptural traditions, and Rauschenberg's early work intuits what's at stake in the contemporary scheme of things: Unintimidated in its rough-and-ready grasp of principle, it delivers the concrete architectonics of sculpture with an unmistakable expediency.[4]

At the floor, where nonchalant pragmatism meets pietistic respect for nature, Rauschenberg's sculptural bodies can be found. "Rauschenberg located sculpture on the floor; he put it there before [Mark] di Suvero," Mel Bochner has said.[5] Recent histories of sculpture celebrate the boldest moves from both mass to volume and verticality to horizontality, and in doing so, they dramatize the tale of the disappearing base.[6] Whether plinth or pedestal, the base is deemed to be a device of sculptural aura. In elevating sculpture, it gives aesthetic sanctuary to the object by designing the void that surrounds the thing. In this view, then, the base is no insignificant item, and some social histories of art maintain that the waning of the base in modern Europe occurs coincidentally with the increasing secularization of the art object.[7] Although not a coercive tale, it is a compelling one. Transfiguration of material into form was not set aside. Even so, when they chose to entail sculpture in social realities or to engage work with the immanentist sense of here and now, Edgar Degas, Auguste Rodin, Constantin Brancusi, Naum Gabo, and Alexander Calder shrunk the base (or dispensed with it altogether), thus contributing to the base's conceptual attrition.

Rauschenberg, however, does not respond to the urgency of this art-historical issue. Except for a few decisive engagements with categorical norms, Rauschenberg treats the history of sculpture casually. Absorbing as if by osmosis the Zen spirit of the times, Rauschenberg brought to this his own bohemian temperament, one that was comfortable with living on the floor. His knack for matter-of-fact placement is a consequence of his attempt to ignore categorical imperiousness rather than categorical imperatives; instead, other factors contribute to where his materials end up. Thanks to the experimental nature of Bauhaus-trained teachers with whom he worked at Black Mountain College, together with the casually obstreperous temperament of Rauschenberg himself, materials end up on the floor because the floor is where one works.[8] Better known for his will to blur the distinctions between wall and floor – as usual, by ignoring prohibitions – Rauschenberg nonetheless helps sharpen the definition of sculpture for others: If painting is an object on the wall, sculpture is an object on the floor, the place more amenable for doing and for making.[9] This, at any rate, was the radical definition some Minimalist and Conceptual artists imputed to Rauschenberg's practice.

Essentially built yet also essentially improvised, assemblage as sculpture shuns a material and formal core. Rauschenberg's way-

ward use of materials and procedures is no exception. His cobbling together of objects derives less from the idealization of the materials and processes that Constructivists believed would fulfill the promise of the Industrial Revolution than it does from the preindustrial methods afforded by scissors and paste. Collage and assemblage assimilate the effects of the machine age to the tinkerer of liberal persuasion, and the early history of collage shows that the anti-iconic impulse may be counted as a factor in some Dadaist artifacts and interventions that were performed in the aftermath of the meeting of collage and the subject of war. Kurt Schwitters, long considered an unrepentant formalist, encoded political and class disorder in his collages; and, like his French Cubist mentors, he made beautiful compositions from what art consumers then would have taken to be worthless. His boxed assemblages – three-dimensional collages laced with assemblages – are prototypes for the more formally omnivorous composites by Rauschenberg.

Built and improvised from what was close at hand is, for instance, *Paint Cans* (1954). Here, cylindrical volumes are encompassed in a rectilinear volume. This formal assertion is not all there is, because, already converted to studio use, the cylindrical cans have been nabbed from life and amassed and jammed in a crate that was once discarded but is now newly utilized.

Thematically, the implications are several. The studio props of the painter became sculpture and moved into greater prominence as art about art preoccupied Rauschenberg, Jasper Johns, and other artists during the 1960s.[10] Even more significant for Rauschenberg, however, is the fact that the tools of the trade and mere things attained equal stature; Rauschenberg neither quarantines things from tools nor tools from form – as if to say that mere stones in the road and chairs or packing crates, pillows or poles, of home and factory, are sculptural art in a primordial aspect.[11] This ethos brings with it its own thematics of work. As with that slapdash assemblage produced in Schwitters's "shop," *The Worker Picture* (1919), aesthetic perfection is not at issue; expediency, not craft, informs the way things and tools are manipulated. So if the repetitive modules of the paint cans owe something to the engineering that informs Constructivism, they also owe their uncouth framing within a crate to a cultivated naïveté and to primitivism as emulated by the moderns at large. Form is leveled to the status of improvised utility – and further: Fabricating a nonutilitarian utility potentially comprehends sculptural form.

Even so, the pots and pans of Rauschenberg's brusque construc-
tions could make the artist vulnerable to the challenge that he is no
artist but a tinkerer – Rauschenberg himself confessing the issue
potentially most damaging to his claim. Indeed, this issue has
haunted assemblage throughout its history.

Assemblage poses what the philosopher Richard Wollheim dubs
"the bricoleur problem."[12] 'Can art be made from life?' he seems to
ask, taking up Ernst Gombrich's argument that it cannot. Can scav-
enging and reusing found things be creative, or do these activities
default on the imaginative promptings intrinsic to art? Under this
aspect, "a work of art would threaten to be little more than an
assemblage or compilation of preexistent items."[13] But it is precisely
in the amalgam selected and made that the aesthetic intention de-
clares itself, replies Wollheim. For in that amalgam artists express
their own repertory of images, tending to choose not so randomly
after all. The individual given to bricolage may scavenge the environ-
ment for things and materials at hand, yet through this selective
assembly the artist expresses certain inner states peculiar to him or
her. For societies as well, assemblage affords an opportunity to
access matters of value or law – and thus gives range to concrete
thought.[14] No wonder – but reassuring all the same – that in this
sense the ancients can supply us with the terms of our discourse:
"[E]ach separate object of the natural world is discovered to be a
compound. Indeed, we still call it a concrete object. . . ."[15]

The composite nature of assemblage, especially when miscella-
neous, was both endorsed and debated in the 1961 exhibition *The
Art of Assemblage* and at an accompanying symposium. Organized
by William Seitz, this show codified a longstanding guerrilla prac-
tice, and, for evidence of this fact, one need look no farther than the
lineup of creative outlaws participating in the symposium: Marcel
Duchamp, Richard Huelsenbeck, and Robert Rauschenberg, to-
gether with the critic Lawrence Alloway and the historian Roger
Shattuck. Under consideration were composite works positing
strong juxtapositions.[16]

Included in that exhibition were Rauschenberg's *Talisman*
(1958) and *Canyon* (1959) – not the instantly memorable and decid-
edly upbeat *Coca-Cola Plan* (1958). Writers on this last work have
dwelt on the imagery of popular culture conspicuous in it, yet once
one gets past the dazzle of ordinary – even vulgar – Americana, one
sees that the challenge to sculpture as a genre rid of painting is
evident as well. A work that is built to hold the Coke bottles is a

surrogate for painting – or as Rauschenberg says, "a sketch for a stretcher."[17] Sculpturally speaking, the "figurines" of cast glass functioning formerly as soda bottles merely contribute sculptural elements to a visual mix more comprehensive and heterogeneous than anything traditionally statuesque. Surrealist in their heterogeneity and Neo-Dadaist because potentially anything goes,[18] the artifacts Rauschenberg spins out under the rubric of assemblage are nonetheless at odds with those of Dadaist predecessors.

Despite the presence of readymades derived from popular culture, Rauschenberg's objects register no trace of censure, none of the pangs of distress at the culture that Dadaists such as Huelsenbeck evinced in his works protesting the dehumanizing effect of commerce and technology. Cultural critics writing years before had taken note of the determination of American modernists to distinguish themselves both from Naturalism at home and the critical negativity from abroad:

Unlike Dada in Zurich, which arose primarily out of anti-war sentiment, an analogous spirit arose . . . against "an over-institutionalized world of stagnant statistics and antique axioms." The unstated problem for American artists, then, was to find ways to avoid both the encrustations of the academy and the vacuum of an a-historical American culture chasing after "Progress, Speed, Efficiency."[19]

Although ahistorical perhaps, Rauschenberg remains undeterred by prohibitions against accepting things contemporaneously co-present as they are – or as they might rearrange themselves in the collective imagination. Moreover, he's determined to encourage the assemblage to include a measure of inefficiency in the images generated.

Speaking on the *Art of Assemblage* panel, Rauschenberg had bristled at the defining term of juxtaposition being applied to his art: For him, the word suggested "a comparison" he was at pains to avoid.[20] Although not the implication meant, rivalry between parts seemed symptomatic of the dualistic form that he had replaced through canny choice and through heterogeneity in order to prevent assemblages from cohering too readily to icons of culture. A restless creativity that keeps materials in flux would persist throughout his career, although time has shown that his sculptures have become simpler even if they may go through phases of dualistic composition. The larger point, however, was well taken. That Rauschenberg doesn't distinguish among mere things, tools, and form shows that

in the history of modern sculpture, bodies do not always accrue; they sometimes agglomerate.

✳

"Object" is a term with special significance for modern art and has even replaced the word "sculpture" in most avant-garde lexicons. To gauge how far sculptural definitions have stretched to accommodate raggle-taggle assemblage, recall Rodin's passion for sculpture as mass animated from within. The term "object" arguably redefines the category of art with which it is most closely allied. Unlike sculpture, the object tolerates the fabricated thing – made, readymade, as well as "made-up" – that enhances the signs of its manufacture and artifice. As antithetical as are the styles of Constructivism and Surrealism, both engineering and tinkering impulses needed a term that acknowledges new modalities of concrete thinking, and "object" serves the purpose nicely. Sometimes it seems that terms proliferate, but as philosophers of art have pointed out, "sculpture" bespeaks a visual grammar profoundly at odds with assemblage's unnerving synthesis. A term neither chic nor quaint, "assemblage" drives a necessary linguistic wedge into the aestheticizing category we call sculpture. Objects are those assemblages that sculpture had once left unnamed.

The Surrealist object is a special kind of three-dimensional non sequitur, and like Joan Miró's *Poetic Object* (1936), it enjoys the luxury of suspending actual objects in fictive constellations that flicker with erotic innuendo. Yet the term "object" is also adopted by sculptors removed from any such pictorial poetics. Neither anecdotal nor symbolic, the Constructivist art done under the rubric "object" emphasizes the material and formal conditions of its existence, an immanentist world that the sculptor/writer William Tucker maintains stretches from Brancusi forward.[21] The concern that sculpture not be burdened by ministering to content extrinsic to it has led to the continual defense of sculptural objectivity. A recent descendant of Constructivism, the late Donald Judd has defended his use of the term "specific objects," which he has applied to his industrial boxes in series or sequence precisely to emphasize the arresting tectonic sensuousness that seeks to keep extracurricular story at bay.

Rauschenberg lays claim to both styles of objects, although with an aversion to keeping the object pure, he is much at home in the raggedy production that delighted the Surrealists. A work straddling

both Constructivism and Surrealism – as if that were even conceivable – does occur now and then. With its hand crank required to hoist the can within the box is *Pail for Ganymede* (1959), a charmingly irreverent example of mechanistic principle having replaced the vitalist and biological force. The criterion of integral, organic form is dumped; governed through viewer intervention, this object welcomes rather than disparages the principle of deus ex machina.[22]

For the most part, however, Rauschenberg's assemblage treats architectural and industrial members as grist for the dissociated kaleidoscope of urban life. In *Oracle* (1965), for instance, a junked window frame, vitrine, car door, and air duct mounted on wheels are house- or auto-body parts extended through a perceptual system dropped in from out of the blue. As though to take advantage of their somatic shape, Rauschenberg (helped by Bell Laboratory engineer Billy Klüver) rendered the hollow machine parts as though sculptural bodies were now synonymous with acoustical chambers – chambers appearing to propagate sound by virtue of the sound emanating from radios secreted within. Impressed by the image of an ear which Duchamp drew while doodling and already conversant with Cage's cross-channel dial-twirling radio pieces, Rauschenberg was primed for making sculptural bodies the source of aural effects at odds with their visual aspect.

Overlaying sight with sound unrelated to it is significant to Rauschenberg's generation. A composite object fabricated to preserve the independence of perceptual systems is constant in Cage's lifelong collaboration with the choreographer Merce Cunningham, and from these radical artists Rauschenberg learned much about the sensory stage. Throughout the 1960s, moreover, Rauschenberg, especially keen on collaborative semi-autonomous performance, grew increasingly disposed to technologically tweaked sculpture. If his French contemporary Jean Tinguely construed the idea of sculpture as a machine in the throes of kinetic frenzy, grinding maladjustment, and/or being blown to smithereens, Rauschenberg is more likely to keep breakdown at bay: To raise the energy of static sculptural elements, he adds a disconcerting kinesis to complicate sculptural presence with ambient surroundings. But for Rauschenberg, as decidedly for Cage, neither the stasis of sculptural things nor the aural static induced in sensory overlay signals a breakdown of technologies; they are merely a legitimate phenomenal expression. Silence and noise, rest and movement are all part of the informational equilibrium in which objects find themselves.

The performances that preoccupied Rauschenberg in the 1960s are beyond the scope of this exhibition – the performances, but not the sculptural residue they produced. Late evidence of this trend appears in his 1987 theatrical stage set for "Lateral Pass," a dance performance by Trisha Brown, which he assembled when the set created by Nancy Graves could not be unloaded during a Neapolitan dockworkers' strike. Once the installation was disassembled, the Neapolitan Gluts series (1989) resulted. So sculpture might then be redefined as an unwitting co-conspirator of events and situations that call for static things to be mobilized. Episodes like this also reinforce Rauschenberg's inclination to treat chaos – or the threat of chaos – as advantageous to art. Again, unlike the Dadaists, who utilized the principles of chance in militant statements against cultural chaos, Rauschenberg welcomes chaos as the provocateur and also the fortunate source of sculptural beauty.

Sculpture, the static byproduct of situations in flux, may reveal the instability inherent in equilibrium, but in Rauschenberg's scheme of things, it is an instability that is exciting, not pathetic. The objects that precipitate from activity become immediately available for re-sourceful use – filled with potential energy, culturally speaking. Perhaps this acceptance of inherently devolving situations – this ability to see opportunity in decay and waste – has allowed Rauschenberg to remain comfortable producing objects, for the most part, not systems.[23]

As Rauschenberg conceives it, the art object is an idea commodious enough. It is potentially inclusive of all materials and things, as the notorious *Bed* (1955) would prove (see Figure 2), it is receptive to traditional crafts and industrial processes, and it is amenable to cultural upheaval. In this last capacity, it could be said to mark the state of affairs – or even to sensitize us to the state of affairs – of Main Street silted up with material information. Sculpture as a category of thought is renovated to take in the world of the artifact. Constrained only by the rules of discontinuity that give to the assemblages before our eyes violent syntax, such artifacts even more broadly reinvigorate sculpture's "expanded field."[24] For if sculpture is demonstrably known through its exercise of spatial properties, then putting sculpture through its dimensional paces helps to define sculpture's identity. Dislodging an element by cranking it up – counter to the gravitational forces proper to sculpture – is one of these exercises. Ensuring that sculpture physically extends itself through sound and movement and modes of activity no less palpable

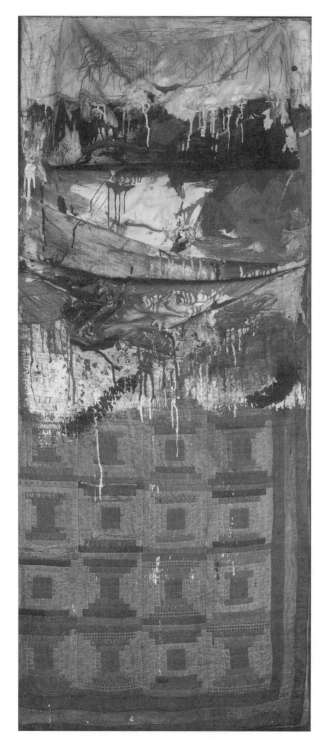

for being immaterial is another of these exercises. Meanwhile, even as Rauschenberg aggravates the conventions of sculpture, the vocabulary of the discipline has in turn come to reflect what sculpture has become. To restate the point: "Assemblage" is a term reflecting the need for a new category of sculpture when contra-standard artifacts come about, whereas "object" encompasses sculpture more comprehensively.

<p style="text-align:center">✳</p>

Rauschenberg is best known for making art objects of found objects, of turning familiar discards to unexpected use. Early and late in his career, however, he has favored alternating these unexpected composites with a prompting naturalism in the found object for a refreshed existence. What Rauschenberg is after is a perennial rejuvenation of materials and things brought together serendipitously; but these days, the composite object that results does not always prove itself through abrupt caprice, and juxtaposition is less marked. At times, his prevailing mode of bricolage recedes to make way for an homage to materials and physical principles: This is how he began his career, and he has never entirely forgotten that, under favorable circumstances, merely indicating the floor can be an utterance; merely spanning floor and wall can decisively define the domain of "in-between." Meanwhile, true to his offbeat formal training, Rauschenberg continues to show he is a master at hybridizing traits to rejuvenate the sculptural stock.

Setting one thing against another alternates with re-presenting natural properties. This nonironic demonstration is more difficult than it seems. In subsequent waves of young assemblagists who are "doing art" now, few seem to grasp the principles that convert a thing into itself that is heightened exponentially. The Cardboard series (1971) is an example of Rauschenberg's ability to return the things to themselves with startling self-evidence. The Jammers series (1976) is another; with cloth and pole, and little else, the works in the series are entirely true to their natures yet altogether cohere in

Figure 2. *Facing page:* Robert Rauschenberg, *Bed.* 1955. Combine painting: Oil and pencil on pillow, quilt, and sheet on wood supports, 6'¾" × 31½" × 8" (19.1 × 80 × 20.3 cm). The Museum of Modern Art, New York. © Robert Rauschenberg/Licensed by VAGA, New York. Gift of Leo Castelli in honor of Alfred H. Barr, Jr. Photograph © 1998 The Museum of Modern Art, New York.

an instant of perception – "instants of perception," Leo Steinberg says somewhere about the nonchalant bricolage of Picasso's sculptural objects. In *Untitled* (from the Jammers series), the paint cans typically so adaptable to sculptural purpose appear to introduce variable form. Gravity will compose and recompose these elements for us; and with their interiors painted to draw attention to the volumetric sculptural proposition, the cans also disperse the sculptural body. In effect, the entire Jammers series expresses a nomadic self-sufficiency. Coming after a period in Rauschenberg's oeuvre of intensively scheduled public performance pieces, and coming after the assemblages that flaunted industrial materials and corporate reach, these "Jammers" propose simplicity. Resourcefulness, not novelty, is their strength.[25]

Rauschenberg's contribution to sculpture, then, may ultimately find its truest expression in a particularly informed kind of finesse. Working from modesty of means to strength of imaginary form, he has devoted his energies to realizing sculpture as the site of the nonprogrammatic object. Extended yet materially fugitive or attenuated things made by Rauschenberg constantly demonstrate the latent possibility of what Heidegger called matters at hand. Commonplace objects fallen derelict as well as the commonplaces of place and position have become conceivable as sculptural property: mass/volume, floor/wall, translation/rotation/oscillation – structural issues, together with certain cultural issues challenging both craft and style, which in turn implicitly govern form, may lend Rauschenberg's three-dimensional chance encounters the air of paradox. Arbitrary inevitability of the commonplace is Rauschenberg's specialty.

The nonprogrammatic object may have displaced sculpture as a genre. If so, then certainly Rauschenberg has been instrumental in giving the changeover credibility. Given the multitudes of assemblagists who now presuppose Rauschenberg's work, the expectations for improvised sculpture are those Rauschenberg helped expose and establish. As the Kabal American Zephyr series (1981–82) illustrates, he has reinforced the tradition of assemblage at least as much as he has helped instigate new approaches. Yet he has a tactical repertoire wider than most assemblagists; moreover, with Rauschenberg, bricolage is no mannerism, for throughout his career it has been integral to his specific artistic style. Ignoring function yet not structure, he will convert the spout of a gas can into the receptacle for a fly swatter (*Ginger* [1983]). The nonprogrammatic object begins, then, to convert use even as it leaves undisturbed the tool's

working parts. Like the mere indication of site in the 1960s and 1970s by artists contriving invisibility within the environment, mention of use carries with it a noninterventionist intention for sculpture that owes much to Rauschenberg's assumption that the tool is interesting in itself. Returning a thing to its nature may be less dramatic than the formal transgressions that made him famous, but both activities center on the objective nature of properties in varying manifestations. In consequence, the genre of sculpture is shown to be much more tractable than presupposed, and it can be readily dissolved within the broadly cultural making and unmaking of the artifact.

If his response to Abstract Expressionism remains his most radical contribution to art, Rauschenberg's ongoing practice of scavenging to put materials and discards in circulation again instructs the nonprogrammatic object in the ways of the world. Technology as the artist's natural ally, not a superstitious threat, is a state of affairs Rauschenberg has appreciated since accepting his childhood environment – the coastal industrial habitat of Port Arthur, Texas. Technology as beneficial and creative rather than as alien is something he has understood since his youthful apprenticeship as a medical technician. No wonder why, in his work, the machine-made and the handmade are subject to the same eclectic fervor for technological and environmental themes. Other artists stage a crisis over technology; Rauschenberg has always assumed that culture and nature are already integrated, and his artifacts are continually expressing this truth as fact.

That things and tools and form are commutational entities is in itself a revelation, brought about as Rauschenberg goes about his sculptural business.

2

Texas, Japan, Etc.
Rauschenberg's Sense of Place

I once asked Robert Rauschenberg why he travels so much. He answered,

I'm tired of sitting around in bars like artists used to and arguing about one line or another. I think those days are fairly obsolete. It used to be nourishment in the days of the Cedar Tavern when I first came to New York. And for the cost of a beer (and sometimes I didn't have to pay for it – it was only ten cents anyway), to be able to have a conversation with – or listen to – Mark Rothko, Ad Reinhardt, Franz Kline, Willem de Kooning, Jack Tworkov. I mean, God, that's a real bargain.[1]

Always on the move, Rauschenberg had been traveling more to feel "the impact of different societies and different cultures"[2] – to Mexico and Chile, China and Tibet – thanks to the Rauschenberg Overseas Cultural Interchange (ROCI), an organization he initiated in 1983 to sponsor his artistic tours. Traveling the cultural world for inspiration rather than to absorb it from the cosmopolitan center of the art world points to a shift in Rauschenberg's life. But does it point to a shift in his art? Given his lifelong restlessness and his far-flung travels, the relevance of place to the style of Rauschenberg's incorrigible artifacts is, at any rate, an obvious matter to consider.

The specific occasion for thinking about the impact of place on Rauschenberg's style was the exhibition of his work at the Contemporary Arts Museum in Houston to help celebrate the 150th anniversary of Texas's statehood. What better choice to inaugurate Texas's sesquicentennial than Rauschenberg, the state's flagship artist who was born in Port Arthur sixty years before (the same community that spawned Janis Joplin) and ranked far and away as Texas's most celebrated visual artist. After closing in March 1986, the exhibition traveled to Dallas, San Antonio, and Corpus Christi on a two-year tour of the state.[3]

A patriotic occasion, the Texas sesquicentennial celebrated that which is indigenous to the culture and proclaimed these local elements to be evidence of a regional identity. But regional ethos may

be appreciated as long as it is taken lightly. Appropriate to the spirit of this sentimental occasion, remembrance of growing up in a culturally deprived corner of Texas, in the instance of Rauschenberg, proves to be much less important than his independent attitude toward his situation.

The exhibition, compiled from recent work, was best seen as a flashback, not a retrospective, of Rauschenberg's artistic independence. (Nor would a retrospective have been appropriate coming so soon after the mammoth shows of his work that had toured the United States in 1976–77 and Europe in 1980.) Scattered throughout the elongated diamond of the Contemporary Arts Museum were the Cardboard series from 1971, the Hoarfrost series from 1974–75, the Kabal American Zephyr series that was done in 1981–82, and the Bifocal series from 1982 – with the four series hung not chronologically but scrambled. Not only the temporal order but the physical installation in the museum was playfully chaotic. Anarchy prevailed, with theatrical pieces off-axis and unprepossessing constructions lying directly in the viewer's line of sight. Nothing was where it ought to have been in that impure museum installation – and, of course, this was its purpose. An arrangement lacking a single reference point but accommodating many is perhaps the best orientation to Rauschenberg's aesthetic, and the museum's choice to scramble the sequence of works, decentralizing the art visually as well, provided an ideal introduction to the artist's unique vision. For the uninitiated, the installation was inviting and friendly; for veteran viewers, it rescued a show of familiar work from easy delectation and gave it its most compelling aspect.

*

The clichés about Texas – that it is big and flat – offer facile analogies to an art whose creator should be celebrated for having forfeited illustrative homage to the region; Rauschenberg's work is certainly not regarded as commemorative regionalism. If Rauschenberg is the artist of the American scene, his topic comes by way of experience, not ideology. The landscape of his formative memories of growing up in Texas is particular, if not unique, to Port Arthur. As he has said, "My memories are terribly local; that you could tell the direction the wind was blowing because of the smell [coming from the oil refinery]; that we were close to the beach, and that the beach was covered with an oil slick. But as a child, this is your pleasure."[4] That which is local, not locale, is relevant to Rauschenberg. The experi-

ences that disgust an adult are free from taint in a child's point of view. If Rauschenberg's coastal memories are not very pretty, neither are they to be construed as aesthetically ignominious. Flotsam from the beach and trash from town are not visually disgraceful – at least not in the uninhibited assemblages that Rauschenberg learned to make of them.

Rauschenberg's childhood reality evidently led to a totally atypical vision of landscape. "In Texas, you can either see over something or see past it," he says. "You can either run over something or run past it"[5] – a tantalizing statement, to say the least, suggesting several meanings key to his aesthetic. Foremost, his comment seems to be a response to a spacious if easily mastered environment in which a person's relation to things is more stimulating than the things found in it. There is the sense that the given world is not so much empty as filled with commonplaces a person is free to respect, manipulate, or ignore – perhaps accomplishing all these at once. Here is the origin, perhaps, of Rauschenberg's aesthetic attitude, a hyperactive disinterestedness that springs as much from temperament as environment, expressing itself in a reckless handling of place. Contrast his indifference to the scenic to the willed veneration of agrarian locale to which Grant Wood was so devoted. To do so is to realize that Rauschenberg is infinitely more matter-of-fact toward landscape and infinitely more imaginative in his transformation of it than the regionalist ever dreamed possible.

If there is a further observation to be made from all this, it is that Rauschenberg is scavenger – regardless of region. Trash is a free spirit, and it is available as much in one place as another. The "Cardboards" which were on view at the Contemporary Arts Museum in Houston come from the artist who had made peace with whatever was available on Captiva, an island off the coast of Florida where he moved in 1971, as much as from the artist who could see over things at Port Arthur or scavenge the streets of New York. The Cardboard series was, in fact, the first one done after his move from New York to Florida; wary of doing "beachcraft," he chose cartons to work with because they are universal detritus. Torn, flattened, and mounted on the wall as if they were art, these "Cardboards" exist on the periphery of culture, *objets trouvés* that commerce has washed up for us to consider. Their appeal is precisely this imaginative formulation of an object redefining art before our eyes. The quality that characterizes the best of these homeless "Cardboards" is not so much the recycling of waste that civilization has both

discarded and taken for granted, but the kind of creativity T. S. Eliot discerned in "thinking immediately at the tips of the senses."[6]

Yet the issue of place haunted the exhibition at the Contemporary Arts Museum, for everywhere in evidence was Rauschenberg's romance with exotic images. Although no part of the series came about while he was traveling, the Kabal American Zephyr series was produced concurrently with the Japanese Clayworks series and the Chinese collages that were exhibited in two gallery shows in New York in 1983. The remarkable feature of those shows was the quantity of art on display, not the impact of travel to China on, say, the hundred-foot-long photomontage bisecting one of the galleries. That spectacular scroll of images from that country seemed a rather characteristic idiosyncrasy within the eccentric invention we had come to expect from the artist.

Generally speaking, materials, images from exotic lands, and even format have had relatively little impact on Rauschenberg's style. In the Kabal American Zephyr series, once again, "found" nature and contrived technology are driven together, and the technological support is invariably spread with images of travel appropriated from magazines. "Why select one image over another?" I asked Rauschenberg. "If it's insignificant, but interesting, if it doesn't make a single point, then it's mine," he said.[7]

Images clipped from magazines (such as *Scientific American* and *National Geographic*), which were then brushed with a solvent transfer and pressed onto the wood veneer panels comprising the technological element, were standard procedure for Rauschenberg at this time. Incorporated into one of the images in the Kabal American Zephyr series, *The Interloper Tries His Disguises* (1982) is comprised (along with tire treads and a wheel) of Asian images functionally indistinguishable from the "insignificant, but interesting" images representing other cultures around the globe that paper this series. That which identifies Rauschenberg's style – his discontinuous, roving imagination – is equally available to all his work. Travel is surely on the artist's mind, but not for the sake of doing ethnological studies.[8]

This stylistic fixity of Rauschenberg's oeuvre persists despite the artist's declared intention that he wants to collaborate with foreign cultures. His humanitarian impulse is well known. Charitable at home, giving money to underwrite young artists' shows or to cover the costs of needy artists' hospital bills, Rauschenberg began traveling on his own behalf to exhibit his art and to make art for the

purpose of exposing foreign artisans to his creative process. But he also traveled because he wanted to give the countries he visited the art he made there along with something else to remember beyond his own personal self-promotion – for instance, the help of a crew sent in advance of his scheduled show in Santiago to repair that city's National Museum of Fine Arts (its dome, originally designed by Eiffel), which had been severely damaged in the 1984 earthquake. Still, fellow-feeling is not to be confused with reciprocal artistic influence. At least, to judge by the Chinese paperworks and the Japanese Clayworks (in these efforts he enlisted the help of local artisans to produce his own work), his use of native techniques resulted not so much in a collaboration of cultures (as he had once collaborated with Merce Cunningham and John Cage, pooling their aesthetic independence) as in something quite different: a transposition of a Rauschenberg into an exotic version of itself. In this sense Rauschenberg travels not to experience but to express – to express his own artistic suppositions. To see past the given image to the visual event of his own making overrides all other considerations.

<p style="text-align:center">✳</p>

The flashback of art from the 1970s, "Made in U.S.A.," along with the memory of work done concurrently while abroad, suggested that however much Rauschenberg may travel to do art, his work is not about place: It is about the euphoria of sight. Rauschenberg may not be studious, but he is engaged in an activity in which the scavenging of materials and images is merely the starting point for the liberty and ascendancy of our visual world. As behavioral studies of early childhood have shown, exercising our senses is preliminary to play, and play is preliminary to genuine and original creativity. Piaget recalls a child who, having developed the habit of bending back to look at the world upside down, soon evolved the practice of bending back for its own sake, laughing as he did so.[9] Considering the world from different viewpoints is not frivolous but intrinsic to the evolution of symbolic thought.

Early modernism is, to a considerable extent, synonymous with such play. The ludic impulse of Kandinsky, Matisse, and Picasso is not excessive energy that spills into play once work is done, but, as ultimately human, it is intrinsic to creativity of any kind, whether its goals are functional or functionless. As Friedrich Schiller realized, play is indispensable to artists. In particular, play has enabled modern artists to invite fugitive materials and transient perspectives to

collaborate with autonomous form; and Cubism has been instrumental in this process. Thinking with Cubism, Picasso and Braque uncovered limitless possibilities in pictorial structure; Kurt Schwitters expanded and perfected the art's material possibilities through collage.

Rauschenberg benefited from these aesthetic advances after a youth lived with a high tolerance for anarchy and an enormous capacity for uncensored play put the entire realm of sight at art's disposal. He first gained notoriety from a disposition that is fundamentally unintimidated by the vernacular materials, images, and objects found in the actual world; but he owes his importance to a greater power. As the originality of Merce Cunningham stemmed from his definition of dance as movement – and that of John Cage came from his definition of music as sound – Rauschenberg's undeniable contribution began in his definition of art as sight. That eagles and tires cohabit with paint is nothing compared to the conceptual leverage of the generalization that visual art is about opening up imaginary perspectives from within the world of sight as such.

<div align="center">✴</div>

Pleasing variants of early, tougher work or unfocused interpretations of new ideas render some recent work less than it should be. Among the better works in the Kabal American Zephyr series are *Pegasus' First Visit to America in the Shade of the Flatiron Building* (1982) and *The Ghost of the Melted Bell* (1981) (see Figure 3). The latter is an instance of expedient bricolage: an artifact via improvisation in which the playful impulse of beachcombing joins forces with and is redeemed by the utility of traditional Japanese packaging. In traditional Japanese practice, natural materials such as bark are pulled around an airtight sushi box to hold it fast, or a sheaf of bamboo is folded over a bit of candy preserves with its own secreted pectin. In Rauschenberg's improvisatory version of this economy, a weathered truss of wood, one which supported both a pillow painted shell-pink and sand, is lashed and nailed together with a direct functional clarity that refreshes.

The Ghost of the Melted Bell is a lovely piece, but compared to *Bed* (1955) – a masterpiece of disjunction – *Ghost* is courteous (see p. 33). To those of us who believe the disjunction of collage to be a significant form of thought, such structural loveliness as *Ghost* produces is not enough; the part-to-part and part-to-whole spatial relationships are expected, and the imaginary perspectives are un-

challenging. Writer Donald Barthelme once said, "The principle of collage is the central principle of all art in the twentieth century of all media."[10] A collagist in his own writing (and a native Texan), Barthelme was the perfect choice to write the catalogue appreciation for the 1985–86 Texas show. He writes nostalgically, however, for in his essay "Being Bad," he praises the messy and disjunctive composition of the work, but he does so as if addressing the imaginative toughness of the art he had loved twenty years before.[11]

It was tempting to blame lyrical sensibility for the ingratiating mentality of the Texas Sesquicentennial Exhibition at the Contemporary Arts Museum, but to have done so would have been to fall victim to an all-too-common prejudice. Lyricism in art is almost always dismissed as weak, but neither pastel color nor calibrated tonality is in itself tasteful, as anyone who knows Cézanne's watercolors of Mont Sainte-Victoire and Monet's late waterlilies can attest. If Cézanne and Monet are historically significant, it is because they are aesthetically (which is to say, philosophically) tough – providing art with, as Maurice Denis remarked, a new synthetic order of the world. In any event, material loveliness does not necessarily render art intellectually soft, and, in fact, the physically pliable and delicate Hoarfrost series was collectively the toughest series in the exhibition. In this instance, to run over vernacular objects with a fine translucence – cloth, or cloth impressed with the world of representations – is to go beyond design. It is a superimposition in the modernist sense of that term, a layering of principles of nature and culture in a rigorous – and beautiful – way.

Critics often describe Picasso's gargantuan output as prolific. Intended as a compliment, the term "prolific" has nevertheless always seemed to me to be a euphemism used by critics for "unedited productivity." Rauschenberg, too, always prolific, admits to some of the artistic impatience he attributes to his hero, Picasso. When, during our 1985 interview, I observed that, although his objects often show a wonderful spontaneity, sometimes (thinking of the Janus-faced cardboard in the Bifocal series) they are too casual, too breezy, he answered, "They are only supposed to be an invitation to your life, not a monument to my permanence."[12]

For those who are conversant with Rauschenberg's career, it is clear he has never been engaged in the pursuit of masterpieces. Still, his poetic answer points to an underlying question nagging many contemporary artists: whether to give priority to transient activity or to permanent form. Fluxus and Arte Povera are art movements

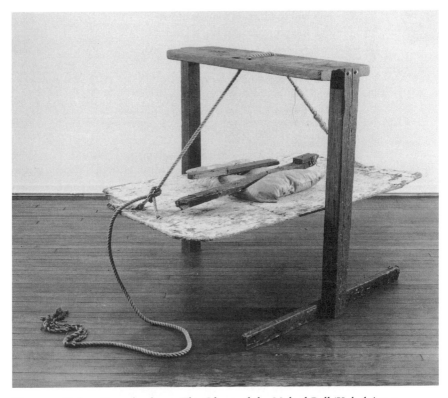

Figure 3. Robert Rauschenberg, *The Ghost of the Melted Bell* (Kabal American Zephyr series). 1981. Assembled construction with acrylic paint, 48¾ × 51½ × 66¾ inches. Collection of Robert and Jane Meyerhoff, Phoenix, Maryland. © Robert Rauschenberg/Licensed by VAGA, New York. Photograph by Emil Frey.

that attempt to radicalize the ephemeral, the transient. Each in its own way proposes an ideology of placelessness that gives priority to artistic activity and promotes scavenging and giving temporary shelter to materials that society not only had discarded but had set adrift from their physical and cultural contexts. Compared to practitioners of Fluxus and Arte Povera, however, Rauschenberg is both more intuitive and more object-conscious: He is surely more formalist. The issue for him to face, then, would seem to be that, although the aesthetics of scavenging and sensitized play seem to militate against selection and judgment, such judgment is necessary for flux to remain intelligent. Wallace Stevens offers some advice on this matter. He says,

There was a will to change, a necessitous
And present way, a presentation, a kind
Of volatile world, too constant to be denied,

The eye of a vagabond in a metaphor
That catches our own. The casual is not
Enough. The freshness of transformation is

The freshness of a world.[13]

If there is an ingratiating aspect to Rauschenberg's recent work, it comes by way of rationalizing weak artistic decisions as necessary byproducts of the flux of productivity. This stance is not worthy of him, for what he makes of what his vagabond eye sees matters very much. Sloppiness or neatness isn't the remedy; advanced or strenuous application is. When traveling, Rauschenberg, unlike most tourists, does not want to possess a country or capture it by photographing its landmarks; but at home, whether he admits it or not, he has indeed created landmarks, and these landmarks have always been built of insignificant materials transformed by a significant imaginative perspective.

3

The Art of Cy Twombly

EARLY PAINTINGS

At the very heart of picture-making are the marks an artist puts on canvas. These marks go beyond depiction yet constitute the still lifes and scenes that comfort us and extend our aesthetic horizons – illusions promoted through the visual matter that constitutes them. An artist's initial encounter with the canvas, however, is not very noble. A smudge, a dot, a line, a smear – all seem to be such unpromising pictorial expressions. Physically slight though they may be, these touches are not too meager to signify any bit of knowledge or feeling that the painting as a whole can signify. In a major sense, then, a painting's entire resources are documented in the brushstrokes comprising it. No one understands this better than Cy Twombly, who has devoted himself throughout his reticent career to an exploration of the expressive potential of the mark – to him, the smallest meaningful unit of painting.

What Twombly offers us is a vision of how the language of painting comes into being – and how physical impulse inflected by content grows, sustains, and questions itself in visual terms. This is accomplished when impulse breeds gesture and rudimentary image – yet remains exploratory and vulnerable throughout the process. Impulse remains exploratory because it is searching for a pictorial solution whose outcome is unknown, and it is vulnerable due to a sense of inadequacy to the task at hand. Suspended between coming and going, Twombly's small, disconnected touches also carry the sense of being forever hypothetical, doomed to partake in an open-ended discourse on painting where marks will continue to accrue without ever arriving at a definition of painting. But his small discontinuities suggest more than the tentativeness of formal ontologies. They also show concision and the intensity of complex meaning presented in a tight compass. So although it is customary to speak of Twombly's seismic touches as displaying great sensitivity, apparent, too, is the great concentration of meaning stored within these touches.

An overview of Twombly's development reveals that his concisely notated sensation and feeling grew in advance of his notation for rational thought. In the mid-1950s, guided by the attitudes and methods of both the Fauves and Surrealists – who placed great value on artistic vitality uncontaminated by sophisticated modes of seeing – Twombly evolved a style of painting originating in the childlike scrawl. Ethereal lines that grope their way down the canvas in a felt approximation of something that cannot be visually defined by line – as well as emphatic, sensual points that attest to momentary passion – make their appearance in Twombly's work. Isolated or mixed, these marks in pencil, crayon, and white oil paint soon come to share the comprehensive space with numerals, flowers, and breasts, although these verbal designations seem too articulate for the visual ingredients that appear so rudimentary and in such disarray on the canvases – that is, not only the diction but the syntax of painting contributes to the emotionality here. Indeed, the incoherent composition suggests that disarray itself is a passionate organization heedless of formal propriety but receptive to the venting of emotion and pleasure.

However expressive they may be, Twombly's early compositions – drawn and written more than painted – were pervaded by the immateriality of their origins. But by 1961 his passionate encyclopedia of subject matter and mediums became intensely physical. Blobs and smears of pigment – reds, browns, pinks, and black, sometimes introduced straight from the tube – now hang on the canvas almost totally undifferentiated as form, yet they are fully expressive of visceral or organic substance with a crudity that drives the art toward luscious beauty. This forceful reintroduction of matter, from which Twombly had abstained for a decade, perhaps occurs at this point in time because the artist was ready to add pigment and color to his formal inventory now that he had explored some of the primitive potential of line. As with his penciled images, the impulsive stabs recall the art of very young children, but they neither captivate us with the nostalgia for simple things nor, as the Surrealists did in their own work, extol the involuntary emissions of the psyche. Along with the Abstract Expressionists, Twombly puts these attitudes in the service of visual considerations so that in his work, line and color at their most formative are also highly formalist in character. His intention is to go beyond the act of painting as practice toward the act of painting as theory; and being analytical and given to classifying, Twombly has set about examining the ramifica-

tions of form that the mark encompasses so concisely. Respectful of the scrawl's indeterminacy, he seeks to derive writing as well as drawing and painting from marks of their common origin in order to isolate the salient properties and principles that identify each uniquely.

When Twombly shifted from a notation of passion to a notation of rationality, he extended rather than denied the expressive range of the mark. With this shift, he began to focus on the mark's tendency to measure itself in space as if it were a reasoning tool that is also a trace of the reasoning process itself. By the late 1960s, he had created a format consonant with this rational inquiry. Its paradigm might be considered the spare paintings of 1969 that were surfaced in gray house paint and incised with a pair of lines and numbers that calculate simple length and present scalar relationship (although in most paintings of this phase, white crayon rather than the wooden end of the brush does the writing). This sparely rational statement in other paintings builds into ambitious plans that are poetic analogues of mathematical calculations and military operations – and that reflect the way a blackboard might record theoretical fervor. Miraculously, these poetic analogues for thinking are not at all coy. One likely reason is that Twombly's feverish diagrams do not seek to compete with science on its own terms, but rather, through touch and composition, they attempt to remain postulates of the imagination. Moreover, in the utterly simple designs, an unsure, revisionary quality to the line conveys not thinking but the feeling of learning how to think – of grappling with the uncertainty of finding a solution, intellectual or otherwise.

In a complementary pursuit Twombly has created art in which mental activity cedes to manual dexterity, the skill involved with learning how to write. Again, Twombly's procedures locate this activity in childhood. Whether done with pencil and chalk on paper or with crayon on gray-painted canvas, his rows of continuous circles recall the earliest Palmer exercises given to children to convert their scrawling and printing into cursive script by encouraging motor control and stamina for writing mechanically well-formed letters, words, and sentences. In Twombly's primer, both the marks and their visual grammar reflect his purpose. The continuity of the loops or the zigzag lines, together with the intervallic regularity from row to row, creates a syntax of coherence that we associate with competency in discourse – discourse that, although not specific or verbal, is nonetheless evoked through a generic grammatical envelope.

So too are mathematical and literary forms made contingent on the ruminative marks that produce them, and this formal dependency is intrinsic to Twombly's art. If Twombly's rhetoric appears natural as well as naturally caused, it is because this rhetoric has been allowed to drift into the mark by accident or inadvertence early on – and later cultivated and consciously isolated. It is tempting to interpret this process developmentally as a process in which a mark, in all its inchoate essence, gradually assumes coherence – that is, it becomes particularity in a world where such consciousness is desirable and where specialization leads to expertise. But it is also true that, for Twombly, the formative scrawl is already fully formed, a network of meaning fully expressive in its own right and not inferior for creative purposes. Nor is mature rhetoric ever so complete that immediacy and indeterminacy are forgotten. Whatever their calligraphy, the marks establish a sense of their being experiential and inquiring, even as they exist as signs of the conventional typology of drawing, painting, and writing. And because the conceptual product is inscribed by process, we appreciate Twombly's proposal that these marks – even the most unpromising – are speculative instruments perennially delving into the nature of their own visual existence. At no point in this questing process is the mark meaningless, Twombly seems to say, and so far his claim has been compelling.

If much is implied by Twombly's notation, much is expressed through it. Neither aimless effusions nor arid exercises, his touches encapsulate both rich content and strong signifying purpose; his ability to empower the mark with a capacity to delineate as well as embody the flux of visual expression is remarkable.

A DISCOURSE ON TWOMBLY

Emerging as a young Abstract Expressionist in the early 1950s, Cy Twombly received strong critical acclaim when, by exchanging his brush for a pencil, he further clarified the Surrealist notion of drawing as the rudimentary source of both writing and painting – that is, of both visual and verbal impulses. A quarter of a century later, two New York exhibitions – a modestly scaled retrospective at the Whitney Museum and an ambitious new multicanvas work at the Heiner Friedrich Gallery – revealed how Twombly's vision had developed and where he stood at mid-career.[1]

Cy Twombly: Paintings and Drawings 1954–1977, a show at the Whitney, was what guest curator David Whitney intended it to be: "an intelligible encapsulation" of Twombly's career.[2] Moreover, since several European collectors and the artist himself lent many of the forty-five paintings and forty drawings that were on display, this retrospective also provided Twombly connoisseurs with a chance to gauge his achievement in light of numerous then-unfamiliar works. This selection tried to persuade those who identified Twombly with a free calligraphic abstraction that color and symbolic content were at least as characteristic in his work.

Among the earliest works on view was *Panorama* (1955), an outsized, white-on-black composition that might be compared to certain Pollocks, although it is more evanescent in the extreme delicacy of its markings, which are derived from a kinesthetic impulse. While a forceful side to Twombly's gesture was elsewhere evident, this show forced one to conclude that Surrealist irritability, not Abstract-Expressionist action, informs Twombly's handwriting. One untitled painting in particular recalled late Arshile Gorky, with his luxurious painterliness reduced to faint but intense sensual points of color and pencil. In other works traces of totemic and biomorphic schema inherited from Surrealism emerge from Twombly's automatic writing – along with considerable explicit sexual notation.

What is remarkable about these early canvases is a sensibility that registers minute expressive and formal distinctions. The viewer was encouraged to tour the show with this awareness, prompted not only by the particular selection of works but also by the exquisite deciphering of Roland Barthes, the Structuralist philosopher and critic who wrote the catalogue essay.[3]

This retrospective put the most weight on the work of the early 1960s and followed the course by which Twombly's concurrent Surrealist and Abstract-Expressionist tendencies narrowed to only the latter as his canvases became more physically expansive, with a clear, very light palette and a generous, if sporadic, application of paint. *The Empire of Flora* (1961), on an Ovidian theme, is one of his most emotionally charged and physically free works of that phase. In it, agitated spots of pink, red, yellow, and black pigment applied directly from the tube, along with pencil scratches and crayon scribbles, generate visual excitement while setting up a correspondence of implication between this *tachiste* stabbing and the creative/destructive forces by which, according to Ovid, heroes die and are metamorphosed into flowers.

Another noteworthy work of this energetic period is *School of Athens* (1961). Painted the same year as *Flora*, it marked a departure, because – as Heiner Bastian explains – it features the artist's first symmetrical composition, a device which will recur as – and which in fact becomes – a major structuring principle in his recent work.[4] Penciled arches – schematic reductions of the architectural perspective in Raphael's fresco – alternate with globs of paint that thwart the spatial illusion, as if the original School of Athens were presiding over a dialogue between the New York School and the Academy of Rome. A problematic painting which focuses on the central image while allowing intervallic relationships to slacken, it is nevertheless an enthusiastic announcement of the code of line versus color that Twombly had been developing. Although in some respects unresolved, *Athens* is more interesting than *Nine Discourses on Commodus* (1963), a series in which one saw the rival principles of color and line narrowly and self-consciously upheld. Coincidentally, this seemingly doctrinaire series demonstrates what had been true of Twombly's growth during these years: that as sensuous and aggressive qualities were strengthened, so too were the structuring principles that opposed and sometimes undermined these qualities.

The next significant phase of Twombly's career occurred in the late 1960s when, abandoning color, he turned to entirely linear compositions and produced the well-known white-on-gray rows of calligraphic loops that so resemble old-fashioned handwriting exercises. Perhaps influenced by Johns's literal and "empty" hatching, which was applied to his targets and maps, and by his deadpan use of numbers and letters in series, he produced these works, which were widely acclaimed by Minimalist partisans who especially valued their blunted sensibility and lack of mythic reference when they were first shown.

Twombly's works utilizing collage feature centrally placed photographic elements as well as sketches in pencil and oil that are based on such elements. Typically, postcard reproductions of art (e.g., an anatomical drawing by da Vinci or a visionary landscape by Frederick Church) and anonymously photographed landscapes that are apparently clipped from magazines or books are the collage elements. But in extending the "found" reference out into the much larger field of the drawing or painting as a whole, Twombly disregards the subject matter of his sources and instead imitates the color and gesture transmitted through reproduction, extracting the style from content and context alike. Often, on another paper mounted

alongside as part of the same work, these abstract studies after "nature" (the reproduction) again might be abstracted to a scrawl that reads as both essence and final reduction of the formal and expressive implications of his source. Linking all the elements is a verbal inscription that provides a key to Twombly's further intent. For instance, accompanying the Frederick Church landscape and a pink wash by which Twombly summarizes Church's crepuscular scene is the shakily lettered word "Epithalamion," a type of nuptial poem whose invocation here refers to the marriage – or inevitable interdependence – of nature and art. Often visually slight, some of these collages depend on the viewer to make the metaphoric connection between a verbal idea and an image.

<div align="center">✳</div>

In general, the collages furthered Twombly's pictorial language of condensed form. In this aim, his authority is often more easily grasped in works from the 1970s, those that adopt a dramatic structure – most notably, *Fifty Days at Iliam** (1977–78), in which the visual narrative earlier attempted in the collages was developed along the lines of a Homeric epic (see Figure 4).

Twombly's work from this period particularly reveals his growing involvement with myth, although classical references had appeared both on his canvases and in his titles themselves since the 1950s. Although Twombly is a contemporary of Jasper Johns and Robert Rauschenberg (who, in 1951, urged that he attend Black Mountain College), his symbolic orientation separates him from them. Although all of them have humanistic underpinnings to their work (Rauschenberg's prints, those that accompany Dante's *Inferno*, come to mind), myth is far more central to Twombly's art; and, despite the intervening years of stylistic assimilation, Twombly maintained his aesthetic connection to the Surrealist and Abstract-Expressionist impulses of the early 1940s, impulses from which Pollock, Rothko, and Gottlieb forged an abstract art of archetypal content. Especially since moving to Italy in 1957, Twombly made this synthesis of form and content his prime quest.

Had it been arranged as Twombly originally planned, his ten-part painting *Fifty Days at Iliam* would have been mounted along both sides of the long art gallery, giving the viewer a palpable sense of walking into the epic space of the painting itself. But as it was

* *Ilaim* is Twombly's rendering of the historical city Ilium (Troy).

Figure 4. Cy Twombly, Installation of *Fifty Days at Iliam*. 1977–78. Philadelphia Museum of Art: Museum views.

actually installed at the Heiner Friedrich Gallery in 1978, the painting hung mostly along one wall – an arrangement which, if diminishing the spatial drama, increased the continuity from part to part and encouraged viewers to follow the thematic and formal sequence.

Twombly's version of the *Iliad* is based on Alexander Pope's translation. In the introduction to his translation, Pope attempted to persuade his eighteenth-century audience to be tolerant of the "invention," both historical and aesthetic, by which Homer deviates from "rule" in his account of events. By condensing the ten-year war between the Achaeans and the Ilians (Greeks and Trojans) to approximately fifty days, Homer could focus on character, especially that of Achilles, whose anger over his feud with Agamemnon dominates political events.

For his part, Twombly no more reconstructs Homer than Homer does the Trojan War. Even more summary in his handling of "facts" than Homer, Twombly concentrates on a few vivid images from Homer that, for him, evoke the essential emotional content of the epic.

The key image is Achilles's shield. Whereas in Homer, the shield, which was lavishly forged with symbolic scenes, is made for Achilles

late in the war, in Twombly's version the shield – or its abstraction – appears first (on the left) as the generative image. Simply an orange-red scribble surrounded by reeling blue and black lines, the shield element is the work's thematic and formal core.

If there is a narrative to this painting, it unfolds in the visual metamorphosis of the initial shield form – that is, in the media of oil, crayon, and pencil. In all ten parts, proper names or descriptive phrases limned in the artist's distinctive hand accompany the images on the canvas. Following a powerfully crude catalogue of names in the panel titled *The Heroes of the Achaeans*, the shield's fiery energy is taken up again by *The Vengeance of Achilles*. Here its power has uncoiled aggressively, and the phallic shape it has assumed is made explicit in the following panel, *Achaeans in Battle*, where line, color, shape, and density are brought into furious activity. This momentum continues in *The Fire That Consumes All Before It* as the bulging mass reaches its most substantial phase.

In *Shades of Achilles, Patroclus and Hector*, the central and climactic panel, three quatrefoil-like shapes seem to weigh and balance the passing of substance and color, and, indeed, in the second half of the work, the active line and touches of color (blue) outweigh the impastoed red. Ratiocinative processes rather than impulse now have the upper hand, and the route toward stasis is made complete in *Heroes of the Ilians*, a section in which a final catalogue is accompanied by an ossified contour of the quatrefoil that the shield has become.

What Twombly presents, then, is the transformation of raw, undifferentiated energy shared by literary hero and living artist alike to energy's sublimated aftermath. While the painting may be called literary, insofar as it is based thematically on a work of literature, it is hardly illustrational. By focusing on symbolic images rather than story, by universalizing the affective content of these images through formal abstraction, and by giving visual continuity and structure precedence over verbal narrative, Twombly has managed to transcend his source without abandoning it.

Twombly's handwriting – the word made visual – contributes significantly to the vitality and success of this series. More generous and direct in its touch than the delicate and sometimes devious automatism of his Surrealist-inspired works, this present Abstract-Expressionist mode is appropriate to the spirit of his epic subject matter and is an excellent means for energizing its fixed and inert historicity. Ultimately, it is the apparent spontaneity of his brush-

work that is crucial to Twombly's art. He did in fact paint all the canvases in this cycle more or less simultaneously. But it is as if, after having planned the series as a whole – even going so far as to determine the specific brushwork each area would require – he approached the canvases fresh, with an unpremeditated attitude. What is remarkable about this complex serial painting is that it does not feel contrived. One can almost imagine the narrative to be still unsettled and in the process of being written.

4

The Art of Being Sparse, Porous, Scattered
Roland Barthes on Cy Twombly

Neither an art historian nor an art critic, Roland Barthes writes so rarely on painting that when he does, we anticipate his commitment to something else. We see this commitment when we discover that Barthes wrote on the art of Cy Twombly not once, but twice. The question immediately presents itself: What urgency or scintillation does this art possess for him, a *littérateur* of cultural scope? Answers may strike us with peculiarly vivid force if we regard Barthes's literary interpretation of Twombly from the perspective of art history, because from the vantage of art history, the semiology that Barthes pursues is literary both in its peculiar emphasis on literariness as well as in its assumptions of the verbal grounding of visual things. From the perspective of art history – art history, moreover, occasioned by the constraints of the catalogue essay – the norms lie elsewhere.

Whereas the catalogue essay is typically bound to honor its function of describing art rather than criticizing it, the catalogue essay specifically occasioned by a retrospective is further bound to administer the entire career of works on display. With time here an epistemological factor, if not also a factor of style, sense must be made of the art through a compelling temporal order that demonstrates and proves the content that the art historian believes significantly integral to the work. The art essay of some intellectual heft, meanwhile, treats the artist's stylistic history as it also engages cultural history in significantly conjunctive or disjunctive ways. In other words, whatever else it is, the catalogue essay is a species of dependent beauty. Its constraints are demonstrably those of occasion, function, and social purpose, the last being tied to educating a public.

Any audience already familiar with the mentality of Barthes has already guessed that he would have exploited the occasion otherwise. Commissioned by the Whitney Museum of American Art in New York to write a catalogue essay, one that would accompany a mid-career retrospective of Cy Twombly's art (spanning 1954–77), Barthes wrote "The Wisdom of Art."[1] Cheerfully frustrating the

curatorial and educational staff in the process, he would pretend to acquit himself with this essay of extravagantly "free" beauty. We shall examine this essay.

Barthes's literary representation of visuality flaunts poetic over historical narrative. He delights in the perversity of doing antinarrative antihistory when professional decorum would suggest doing otherwise. Barthes indeed exercises the option to be literary that is accorded *hommes de lettres* when commissioned to write catalogue essays. Topics freely adapted from Aristotelian poetics, announced at the outset, will become the mobilized nodal points under phenomenological consideration. A fact, a coincidence, an outcome, a surprise, an action – these are the terms of interest.

Material facts are noted. Elements prior to art – pencil scratches, brown smudges – are seen "as stubborn substances whose obstinacy in 'being there' nothing (no subsequent meaning) can destroy." The pencil line has come to usurp the place of the brushstroke, but it is not noted as such.[2] Rather, in Barthes's schema, pencil is less an instrument and more a residue comparable to materia prima.[3] Barthes has found a visual analogue to the prelinguistic verbal utterances remarked by Julia Kristeva (see Figure 5).

Graphic elements receive a provisional taxonomy: scratching, smudging, staining, and smearing. Then the written elements are mentioned, and the names Virgil, Orpheus, the Italians (all used in the paintings by Twombly) lose their "nominalist glory" as a result of having been written clumsily. Even so, this clumsiness of application "confers on all these names the lack of skill of someone who is trying to write; and from this, once again, the truth of the Name appears all the better."[4]

Barthes next entertains chance under the aspect of inspiration. The material smudges and stains seemingly thrown across the canvas, separated in space, produce in Barthes "what the philosopher Bachelard called an 'ascensional' imagination: I float in the sky, I breathe in the air. Those stains: it is as though Japanese aesthetics inform them."

Up to this point Barthes has cited works from the early 1960s. *Mars and the Artist* (1961), a work on paper from 1975, now prompts a passage contemplating symbolic composition featuring furious lines at the top and a contour forming a flower below, a flower accompanied by the artist's name. Figurative and graphic elements combine to raise the issue again of representation. "It is never naïve . . . to ask oneself before a painting *what it represents*,"

Figure 5. Cy Twombly, *The Italians*. 1961. Oil, pencil, and crayon on canvas, 6' 6⅝" × 8' 6¼" (199.5 × 259.6 cm). The Museum of Modern Art, New York. Blanchette Rockefeller Fund. Photograph © 1998 The Museum of Modern Art, New York.

he says. People "want meaning" from a painting and are frustrated if the painting, this painting or another (here, Barthes returns to *The Italians* [1961]), does not give them the understanding they seek. This is especially so since viewers seek meaning by way of analogy from the title they read to the image they see. Looking at *The Italians*, people are bound to ask, "Where are the Italians? Where is the Sahara?" Even so, Barthes maintains, the viewer intimates a proper solution or outcome consonant with the painting at hand and perceives "what Twombly's paintings produce . . . : an effect." Explaining his choice of the word "effect" – that is, he associates it with the French literary tradition (from the *Parnasse* to *Symbolisme*, it "suggest[s] an impression, sensuous usually visual") – he said that it is the very word that for him captures the airy qualities in such early paintings as *The Italians* or *The Bay of Naples* (1961), qualities suggestive to Barthes of an effect of the Mediterranean.[5] It is a

Mediterranean effect "into which [Twombly] introduces the surprise of incongruity, derision, deflation, as if the humanist turgescence was suddenly pricked" – or else through such deflationary pricks and clumsiness, there arises the experience of *satori*.

Finally, the drama of it all registers. A designation integral to "a kind of representation of culture," one achieved not through "depiction" but through "the power of the Name," animates these paintings. The name that stands in for the subject in classical painting presents the topic in these paintings as well: that question of rhetoric reflecting what is being talked about. What is being talked about in the painting as subject falls back on the subject who painted it: Twombly himself.[6]

If an historical narrative may be defined as a temporal ordering of events happening under the aegis of an intellectually predetermined scheme, then a poetic nonnarrative may be said to propose a contingently arrived-at simultaneity, one where events that might have happened breathe with life.[7] History whose causal or logical temporality has relaxed serves the ascendancy of the lyrical narrative; at least since Wittgenstein, theories of interpretation have displaced explanation, and they have built upon the longstanding contention between the human sciences' reliance on meaning and intention and the analytical sciences' reliance on logic and necessity for what constitutes explanation in history.

Barthes's interpretative performance puts such history on notice, particularly that sort of docile unfolding of fact and biography associated with the norm of historical narrative that is appropriate for the museological occasion. A declared Symbolist bias aids and abets Barthes's phenomenological reading of Twombly. Sensation as such is all-important. That Barthes searches out the tangible effect of emotion shows a predisposition to view Twombly as Baudelaire viewed Delacroix.[8] But Barthes's assumption that poetic effect and sensation are synonymous (revealing a bias the Surrealist poet Paul Eluard would come to reinforce) leads Barthes to overestimate this content: He will neglect or otherwise discount the cognitive component in Twombly's visual discourse. Even though in another, subsequent piece on Twombly he notes that gesture conveys intellection, that comment is mere mention, and it contrasts with the weight given to intuited sensation with resultant *satori*, putting analytic intention at a clear disadvantage.[9] A manifested spirit-within-matter is Barthes's interpretive choice.

In Barthes's scheme of things, values-centering on epitome gives

privilege to paintings and essentializes sense and significance. Selective attention paid to early work establishes a core stylistic identity for Twombly – a core stylistic identity, furthermore, that accords with Barthes's own. When Barthes wrote this first essay for Cy Twombly's retrospective in 1979, he chose to concentrate on the paintings created in 1960 or thereabouts, those done relatively early in the artist's career. Here is an occasion to examine the significance of Barthes's selective attention as an historical representation of the artist and as a stylistic representation of himself.

Discarded by Barthes are various alternative themes of an artist's retrospective career. Among the art-historical discourses not assumed by him is, least interestingly, the chronological account typical of catalogue essays, at least in the United States in the 1950s and 1960s (although still often obligatory). As the discursive yet redundant form of the listed biography otherwise placed in the back pages, this chronicle of a life also unfairly stigmatizes all art history – as though chronology and history were synonymous, both despite the fact that "history" is a universal term covering any number of particular temporal employments; and despite the fact that in the allowable decorum governing catalogue practice, most approaches, ranging from formalist to cultural, are practiced simultaneously.

Attention paid to chronology in the Twombly catalogue is abbreviated indeed:

Cy Twombly was born April 25, 1928, in Lexington, Virginia, studied at Washington and Lee University in Lexington, Boston Museum School in Boston, Massachusetts, and [the] Art Students League in New York. In 1951 he studied at Black Mountain College, North Carolina. Between 1951 and 1953 he traveled and lived in North Africa, Spain and Italy. In 1957 he moved to Rome where he still lives.

This is the entire biographical text, printed in the back of the catalogue alongside a chronology of exhibitions that follows reproductions of Twombly's work. Ever since *Sade/Fourier/Loyola* 1971), we have come to expect this inverted priority of fact and interpretation from Barthes, and here it is again. But independent of this, many artists of Twombly's generation – especially those raised on avant-garde formalism as well as those in color-field painting who belatedly joined in the formalist rhetoric – disallow anecdote, incident, and other signs of the personal biography which are doted on by editors of glossy art magazines. Twombly has long distanced himself from public appetite. In this sense the intentionalist fallacy will be

defended wherever catalogues devoted to him appear, and as with the catalogue copy for this retrospective, biography is similarly perfunctory elsewhere.

Chronology, by no means only a normative historical approach for catalogue writing, may occasionally prove even strategic.[10] Yet social history may be the preferred mode when treating entire art movements or when plotting artistic interventions such as those by Andrea Palladio or Vladimir Tatlin or Man Ray, whose functionally dependent art or career is inextricable from milieu and cultural context. In fact, a culturally contextual approach to art writing is more commonly employed than is readily acknowledged by those who want to stereotype the historical enterprise by limiting the scope and resourcefulness of its instrumentality.

Although intellectual antagonists, formalism and social history coexist in educating the public. One need only remember the debate in the 1930s between formalist Alfred Barr (first director of the Museum of Modern Art, who in 1929 coined the term "Abstract Expressionism" to refer to Kandinsky) and social art historian Meyer Schapiro over the meaning of abstract art. The subsequent emergence of the New York School provoked rival histories and commentary by the art historians Meyer Schapiro and Robert Goldwater, by the formalist Clement Greenberg and the humanist Harold Rosenberg – both cultural critics – and by the formalist chronicler Irving Sandler and the cultural critic Dore Ashton.

Essays by critical historians or semioticians are prevalent in certain museological enclaves: Much depends on the intellectual and administrative freedom given museum staffs by their board. By the 1970s and sporadically thereafter, when Barthes was approached by the Whitney Museum, the critical paradigms applied to catalogue essays were quite variously creative. Recall, for instance, Lawrence Alloway's applied communication theory and semiotic overlay on American Pop Art for the Whitney Museum after decades of writing about the subject which he had initially defined and traced in Britain and the United States.

These days, however, the thematic approach favored more and more in an era of nonspecialist audiences is also ironically most amenable to the *littérateur*, because, of all the typologies, this one requires the least scholarly specialization or comprehension. The thematic approach lends itself to lay percipience, which is expressed in the aperçu and in the impressionistic criticism that poets write when writing on art. Together with Meyer Schapiro and Rudolf

Arnheim, poets – and artists – were conscripted by *Art News* editor
Thomas Hess to review and cover Abstract Expressionism in the
1950s, when such painting was shunned almost everywhere else.
That's how the poet and lawyer Harold Rosenberg, who had pub-
lished Vorticist poems in *Poetry* magazine in the early 1940s, found
a forum for his metaphoric art criticism, which mobilized enthusi-
asm for "action" painting. In contrast to the sociolinguistic practice
of our times, when an avid appetite for simplistic popularization in
the press assumes a reception made queasy if confronted with art
history, intellectual history, or criticism, Barthes's playful interpre-
tation of Twombly supplies what the public wants; yet his interpre-
tation does so elusively. As sensuous impression, Barthes's art writ-
ing is meanwhile consistent with a tradition of the belletrist liberal
construal of his object.

<p style="text-align:center">✳</p>

Since, after all, a retrospective raises the question of style across
time, let us review Cy Twombly's career by decade to ascertain the
interpretive spin Barthes puts on the matter at hand. Although ig-
nored by Barthes, the decade of the 1950s was indeed represented in
the retrospective exhibition and catalogue. A formalist would have
taken note that, in Twombly's work, *matière* and tactility, both
registering the artist's allegiance to *art brut* (and Jean Dubuffet in
particular), give way to attenuated expression. Reliance on line is
conspicuous. If style is "patterned selection of possibility afforded
by forms,"[11] these early works reveal Twombly's interest in exploit-
ing reduction for expressive possibility; yet given the variety of ex-
pressionist tendencies that kept pace with the stylistic milieu of the
period, Twombly's personal style, it may be guessed, will continue
to form in response to the period style.

Given the emphasis that Abstract Expressionism placed on Nietz-
sche – that anti-aesthetic archaism the anteriority of which was
already a commonplace by the time the craze for Nietzsche reached
the United States – we might assume Barthes would have laid even
more emphasis on expressions of Dionysiac archaism made lean.[12]
Neither children's art nor the art of the insane – whose grammatical
and lexical forms are writ large in Twombly's work (as they are in
European and Europeanized art of the 1950s) – figure in Barthes's
discussion, except through the attribute of clumsiness. Were he to
have mentioned the aesthetics of children's art, as he did in his
second article, "Cy Twombly: Works on Paper," then his interpre-

tation of Twombly at this stage would have had to reformulate itself. It would be obliged to consider the sensorimotor handicap Twombly deliberately undertook when drawing with his left hand to place himself at a disadvantage to acculturation.

Drawing the graphic equivalent of the prelinguistic utterance and so sacrificing linguistic competence by reducing one's means – such was decidedly part of the ethos of authenticity inscribed in Twombly's aesthetic. Because of this, it is tempting to wonder why Barthes laid so much emphasis on *satori* if the Greek concept of vulnerability, "which is essential to the manner in which the excellent man conducts himself," was culturally closer at hand.[13] The answer might be that, with Twombly classified as a Symbolist, surprise – and ironic surprise especially – lent the notion he needed to fill out his scheme. To return to the phenomenological without delineating the historical era associated with it may be Barthes's implicit purpose.

Although literary critics and art historians alike do tend to disregard the stray, idiosyncratic, or occasional manner as intellectual noise irrelevant to the style of art unfolding before them, art historians more readily accept the deviation because their commitment is to an unruly universe of experiential findings even at the expense of the rational principles they hold to be true. Barthes's adherence to an original grammar of style located in those values deemed representative of the artist's work centers on works from the early 1960s, the years when the artist came into his own. Given this selective attention to the early 1960s, the grammar of dispersal, disposing of lexical smudge and smear, is adequate to interpreting Twombly at this moment. It accounts for the highly articulated range of material properties a painterly mark can manifest; not merely various, Twombly's mark-making unsystematically encapsulates a set of intensely sensuous and expressive reductions[14] – and Barthes gets a good grip on this heterogeneous material anatomy even if, semantically, he could have noted that a fully formed lexicon is implicit at this early, so-called primitive, stage.

The consensual cultural reading reinforces Barthes's interpretation. The milieu at Black Mountain College – where John Cage, Merce Cunningham, and Robert Rauschenberg brought fruitful anarchy to the disciplined yet pragmatically oriented *technē* that had been brought there by Joseph Albers, Anni Albers, and other exiles from the Bauhaus – fostered radical experiments with materials and craft. It also gave rise to radical renovations of definition. For instance, music now construed to be anything derived from the prin-

ciple of sound is answered by the notion that dance incorporates all kinesis. (Anecdotally, this assumption of art as materially and formally comprehensive extends to Twombly, who, only a few years ago, wondered aloud if he would ever hear again "a certain Futurist music entitled *Veil of Orpheus*," which he had heard long before. Fortunately, I, too, had heard Pierre Henry's *Veil of Orpheus* and could supply Twombly with a cassette of this *musique concrète* of 1953, which is largely percussive thanks to its object-generated sounds and so provides an aurally dispersed lexicon of timbre and rhythm – and which, by the way, still sounds new, unlike so many experiments that have attained a quaint status as period pieces.) Twombly's effort to realize the phenomenal visual analogue to aural sound structures remains underappreciated because naïve viewers (including the more discerning Barthes) perceive, at best, a rarefied sensibility.

Further issues of signification arise even where Barthes is strongest. *The Italians* seizes his attention as a painting whose title finds no objective or subjective representation on canvas; the relation of signifying title to signified subject remains tantalizingly abstract. "Where are the Italians? Where is the Sahara?" he asks in vain.[15] Yet even as the nonreferential title underscores the abstract nature of painting itself, Symbolist traces abound, if only to manifest the content of this style, which animates nothing providently. Given the chromaticism and wet-in-wet pigment decidedly present in *The Bay of Naples* and *The Empire of Flora* (1961), for instance, more needs to be done to elucidate content than Barthes's hedonist impulse will allow. Barthes may have even suppressed the latent historical content suggested by his questions that only a few years ago he might well have allowed himself to recall.[16] Another mention of *The Italians* confidently asserts its allusion to the classical spirit, but, if anything, Twombly's calligraphic mark serves the Nietzschean barbaric revitalization of that classical spirit.

Perhaps because pursuing the Mediterranean effect under the aegis of French grace, Barthes ignored the consensual interpretation that could reinforce his own sensualist bias. As though unfamiliar with André Breton's writings on Arshile Gorky – not to mention the painterly antecedent to Twombly in Gorky – Barthes disregards both the Surrealist gynecological vernacular and the scatological corollary to *matière* deposited on canvas. Nor in his mention of the Mediterranean effect does Barthes take into account that this very Surrealist content prevented Twombly from being accepted as an Abstract

Expressionist when the lines of aesthetic and ideological battle were being drawn up – and that Twombly's move to Italy in 1957 was due in large measure to the pressures to become a purist when the impure state of throwing figural and abstract gestures and signs together in a condition of contested agony was his abiding interest. These very vestiges of Surrealism, not to mention figuration as such, were prejudicially received by the formalist critic Clement Greenberg. The artistic climate in the 1950s and 1960s, which was decidedly formalist and materialist, promoted color-field painting, at the time Minimalist objects. Europe, not America, remained more hospitable to art nurtured in the legacy of Symbolism. Barthes does not rehearse this critical face-off, so he does not exploit the situation debated within painting – Twombly's painting – itself.

Even early on, Twombly's paintings take up the issue of radical aesthetic purity. In the 1961 painting *School of Athens* and with determined frequency thereafter, Twombly engages in a structuralist discourse conflating expressively and rationally coded painterliness that dramatizes the possibility of synthesis. Today, I show no slides of this painting, with its schematic stairs that serve as a rectilinear dais engaging vehement gesture as *The School of Athens* (1961 and the New York School play out their destinies jointly.[17] Nor is there a slide of *Leda and the Swan* (1962), the necessary antagonism of whose theme throws together a formalized expressionism. Yet both works were on view in the retrospective. Deservedly well known are the paintings by Twombly that treat mathematical and rational discourse as felt ideas. In a deceptively simple formal conversion, what was white is black and what was black, white; and the field of sensation has become a didactic field of operational thought.

On Twombly's "blackboards," the semantic range of the mark has been reduced to almost sheer uniformity: Some feature a single line read as measurement – the notion of measurement – by virtue of a number placed above, where convention would mandate. Syntax as operational thought being more elaborate elsewhere, campaigns or topology become the elusive subject of a serial accumulation of line, one heavily qualified by trial and error – or at least the apparition of trial and error inscribed, erased, and reinscribed. In consequence, the quarantining of poetic from scientific discourse advocated by the New Critics is, in Twombly's calligraphic compositions from this phase, synthesized. The field of thought seems as

creative as critical, as expressively self-forgetful as empirically in-
quiring. But whereas the dialectical process seems to have intervened
at the point of origin in some canvases, in others, isolating poetic
from scientific vocabulary seems more clear-cut. In any event,
Twombly's analytical intention is in the foreground.

Jasper Johns owns a painting by Twombly in which the calligra-
phy has achieved the perfect neutrality and uniformity that earlier
paintings had barred from their surfaces. This, of course, is not a
consequence of development, insofar as Twombly's skill – indeed,
his virtuoso *technē* – was evident all along in the pictorial intelli-
gence, as Barthes noted, wherever one looked. Here, rather, is
captured the antithesis of the prelinguistic sign which is seen in
abundance earlier on developmentally; this evidence of motor con-
trol revealed through the Palmer method of calligraphic training for
children proves the code of acculturation and mastery. It is, further-
more, the symbolic code for prose. Barthes ignores this phase of
Twombly's art almost entirely, perhaps since its style might seem to
refute that which he had identified as recently his own. In evoking
the authority of the poetic mark, then, Barthes may be reluctant to
acknowledge the full spectrum of Twombly's discursive intentional-
ity.

Barthes's selective attention to the original phase in Twombly's
art treats the oeuvre as an enactment of Barthes's own late poetics.
Aphoristic impressions, willfully literary but not historical, stand for
Barthes's declared representation of Twombly's history on the occa-
sion of the retrospective. What Barthes leaves out is cultural context
in the panorama of the stylistic milieux in which Twombly moved –
and to which his embedded rhetoric gave witness. The mid-1970s
saw a relatively conservative historicism in art. Neo-Expressionism
purported to recuperate meaning, yet with few exceptions, artists
revised only illustrative and familiar ambivalences to nationalist
themes. Against this postmodernist reaction, Twombly's reinvest-
ment in figural imagery seems to be more continuous with his own
poetics than appropriated from without.

The retrospective featured a few of these efforts and included
canvases and drawings penciled with single mythic names – or,
rather, a penciled name together with a reductive graphic symbol
serving as attribute. Thus, "Virgil" was erased by applying paint
that smeared the graphite; "Dionysus" rides a phallus; "Orpheus" is
set above a launched strong diagonal in awkward cursive script. In

light of work soon to follow, propulsive gestures organizing themselves into a nearly pacific image in *Mars and the Artist* may dramatize the motivated sign as well.

Twombly's so-called return to figuration, then, is symbolic – a virtue or quality enacting a name. With a modernist's clarity and using the universality of poetic sign to treat topics, Twombly himself seems to be insisting on the Structuralist phase of Barthes's early rhetoric. Free variants on a thematic constant abound. Here, then, are early modernist ideograms whose formalist reductions function equally as sign-system and as reference. Although beyond the scope of the retrospective, the epic *Fifty Days at Iliam* (1978) was available for viewing courtesy of the Dia Foundation at the same time, and it might well have existed in transparencies for Barthes to see. A single painting comprising ten canvases now on permanent view at the Philadelphia Museum of Art, Twombly's *Fifty Days at Iliam* is truly a major work from his career (see Figure 4 on p. 42).

Poetry ignores writing as a figure of history in styles, according to Annette Lavers.[18] But Twombly's thematic inscription of epic into a lyrical mode compels attention to this implication of history, if only to lend myth the experiential feeling of history. Meanwhile, taking a linguistic approach to structure, Twombly seems to "omit what is accidental or contingent . . . and gives imaginative expression to the essential type,"[19] because he utilizes style and schema alike to encapsulate the drama of Apollonian and Dionysian crisis. Note, then, the evolving or devolving image-concept.[20] Whether single or manifold, each image is precisely that, Aloïs Reigl would argue, because it is condensed by virtue of enfolding motivic transformations:

Shield of Achilles
Heroes of the Achaeans
The Vengeance of Achilles
Achaeans in Battle
The Fire That Consumes All Before It
Shades of Achilles, Patroclus, and Hector
House of Priam
Ilians in Battle
Shades of Eternal Night
Heroes of the Ilians

Action painting, having accrued libido and animus, subsides into gesture; gesture subsides into contour. Remember the myth of Flora

memorializing the destiny of warriors who, when they die, undergo a transformation and metamorphose into flowers. Having painted this symbol early on (in vivid chroma), Twombly in mid-life will have continued to grant the motif of the heart (or flowering heart or passionate flower) in the schema of the rosette so that it may be interpreted as a funerary remembrance.

Now note a conversion from the diachronic story into a structure featuring transposition and reflection. Where in Homer's myth the empowering shield had been placed centrally in the narrative, Twombly's retelling has the shield initiate the action. Occupying the center of Twombly's narrative is the scheme of rosettes symbolizing the shades of Achilles, Patroclus, and Hector – and, in reflection on either side, images of victory and defeat, passion and reason, which represent, left and right respectively, the houses of the Achaeans and the Ilians. Painting and drawing administer the contesting forces of passion and reason in the synchronic epic Twombly has constructed for his *Fifty Days at Iliam*. The question remains: Why did this not appeal to Barthes, the once master Structuralist? I believe it might, had not Barthes, years before, disavowed this Structuralist possibility for himself. If the catalogue essay on Twombly demonstrates anything, it is a stylistic representation of Barthes himself in a post-Structuralist phase, someone acknowledging that the validity of the artist might be enacted in a form and manner compatible with his (the artist's) own beliefs.[21]

The ahistorical aspect of Structuralism could be said to be expressed by those who treat a retrospective study of art thematically on a sample of work meant to suffice for the entirety. In this sense, the Aristotelian categories Barthes imputes to Twombly's work emerge not only through the suggestive link with actual text on canvas but also through the adoptive myth located in mythic time which Twombly desires for his archaic modernity, a mythic time to which Barthes willingly subscribes. At least for the duration of the catalogue essay, Barthes treats those Aristotelian terms as though they were *churinga* of European vintage – verbal objects of symbolic representation removed from the depths of a cave to be verbally caressed and prayed over, and then returned to their proper archival setting once the connection between the present and mythic past has been made. (Refelt and thus remade, as George Poulet might advise, the terms may now be said to embody the essences to which they refer.) Let's say this ahistorical metaphor for history is not incompatible with Barthes's synchronic approach to Twombly's style but

represents a thematic appreciation of symbolic events, acts, and effects more connected to a mythic saturation than to its modern and contemporary histories that contextualize conditions and intentions. But it is the post-Structuralist scatter and dissemination to which Barthes returns at the end of his essay that gives emphasis to his own intentions. Having inverted the intellectual hierarchy by which the structure of history culminates as a sequence of contextual approaches to an event – in this case, the event of Twombly's particular paintings – Barthes distributes free variants of key terms throughout the essay, and the sensuous effects of these terms scattered throughout the essay constitute a field of *écriture* closer to art appreciation than to art criticism.

The significance of Barthes's impressionistic and selective attention, then, is meant to reinforce Barthes's own late style of transfigured dissolution. The columns he wrote for *Le Nouvel Observateur* from December 1978 to April 1979 reveal, as much as do his late books, this post-Structural rationale for style in which the particular – the occasional – moment at hand is historically embedded in life, and this is as much of a claim to structuring history as he wishes to make. This is why, toward the close of his catalogue essay on Twombly, he writes,

Thus this morning of 31 December 1978, it is still dark, it is raining, all is silent when I sit down again at my worktable. I look at (*Herodiade* [1960]) and have really nothing to say about it except the same platitude: that I like it. But suddenly there arises something new, a desire: that of *doing the same thing*; of going to another worktable (no longer that for writing), to choose colors, to paint and draw. In fact, the question of painting is: "Do you feel like imitating Twombly?"[22]

And so Barthes, himself a transient figure inscribed as Proust inscribes himself within a text, closes his essay by considering the topic of production and the drama of doing that initiates Twombly's art and essentially permeates it.

5

Narrating the Hand
Cy Twombly and Mary Kelly

A developmental narrative encoded in handwriting relates two artists whose practice, never linked, would apparently suggest antithetical aesthetics.

The term the "New York School" constitutes a loose federation of artists circa 1948 (so named not because New York is where the artists were born but to designate the place where they eventually convened) and serves to define the aesthetics of an artistic capital in a country newly and only reluctantly sophisticated in art. Abstraction, filtered through the aesthetics of Europe and Asia, contributed significantly to the notion of artifacts as "paintings" that would not be *pictures*. Along the way, formal reduction advanced an abstract version of metaphysical content.

Unlike color-field painters, the Abstract Expressionists cherished the seismic gesture and its assimilated visual language. This was the immediate context for Cy Twombly, who yielded to calligraphy and ideograms along with the rest of his generation yet hung on to make a studious and discriminating practice of handwriting.[1] (It was because he insisted on incorporating written language into visual language that Twombly was ostracized by the color-field purists.) If archaic expressions of the sublime inspired Barnett Newman, the same urge to Nietzschean "primordial, predatory passions" became concretized in the crude pigment Twombly applied to his canvas. An archaic sublime particularized – this might be a way of characterizing Cy Twombly's resistance to metaphysical generalizations of myth and symbol.

In *The Italians* (1961) we see that instead of the optics of color-field, Twombly proposes haptic smears of pigment. Indeed, *matière* signifies form and content. More radically than Jean Dubuffet, who is congratulated for the *matière* characterizing his *art brut*, Twombly remains uncompromised here; in this and other work, lyricism does not ameliorate semantically "tough" smears coming directly from the tube.

For this and much else, I suspect, the conceptual artist Mary

Kelly admires his art. When a few years ago I mentioned that I continue to teach her *Post-Partum Document* (1973–79), comparing it to the art of Twombly, she remarked, "Oh good. I'm tired of hearing my work always given a Lacanian reading. And I respect Twombly's art very much."

The cultural context for Kelly's verbal artifact, briefly, is this: Conceptual art, in which language theorizes visual images, often consists in words entirely, and Kelly's *Post-Partum Document* decidedly conforms to this expectation. Beyond this, in some conceptual practice documentation gives rise to a kind of metalinguistic naturalism, and from the 1960s well into the 1970s – from Hans Haacke to Christo and from Bernd and Hilla Becher to Richard Long – the advocacy of objectifying perspectives extended into long-term documentary projects and what has been dubbed "real-time systems."[2] Yet preceding this – and perhaps as significant to deriving a comprehensive cultural framework for Kelly's piece – is the display of public art-actions, ranging from happenings to street theater to demonstrations, events of which Allan Kaprow would be a conspicuous progenitor.

In documenting an infant's first seven years of linguistic development, Mary Kelly's ongoing project *Post-Partum Document* is indeed a realization of an art action in real time. Meant to objectify the subjectivities of mother and child, Kelly's parenting linguistic behavior is now a matter of public record in a book and on exhibition in galleries.[3]

This artifact is highly concrete – no more so than at the outset, when diapers recording excrement of the artist's infant son become a concretion of this child's initial expressive linguistic traces. "Artistic behavior entails a synthesis of the practical and conventional," it has been said, yet here such expressive synthesis is taken literally.[4] For *Post-Partum Document* does not simulate acculturation; it evidences acculturation in actuality (see Figure 6).

Differing ultimately on matters of poetic and scientific discourse, Twombly and Kelly nonetheless share a certain bias toward language as being a sign both visual and verbal in nature. Generally speaking, they believe a graphic nexus sustains the conjunction of visual/verbal means; that language organizes the self, not the other way around; that the developmental scheme for language acquisition constitutes a significant narrative; and that material and behavioral manifestations of the hand compensate for a former subjective eval-

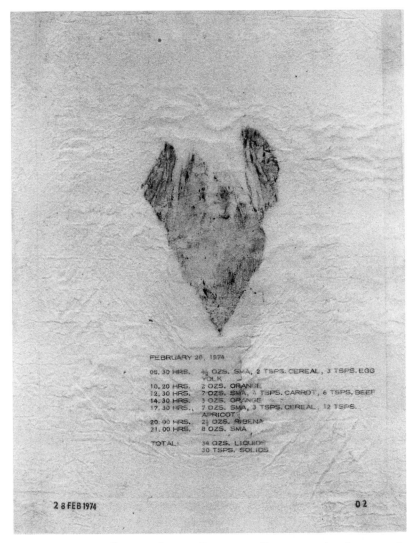

Figure 6. Mary Kelly, *Post-Partum Document: Documentation I.* 1974. 28 units, 14 × 11 inches. Art Gallery of Ontario. Photograph by Ray Barrie.

uation of originality and creativity. That is to say, Twombly and Kelly both stress the social instrumentality of language; theirs is a project that accepts the practical and conventional nature of language as a social scheme measured behaviorally and developmentally even as it is made particular and concrete in individual practice.

*

Assumed by both artists, evidently, is the coincidence of scatological stains with beginnings. From these concrete sensations a realm of physical knowledge establishes itself, presupposing the positivist commonplace that "all knowledge comes from the senses and results from an abstraction based on sensorial data."[5] Considering excrement to be an expression of *matière* that is authentic or at least trustworthy (given that whatever may be fed the infant, its metabolism is not as yet cultural), both artists believe that *matière* in this form is concrete and individual without, however, being beholden to the notion of individualistic expression. A further point: Both artists seek an alternative to the expressive theory of art by emphasizing the material nature of marks and their role in observable practice. With physiological actions to be stressed over the psychological ineffability that emerges at childhood, both Twombly and Kelly seek to argue for mark-making and writing that register this stage of development; and in this they both agree.

*

What follows is a comparative study of the developmental behavior inscribed by Twombly and Kelly in their mark-making practice. From scribbles that yield to mastery over motor control and thence to calligraphy that registers in its physical and symbolic prowess a cognitive content, writing by Twombly and by Kelly and her son reveals the schooling of the hand. Mere sensible intuition to many art critics, Twombly's handwritten practice should by now be recognized for its sophisticated coding.

Something very like a myth of origins may be inferred in both Twombly's and Kelly's decisions to allow signs of *matière* to initiate the developmental sequence.

Paintings from this period in Twombly's career include a certain large unsized canvas, virtually blank except for occasional visual stutterings such as we've seen before. Here mark-making is decidedly primitive, yet it is sophisticated in proffering incipient semantic difference from mark to mark; the formal crudeness of the archaic visual language is thus adequate to affective and cognitive registers of meaning – or so Twombly's rendering of *matière* would argue. The title of the work, *The Age of Alexander* (1960), only reinforces the synonymy that is made between archaic ages of civilization (or, if you prefer, the primitivistic origins of any civilization in children, as Vico

would have it) and culture itself, insofar as the title of the painting condenses in a name an allusion both to an heroic utterer and a vulgar utterer in Alessandro, Twombly's then newly born son.[6]

Yet in a concrete, experiential sense Mary Kelly subscribes to a notion of prelinguistic origins. Proof of this is that smears on diapers come first in the theory of the sublimation of *caca*, and they initiate the developmental sequence. In other words, if Kelly did not believe in developmental origins, then she would refrain from showing defecation as a legitimate part of the sequence – or else she would shuffle early and later expressions, oral and anal (or, most radically, she would have refrained from her intervening in the process of maturation and would have displayed the results of her having left her infant to forage for himself in the wild). However, she elected to perform other narrative interventions in the developmental course of things.

It has been observed that making "marks on paper will come about only with parental intervention." Or so Miriam Lindstrom observes.[7] "Introduced to the child before or after it starts to babble," she goes on, "scribbling will continue until about the age of four years."[8] Looking from Lindstrom's heading, we read, "Stages of Development: 'Scribble and chance forms, controlled marks, basic forms, first schematic formulae (ages 2–5).' "[9]

Twombly's approach to the acquisition of writing in this phase is elaborated in *Mars and Venus* (1962) and in other works. As Lindstrom might describe it, "The first scribbles are made by swinging the arm back and forth or up and down in an arclike movement. This is varied by a pounding or jabbing movement, resulting in dots or hooks as the point leaves a short trail before the tool is lifted from paper."[10] Writing about *Leda and the Swan* (1962), she says, "Next come single arcs, still made by the original swinging movement of the arm, but now in one direction only, the tool being lifted at the end of the first stroke instead of being returned to the starting position."[11] (See Figure 7.) Primarily utilizing the behavioral vocabulary of childhood calligraphy, Twombly extracts an unsentimentalized beginning from the myth of origins. In contrast to the realm of sublime feelings so tempting to romantics of his generation, Twombly lends behavioral semiotic clarity to the gestalt of affective expression. Material affectivity has found a concrete situation in documented studies of childhood development; and so, in effect, by having chosen this source for calligraphy, Twombly gives precedence to historical fluidity over mythological fixities.

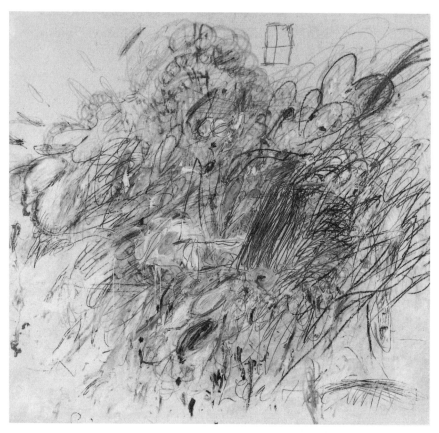

Figure 7. Cy Twombly, *Leda and the Swan*. 1962. Oil, pencil, and crayon on canvas, 6' 3" × 6' 6¾" (190.5 × 200 cm). The Museum of Modern Art, New York. Acquired through the Lillie P. Bliss Bequest (by exchange). Photograph © 1998 The Museum of Modern Art, New York.

How does Mary Kelly approach this same situation? "Documentation II: Analyzed Utterances and Related Speech Events" chronicles "the transition from single-word utterances to patterned speech (syntax) . . . recorded in daily 12-minute sessions, over a period of 5 months, from January 26 to June 29, 1975."[12] "Documentation III: Analyzed markings and diary perspective schema . . . were based on recorded conversations between mother and child during the crucial moment of the child's entry into an extra-familial process of socialization – that is, nursery school."[13] During this time, at the age of twenty-eight months, her son has been induced to draw on paper

would have it) and culture itself, insofar as the title of the painting condenses in a name an allusion both to an heroic utterer and a vulgar utterer in Alessandro, Twombly's then newly born son.[6]

Yet in a concrete, experiential sense Mary Kelly subscribes to a notion of prelinguistic origins. Proof of this is that smears on diapers come first in the theory of the sublimation of *caca*, and they initiate the developmental sequence. In other words, if Kelly did not believe in developmental origins, then she would refrain from showing defecation as a legitimate part of the sequence – or else she would shuffle early and later expressions, oral and anal (or, most radically, she would have refrained from her intervening in the process of maturation and would have displayed the results of her having left her infant to forage for himself in the wild). However, she elected to perform other narrative interventions in the developmental course of things.

It has been observed that making "marks on paper will come about only with parental intervention." Or so Miriam Lindstrom observes.[7] "Introduced to the child before or after it starts to babble," she goes on, "scribbling will continue until about the age of four years."[8] Looking from Lindstrom's heading, we read, "Stages of Development: 'Scribble and chance forms, controlled marks, basic forms, first schematic formulae (ages 2–5).' "[9]

Twombly's approach to the acquisition of writing in this phase is elaborated in *Mars and Venus* (1962) and in other works. As Lindstrom might describe it, "The first scribbles are made by swinging the arm back and forth or up and down in an arclike movement. This is varied by a pounding or jabbing movement, resulting in dots or hooks as the point leaves a short trail before the tool is lifted from paper."[10] Writing about *Leda and the Swan* (1962), she says, "Next come single arcs, still made by the original swinging movement of the arm, but now in one direction only, the tool being lifted at the end of the first stroke instead of being returned to the starting position."[11] (See Figure 7.) Primarily utilizing the behavioral vocabulary of childhood calligraphy, Twombly extracts an unsentimentalized beginning from the myth of origins. In contrast to the realm of sublime feelings so tempting to romantics of his generation, Twombly lends behavioral semiotic clarity to the gestalt of affective expression. Material affectivity has found a concrete situation in documented studies of childhood development; and so, in effect, by having chosen this source for calligraphy, Twombly gives precedence to historical fluidity over mythological fixities.

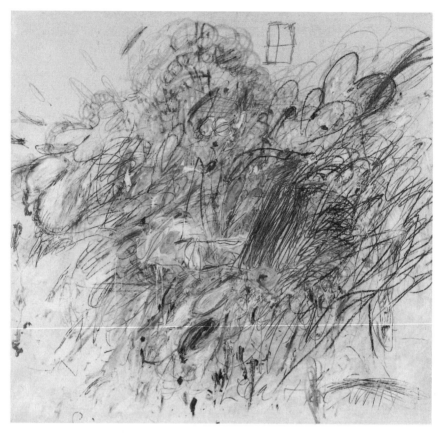

Figure 7. Cy Twombly, *Leda and the Swan*. 1962. Oil, pencil, and crayon on canvas, 6' 3" × 6' 6¾" (190.5 × 200 cm). The Museum of Modern Art, New York. Acquired through the Lillie P. Bliss Bequest (by exchange). Photograph © 1998 The Museum of Modern Art, New York.

How does Mary Kelly approach this same situation? "Documentation II: Analyzed Utterances and Related Speech Events" chronicles "the transition from single-word utterances to patterned speech (syntax) . . . recorded in daily 12-minute sessions, over a period of 5 months, from January 26 to June 29, 1975."[12] "Documentation III: Analyzed markings and diary perspective schema . . . were based on recorded conversations between mother and child during the crucial moment of the child's entry into an extra-familial process of socialization – that is, nursery school."[13] During this time, at the age of twenty-eight months, her son has been induced to draw on paper

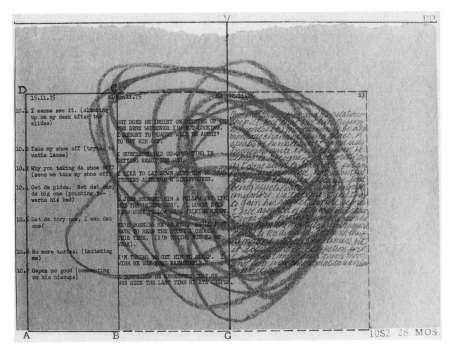

Figure 8. Mary Kelly, *Post-Partum Document: Documentation III.* 1975. 10 units, 14 × 11 inches. Postmasters Gallery, New York. Collection Tate Gallery, London. Photograph by Ray Barrie.

and has produced this: Here arcs drawn continuously show her child's demonstrated mastery of the earliest stages of mature motor control required by society as proof of sustained thought (see Figure 8).

The same paper records a conversation that mother and son carried on the same day in parallel activity. At some point he says, " 'Get da pillow not dat one. Da big one,' (pointing towards his bed)." If, as Quine puts it, "the significance of a sentence for a person is defined in terms of the disposition of that person to respond when queried by either 'Yes' or 'No' when presented with a given type of object,"[14] then what takes place here is the son's mastery of the significance of sentences during reflection. (Separation from the mother through engagement in the material language, thus proving the characterological force of Hegelian negation in development – this is the standard Lacanian interpretation.) Pointing and commanding, the child is registering the behavioral utility of sen-

tences – and thus that they signify sense. Mary Kelly has chosen to show by this means that her son, demonstrably in control, is also subject to frustrated communication, because of the problem of the dialogue's intersubjectivity when translating wishes to actions. Mother does not apprehend command, so son is frustrated. Interpreting ostensibly transparent commands which are shown to be opaque lends to this exchange a decided developmental and social character.

The acquiring of language as a social art is not contradicted by the tendency to interpret this exchange between mother and son as an episode in a plotted story. Rephrasing this in narrative terms, we might say that the folk tale reveals the plot through crisis. Indeed, several critical moments enter into each encounter by the hero in his quest for knowledge coincident with obtaining an object. As Mary Kelly tells it, the role of narrator switches from mother to son and back, and, insofar as son commands mother, son also initiates action. Standard mention of the struggle for power aside, the son's manipulation of language shows the necessity of learning to make choices in life, choices for which the folk tale, conserving the social order, also functions as a rehearsal. Meanwhile, exercising his right to perform choices is intrinsic to her son's narrative, because in narrative, change, choice, and confrontration are points at which narrative is articulated.

Post-Partum Document lets actors speak and write for themselves – at least this is the apparent situation, relative to which Twombly's *Age of Alexander* shows the father acting on behalf of his son. The inversion of this, however, is also true: When giving her son permission to speak by representing baby-talk in dialect (not phonetically), what is Kelly doing but appealing to a simulacrum of another's language? On the other hand, Twombly may not be representing his son's language skills indirectly, after all. Recalling the consideration he paid to the study of Japanese calligraphy – and, indeed, to oriental thought during the 1940s when Twombly, among others of the New York School, was coming of age – we can argue that not all occidental gestures which brought forth Abstract Expressionism were orientalist. Instead, insofar as it is possible to integrate knowledge of any kind, it may be that an acculturation through the assimilation of form may actually produce an authentic calligraphy of one's own. This, at any rate, is what originality means to students of calligraphy, either native-born or foreign. In other words, Twom-

bly is arguably not re-presenting anything outside, having assimi-
lated the mode of occidental scribbling thoroughly.

"Document VI: Pre-writing Alphabet, Exerque and Diary,"
writes Mary Kelly in the book that will aggregate the documentation
of her and her son's "project." Kelly explains,

The documentation is inscribed on stones and set out in chronological
order. Each inscription is divided into three registers (analogous to the
Rosetta Stone) with the child's 'hieroglyphic' letter shapes (pre-writing
alphabet) in the upper portion; the mother's print-script commentary
(exerque) in the middle section and her type-script narrative (diary) in the
lower part.[15]

Documented in the project is an instance of her son's writing on
a slate at 3 years 5 months, making his first x's, which he calls
"crosses" and which are oriented like the plus sign. Her son Kelly
Barrie makes a sign of writing.

Having the child write on slate rather than on, say, linen canvas
(or on a diaper) signifies Mary Kelly's intention to give consequential
sense to the frame of discourse. Slate is an archaism symptomatic of
reference to the origins of grammar school fundamentals. Mary
Kelly is not neutral, then, when it comes to signifying modes of
inscription that account for the socializing process.

Throughout this phase of learning to write, the son's attempt to
print letters is answered by the mother's selective reinforcement of
his behavior in sentences utilizing words with that day's letter to be
learned. Names with a tincture of metaphor, supplied by the mother,
conform to syntactically proper sentences. The arbitrariness of lan-
guage having been noted, the sign of creativity becomes reinforced
as play: "X IS FOR ALLIGATORS X-ING X'S," the mother writes.
"X IS FOR XENURUS HAVING AN X-RAY. GOOD NIGHT
LITTLE X. XENOPHON, XERXES, XEPHOSURA. GOOD
NIGHT LITTLE X." Conspicuous here is the semantic drift from
names only the mother could know to words with a "Z" sound
incommensurate with the "X" to be taught. Indeed, the use of the
very letters themselves (emphasizing the letter "X" pictorially copied
from Latin, ultimately Greek) is meant to emphasize the dual actor
in this register on the slate.

Acknowledging the mother's response as such is the point of her
third discourse, which is typewritten. It provides the irrevocable shift
to writing from speech in the social framing of the activity of child-

rearing. Mary Kelly's choice is to objectify her own circumstances even as she elects to present the subjectivity of expression narrated in the first person: "Parents (i.e., mothers) are required to supervise children at the playground once a fortnight. How I dread it! I don't really want to know what he's like at school." And so on.

Anticipating Kelly's discourse on slate is, of course, the well-publicized practice by Twombly: His canvases from the mid-1960s, covered with gray housepaint, are drawn on in chalk. It is these works that have become informally dubbed his "blackboard" paintings.

In Twombly canvases devoted to mathematical notation, a horizontal line drawn freehand – unruled, that is to say – is left to register the muscular unevenness of handwritten behavior when tentative or when introspective because devoted to inquiry. While the seismic connotes affectivity in designating the language of the emotions, it also takes note of the probing nature of research, with its introspective calculus marked by inattention to the good gestalt of handwriting intended for public consumption. In contrast to Klee's certitude in rendering such signs, Twombly inscribes incertitude that is not unlike Kelly Barrie's scrupulous attempt at writing the letter "X."[16] In Twombly's notation, a handwritten line, together with a number that may – or may not – measure its length, offers itself to tremulous scientific instrumentality. Not all such canvases, however, calibrate this uncertitude; in other canvases of chalk boards, topologies render a kind of non-Euclidean geometry rhapsodically.

Let us return to Kelly Barrie's slate, then. "B IS FOR BALLOON," Mary Kelly says. "This is the first letter he has constructed for the express purpose for writing a special word – his surname." (See Figure 9.) Mary Kelly notes and deliberately reinforces the critical moment of naming because that past moment of self-reflection in her child corresponds with the mirror stage of legend – or perhaps a denied reflection on the mother's part. She continues,

On the one hand [. . .] [is] writing anterior to speech [. . .] which resists signification. And on the other hand, the graphic rhetoric of children's books referred to in the mother's annotations to the child's script [. . .] implies a certain coagulation of the signified, underlining the logocentric bias of the system of language to which the letter ultimately subscribes; a system privileging naming and the proper name that pronounces the beginning of writing with the child's inscription of his father's name.[17]

A denied reflection of her own last name that had been given Kelly Barrie along with the father's last name may indicate that Mary

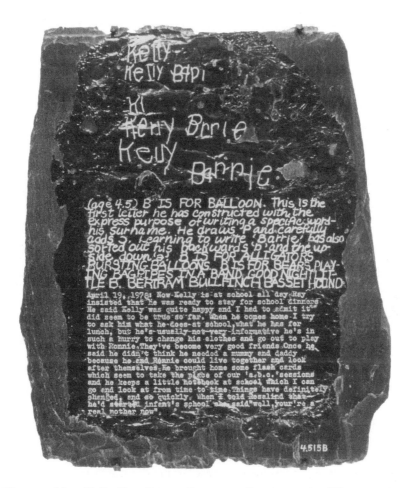

Figure 9. Mary Kelly, *Post-Partum Document: Documentation VI*. 1979. 18 units, 14 × 11 inches. Arts Council of Great Britain. Courtesy of Postmasters Gallery. Photograph by Ray Barrie.

Kelly continues to subscribe to a dogmatic conception of patrimony despite evidence in her life to the contrary. Meanwhile, conventions of cultural indoctrination of the self proceed on schedule. What follows is by now the ritual of play. "B IS FOR ALLIGATORS BURSTING BALLOONS. B IS FOR BEARS PLAYING BAGPIPES IN A BAND. GOOD NIGHT LITTLE B. BERTRAM BULLFINCH BASSET HOUND."

This formulaic verbal play that is taking place on the slate where learning takes place constitutes a didactic zone for both mother and

son, a place where sentences conforming to expected conventions rehearse appropriate alliterative skills. This is not exactly the writing of imagination. Although alliteration displays "nonsensical sentences," the syntactical conventions overrule them; moreover, by displacing onto dancing animals lessons that are proper to humans – as in folk tales, or as in folk tales tediously and tendentiously revisited in children's literature – the lessons there to be learned take priority over any culturally independent imagination. This is not the way to Vico Road, Dalkey.[18] Or, put another way, this activity of Mary Kelly pertains to heuristic play; it does not pertain to art.[19] The function of alliterative aestheticizing sentences here is that of making "B" memorable, and by granting rudimentary literariness to the sentence, Mary Kelly ensures that the "B" remains in the cognitive foreground.[20]

Learning is changed behavior – this, at least, is the behavioral definition. Taken for granted here is the desirability of changing the son's linguistic behavior to conform to the conventional and practical norm. In print meant to make intelligible the zone of didactic play, Mary Kelly has inscribed, "He draws P and carefully adds 'ɔ.' Learning to write 'Barrie' has also sorted out his backwards 'b' and his upsidedown 'ə'."[21]

A narrative such as the narratives we call history would record a sequence of changed behavior that witnesses deem significant. In addition, *Post-Partum Document*, the history of developmental graphic behavior, lends credence to this definition of narrative. With writing the goal of all this effort, it is recorded that "B" "is the first letter he has constructed with the express purpose . . ." where meaning and intention inscribed in use attain the acculturation sought. This slate, inscribed with "B," constitutes the last slate in the book documenting Kelly Barrie's demonstrable mastery in writing, and it supplies the sense of an ending, insofar as by convention he has attained self-definition.[22]

In the fabula of mastery of writing, meanwhile, Twombly had already attained considerable authority. The mid- and late 1960s saw him producing paintings in pencil in which handwritten lines that were accompanied by numbers conventionally denoting measurement in other circumstances – or so-called blackboards with "advanced" mathematical topologies and calculations – indicate the scope of scientific cognition. Even better known are the "chalkboards" that demonstrate his mastery of cursive script from 1969. Calligraphic exercises derived from the Palmer method eloquently

condense schooling in acculturation once eye and hand coordinate to produce mature writing. If a developmental narrative entails a tale of antecedent and consequent behavior, then the two decades when Twombly produced these paintings that were devoted to the stages of acquiring linguistic mastery in written analogues to cognition unfold such a narrative.

Conventionally defined, narrative means "telling a story," and although an extended consideration of this definition lies beyond the scope of this essay, relevant here is mention of Twombly's many-part painting *Fifty Days at Iliam* (1977–78), which compounds dia-chronic and synchronic structures.[23] A structuralist theoretical un-derpinning is mobilized. Telling a story becomes fabula, then, and not only in Twombly's selective resequencing of the heroic story of war. It engages the artist's penchant for scrawling and smearing names of the Achaeans, defiled as only graffiti can do to the heroic war once the history of actual battle has done violence to the pristine anticipation. See, for instance, the canvas from the Iliam series enti-tled *Heroes of the Achaeans* (Figure 10).

Embedded in Twombly's epic painting, meanwhile, are several distinct registers of *écriture* that correspond to the poetic logic of language acquisition – roughly in sequence first from poetry to prose reductions, and from there to an admixture of literature and writing, and from prelinguistic stutterings to schema for rational thought. This last may be seen to be condensed as "A" and "Δ" coalesce in this name among a catalogue of names, for beyond being a "most prominent element in a text," the name also constitutes a symbol, a symbol condensing alphabet and mathematical notation.[24] Integral to Twombly's graphic semiotic in this and most other work is that sensations come in already schematized symbols utilizing correct orthographic notation within a name.[25] If not predetermined in all respects – and almost always intuitively *enacted* – Twombly's callig-raphy nonetheless signifies the artist's analysis of handwriting into reductive developmental concepts. In other words, the epic painting retelling a tale of Greece comprehends signs of the material and the symbolic cognition within the poetic discourse inscribed there.

<p style="text-align:center">✳</p>

Let us return to the citation from James Joyce. "Vico Road, Dalkey" allows a brief consideration of the modern interest in the archaic generative cries and babbling by which the humanist Vico became the father of developmental linguistics, among other fields not yet

coined in his age. Language as the comprehensive term governing not only a person's cognitive growth but also the very substance of identity is a truism that rests with Vico, and so, however briefly, let us note his model.

Although associated with popular accounts of the myth of linguistic origins, it is Vico's profound historicism that scholars have come to celebrate.[26] The rhetorical age into which Vico was born assumed a rational and nonvarying conventional implementation of the materials of expression, for which a person need only acquire a certain skill. In his maturity, Vico deviated from this model of extrinsic expression, and he arrived at a model in which languages seemed to be "vehicles of a complex and differentiated historicity which is not reflected but *actualized* therein."[27] He came to believe that language was not artificially assigned but that it facilitates cognitive development and thereby "partakes of a historically definite patrimony of culture."[28] Two hundred years after Vico, Mary Kelly is helping to reinstate the rhetorical model of preexistent ideas – but with this difference: *Post-Partum Document* chronicles language acquisition of predetermined cultural conventions as a process to be investigated empirically and individually.

Observing the process from babbling to speech in his own children provided Vico with a method adopted later as standard in the practice of developmental child psychology. His theory of pedagogy, developed experientially, led him to repudiate the formalism of exclusively textbook learning for what the Bauhaus and Black Mountain College would call *learning by doing*. Experiment, improvised or methodical, is characteristic of the approach of both Twombly and Kelly. Both Twombly and Kelly presuppose the observed process of learning to write when translating the creative process from a subjectivity associated with Abstract Expressionism to an objectivity of some sort, and they liken this objectification to learning to write – or in Twombly's case, unlearning it to learn it again (that is, to the expressed stages of rudimentary impulse, demonstrated trial and error, and learned motor control in calligraphic notation). Kelly, meanwhile, has adapted the very approach of experiment, and with positivist exactitude she has saved and labeled specimens, she has recorded data, she has persisted in a method over time, and she has incorporated intersubjective responses and presuppositions of the experimenter in her findings on language acquisition. Coincident with this work was the timely reappraisal of Vico himself, when, in the late 1960s, the language of empirical procedures also lent art

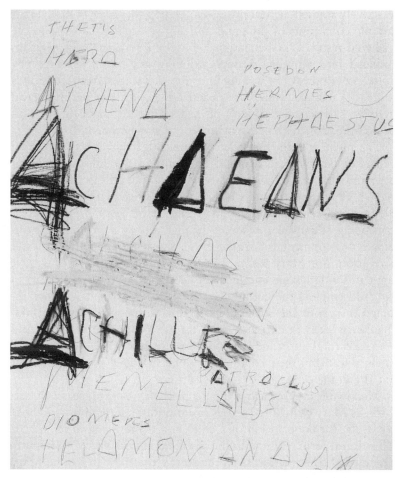

Figure 10. Cy Twombly, *Heroes of the Achaeans*, from *Fifty Days at Iliam*. 1977–78. Oil, oil crayon, and pencil on canvas, 76½ × 59 inches. Philadelphia Museum of Art: Purchased. Photograph by Graydon Wood.

terms of research and extended investigations. ("Investigations," a word utilized increasingly to represent artifacts through description, was meant to register awareness of the turn in philosophical description.)

Actually, the relevance of Vico to this discussion is several-fold. Historicist presuppositions are at work to modify the fixed idea of inherited language acquisition. Presupposed on the one hand by Twombly is the idea that the past is relevant to the present and can

be actively studied in vital processes; and on the other by Kelly, that variable conditions of time and milieu give a particular cast to the predicted result. Whether implied or actual, temporal processes introduced into painting through drawing are meant to show the plotted development of writing in its marked stages. In effect, Kelly's artifactual records, which are ordered along distinct narratological registers, serve to make Vico's plotted scheme of linguistic development compatible with her own structuralist experiment.[29]

The most relevant reminder of Vico still remains his pioneering studies of language acquisition, especially in the substantiation of the claim that the linguistic activity of childhood inscribes culture itself. Calligraphy is a nexus of quite occidental values that are relevant and crucial to our understanding of Twombly's informal sequencing of canvases, wherein through a drawn writing there unfolds a developmental narrative from intuitive to cognitive cultural inscription. For Mary Kelly, the fact that both the basis of culture originates in language and that the history of speech and writing in the child emplots the cultural patrimony is consistent with her assumptions about the social construction that constitutes the child. Thanks to ideas in currency from the philosophy of language and from structural anthropology, discourse theory is elevated to a governing paradigm; thus, too, is Vico acknowledged as an antecedent and ally in the centrality of language in art.

Meanwhile, representing the acquisition of language as an artwork, as Mary Kelly does, shows assumptions compatible with those that enlist the cooperation of a child in a demonstration of embedded cultural form. (Although the so-called natural entity "the child" is a cultural construction from the start – that may in fact be Mary Kelly's proposition – the mediated aspects of biological and cognitive nature have been long acknowledged as natural.) Then, too, Kelly's project, rationalized through discourse theory though it may be, is taking place under the aegis of the documentary investigation that in the 1970s attempted to naturalize the cultural formalism of the prior generation; however, the structural reconsideration of the documentary artifact adds a culturally self-conscious layer to this naturalism.

In the documentary style that attaches to Conceptual artifacts from the mid-1960s on, writing and verbal forms of language – not visual form – are the subject and strategy of art. Evidence of this may be seen, once again, in Mary Kelly's piece, for the third of three verbal registers on each of the spelling slates coincides with the

process in which the narrative of language acquisition is transferred from the home to the school and, in consequence, reveals the mother's responses toward the son's becoming less docile with respect to her authority.

This register is typewritten. With Mary Kelly's entries written on the typewriter, there now comes an historical constraint placed on her material choice. Smith-Corona's declaration of bankruptcy in 1995 provides the historical terminus to a once up-to-date technology, an instrumentality of objectivity, therefore, placed in jeopardy. Marked by a kind of *terminus ante quem*, even typewriting, like painting, reveals itself subject to historicism; indeed, in consequence, brushes and typewriter are suddenly in parity, because both technologies are rendered obsolete. The argument that would have the typewritten text as neutral objective information is thus framed through a period instrumentality of such a rhetoric of objectivity.

This is to say that Mary Kelly's artifact is an expression of her time. In adapting a framework of preconceived ideas in language acquisition to the individual history and practice of learning to write, Kelly in effect answers Twombly's calligraphic scheme of cognitive growth with a scheme appropriate to the behaviorally concrete actions frequenting art in the 1970s. Together with the actuality of art actions and participation events, *Post-Partum Document*, among other books and catalogues, assumes a special significance in the panoply of artifacts devoted to replacing things with works *of* language and *about* language.[30]

6

When Is a Door Not a Door?

Jasper Johns

Built as much as brushed and planned as much as built, early paintings by Jasper Johns put the felt spontaneity of Abstract Expressionism on notice. Motivating the artist was a wish to build "an object."[1] With hindsight we can say that the constructed paintings he brought into being between 1955 and 1964 challenged the status quo not simply because they looked different from Abstract Expressionist works but also because they addressed some of the same questions of art-making that the Abstract Expressionists were concerned with; however, they arrived at foreign yet equally valid pictorial solutions. If for no other reason than to redefine in manifest terms what we mean by "making a painting" and "the object of art," Johns built paintings that display these two meanings. The very embodiment of intentions, Johns once said,[2] serves to absorb us in the object even as we study it, while it "draws our attention," so to say, to the practice of art as concrete thought. The question now is this: What is the function of surface, edge, and attached elements in this praxis? We can address this question by discussing the relation of edge to surface in several of Johns's early works.

In his *Target with Four Faces* (1955) surface is the location where sight meets site (see Figure 11). Beneath a row of boxes, each one of which houses a cast of a face cut below the eyes, sits a painted target, as though to effect the displacement of sight from the four sightless masks at the canvas's upper edge to the canvas's center. Because with every description of the art object an interpretation insinuates itself, another plausible description might well suggest that against the simple centrally placed fixity of site shown by the bull's eye, there exist in dialectical relationship at the edge of the target four serial viewpoints, the one and the many together signifying the available stances on perspective. This margin, where several sightless gazes perch, establishes a modern, decentralized perspective that may be at odds with the assumed centrality of a Renaissance

perspective, so that the new paradigm of perspective is taken with the traditional without superseding it.

Although Johns reported that he had intended to build an object, he was not necessarily indifferent to antecedent Surrealist objects: His own early art objects are decidedly a response to them. It is instructive, for instance, to compare his boxy paintings with Joseph Cornell's boxes, known to Johns since 1954, for we can see that Johns's analytic treatment of the motifs already existed thematically in Cornell's shadow box of interiority.

Compared with Cornell's thematic treatment of sight, Johns's constructions create a logic of sight. In Cornell's *Medici Slot Machine* (1942), the figure of a young Medici prince (a reproduction of a Renaissance portrait) is the centrally placed image, one whose eyes and superimposed axial sight-lines coincide (see Figure 12). Syncopated with this figure are smaller, serial images of the same face (and other faces) repeated along the vertical edges of the box. Taken together, these faces dramatize the interplay of central and marginal site, the locations of which present the polarities of sight offered in the one and the many. In Cornell, central and marginal perspectives are particular, serendipitous, and approximately axial; in Johns's concrete analysis of the perspectives from the margin and from the center, however, these same elements are general in type and absolute in location. In Cornell, the axes that pass through the gaze of the Medici boy, focusing our sight, bring about concinnity, especially since the vertical axis drops straight down, drawing our eyes to a round compass at the foot of Cornell's constructed world. Johns, instead of creating a harmony between these central and marginal elements, establishes a tense equilibrium between concentricity and seriality – that is to say, between a one-point perspective and a multiple-point perspective. To do this, he first addresses the physical margin of the artwork, the place where sight is literally and metaphorically cut off. This margin of occluded sight then informs the center, whose ocular hegemony is all too intact.

As with the artist John Graham, so too might Johns be said to have utilized the eye as "a causeway between inner and outer knowledge,"[3] but, unlike Graham's mystical effects, Johns's art shows the inner oracular knowledge at odds with its palpably materialistic (objectlike) realization in a work of art. As a consequence of this tension, antagonistic notions of perspective are made evident, solid. Furthermore, in Johns there is no more glass surface through which

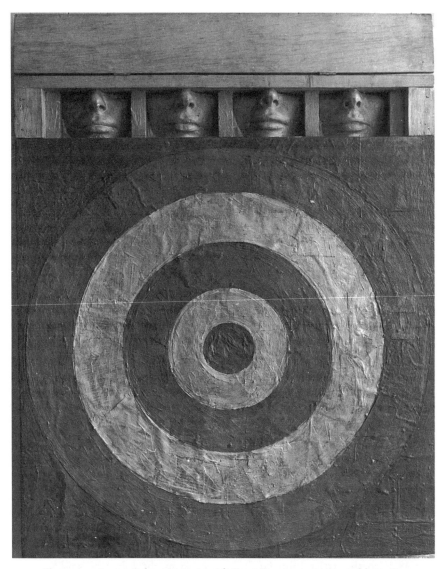

Figure 11. Jasper Johns, *Target with Four Faces.* 1955. Assemblage: Encaustic on newspaper and collage with objects, 26" × 26" (66 × 66 cm) surmounted by four tinted plaster faces in wood box with hinged front. Box, closed: 3¾" × 26" × 3½" (9.5 × 66 × 8.9 cm). Overall dimensions with box open, 33⅝" × 26" × 3" (85.3 × 66.7 × 7.6 cm). The Museum of Modern Art, New York. © Jasper Johns/Licensed by VAGA, New York. Gift of Mr. and Mrs. Robert C. Scull. Photograph © 1998 The Museum of Modern Art, New York.

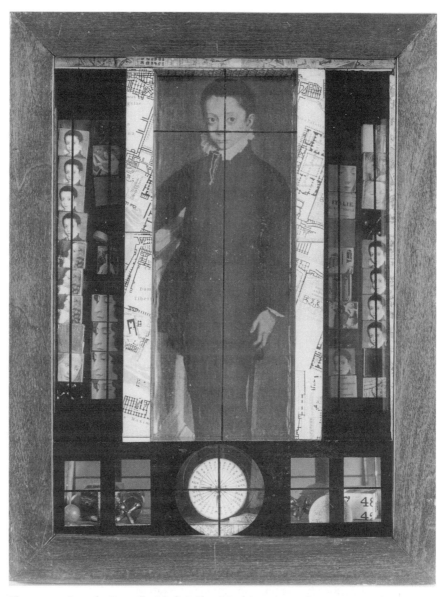

Figure 12. Joseph Cornell, *Medici Slot Machine.* 1942. Box construction: stained hinged wood box with glass pane containing painted glass, metal jacks, photographs, printed papers, wood cubes, wrapped in printed and colored metal papers, glass and wood marbles, wood game pieces, mirrors, and compass mechanism, 15½ × 12¼ × 4⅜ inches. Private Collection. © The Joseph and Robert Cornell Memorial Foundation. Photograph by Hickey-Robertson, Houston, courtesy of the Menil Collection, Houston.

one sees into an imaginary world: The opaque plane is sufficient to project the problematic of sight. It is as if Johns had taken Symbolist concrete thought to an extreme in order, as the Surrealist André Breton might have said, to follow through on the impulse to make the imaginary real.

By no means do all of Johns's early built paintings utilize the actual physical margin of a canvas to dramatize the opposing logics of serial and one-point perspectives. Surface itself is the principal focus in several of his works, and it is made the subject of painting through a constructed incursion: an internal edge to which our sight is drawn. Johns's calculated, constructed linear seam has a very different relationship with the surface than, say, Lucio Fontana's spontaneous assault on the canvas, an assault which does violence to it, leaving a palpable gash in its fabric. As opposed to this *matière* of a cut meant to engage the emotions in the *tachiste* approach to art, Johns proposes a cerebral sort of ontology. As seen by Johns from a psychic distance, the first function of this constructed incursion is to manifest its surroundings.

If we compare *Drawer* and *Gray Rectangles*, both done in 1957, we can examine the difference in the nature of surface in *Drawer* – a canvas into which the front panel of a chest of drawers has been set – and in *Gray Rectangles* – a canvas into which three stretched canvases have been set (see Figure 13). What difference, specifically, is there between a construction of canvas incorporating an object and the same construction of canvas incorporating itself? *Drawer* is materially emphatic, despite the piebald brushstroke that seeks to camouflage the construction, whereas the more evenly stroked *Gray Rectangles* suggests a metaphysical version of the material object framing itself, so that it presents its being as a Heideggerian No-Thing-ness rather than as nothing or emptiness. Lines from "Skin," a poem by Frank O'Hara, that were incorporated by Johns into his *4 the News* (1962) a few years later are relevant here:

> and holes appeared and are filled
> the same holes anonymous
> no more conversion: no more conversation
> the sand inevitably seeks the eye
> and it is the same eye.[4]

Imported into Johns's painted *Drawer*, the found facade of a drawer allows the filled holes where the drawer is fitted to be discerned as a

Figure 13. Jasper Johns, *Gray Rectangles*. 1957. Encaustic on canvas, 60 × 60 inches. Private Collection. © Jasper Johns/Licensed by VAGA, New York. Photograph by Rudolph Burckhardt.

semantic shift, as though signaled from within the now literally objectified art object.

That the internal edge is also constructed is more evident in *Gray Rectangles*, the physicality of whose seams, stressed by traces of color, makes of an immaterial and neglected element a discernible entity. This internal edge is meant to render the notion of edge palpable. Furthermore, to put stress on the cut impels us to read a relationship, of which this edge is a mediating device. Later in his career, after Johns had abandoned construction, he still employed edge as a distinct perceptual entity that, if the artist so chose, isolated shape from shape by announcing a semantic shift in the discontinu-

ous edge between shapes. (See, for instance, either the colored or the monochrome version of *Racing Thoughts* [1983], respectively at the Whitney Museum of American Art, New York, and the Collection of Leo Castelli, New York.) In consequence, the embedded surface within a surface may suggest a consideration of parts and wholes. A fragment of a chest of drawers inserted into the canvas may be construed as a part completed by a whole; a standard prefabricated stretched canvas – a readymade, so to speak – inserted into another canvas presents the inversion of this whole. Says Johns, "[What] interests me [is that] that whole can be thrown into a situation of which it is only a part." He approves of my inference that the whole canvases inserted into *Gray Rectangles* present a model embedded within the actuality – even as the polysemy also allows us to interpret an inserted canvas as a sample of canvas. In any event, the imported surface is an intervention that returns the surface to itself. Furthermore, just as the marginal edge has migrated to become an internal edge within the surface of the painting, so also does the planar surface intervene in the larger field so that it does and does not belong to the surrounding surface with which it is coextensive.

Perturbation of surface creates one sort of object. To insert a foreign object into the internal seam creates a statement of a different sort. Once the surface becomes the site of material and rhetorical insubordination, the entire painting is reconfigured; it is designed to propose a counterargument directed against prevailing aesthetics. Robert Rauschenberg's refutation of spontaneity, *Factum I, Factum II* (1957), is the most famous of these mutinous acts, yet Johns's objects also questioned the Abstract Expressionists' protocols. Indeed, taking on issues of spontaneity, risk, and "the new" with his very deliberate intellectuality, Johns was provocative from the start.

Painting with Two Balls (1960) presents a built, material equivalent to psychic tension, with two of its internal edges held open with inserted objects. However, this is a dissembling construct of psychic tension, one in which struggle is made literal. Mending plates, screwed into the gesturally painted panels, seem to pull the panels tight even as balls pry them apart; yet, for the person observing this work, Johns says, the work displays not physical tension but only "the idea" of such tension. He recalls that once the balls were jammed between the two panels, he had to rebuild the support to compensate for the physical distortion of the bulging rectilinear frame and warped canvas. To prove a point – to score a point against the Abstract Expressionists – he "chose to deceive in order

to give [the] impression of equilibrium" by mechanical or physical means. The equilibrium of mechanical forces prying open a planar surface, even as this surface is braced shut, re-creates neither Hans Hofmann's emotionally informed "push–pull" optics nor Willem de Kooning's aesthetic of sensually charged psychic distress. In Johns's rhetorical reworking of action painting, we see creative struggle replaced by the deceptive appearance of mechanical forces at work.

Johns's masterly sleight-of-hand compensation for distorted construction argues the case for an authenticity in his work that advances beyond trivial parody. As Greek architects employing entasis knew, sleight-of-hand argues for the priority of viewing over making, with authenticity of reception achieved as a consequence of artistic manipulation. The hardware employed in Johns's literal misreading of the metaphor of tension and struggle may not suffice to express fully the tensions inherent in the idea of creativity, but this shift to dissembling mechanics does not diminish the considerable iconic power of *Painting with Two Balls*. Among his early works, in fact, it remains exceptionally compelling. Johns's truing and fairing intelligence proves to be as legitimate a means of expressing creative presence as Abstract Expressionist nerve – or "ballsiness."

Nor was this painting an isolated example of Johns's sparring with the ideals of the New York School. If, in *Painting with Two Balls*, balls usurp the principle of risk, in 4 *the News* an actual rolled newspaper jammed between canvases drives a wedge into the stance of innovation. As eye-catching as a target, the wedged seam is instrumental in creating for art the possibility (to cite the poststructuralist phrase of Mary Ann Caws) of "an interruption against closure."[5] Together with Rauschenberg, Johns was instrumental in preventing closure in the discussion of aesthetics after World War II. These constructed paintings, in which the deliberately fabricated margin has penetrated the spontaneous, gestural center to its core, were instrumental in deconstructing the innocence of Abstract Expressionism, showing it to be a rhetoric.

7

Jasper's Patterns

In art, as in literature, what catches the eye may lead the unwary to false conclusions. The American flag that Jasper Johns once painted in series (1955) has ever since been used in snappy characterizations of his art, as if emblematic Americana is what it is all about. But by now, even the most naïve should realize the absurdity of this use. As our sole entry to the Venice Biennale this year [1990], Johns, pleading his case by way of a diversity of paintings done from 1974 to 1988 – thirty years after he displayed his flags – makes evident that no single motif can stand as his trademark.

If anything, the situation now reverses itself. First shown in the American pavilion in Venice and more recently in a slightly expanded version at the Philadelphia Museum of Art is a retrospective of recent work that will strike the casual viewer as hopelessly disparate. What, after all, do arrays of hatch-marks, a cast of an arm, and a representation of a Mona Lisa decal have in common? If, however, we are willing to put aside the notion that an image – any one image – identifies Johns, then certain binding principles suggest themselves. Among them is one which, although not exhaustive, renders much of Johns's willful diversity lucid and his frivolous pictorial escapades coherent.

Indeed, the more we look at this miscellany, the more it seems to conform to a kind of conceptual pattern painting – an irreverent coinage, considering that the dubious revival of decoration in the early 1970s called "pattern painting" seems aesthetically remote from Johns's decidedly anti-ornamental canvases. Characteristically, however, Johns's notion of pattern is as cerebral as it is comprehensive – or so we realize as we scan the canvases in this exhibition, our glance taking in the cross-hatching, stencils, casts, and other visual matrices populating his works.

This display of templates and hatch-marks elaborates Johns's longstanding obsession with public language and the received visual ideas of culture. Representing space is a conventional activity, and whether the space to be described is a face in shadow or the mapped

expanse of the United States, the visual notation associated with spatial representation is common parlance. Or so Johns has always maintained. Assembled for the show are the best of Johns's cross-hatched canvases, some in two versions – *Dancers on a Plane* (1982–83), *Between the Clock and the Bed* (1981), *Celine* (1978), *Corpse and Mirror* (1974), and, isolated from these in a room of its own, *Scent* (1973–74), the earliest of this group and the painting that curator Mark Rosenthal has chosen to inaugurate his presentation of the artist's late and sudden abstract phase. (See the book cover.)

Scent presupposes our familiarity with fundamental visual conventions, specifically those of graphic art. Only then is it possible to appreciate that the hatching we have seen in Rembrandt's seventeenth-century improvised etchings of raked light falling across a cluster of trees – or in eighteenth-century mezzotints bearing totally programmatic linear schemes for architectural landscape – is present here in entirely bald statement: *Scent* is wholly composed of the hatched, generic notation for *area*. Color is standard, too. Orange, green, and purple, instantly perceived as the gestalt of secondary colors, cluster according to a syntax of map-making; primaries of red, yellow, and blue hint their presence in the interstices. Not a description of the world of seventeenth-century Netherlands, *Scent* is not even a reprise of the U.S. maps Johns painted in the early 1960s, works in which the standard schematic for this country's internal boundaries becomes a kind of grid doused by juicy Expressionist gesture that compensates for the rationale the map proposes. The cartography of *Scent* is different. Now much tidier, it builds efficient systems of regions, adjacent yet distinct, with a kind of mark that is at once a graphic code for representing area and a schematized gesture derived from the zigzagging wrist and shoulder that produced Abstract Expressionist brushstrokes. Cross-hatching, a pattern in itself, identifies the germ of the patterned whole.

In Johns's view of things, pattern is constitutive structure, not detachable decor. Moreover, in his hatched paintings – done a quarter century after Jackson Pollock's all-over fields – Johns seems to be taking up Abstract Expressionism to comment on the issue of space and its centrality to modernist art. For some orthodox modernists, the choice of spatial pattern is no idle matter, because it represents the avowal – or disavowal – of twentieth-century aesthetics. Central to this avowal is the idea that, whatever else modern art may be, it is marked by a major shift from illusionist space describing a transparent world of events to nonillusionist space concerned

with describing medium and form. Assuredly, this is a biased model, one extending to culture, which equates spatial conceptions with worldview – and, thanks to a stubborn misunderstanding of the Albertian notion of perspective, one that furthermore privileges Italian over Flemish and German art.

It is this by-now cultural given that Pollock extended in his *Scent*, his last painting, and to which Johns in his own painting *Scent* responds. The mandate, as Johns evidently sees it, is to take on the surface-acknowledging conception of space and perpetuate it even in dispute. So whereas in his hatched canvases, Johns answered the individuality of Jackson Pollock's action paintings with a visual language that was as deliberate and conventional in its own way as Pollock's had been spontaneous and free, he maintains the allegiance to the radical modernist space his Abstract Expressionist forebear inherited.

Essence is expressed by grammar, Ludwig Wittgenstein declared early on in his philosophical pursuits, but even before Johns read Wittgenstein in 1961, he was thoroughly absorbed by the issues of visual language – its order and meaning. His hatched paintings only continue this fascination. In *Scent* the visual schema of cross-hatching is nothing less than the grammatical germ that grows into the all-over visual field, the nonhierarchical, nonillusionist essence of space on which all else depends. It is, moreover, the subversive essence that infiltrates all-over composition with alternative arrangements and new spatial orders. As the late Tom Hess pointed out when Johns's *Scent* was first shown, a hidden pattern of symmetry is embedded in the all-over scheme. Much like Henry James, whose notion of the figure in the carpet established a poetics of withheld meaning within the style of writing itself (the syntax of the sentence reflecting in microcosm a hidden, ever-retreating solution to a problem), Johns insinuates a configuration in his overall carpet, introducing the specter of order into the apparent disorderly state of affairs. Indeed, in his *Scent*, two different internal arrangements lend coherence to this apparently aimless field of marks. (The first of Johns's Wittgensteinian color arrangements that utilize clustered green, orange, and purple is both symmetrical with respect to the painting's internal edges as well as circular in that pattern's links to the external edges; the other embeds "squares" within the field.) From skeins of hatch-marks to broadloom spatial field, *Scent* represents a concatenation of at least four different organizations of space, a compound essence, not an ornamented, simple one.

The significance of this is that, unlike modernists who proclaim a single restrictive grammar, Johns always argues against the certainty of one grammar and for the uncertain coexistence of several significant ones. Multiple orders embedded or entwined in each other introduce alternative orders of pattern, creating the all-over spatial field. By adopting this plan, Johns sums up the definitive modernist viewpoint on space while decidedly qualifying the modernist claim to definitiveness. He can do this thanks to the complex signifying power of his hatched notation. Drawing on the history of the mark – and savvy in the worldviews ascribed to certain spatial paradigms, Johns has deliberated long and hard to give us polysemous field paintings that are in pensive control of a complex modernity.

<div align="center">✳</div>

Over the decade from the time he produced *Scent* to 1983, Johns concentrated on hatching exclusively, although by 1982 he was importing other kinds of pattern into the pictorial space of the canvas to recontextualize meaning. Although previously he had been most concerned with representing abstract space, the pictorial space of the studio or private museum now particularized Johns's mode of address. Returning to recognizable subject matter reinforced this new direction.

In the Studio (1982) is a rare instance of Johns's engaging an identifiable genre. Precisely because, in constrast to any prior artwork in his oeuvre, the setting of the studio containing standard apparatus of an artist's practice is pristinely evident, we realize he is treating the studio situation as a commonplace. In this assemblage, a painted wall plane and a reference to the floor plane indicate the setting. Reinforcing the illusion of flatness are actual attachments: Physically mounted to the canvas from the bottom is a wood stick; attached above it is a wax cast of an arm holding a cloth to the surface of the canvas. Taken together, these few sculptural elements, along with representations of painting and drawing, provide the meager furnishings with which the artist must conjure an imaginary world. Yet the sense of the studio as garret is soon displaced by the richness of implied artistic practice.

We might say that here, rephrased slightly, is a collection of things that at once represents the artist's own world, the media available to him or her, and the traditional academic props and tools that have so often functioned to help an artist in his or her métier.

Typically, in academically realized studio pictures, the artist's presence comes into being by a visible sample of his art leaning against furniture or hung on the wall. It is the same here, where current cross-hatched paintings – or studies for them – hang with works that are nailed illusionistically alongside an actual straight-edge, anatomical cast and other objects. In contrast to the contrived disarray that a picturesque rendering of the studio would proffer, however, Johns's approach distances itself from a quaint treatment of the subject. The commonplace idea of the studio is organized: Neatly aligned groups of things invite comparison and structural classification. In case we needed further proof that Johns is addressing the topic of the studio not as an actual place but as an idea of *this* place, note the ruler, virtually pointing to painted lecture-demonstration paraphernalia behind it.

Evidently about Johns's own practice, *In the Studio* provides the conceptual envelopes of praxis as well. In this sense, no matter how specifically figurative, Johns's paintings, which are furnished with ostensible definitions, address abstract aesthetic considerations. To take an example, consider the paired studies for cross-hatch paintings (in secondary colors) appearing on the right: They exaggerate the rhetorical difference between draftsmanly and painterly alteregos in the same composition. The draftsmanly version bespeaks control; the painterly sighs and confesses its fluid condition. (Current work recently on exhibition at the Castelli Gallery further exaggerates the stylistic polarity between linear and painterly rhetoric by revamping Picasso's *Weeping Woman* [1975].) Thus, Johns argues, structure generously allows both blurred and sharp renditions of the same form. *In the Studio* converts the particulars of Johns's artistic practice into an allegory of all painters' concerns.

If *In the Studio* establishes a generalized model of studio practice, it is thanks to the fact that it is stocked with concrete examples to be taken as rules: casts, templates, straight-edges, tracings, and patterns – all practical guides for the artist at work. As in conventional studio paintings, this one by Johns features an anatomical cast, a cast recalling academic plaster casts from which artists traditionally learn to master the canonical form of the human body. Although Johns's particular wax casts of friends' limbs (with hatch-marks mapping particulars, not essences) are distant from the generic Roman paraphrases of the Greek ideal, they are casts nonetheless and so constitute a kind of second-order discourse about the body. It is by no means frivolous, then, to note that the collection of hatch-

marks, casts, templates, and straight-edges exemplifies the true do-
main of conceptual pattern painting for the artist-in-training or for
anyone who might apprentice him- or herself to the practice of the
studio.

In Johns's academy, the cast typically exists as a fragment. Ever
since 1954, when Johns mounted fragmented cast body-parts atop
the painted image of a target, he has valued the fragment for a
special reason that Wittgenstein articulates when he writes,

It is as if one saw a screen with scattered colour-patches and said: the
way they are here, they are unintelligible; they only make sense when one
completes them into a shape. – Whereas I want to say: here is the whole.
(If you complete it, you falsify it.)[1]

Of interest for us here is the conceptual sufficiency of visual data,
even if Johns does not follow Wittgenstein's call for description
literally. By superimposing a schema of discrete red, yellow, and
blue patches onto a particular cast arm, Johns resists the naturalistic
coalescence that makes shape intelligible and reassuringly "just like
life." Without credibility as life yet wholly credible as art, this frag-
ment, with its nonintegrated color system, is not deficient or incom-
plete: It is complete – artistically complete – as it is. Johns's advice
to artists, then, would seem to be this: Because incompleteness of
description is a given, it is best to acknowledge it by frustrating
expectations of naturalism, exploiting the difference between repre-
sentation and description, rather than by attempting to resolve a
painting through the literal completion of all forms.

The cast arm is by now integral to Johns's iconography. *Peri-
scope (Hart Crane)* (1963) and *Diver* (1962) (see Figure 14) both
depict an arm sweeping a circle, just as an arm of a clock might
sweep the face's diurnal cycle or as a painter's arm, as an instrumen-
tal extension of the absent artist, acts metonymically while enacting,
metaphorically, his or her absent presence. Thus *In the Studio* sum-
mons the wax cast to embody both the object of art and its human
subject – the artist at work.

The identification of art with work and the worker has enjoyed
a rich and ramified history. Elevated by nineteenth-century Realists,
the theme of art as real-life practice inspired Gustave Courbet who,
in his masterpiece *The Studio: A Real Allegory of the Last Seven
Years of My Life* (1855), put himself in the role of a gifted artisan
who could represent all the forces of society that had come into
being since 1848. In such a pragmatic climate, inspiration is deem-

phasized as work is elevated. Consistent with this idea is the attitude taken by Thomas Eakins who, in *The Gross Clinic* (1875), reassigns the heroic task to include work done by the professional surgeon. Standing in a teaching amphitheater, spotlighted by necessity, the surgeon does his or her work, lecturing to would-be doctors about the dissected body lying before them all on the operating table.

The artist's practice has been accorded dignity by the transforming of the academy into a workshop. In the twentieth century, elevating technique and know-how as much as promoting avant-garde experiment, the Bauhaus, flourishing in Dessau during the Weimar years, was just such a workshop for artists. Its rigorous hands-on course in techniques and materials became legendary. And when Hitler shut down the Bauhaus and its artists fled to the United States, the course on techniques and materials came here. It was taught, for instance, by Joseph Albers at Black Mountain College – the school to which Robert Rauschenberg came in 1948, nearly fully formed and an inspired delinquent with little respect for materials but with a surfeit of brilliance in handling them. By the time Rauschenberg moved to New York and befriended the autodidact Johns – they were closest from 1955 to 1960 – the philosophy of "learning by doing" was already widespread. Practice rated higher than product. It is no wonder, then, that common parlance among artists learning from and sparring with the Abstract Expressionist generation reflected this. Praise from studio teachers rarely took the form of "it's finished"; it almost always took the form of "it works."

Johns's world of the studio presupposes the self-sufficiency of artistic practice without adopting the stance of the heroism of the artist–worker and without fetishizing the handicraft. On one hand, in Johns's paintings the artist makes himself known only through his instrumentality and effects. What Leo Steinberg early on called Johns's exposition of "operational processes"[2] explicitly announces itself in *Fool's House* (1962) – here, the letters of the title are stenciled across the canvas to spell "Fool's Ho . . . use" – yet weaves itself in and out throughout his oeuvre. Now operational processes and Wittgensteinian notions of uses are kept at a contemplative conceptual distance. Gone is the brio of Johns's early gestural maps and swept circles. The tighter, drier surface of the late paintings bespeaks a cautious mode of address. Johns has deliberately adjusted his facture away from generic notation both to reflect a scrupulous attention to particulars and, with this increased precision in *In the*

Figure 14. Jasper Johns, *Diver.* 1962. (Photo after restoration, August 1988.) Oil on canvas with objects, five panels: 90 × 170 inches. Private Collection. © Jasper Johns/Licensed by VAGA, New York. Photograph by Jim Strong.

Studio, to give us a pattern painting in which the *picture* of studio practice is commensurate with the *model* of studio practice.

✳

Those of us following Johns's artistic development are not surprised to see in the recent exhibition canvases in which pattern enriches the discourse of representation. Ever since 1965, when the architect Robert Venturi cited Johns as an exemplar of what we term post-modern art, the aesthetics of complexity and contradiction have gained high visibility. What postmodernism is exactly, or, for that matter, whether it exists – whether it rather is extending the ramified nature of modernism as practiced, say, by Picasso – is debated end-lessly. What is far more evident is that from the first, both Johns and Rauschenberg challenged several assumptions about pure painting and have continued to do so throughout their careers.

Jammed with images of a disparate nature, *Racing Thoughts*, painted twice, in 1983 and in 1984, initially swamps us with visual overload (see Figure 15). Mark Rosenthal aptly characterizes this painting as Johns's "private museum." Better yet, with cognizance of the origin of museums, *Racing Thoughts* may be likened to a curio cabinet stuffed with everything from paintings to elephant

tusks that is pleasing to the amateur, knowledgeable connoisseur. Johns's popular art museum takes an intriguing form. If a pattern signifies an original model worthy of imitation, then da Vinci's *Mona Lisa* and, to a lesser extent, George Ohr's pottery may exemplify such originals, which by virtue of their dissemination through mass reproduction or fine painting like Johns's own work constitute a range of visual models we presuppose. Add to our cultural supply (by virtue of their reproduction as prints or posters, and then by Johns's imitation of these reproductions) the lithograph by Barnett Newman and the Swiss poster warning against danger from falling ice.

Of this hapless concatenation of things, it is also possible to say that we see a composition organized like a bulletin board (or its antecedent, the letter-rack), and biographers of Johns substantiate this possibility. In this subgenre of still-life painting, one realized with *trompe l'oeil* virtuosity in nineteenth-century America by William Harnett and John Peto, a seemingly innocent but entirely calculated miscellany of images – including ticket stubs, playing cards, and string, along with other reminders and mementoes of daily life – consoles us with expert, infinitely calibrated powers of description. Comparison with these *trompe l'oeil* studies reveals how removed Johns's *Racing Thoughts* is both from them and from the "art of description"[3] that the seventeenth-century Dutch lovingly practiced. In the 1984 grisaille version of his subject, Johns has made little attempt to fool perception, for although he may be fascinated with the scope of possible representations, he has not bothered to pursue the high resolution and polish that lend *trompe l'oeil* the suggestion of a transparent actuality. The pot is schematically modeled, and the spigots could not pass for illusionism under any circumstances. In translation, the *Mona Lisa* has lost her celebrated chiaroscuro, and in contrast to a Harnett counterfeited violin, Johns's wood grain wall is barely a diagrammatic pattern. But it is precisely the disparity between the deceptions practiced by Peto and Johns that is crucial to understanding the latter artist. In writing on the work of Raymond Roussel, Michel Foucault speaks of "reproductions inadequate to their subject,"[4] and we see in Johns's work a deliberate inadequacy in mimicking the descriptive illusionism that would initially seem to be its subject. But it is precisely Johns's patently false and inferior mode of representation that sets up expectations of lifelikeness yet fails to deliver on its promise, thus preparing both

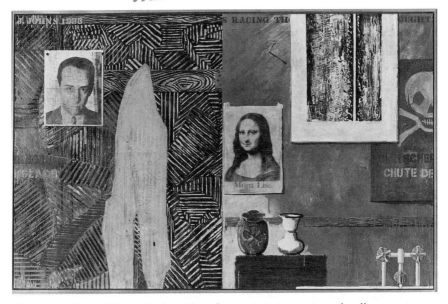

Figure 15. Jasper Johns, *Racing Thoughts*. 1983. Encaustic and collage on canvas, 48⅛ × 75⅛ inches. Whitney Museum of American Art. © Jasper Johns/Licensed by VAGA, New York. Purchased with funds from the Burroughs Wellcome Purchase Fund, Leo Castelli, the Wilfred P. and Rose J. Cohen Purchase Fund, the Julia B. Engel Purchase Fund, the Equitable Life Assurance Society of the United States Purchase Fund, the Sondra and Charles Gilman Jr. Foundation, Inc., S. Sidney Kahan, the Lauder Foundation, Leonard and Evelyn Lauder Fund, the Sara Robey Foundation, and the Painting and Sculpture Committee. Photograph © by Dorothy Zeidman.

the frustrated viewer to discover the motivation for this mode of representation and the rest of us to seek meaning elsewhere.

For one thing, like Marcel Duchamp, Johns takes pains to distinguish between modes of appearance and modes of apparition. Craig Adcock explains that an appearance draws on usual sensory evidence. An apparition, however, brings to our attention special configurations.[5] Referring to Duchamp's notes for the *Large Glass*, Adcock mentions photographic negatives, linear perspective drawings, mirror images, and shadows: "Duchamp conceptualizes these $n - 1$ dimensional 'slices' in terms of their being 'molds.' A mold is a mirror-reversed, inside-outside version of the molded object," Adcock says.[6]

For another thing, in this private museum are pictures of pictures of art painted not to emphasize the transparency of realism but to

reveal the levels of representation intervening between us and the original object. What has happened is that we have been deceived by ourselves; we have been deceived into believing that our powers of instant recognition – of the gestalt of *Mona Lisa*, say – permit us to understand exactly what we see. Precisely because we are looking at a cultural cliché, we may not notice that the image of *Mona Lisa* as depicted by Johns is not a description of da Vinci's image; it is a description of the image several times removed. Johns once said that he was interested in working with "things the mind already knows [. . .] things seen and not looked at"[7] – and, we might add, *things the mind thinks it knows, but doesn't*. In *Racing Thoughts*, instant recognition of the familiar image is blatantly at variance with the observed experience of the representation of this image.

In the raveling process, meanwhile, the once authoritative representation loses its inviolate status. With the received visual knowledge weak, the eye readily cannibalizes the gestalt for usable parts. Formal decomposition proceeds apace.

Once we understand that received images have no artistic authority here and (as with Wittgenstein, but also William James) that the world is made up of relationships not things, our eye travels frantically back and forth across the surface of the painting in search of meaningful constellations of related elements, as Johns has predicted – indeed, ensured – it would do. As much as the abstract *Scent* is about relationships among patterns, the figurative *Racing Thoughts* is a painting about patterns of relationships. In a very real sense, *Racing Thoughts* proffers a conceptual puzzle in which families of related elements define and redefine themselves in provisional orders. The many faces hidden in the picture (from Castelli's young visage to a skull, from silhouette to full face) make themselves known, but this is only the most clichéd and blatant family resemblance to be seen. Other embedded families of themes and of form exist. Rather than enumerate them, however, it is important to note that, thanks to Johns's tactical approach to draftsmanship, the viewer is just as likely to move from general to specific classification as the other way around.

For instance, to note that *Racing Thoughts* puts forth a collection of household objects is to identify certain shapes as a pair of vases set atop a wicker basket. To revise one's view and see a painting stocked with optical illusions is to admit, then, that what was a vase defines itself accordingly as an optical illusion that links with the painted parallel lines which perceptual studies call "grating." To

decide that, rather than household objects or optical illusions, *Racing Thoughts* is really a display of visual form is to see negative shapes spring up where the vase and internal border of the lithograph had been – in other words, pattern presenting itself as such, with drawing and the gradations of the gray scale playing across the surface of the canvas announcing themselves. To regard *Racing Thoughts* as about the thematic contrast between falling and mirroring elements in the left and right halves of the painting is to discover drips, running water, and the hanging, putty-colored paints that once seemed so innocent but now allude to skin – the skin of canvas to which Johns refers so often elsewhere. And to regard this painting as a private museum is to see evidence not only of da Vinci and Newman but also of Michelangelo, who in *Last Judgment* held his own distorted hanging skin imprinted with his face. (A recent article by Richard Shiff discusses the importance of anamorphosis in Johns's art.)[8] Duchamp receives special attention in Johns's private museum, with allusions that start with his own disfiguring of the *Mona Lisa* and spread throughout the painting with references that do homage to his mentor's *Large Glass*.

The point of all this impacted reference is, first, that *Racing Thoughts* refers only in part to things described; it lavishes at least as much attention on contingent systems of description. Things – or parts of things – find their meaning by their position within a conditional set of relationships, or, rather, within several coexisting sets of relationships. With each system of description, the visual world of *Racing Thoughts* realigns itself to accord with this view. The purpose of stocking his composition with apparitions while depriving us of satisfying appearances, then, would be to frustrate our lazy habits of apprehension and to induce an active search for meaning by having us cut and rearrange the static visual givens – the ready-made language, as Foucault would say of Roussel – until we appreciate the part each plays in a revitalized larger context.

It is not too farfetched to say that, once again, Johns has presented us with a redefined notion of action painting – active perception on our part is prerequisite to meaning. In the course of scanning the miscellany of *Racing Thoughts*, trespassing beyond the visual givens, and taking what parts we need in order to hook them with visual elements distant from our starting point, we are making the work of art happen. Meanwhile, as we delve again and again into the painting, we bring into being only fugitive relationships; we bring to the disparate visual elements only contingent, temporary

order. The viewer is conscripted by Johns to attack the givenness of culture en route to creative discovery, yet he or she can only highlight the ephemeral nature of creativity and the relativism necessitated by unstable form. Enactment in Johns's worldview would seem to entail a Sisyphean fate of witnessing forms of language reverting to their static, received state as soon as active reading ceases.

The fugitive visual systems to which this painting gives rise entail a moral component – or so Johns implies. As our glance ricochets off images, we soon come upon the stenciled words of the title interrupted by the image of Newman's lithograph and read, "racing th . . . oughts." Speculating on this sight, we can say that, whether taking the form of stencils, tracings, casts, or templates, these patterns provide standards that the artist inherits and acknowledges in his art. In other words, a description is not neutral; it is a prescription for perpetuating cultural value. Especially when, as inscribed on Johns's canvas, a plethora of provisional "oughts" rather than a select few permanent "oughts" substantiate history, the question becomes: Which of these norms ought an artist to choose?

This is by no means the only time we have been urged to consider that a changing focus of value is linked to changing modes of observation. Sense, pictorial or otherwise, depends on cultural indoctrination, and scientists as well as artists may find themselves defending incompatible descriptions of the same visual stimuli. Thomas Kuhn suggests that in contrast to mathematical proofs in which rules are set out from the start, debates over scientific description leading to choice of theory presuppose competing value systems. Should one enclave of scientists convert another to its view, Kuhn maintains, something like "a switch of gestalt" will take place. In this paradigm shift, "What are ducks in the scientist's world before the revolution are rabbits afterward."[9]

I mention the image of the paradigm shift to show that there is life beyond the pages of Gombrich, pages which, in utilizing this Wittgensteinian optical illusion to disseminate a fundamental perceptual notion, have disseminated it so widely as to produce a cultural cliché. On the other hand, once this debased ambiguous figure enters painting, it is not necessarily consigned to eternal kitsch, especially given Johns's thoroughgoing, thoughtful association of this ambiguous figure with profound relativism. The silly young lady/crone takes on new weight when integral to the argument that methods and processes are not neutral but are instrumental in determining knowledge and values.

Racing Thoughts belies the cliché that paintings created by culturally given patterns of received ideas are superficial. It is an intellectual's reflex that only artistic individuality can transcend the shallow values of society. But if any expectation is defeated in this painting and elsewhere in his oeuvre, none is more remarkable than the one by which Johns utilizes pattern to undermine pattern. In Johns's hands, cultural givens can be instrumental in fighting rote responses. Johns confesses as much early on in his career when writing about Duchamp's *Large Glass*:

Duchamp's wit and high common sense ("limit the no. of readymades yearly"), the mind slapping at thoughtless values ("Use a Rembrandt for an ironing board"), his brilliantly inventive questioning of the visual, mental and verbal focus and order (the beautiful Wilson-Lincoln system, which was never added to the glass . . .).[10]

Johns cannot legislate against our shallow response to an image that can be taken in at a glance, but in fighting pattern with pattern he has enlisted this response to defeat itself.

Frame of Mind
Interpreting Jasper Johns

Notoriously difficult to interpret, the paintings of Jasper Johns have tempted many critics to exercise the option to clarify or to illuminate each painting's visual enigmas. Although their interpretive effort is not startling, the interpretive range is, insofar as the defense of Johns's art has come from critics whose paradigms are conspicuously competitive and often antithetical to each other's. What follows is a consideration of major stylistic positions assumed by critics to be true.

Leo Steinberg was one of the first art critics to write on Jasper Johns's work. His 1962 essay is exceptional not only for its confession of the author's bewilderment but for its treatment of his own doubts as the subject of the inquiry.[1] Steinberg's difficulty in understanding the stony-faced targets and shy numbers of Johns's early work was admittedly and largely defensive. But unlike the typical philistine reaction toward unknown art, he found his own doubt exhilarating. For once, he had encountered something genuinely strange. His own expertise ranged from Borromini's San Carlo alle Quattro Fontane to Picasso's revamping of Delacroix. Clearly, he came to Johns armed with both an intrepid intellect and a cargo of styles at his disposal, yet he found himself routed. And for Steinberg to confess his bewilderment was, in effect, to declare Jasper Johns an original.

Read today, after some thirty-odd years of Johnsean criticism, this early essay is striking for its groping description of the art. In it, Steinberg goes farther than he might have gone had he relied on his favorite intellectual preconceptions. As a result, rather than representing a failure of nerve, the essay is exemplary in its intellectual receptivity – in its capacity to respect first aesthetic encounters.

Since Steinberg wrote that essay, critics of an unusually wide range of intellectual assumption have added their voices to the interpretation of Johns. It is fascinating that critics who would otherwise ideologically annihilate each other all want to lay claim to him. Discourse on Dan Flavin, for instance, is not so contentious or so spread in range. Even the writing on Willem de Kooning is relatively unanimous on the matter of explaining the meaning of that artist's

painterly abstractions. But even a cursory survey of the literature reveals a strong urge by varied critics either to possess Johns or to convert him to their special brand of modernism; and if this phenomenon is not unique to Johns, it seems especially true of him. The complexity of the issues Johns raises and the ambiguity with which he handles them only fan critical conjecture about the meaning of his art and its place in art history.

More than a quarter century of discourse has produced much more insight and illumination than ultimate clarification of his art – and, in the process, a considerable degree of intellectual projection. By now, the intentional object of thought and desire (to use Brentano's terms) projected onto Johns looms quite large. Whereas the early "flags" and "maps" were dismissed as Neo-Dada, Johns's later stylistic "fountains of youth" were called Impressionism, Symbolism, Cubism, and also a naïve realism – interpretations which more reflect critics' own intellectual preoccupations than explain Johns's art. More often than not, critics adopting one of these stylistic positions have construed the others not as legitimate alternatives but as fierce competition. The idealists who interpret Johns's art as Symbolist, for example, are largely ostracized by the realists who see his art derived from Impressionism or Cubism – both idealist and realist camps of critics signal through their positions on Johns their exclusive vision of art history. A survey of some of the major positions – and projections – will demonstrate this.

Most critics tacitly agree that, while Johns's painting is cerebral, it is not strictly Conceptual. One cannot imagine his "seminar on ideas" in art conducted without the sensuous art object; from this, a rough consensus among some critics arises. Johns is difficult to classify, but if they had to choose his essential stylistic affinity, Max Kozloff, writing early, and David Shapiro, writing late, would anchor Johns in Symbolism; however else they disagree, they basically concur on this. In his monograph written in 1967, Kozloff dubbed Johns "a reverse Symbolist." He wrote,

The *fin de siècle* sensibility postulated a coalescence of mind charged into matter. Between the Symbolist's sensing of objects in the outer world, and his awareness or knowledge that he senses, there is an ambiguity which no instrument is better to explore than art.[2]

At one point in his argument, Kozloff appeals to Albert Aurier, the critic who found a way of talking about Gauguin's and van Gogh's drastic visual inventions. In appealing to Aurier while discussing

Johns – whose art he characterizes as Symbolist, Synthetic, Decorative, and Ideological – Kozloff has in mind not the visual heat of these painters but the peculiar imaginative leap from manifest pigment and brushwork to latent meaning that the symbol embodies if it is doing its job effectively. Kozloff says,

... in this contextual mingling of sense data and mental construct, the real aims were impossible of fulfillment and art would always be striving to express the logically inexpressible.[3]

What is germane to Johns and what is Kozloff's projection? To winnow one from the other is to try to separate the most universal characteristic of Johns's art from the art itself. Consider an example: If *Target with Four Faces* (1955) and *Tennyson* (1958) elude logic, *Fool's House* (1962) and *According to What* (1964) are intellectually straightforward paintings about practice and about artistic rhetoric. Hasn't Kozloff projected mystery onto fundamentally divergent kinds of mentality? Perhaps, but while he has let such distinctions slip by, he has caught the major one: the fact that Johns's art is about complex ideas presented in simple-minded appearances. The spectrum of experience that obtains between surfaces and depths, between said and unsaid utterances, between the inert conventions of visual language and the creative meaning they embody – this uneasy situation, so basic to Johns's vision, is the one that Kozloff has deemed evidence of Johns's affinity with Symbolist art.

Given his art historical training under Joshua Taylor at the University of Chicago, Kozloff approached Johns in a way that is not altogether surprising. On the emergence of Post-Impressionism, Taylor wrote,

To free the eye from traditional formal preconceptions was a notable step, but once the relationship between eye and mind was considered not fixed but subject to investigation, there was no reason to suppose that the more venturesome artists would be content with what they came to consider mindless perception, in which the eye never challenged the mind.[4]

Taylor's characterization of Post-Impressionism may be standard, but it supplied Kozloff with an aesthetic disposition toward emphasizing the creative friction between intellect and sensations.

Proof of this love of intellectual strife may be found in Kozloff's review of Edgar Wind's *Art and Anarchy*, a book seen as contributing to our awareness of the "problem of our fluctuating consciousness of art." In that review, he wrote,

If the French have been poetic and speculative, the Anglo-Germans are historical and psychological, and thus bring their readers infinitely closer to an awareness of the reciprocal paradoxes of their aesthetic experience.[5]

Admirable here is Kozloff's attempt to preserve the antagonism of the cultural opposition between French and German viewpoints at full strength even as he acknowledges Wind's embrace of the German virtues. A true dialectician, Kozloff does not caricature the intellectual rivalry between these cultures. His advocacy of cultural drama is easy to miss, however, since he casts his own critical role so much more modestly. He writes,

Indeed, criticism's merit lies in the fact that it is neither a work of art nor a response, but something much rarer – a *rendering* of the interaction between the two. Best, then, that it reconcile itself to virtual rather than actual meaning, the ambiguity of symbolic reference as opposed to the pidgin clarity of signs.[6]

If Kozloff's notion of criticism values the mingling of the imaginative mind with the sense of data in paint, is it any wonder that he respects a painter who performs that quintessentially critical function? Putting it another way, consider that even though Kozloff has bestowed higher praise on Rauschenberg for being not only the more imaginative artist but also the best of the younger generation,[7] his high regard for Johns's "richly thought out" art[8] may well be founded in a feeling of personal rapport with the speculative cast of mind of this artist.

In his monograph on Johns, Kozloff brusquely dissociates himself from the "humanists" Leo Steinberg and David Sylvester. Penalized by moral critics for being merely evocative or associative, almost aimlessly interpretive,[9] Kozloff is not only willing to classify Johns's art but also to evaluate it – and in a low-key way he is penetrating in these matters. Moreover, he sets limitations on his own conviction: If he refuses to be doctrinaire about Symbolist commitment, neither does he blindly adopt Symbolism's tendencies toward mysticism. Furthermore, however predisposed, Kozloff is not bamboozled by the intellectual pretensions and unmitigated liberality of the take-it-or-leave-it play ethic that Conceptual artists claim – as an intellectual scuffle in the pages of *Artforum* would later reveal.[10]

<div align="center">✳</div>

Nowhere does David Shapiro's 1984 essay on Johns's drawings[11] declare Johns a Symbolist. But Shapiro's own appeals to authority

lean heavily on William Blake, Friedrich Hölderlin, Novalis, Rainer Maria Rilke, and Johns's "great precursor," Albert Pinkham Ryder – all Romantic visionaries who, from a certain point of view, might be said to presage Symbolist poetics. These men, together with the great Symbolist Freud, comprise a curious list of influences, as subjectively inclined as any that have been ascribed to Johns. But for this very reason, Shapiro's own investment in Johns is clear. An aesthetic reevaluation of the surface suggests a link between Ryder and Johns; the philosophical inclination (or vegetal "tropism") of Hölderlin's sensuous surfaces may be the associative connection with Johns. However causally remote, however historically farfetched, Shapiro's view of Johns as being in league with the visionary poets and painters is not so far removed from Kozloff's basic stylistic analysis.

In Shapiro's view, Johns's thought-paintings show a connection with Symbolist art both in their sentimental equivalences of the inner world of the psyche and in their display of the mind of matter. But behind all this, Shapiro is far from shedding his Romantic influences in his assumption that the notion of art for art's sake is valid as long as the art is the work of the artist-as-seer or artist-as-prophet.

Schiller tried to convince Goethe of Hölderlin's worth, and he failed, partly because Hölderlin's poetic excesses were unintelligible in terms of Goethe's own poetics. At the very least, the artist of true merit is singular, and Shapiro does not want this point lost on viewers who erroneously believe that Johns's visual commonplaces reduce him to an artistic drone. It may be too much to say that Shapiro believes, like Hölderlin, that God is in all actuality, but he writes as though he believes that at least it is possible and valid to regard all actuality transcendently – darkly, but transcendently. "In the wind, the flag is full of noise," Hölderlin wrote.[12] Shapiro's own reading of Johns recalls Paul de Man on the Romantics:

The violence of . . . turmoil is finally appeased by the ascending movement recorded in each of the texts, the movement by means of which the poetic imagination tears itself away, as it were, from a terrestrial nature and moves towards this "other nature" mentioned in Rousseau, [one] associated with the diaphanous, limpid and immaterial quality of light that dwells near to the skies.[13]

For Shapiro, Romantically driven art is absolutely meaningful. The late poems of Hölderlin – written after the poet was discouraged from an ecstatic embrace of Hellenism and thwarted even from

teaching Greek (Achilles "has died and is lost to me") – are lyrics filled with meaning precisely because they are fragmentary and syntactically ambiguous remnants of a life. If Shapiro dwells so much on this kind of poetry in his essay on Johns's drawings, it is evidently to assert a stylistic link between these poetic fragments and the modernist shards in Johns. Shapiro would further maintain that it is through Johns's syntactical gaps and cross-overs that the artist expresses the meaning*ful*ness, not meaning*less*ness, of certain ineffable domains.

Shapiro's own orphic poems are irrationally radiant. They are evidence that he is invested in the azure, whether Hölderlin's or Mallarmé's. On the one hand, he projects this inspiration onto Johns; on the other, he performs art in his criticism. His poetic license is perhaps further justified by the small library of official biographies on Johns that had already been published, and they made possible his own articulation of aphoristic musings. In his monograph on Johns, peppered with references from Freud to Viktor Shklovsky, Shapiro proceeds not merely to explicate Johns but also to assimilate him to what he calls a "radical pluralism,"[14] and he did so on the assumption that because archivists of Johns have taken and will take care of that assimilation, there's no need to repeat their efforts. It was said of Hölderlin that "the function of poetry is to express [an] articulated response to the Deity,"[15] but this observation also applies to Shapiro's view of Johns. In an art scene of simple-minded and shallow projects, few artists approach Johns's highly articulated response. Shapiro may be exaggerating his case for Johns as a visionary poet among artists, but, in my view, there are specific works by Johns which are poetic in just the way Shapiro wishes the entire oeuvre to be.

※

Both Kozloff and Shapiro admire Johns's art for its intellectual and spiritual strenuousness. A partisan of Johns might say that it is not that Johns is difficult; it is that other artists are too easy. Moreover, "difficult" is – or used to be – a term of praise, referring to art that would resist all facile engagement; whether or not a particular canvas advertises the agon of physical process, it reveals a metamorphosis of thought embedded in the artwork. The most significant art frustrates artistic expectations and, if truly ground-breaking, causes a radical conceptual renovation of our notion of art. In George Steiner's understanding of the term, difficulty at its most

ambitious is conceptual originality and, as such, marks the greatest artists' highest aspiration. But what we now see being embraced, especially by artists who have joined the entertainment industry, is the denial of difficulty. Critics undistracted by the marketplace, however, construe style as something entirely different from trends or, for that matter, idiosyncratic manner; they admire Johns for his attempt to address theories of painting on the most conceptually ambitious level.

Not all difficulty is so worthy. Because mystification is often mistaken for mystery, perhaps it is appropriate to declare that, just as Heidegger was overprotective of Hölderlin's "unsaid" utterances, so too are art critics protective of Johns's "difficulty." Turning to George Steiner's use of the word, once more, we may infer that some of Johns's difficulty may be tactical, a deliberate distancing designed to keep tourists and bureaucrats away. Although such alienation has value, it may also intimidate anyone who would question the ideational premise of Johns's art. The difficulty that is intelligentsia's appetite is the nonintellectual's phobia; it does not sit well with everyone.

Whereas to Shapiro, difficulty simply means doing one's best, to Harold Rosenberg, difficulty is misconceived if it is premised on ideas rather than on feelings. Rosenberg's criticism of Johns's art reflects this sentiment. Devoted to Charles Baudelaire and Paul Valéry, Rosenberg was a late Romantic paradoxically distressed by Symbolist aesthetics. Compared to Kozloff, at any rate, Rosenberg was decidedly resistant to Symbolism. Throughout his writing career, he maintained that the essential transaction of art, no matter how intelligent, takes place not between sense data and mental construct but rather in the imaginative metamorphosis of feeling.

Given this idea, it is fascinating to read Rosenberg's two essays on Johns, one written for *Vogue* in 1964, the other written for *The New Yorker* in 1977, a year before the critic's death. It may come as a surprise to anyone rereading the early piece that this admitted curmudgeon toward usurpers of Abstract Expressionism was deeply absorbed in Johns's art and tentatively hopeful for his future. In the early essay, Rosenberg gives a patient textual reading of Johns's work and does not think that the artist's hermetic compositions, packed with a richness of aesthetic discourse, were too scholastic. Independent of Kozloff (who also reviewed Johns in 1964), Rosenberg asserted that the stylistic point of reference for Johns's forma-

tive works lies in Symbolism, albeit a heavily qualified Symbolism. He wrote,

In bringing the earlier [Abstract Expressionist] art to bear on his ready-made symbols, Johns, however, expelled its metaphysical and psychological essence. Whereas the older artist, having inherited through Freud and Surrealism the Symbolist conception of art as part mirror image, part enigma, spoke of "getting into the canvas," Johns stepped resolutely back. . . . The adventurer or autobiographer in paint has been replaced by the strategist of ends and means.[16]

Drawn to the Talmudic mentality of Johns's art and its fine discriminations of meaning – even going as far as to say the "most joyous effects have been obtained by juggling the clichés of depth and flatness"[17] – Rosenberg nevertheless could not fully endorse the artist. He could not forgive Johns for choosing the readymade images he did, images which Rosenberg deemed tantamount to conceding too much accessibility to the public.

The 1977 article, which was published at the time of the Johns retrospective at the Whitney Museum of American Art, begins with a quote from Baudelaire that announces the critic's own aesthetic expectations and the source of his ultimate disillusionment with Johns. He wrote,

What is pure according the modern idea? It is the creation of an evocative magic, containing at once the object and the subject, the world external to the artist and the artist himself.[18]

In contrast to Abstract Expressionism, the article argues, Johns produces art "completely manageable by the artists. . . . No more romantic fumblings, supported by declarations that 'when I am in my painting, I'm not aware of what I'm doing.' No more pretensions of invading the Unknown. No more self-expression."[19] Rosenberg's ambivalence toward this detachment from sentiment is palpable. On the one hand, he respects Johns's critique of fraudulent feeling; on the other, he disavows Johns's wish to eliminate emotion in art. As well as renewing his admiration for the early "flags," "targets," and "numbers," here Rosenberg also praises *Weeping Woman* (1975) for "arousing feeling through color."[20] More surprising to those who believe that Rosenberg was totally impervious to Johns, he responds to *Untitled* (1972) – a triptych of hatching, flagstones, and assembled casts of limbs – for evincing "an arbitrariness far exceeding that

produced by Abstract Expressionist inwardness, since inwardness imposes necessities that tend toward an order."[21] Just when one would expect Rosenberg to be most rigid, he produces a glorious insight into the ulterior purpose of a "strategy," redeeming arbitrariness in the art as effectively as Kozloff and other partisans of Johns had been doing all along.

This later article is by turns exasperating and poignant. As a loyal defender of radical Abstract Expressionism, Rosenberg put his entire faith in gesture and color as authentic bearers of feeling. From his point of view, Johns might be considered a lapsed Symbolist – where is Valéry's rhythm curved through a feeling? In the same defense of Abstract Expressionism, Rosenberg discredited much else. His lifelong disgust with art whose accessibility to mid-cult values compromises its difficulty (as exemplified in the then-popular Bible movies) helps to explain why he considered Johns's work with public images a betrayal of the artist's personal integrity. In taking this stance, Rosenberg willfully ignored the difference between public subject matter and the unofficial, philosophical content that is Johns's concern.

<div align="center">✳</div>

Lawrence Alloway, adopting a semiotic interpretation of Johns's so-called Pop Art, understands this distinction completely and refuses to assign things the mind already knows to impulses of the philistine.[22] Most critics, including Alloway, value Johns's difficulty and his resistance to habitual experience. Steinberg, Kozloff, and Shapiro, each in his own way, have taken "difficulty" to mean the breaking down of public language – a tradition since the Symbolists and Cubists. If anything, critics have accused Johns of being too hermetic, interested only in the close reading of signs; it is a tacit assumption of Johns (and of many modernist artists and critics) that taking any image at face value reflects an obtuse and gross reading of signs common to outmoded popular "lit" culture. Poster-sized emotions and events that manipulated the public were Baroque art's concessions to the secular communication of the sacred, but they could not be further from Johns's project. Thanks to the legacy of art history, that project can presuppose an inherited visual literacy – if not total mastery – of emotional and intellectual meaning.

The contention over difficulty indicates that, even among critics who use "difficulty" as an honorific, disagreement reigns. Whereas some critics believe art is nothing if it is not a product of strenuous

and sensitive articulation, others consider this sort of difficulty as an excess of imagination (if not a kind of obscurantism). Furthermore, whereas some critics demand conceptual originality of art, others disparage any art that is contaminated by ideas. Difficulty, irony, doubt, negation, and other concepts that have been fought over by ethical and aesthetic critics may largely be gone from the current discourse on Johns; but wherever encountered, these terms are sure to mark a source of intellectual tension among critics. Even the meaning of the seriousness of Johns's brushwork is debated. If the deliberateness of Johns's brushwork is salutary for Kozloff, for Rosenberg it is an index of aridity and proof of a lack of emotional core. Kozloff might respond that this dryness reflects Johns's indication to us that he is strongly committed to the speculative French branch of modernism, not to the psychological German line of descent.

Curiously, the battle between the poetic and speculative French-descended branch of modernism and the psychological German-descended branch is an obsession in the writings of critics who are closely associated with French formalism. Until recently, most critics writing on Johns considered the artist to be an unrepentant modernist addressing issues of representation, perception, and all that pertains to form. This is especially true of the "official" biographers, men such as Michael Crichton, Richard Francis, and Robert Bernstein, who are presumably advised closely by the artist. But of the "unofficial" writers, Barbara Rose and Rosalind Krauss similarly elevate the notions of space, surface, and medium – and they do so in tacit agreement with Roger Fry who believed that, in classic art, form expresses content. Although on actual examination, their criticism – Rose's especially – is not as strictly formal as their ideological enemies assume, their early articles on Johns conceive his style along traditionally French lines.

Rose's essential argument is that the best way to grasp Johns's art is to appreciate fully the implications of his rejection of both abstraction and expressionism in Abstract Expressionism. Turning away from this kind of painting, she argues, leads Johns to bond with a very different modern style. However historically remote, contends Rose, the materialist touch and surface of Impressionism are the ingredients crucial to Johns's style now. She writes,

Moreover, the rich brushstrokes making up their surfaces were not the broad uneven arm swings of action painting, but identical units, method-

ically applied with equal pressure over the entire surface. Thus, not only the facture but the physical character of the surface, with its sensuous impasto, was reminiscent of mature Impressionism – the original source for the all-over style in painting.[23]

Rose's definition of Impressionism brings to mind Roger Shattuck's scientific reading of the late Monet. Rejecting the subjective naïve Impressionism, Shattuck wrote,

Monet approached the painting of *matter itself*, matter so thoroughly penetrated by his eye as to appear as field, as lines of force, dissolved into energy in a way comparable to Einstein's scientific insight that matter is convertible to energy.[24]

For Rose, Johns's manner of painting flags, targets, and numbers represents "the coalescing of two forms of realism: the 'literalist' realism of abstract art as well as that of representational art," with Cézanne and the "philosophical realism" of Mondrian as necessary intermediaries.[25] In Rose's scheme, Marcel Duchamp's appearance is a cameo, but it is a crucial one. What Johns learned from Duchamp, she notes, is never to repeat himself, and toward that end he changed the context of art, for by changing context he created new meaning. Each new context reveals a different aspect or facet of Johns's dominant themes: mimesis, space, time, and memory – and their complex interrelationships.[26]

Aligning Johns with Impressionism seems forced, but Rose intended to show Johns's distance from the transcendent spirituality and the personal emotion inspiring the Abstract Expressionists. In her view, Johns is an anti-idealist – and certainly anti-Romantic. Without saying so, she subscribes to Linda Nochlin's assertion that the pigment and surface of Realism find their analog in Impressionism and subsequent styles. When she addresses the radical all-over composition made by the paint that Jackson Pollock flung across the canvas, she, like Shattuck, also swears by the centrality of the *matière* in the history of modern art. As for Johns, Rose's evaluation, in contrast to Krauss's (about which, more anon), is that he does not rake "the analytic Cubist grid with [the] all-over structure of [the] late Monet"[27] but, through the literalist realism of paint, "the nature of representation [is] dissected, analyzed."[28]

Rose's own commitment to the lineage of Courbet may explain why she links Johns's hatched canvases, which are comprised of rotated and reversed squares, to James Gibson's studies in perception[29] rather than to the avant-garde structures of aural and visual

serial composition by which all-over field painting is profoundly redefined. Unfortunately, in doing so, she nearly squanders her best contribution to the critical understanding of Johns. Still, in referring to Gibson's major theme, the relationship of memory to perception, Rose does reveal her susceptibility to the cognitive content behind perceptual facts.

At any rate, Rose believes that the key to Johns's style of painting is not to be found in Symbolist idealism but in the realism informing the material sensation of Impressionism. Nothing short of the meaning of modernism is at stake here. For Rose, the metaphysics and technology of idealism are simply off limits, throwbacks to the nineteenth-century system of values that modernist artists of the twentieth century have shed – even if art critics have not.

In my view, Rose is the most straightforwardly analytical of all the Johnsean critics and, in her own way, the least intellectually intimidated by received stylistic notions of Johns. Undistracted by the sensitive associations that inspired Shapiro, for instance, to produce criticism that is brilliant and creative if scattershot – answering art with art, so to speak – Rose goes straight for the essential organizing principle behind Johns's art. At the same time, she can seem desperate to justify embarrassing aspects of the origins of the art that she believes to be great. I detect such desperation in her revised analysis of Johns.[30] To explain Johns's style, Rose contends, one must take into account his indebtedness to American *trompe l'oeil* realism. "This response derives not from Symbolist or Cubist aesthetics," she writes, "but from fundamental American attitudes towards illusion as trick."[31] To understand Johns is to realize that he is

a provincial painter whose ideas regarding illusion were determined largely by limited experience with local sources. The impact of Duchamp and Wittgenstein on such a mind was to bring its potential for abstraction into line with modernist aesthetics.[32]

Rose calls Johns a naïve realist. At once an audaciously candid appraisal of his autodidactic origins and a plea for his admittance into the canon of modernism, this appellation suggests that Rose is straining to find a way to redeem Johns's figurative art by rationalizing *trompe l'oeil* as ultimately modernist. Although illusion is only one of the many calibrations of representation featured in Johns's nuanced and exhaustive scale of visual meaning, critics committed to abstraction are worried about representational art. They must

therefore find a way of living with the illustration that Johns breaks down into formal elements and scuffs up with paint.

✳

Rosalind Krauss is the author of a 1965 article[33] on which Kozloff based much of his book on Johns and which Rose refuted, so it ought to be credited with initiating a discourse on Johns in a major way. For her own part, Krauss roots Johns in Cubism, not because of his multiple perspective – the spatial consequence of Cézanne's rotating point of view that Johns is known to admire – but because of the thoroughgoing flatness of his canvases, raising the issue of nonillusionist realist space interpreted radically.

Here, I want to draw attention to Krauss's provocative reassessment of Johns in 1976.[34] This article is remarkable for Krauss's attempt to cope with a body of work that had drastically altered since her earlier writing on him. Krauss observes that, whereas the shifting relations between illusion and nonillusion are surely intrinsic to Johns's Flag series, his later work shows a layering of other concerns: practice (*Fool's House* [1962]), the morphology of representation (*Decoy* [1971]), and so forth. Even so, she argues, despite the fact that he had broadened his subject, Johns's unwavering strategy had always been to distance an image from its source in life; and it is for this reason that his art had been essentially ironic. But starting with the hatched paintings, she maintains, he dropped the ironic mode altogether, and from that point on, his work has been about history.

In what sense did Krauss intend this? She seems to mean that references to Picasso's and Pollock's abstract notions of space are manifestly direct in the hatched paintings *Weeping Woman* and *Scent* (1973–74). "Picasso declared that the longing for depicted depth was to be the major problematic of a modern style."[35] According to Krauss, Johns's hatching is "less a matter of surface contradictions and paradoxes, . . . [instead] seeming to bow to analytic procedures through which recent abstract painting has elaborated the rules and values of the picture surface."[36] Perhaps Johns's hatching seemed analytical to Krauss because the marks neither appropriate Picasso's space nor presume it but dissociate that hatching by way of citation. From analysis to citation of the same hatching – this is how Krauss affects the maneuver from irony to history, forcing parity of two incommensurate terms.

Both Krauss and Rose are formalists; but once again, their ap-

parent agreement on Johns is illusory. Rose not only rejects the position Kozloff takes – that Johns is a Symbolist – she also disagrees with Krauss's assumption that Johns's art derives from Cubism ("the notion that Johns's work of the late fifties is related to Cubism is as false as it is superficial").[37] She believes irony to be intrinsically historical, for aa historical perspective is precisely that which is cognizant of its own apprehension. She writes,

> Irony establishes that [Johns's] duplication or repetition of pre-existing techniques, images, and styles are *not* identical with their sources, from which they are irrevocably alienated by awareness. . . . Irony is not a tool of superficial ridicule for Johns, but an essential means to emphasize his awareness that history repeats itself.[38]

As with his serial 0–9 numerals, each incorporating the previous one, Rose maintains that art by Johns is as historical as art by Abstract Expressionists who leave a visual spoor of past processes.[39] In another sense, as any artist's retrospective shows, all work can be said to be historical to the extent that it builds on accumulated experience.

However devoted she may be to quarantining aesthetics from ethics, Rose notes in passing the difficulty or negation by which Johns proves his "commitment to going against the grain instead of with the traffic . . . and the dialectical ethos of modernism . . . leading to the condition of permanent doubt."[40] Rose's special pleading notwithstanding, the idea of irony as an existential term for the path of most resistance is bound to be found wanting in Johns by critics for whom the ethical self is art's essential project. Krauss, for her part, in her 1976 article on Johns mentions only in passing Kierkegaard's legacy of irony, as if to pay homage to the notion that ethics is inherent to the uses of irony even as she ultimately discounts this view. In fact, she ignores the interpretation of irony as a matter of ethics because it is irrelevant to her purpose. A mere glance in the direction of Kierkegaard suffices for Krauss, as she assumes that irony is a matter of aesthetics rather than ethics: Not the self-imposed task of living the difficult life in art, but Romantic irony's "rapid fluctuation of feeling" (in Wylie Sypher's phrase) is the source, for her, of Johns's kind of ambiguity. Not finite or restricted to a specific image, the irony is infinite, demanding constant critical vigilance. Rose calls irony a modernist theme; rejecting the implications of content, Krauss assigns irony a formal role. For her, Johns manages well enough without critics imputing existential intention

to him. And indeed, having questioned the received meaning of images, Johns undermines the visual cliché by forsaking its intended sense and breaking down, negating, and reconstituting new meaning.

"Irony" is a loaded term. Invoking irony, all too many critics conjure an image of the artist as philosophical – and, indeed, partisans of Johns are in danger of projecting onto him the rank of philosopher simply because his art is critical. A critical stance is not necessarily profound, but, to my knowledge, no critic has crossexamined Johns's irony in sufficient detail to determine whether that irony holds up under scrutiny, not without resorting to the easy attack – to dismiss aesthetic irony categorically as being merely a tease. Irony is such a vague term because it has come to represent any of a number of self-critical or qualified statements.[41] Nevertheless, our sense of modernism depends on this misreading.[42] Irony is a kind of aesthetic principle of simultaneous contrast employed to identify modern art's self-consciousness, its infinite inquiry into art's own intellectual and formal assumptions.

As for Krauss, I suspect that underlying her own forced antithesis of irony and history is an obligation inherited from modernism. The ideology of modernism is on record as liberation from the suffocating obligations of tradition and the contingency of history – our problem, says Nietzsche, is that of remembering too well. For Krauss, who sees herself devoted to the cause of modernism and applauds jettisoning the past, history is surely suspect. The notion of history as a mere chronicle of events is unacceptable. Plot – not story – marks the development of culture. Given her aversion to history, why does she suddenly espouse it? If Krauss proposes that, with Johns, history supersedes irony, perhaps the influence of Hayden White's tropological model of history led her to do so. White finds the historian's task to be inherently ironic: Unless one is to be a mere compiler of documents, one must treat these primary sources as if they do not mean what they say.[43] Still, White concedes that the ironic view could be superseded by other perspectives. He writes,

If it can be shown that irony is only one of a *number* of possible perspectives on history, each of which has its own good reason for existence on a poetic and moral level of awareness, the Ironic attitude will have to be deprived of its status as the *necessary* perspective from which to view the historical process.[44]

The influence of White's ideas may not be the only explanation for Krauss's lurching from irony to history. Perhaps, too, by appeal-

ing to an historian who comprehends history from a tropological perspective, Krauss can arm herself against those who, like the Marxist historian Frederic Jameson, charge structuralists (as Krauss claims to be) with linguistic projection.[45] With White's spatial organization of temporal concerns backing her, Krauss feels free to appropriate temporal structures for Johns's spatial concerns. Moreover, she has shown that she can co-opt the term "history" – the key term utilized by the intellectual opposition – without relinquishing her basic formalist point of view. No one has a patent on that concept, she seems to say, not even those who claim exclusive ownership of the dialectical process.

Above all else, Krauss's shift from irony to history is symptomatic of today's general trend within the artistic community to realign intellectual coordinates from those of space to those of time. Thanks to White – but also to Jacques Derrida and other literary theorists who urge that contingency be reintroduced into the intellectual models of history – Krauss and other art critics have invented a framework that allows them to pass from spatial to temporal modes of thinking about art. Barbara Rose also has shifted her stance on Johns. Whereas in 1970 she mentioned only memory in her thematic list, now, in *Souvenir*, Rose's monograph-in-progress on Johns, memory and time presumably will replace mimesis and space in her interpretive thematics.

Among the consequences of this ideological shift to history, conventional art history may again come back into critical favor; after all, its discipline almost always includes an explanation of causes as well as period history and an ideology of the art object screened in the dark. The Neo-Marxist art writers Fred Orton and Charles Harrison make a plea for studying Johns's art as a product of both the postwar political climate and the social circle of the 1950s as a way to remedy the formal reading that has dominated criticism of Johns;[46] but they plead as if they were ignorant of the practices of conventional art history which, since Aloïs Riegl, has given us social milieu and period values along with stylistic analysis.

Art history offers the inclusive approach Joseph Masheck practices. To him, history accrues meaning in an Eliot-like sense, synonymous with that past which the present knows. His stylistic analyses often take the form of a presentation of an aesthetic idea realized through time – they reenact the idea's creative potential, so to speak. Quick to mark the "greatness" of Johns's hatched paintings when they first appeared, Masheck wrote not an evolutionary account of an idea but a pluralistic reconsideration of Johns that included the

artist's connection to Duchamp and even suggested a possible connection with Ad Reinhardt in the cross-format created by the paintings' internal boundaries.[47] Without discussing format's particular relevance for Johns, however, Masheck opens himself to the accusation of theological projection. Thoroughly conversant with Reinhardt's spiritual proclivities,[48] Masheck could very easily have grounded this format of transcendence in the interest in "nonaction" painting that Johns and Reinhardt share – the principle of passivity that remains *of* action even as it seems to deny it. (Less likely allied to the Christian Passion than to the Zen way and yoked to an avantgarde of permanent resistance, the hidden cross in Johns's hatchwork is, nevertheless, a vehicle for extending the passive resistance to "action painting.") Rose is an anthologist of Reinhardt's writings, but it is noteworthy that Masheck, not Rose (whose ideology of realism does not allow her to ascribe idealist tendencies to Johns), seizes on the opportunity to suggest this spiritual dimension.

In any event, now that critics are abandoning structures of space for structures of time, history is being invoked as the sacred term. But art history is only one of several historical modes now being invoked by art critics. From narrowly sociological to broadly tropological modes of thought, art criticism is avidly appropriating varied notions of history. As a consequence, we can expect to see territorial wars fought over *time* just as we have seen them fought over *space*. Critics have already begun to reinterpret artists' works in light of this intellectual competition, and Johnsean criticism, which is crucial to our art chronicle, is bound to be subject to revision by critics representing each mode of historical consciousness.

Thanks to a relativist view of history, notions of Johns that once seemed quite idiosyncratic now seem less so. Shapiro's approach to Johns by way of Hölderlin's sense of active memory is not so strange now that Narcissus is being kicked upstairs and replaced by Mnemosyne. Nor does Donald Kuspit's short piece on eschatology in Johns's images from around 1980 seem peculiar today;[49] indeed, Kuspit's views seem well borne out by the artist's literal depiction of skulls and other indices of Heideggerian mortality – that is to say, the principle of time-in-us. Interestingly enough, some critics' historical and psychological biases that were once considered too idiosyncratic to apply to Johns's work are more relevant now that Johns has shifted his own aesthetic concerns. Especially since his postmodern phase, Johns's art is overtly historicizing in a way that both reflects current trends and retains stylistic integrity. Rather than

mimicking the parade of styles and stylizations (as artists Komar and Melamid do), in quoting da Vinci or Barnett Newman, Johns proposes a meditation on technique, representation, and other obsessions that have preoccupied him from the start. Characteristically, his Duchampian mentality fits the historicizing fashion to his own aesthetic needs.

<p style="text-align:center">✳</p>

A retrospective look at the criticism on Johns reveals a major intellectual split at the start of his career, one which grows only more complicated with internal discord as time goes on. Speaking to the content of Johns's paintings, not to their subject matter, some critics remark on the affinity between them and the thought-paintings created by the Symbolists. Although there are occasional forays into each other's camps, the Symbolist critics whose sources lie in idealism and Romanticism are not on speaking terms with Impressionist and Cubist critics whose final appeal to authority is realism. Many critics consider Harold Rosenberg to be an ideologue, but that's largely because critics descended from realism find his call for mystery anachronistic in the modern era; to this day, they will say that Rosenberg "got Abstract Expressionism all wrong."[50] Yet from the Romantic point of view, of course, the realists are the ideologues, with their insistence on the fixed divinity of space and matter. The ideological war accompanying Abstract Expressionism has not disappeared; it is as entrenched as before, only subtler.

The reason the battle of ideas is more subtle in the recent criticism of Johns than it once was in the critical writings on Pollock stems from the inherent complexity of Johns's response to the changing cultural situation around him. Put another way, it is easier to determine the style against which Johns initially reacted than it is to determine any style with which he subsequently identifies; and although Abstract Expressionism may be the obvious starting point for his own thinking, he did not take art history as his exclusive frame of reference thereafter. An art historical interpretation of Johns is not irrelevant, however. It is simply partial, and it is contingent on a specific phase of Johns's visual thinking (existentialism, formalism, gestalt perception, or postmodernism). Throughout his career, it has been style of thought rather than style of visual manner that has governed the development of Johns's art.

As perverse as it may sound, in my view, Kozloff *and* Rose together form the indispensable core of Johnsean criticism: the ide-

alist Kozloff penetrating the meaning of Johns and articulating it through the immanentist method of heightened perception; and the realist Rose better at analysis in defense of modernist ideology. More than a matter of connoisseurship, the imaginative intellect with which Kozloff explains Johns exemplifies not knowledge but a profound understanding of the art. By the standards of Trotskyite individualism, Kozloff is too liberal for the good of culture. Yet on Johns, Kozloff is the exemplar of responsible creative criticism – imaginative yet relevant; experiential and alive to affect; and, most of all, susceptible to the particularity of the specific artwork before him. Rose, meanwhile, is the unique analyst among critics studying Johns. She is the critic most in command of both the theoretical basis for style and the central position of style in art history. For intellectual penetration, no other critic has approached her analysis of the meaning of Johns's mark and the meaning of the formal organization of the hatched paintings. On the other hand, she is absolute in her advocacy of realism. In contrast to the idealism of Kozloff, Rose is more conspicuously principled – but also more doctrinaire.

<p style="text-align:center">✳</p>

To many critics, myself included, Johns is among the very best to arrive after Pollock and de Kooning. This respect is well-founded. Critics track his progress because Johns is one of the few serious artists to have emerged in the Abstract Expressionist period who is capable of, as Lévi-Strauss might put it, thinking with the medium.[51] Whereas most artists merely vary their initial manner of painting or change only to gentrify a once-radical style originating elsewhere, Johns's work evinces genuinely tough development: Each phase is premised on drastically altered principles. This is the conceptual originality to which Leo Steinberg first responded, and it is the ontological difficulty, as Steiner might say, that distinguishes Johns from the majority of visual practitioners. Because theory, not comeliness, guides the development of Johns's profoundly aesthetic art, critics are drawn to him. Too important to ignore, even when his art does not conform to the "correct" style or ideology, Johns's painting is an art that irritates viewers – when it does not inspire them – and it causes them to respond to the nature of the art object afresh.

The critical investment in Johns is immense. Perhaps the best evidence of this fact is the argument by critics and art historians over style, insofar as to assign Johns a style is no less than to shore

up a genealogy and proper line of descent through art history. And as Johns shifts the direction of his art, critical investment becomes more pronounced, as the arbiters of culture react hysterically or try to rationalize the artistic change with their own intellectual preconceptions. Add to "style," "difficulty," and "irony" those terms of intellectual currency whose worth and timeliness are reflected in all valiant critical discourse, and one sees proof that critics are brooding about Johns's commitment to modernist values, because it is unthinkable to critics that significant modernist art can be done without regard to them. Finally, critics are projecting even the metaphor of history onto Johns. Now that time is seen as the antidote to the malaise of space, there will be no stopping interpretations of Johns's art that exploit this thematic dimension.

Because Johns responds to issues, critics can interpret his art from several legitimate points of view, but they are also more likely to project onto his work cultural concerns of particular interest to themselves. Critics' different stylistic biases jump to the fore, as they do not in the fairly homogeneous critical literature on de Kooning. To read art criticism about Jasper Johns is to witness a contest of paradigms – a contest that is played out whenever critics are intent upon legislating their own interpretations of messy, complex events that will become history. The assumption of many critics is that only their paradigm is worthy; they rarely write criticism that shows an awareness of the fact that one person's history is another's superstructure. But the nature of Johns's complex and shifting art renders that exclusive view absurd.

Perspective on Johns is further complicated by our particular moment, a time when to reread early criticism of Johns is to witness an upheaval in meaning. John Cage was once asked why we should concern ourselves with history. His reply: "To thicken the plot."[52] Coming across this reverberant aphorism in Rosalind Krauss's early article on Johns, a reader is likely to feel that these words were prophetic and meant for us today.

The Specter of Art Hype and the Ghost of Yves Klein

Although he was not particularly gifted in the conventional artistic sense, Yves Klein (1928–62) was nevertheless a conjurer of painting and theater – someone who was as preposterous as he was ready to seize upon the aesthetic issues of his age. The son of French painters, one of whom was a practicing Abstract Expressionist, Klein grew up in a milieu that took for granted the shamanism avowed by the artist deeply intent on creative action. Although by the early 1950s, irony on both sides of the Atlantic was commonplace – and artists as different as Ad Reinhardt had purified and Robert Rauschenberg had sharply doubted painting's metaphysical content and heroic stances – Klein remained convinced of these matters. Yet one could not be sure. In any event, Klein's flamboyant, intense practice made a strong impression on artists in the United States. Having seen his canvases thickly flocked with ultramarine pigment and having read about his orchestration of paint-drenched nudes performing as "living brushes," American artists were quick to exploit Klein's literal transcriptions of heroic gestures. Minimalists responded to the tactile and retinal physicality of his paintings; practitioners of Fluxus, Happenings, and street theater variously elaborated his sense of performance; and Pop artists gained from Klein's insight the notion that photography and media at once copy and dissemble the appearance of the natural world. In 1982–83 a retrospective of Yves Klein's output toured the United States (the Rice Museum, Houston; the Museum of Contemporary Art, Chicago; and the Guggenheim Museum, New York) before closing in Paris. Recently seen at the Whitney Museum of American Art was BLAM! The Explosion of Pop, Minimalism and Performance (1958–64), a show with conspicuous traces of Klein's influence. The following article scrutinizes one work by this French Force for Change in American Art.

On January 12, 1960, painter and performance artist Yves Klein leapt from a second-story ledge to a residential Parisian street below (see Figure 16). Hurtling himself through space, thus risking life and limb, was a singular event. The photograph of the event was as dramatic as a tabloid's front page – shocking the public into noticing the bizarre French Neo-Dadaists. Since that time, the photograph has been scrutinized by some in the art world almost as closely as

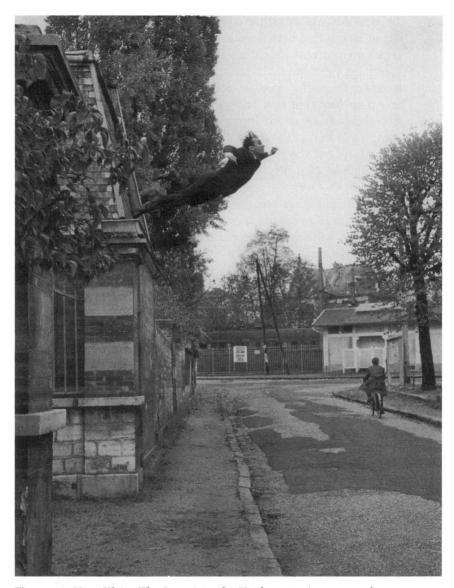

Figure 16. Yves Klein, *The Leap into the Void.* 1960. A conceptual event principally embodied in a photograph by Harry Shunk of Yves Klein leaping from the roof edge of a pavilion at 3 rue Gentil Bernard, in the Paris suburb of Fontenay-aux-Roses. Private Collection. Courtesy of the Menil Collection, Houston. © 1998 Artists Rights Society (ARS), New York/ADAGP, Paris. Photograph © 1981 Harry Shunk.

the Kennedy assassination snapshots for evidence of authenticity; for, in fact, it had been published in two versions, one showing the urban environment altered to remove a passing train and cyclist.

Fifteen years later, art historian Nan Rosenthal exhaustively researched the entire episode. She concluded that Klein did indeed take that jump (but over tarpaulins held under him for safety); that several rehearsals of the leap were needed to shape the perfect trajectory; and that in the darkroom, photographers created a montage of the leap and the background purged of traffic, thus eliminating the mundane elements that interfered with Klein's notion of the pristine void. Over the years, Klein leaping, seemingly oblivious to his own suicide, has remained particularly tantalizing. And critics have continued to speculate on its meaning. It seems safe to say that speculation will continue no matter what the evidence: Biographical data will not undo the perfection of the teasing image, which insists on its own authenticity even as it confounds authenticity on every level.

Ethical authenticity haunts the discussion of Yves Klein's leap. An image so startling, so instantly compelling, and yet so implausible, the photo of the leap challenges us to authenticate its actual origins in a way that may start with a detective story concerning technique but ends with our pursuit of the elusive issues of the integrity of self-discovery and authenticity as a mode of being. Today, in the 1990s, appropriation of personae and roles has become standard postmodern practice. Whether in painting (David Salle), photography (Cindy Sherman), or performance (Eleanor Antin), mimicking cultural role models has superseded the struggle for individual integrity that prevailed as the ideal forty years ago when Yves Klein came of age. Then in the 1940s, the ethics of authenticity inspired artists with its special meaning. Abstract Expressionism fell under the spell of this peculiarly existential notion, whereby the artist, acting from an inner agonistic urgency, strives to fulfill the unique potential of the self and his or her art. "Authenticity and individuality have to be earned," says Sartre in his rephrasing of Heidegger.

I shall be my own authenticity only if, under the influence of the call of conscience I launch out towards death, as towards my own particular possibility. At this moment, I reveal to myself in authenticity, and I raise others along with myself towards the authentic.[1]

On the one hand Klein's *Leap into the Void* may well be the perfect visual illustration of authenticity, for it palpably demon-

strates the sincerity of a man who is no longer content with merely espousing an attitude, actually assimilating the notion of his own death. On the other hand, because taking the existential trope literally is not proof of authenticity – it is instead a mechanical translation or a comedic reduction of meaning by which a vaudevillian enacts direct engagement with the world – the leap is sheer acting. It is this latter possibility that suggests insincerity – or if not insincerity, naïvety and a simpleton's literal worldview. But in either case, it is a false enactment of the striving for self-fulfillment so valued by the Abstract Expressionists who were Yves Klein's contemporaries. Whether or not Klein knew the Sartrean metaphor of the existential leap directly, or indirectly, absorbing it as common knowledge, the image he produced replicates its meaning exactly – but erroneously. If the possibility of faked evidence is unnerving, Klein's literal-minded interpretation of authenticity is most disturbing because it suggests not merely toying with ontological integrity but fundamentally misconstruing it.

To judge by the process of how the image of the leap came into being – both how Klein rehearsed the act in an extended shoot before a camera until satisfied with the execution and how the resulting images were manipulated in the darkroom – we can see that the artist contrived this spontaneous act at the expense of spontaneity. Moreover, it is not the leap but the photographed image of the leap that at once captures and doles out breathless ecstasy. "The Leap into the Void," the catalogue listing reads, "a conceptual event principally embodied in a photograph by Harry Shunk. . . ."[2] Thus, spontaneity was preplanned, and Shunk's collaborative artistry helped fabricate the image through photographs edited for the purpose of selecting the most tantalizing moment in the leap's trajectory.

Photography, then, was not so much a witness as a subtle co-conspirator in forging the leap of authenticity. Like photographs of environmental earthworks that are too remote for direct viewing, documentary photos and films of performances communicate art by proxy, and in many instances, this secondary source material has come to supersede the reality of the event itself. By the time Klein had masterminded his photograph, the problematic nature of documentary material had become an especially savory literary topic. It had prompted Alain Robbe-Grillet to argue in both his essays and his novels that the photo's information describes only the exterior of events whose underlying reality lies inaccessible to the viewer obsessively trying to reconstruct the definitive reality of what must have

been. It would lead Michelangelo Antonioni in *Blow-Up*, that cine-
matic souvenir of the 1960s, to show that the more rapid the disin-
tegration of a witnessed event through successive photographic
enlargements, the greater the speculation about the nature of the
event's reality – the more so because we assume a photograph to be
objective.

The Leap into the Void, as subjective as it is ambiguous, eludes
absolute interpretation. What, after all, is the meaning of a work
which first seems to be an action of an attitude, then a photographed
image of this enacted attitude? What is the meaning of a photo that
exists in two versions and in two different contexts – one as an
exhibition catalogue, and the other as a self-published tabloid? Evi-
dently, for Klein, performing the leap for photographers was only
the beginning of his staged authenticity. On November 27, 1960,
Klein published *Dimanche* (Sunday: the Newspaper of a Single Day),
filling it with photojournalism written by himself about his mono-
chromatic paintings, his fire fountain, and, of course, his leap. The
latter came complete with a photo and a headline ("A Man in
Space!") – and it was extravagantly captioned, "The painter of space
throws himself into the void!"

Although it is certainly possible to construe the tabloid as rabid,
self-promoting hype, Klein's personal aggrandizement is not the en-
tire message that the image itself sends out. Rather, the newspaper
seems to offer an extension of the role-playing that is required to
dramatize the leap. Lionel Trilling, who discusses the sincerity of
role-playing in his book *Sincerity and Authenticity*, reminds us that
acting is not necessarily inauthentic; it can be an outward sign of an
inward vitality. The Greeks, for example, enacted the roles of ideal
beings as if they themselves embodied these ideals. Perhaps, then,
Klein's tabloid is an expansive form of the intimate immensity that
Klein is conscious of as he plays his role, the role of the ideal artist,
somebody existentially construed. Flying hair, wildly manic eyes,
arched body – all in perfect consonance with the metaphysical leap –
Klein's abandon is only further launched by the newspaper's pro-
motion of it.

Nevertheless, beyond this – or should one say, coextensive with
it? – is Klein's skepticism regarding his own act. Blanketing the
newspaper with sensational copy that mimics yellow journalism,
Klein's exposé undercuts his performance. It is this flamboyant self-
betrayal that Nan Rosenthal has in mind when she proposes Klein
to be pursuing an art of "conspicuous fraudulence";[3] so irrepressible

is his hype, she says, that anyone who desires can see through his disguises. If the photo of the leap conceals some evidence of its fabrication, Klein's one-issue vanity press loudly confesses it.

At some point, one comes to the realization that whatever metaphysical values Klein holds, his practice demonstrates his belief that fraudulence or authenticity is irrelevant when dealing with art. Once again, as in the photo of the leap, a case can be made that Klein is only taking advantage of the deception inherent in all perception of visual illusion. Accustomed to painted illusion, we fall into the trap of believing photographic illusion, and then we are offended when we are fooled. Our cultural expectations of photographic truthfulness have not prepared us to be sceptical when viewing a human in danger; but artists have always indulged their prerogative for legerdemain. Within this view is the idea of Magritte's pipe, with a bold caption – "This is not a leap!" – performing Magritte's paradox for us once again.

Nor is the specialized notion of existential authenticity immune from artistic manipulation. But our expectations suggest otherwise. It is certainly understandable how, on seeing the *Leap into the Void*, viewers can be misled into expecting Klein's full commitment to the existential value to be first and last an ethical – not aesthetic – choice and then to judge the art inauthentic when realizing that Klein's commitment is to artifice. If the disparity between the ethics of authenticity and the sleight-of-hand that brought its image into being distresses those invested in existentialism as a guide to life, Klein remains unperturbed by the problem; authenticity or not, for him artifice only enhances art's intrinsically magical properties.

Ultimately, one is tempted to pronounce *The Leap into the Void* more sophisticated than the man who produced it. Larry Rivers, who knew Klein in Paris, says, "Klein had a great desire to convince people of his beliefs, especially his belief that anything can be art – walking to get a newspaper, feeling the wind in your hair . . . , but to call him naïve is to disparage the vitality of his practice" – and his sincerity. "There was very little irony in Klein,"[4] Rivers says.

Then, again, Nan Rosenthal reaches the opposite conclusion. Too many works demonstrate knowledge of Marcel Duchamp, she contends, for Klein to be perceived as innocent. But if Klein's artistic sophistication seems destined to remain debatable, uncertainty is forever guaranteed by the speculative nature of aesthetics, which, like ethics or metaphysics, cannot be proved, only asserted. Perhaps on some level Klein intuited that, as a speculative cultural value,

authenticity is predicated on belief; his ironic artistic colleagues certainly realized that once cultural values shift and disbelief sets in, the art so recently brave with authenticity now seems devoid of it.

If not Klein, then Klein's photo contrives a transparent image whose meaning is nonetheless scrambled at every level. It is also a perfect icon of the age at that moment when, as Trilling says, art as well as morality was in the process of revising itself. For the transition between Abstract Expressionism and the reactions to it in Pop and performance art that emerged in the 1950s, the authenticity of "action painting" caught a glimpse of its own image: "Candid" photographs of Jackson Pollock did as much to create the attitude of authenticity as the paintings themselves. When in 1949, Yves Klein saw *Life*'s photo essay on Pollock, he was riveted by it. With such awareness of the self-consciousness of performance, authenticity would become simply another ingredient collaged into the aesthetic mix.

Expressionism and Other Expressivities

10

Harold Rosenberg
Transforming the Earth

In the winter of 1947–48, a magazine devoted to the uncertain protagonist entered the world. Titled *Possibilities,* it called for an aesthetics of spontaneity within and against Heideggerian bleakness. Included in its pages were some diary-like thoughts on the process by which Hamlet becomes fit for avenging the death of his father and thus worthy of his life assignment, or role. This essay, by Harold Rosenberg, found its way into print just as a new purposefulness had sunk into canvas.[1] Somber and earnest and not yet institutionalized, Abstract Expressionism had found its historical role, and Rosenberg, in his groping manifesto of the new spirit, had helped to author it.

Given the recent political evisceration of Europe, it is no wonder Rosenberg invoked Hamlet, a figure deeply troubled by the moral implications of the political situation in which he finds himself. To the literary intellectual of the anti-Stalinist Left, politics had effectively stymied all hope for humanity – first, in 1939 (with the Moscow–Berlin Pact) and again in 1940 (with the fall of Paris, which brought Rosenberg to observe that "the laboratory of the twentieth century has been shut down"[2]). Looking to Europe for models of an enlightened behavior seemed to Americans altogether untenable.

As a symbol of the intellectual after World War II, Hamlet – a civilized man whose flaw is the cerebral complexity that comes with education – becomes the paradigm of a bereft, contemplative person who is bound to a situation requiring action. But Rosenberg's concern was with the actor playing Hamlet, and he proposed that being too aware of one's responsibility in destiny is not unlike the actor's being too self-conscious of his or her artistic choices and so becoming paralyzed just when he or she should be moving forward. Even so, the question remains: How does a participant–observer situate the self to the advantage of culture? The answer would be for the actor to enter the illusion of the drama so entirely that the contradictions between him or her and the character he or she is playing disappear – or, as Rosenberg would say in his famous 1952 essay,

"The American Action Painters," "The role of the artist is to become so involved with the art that distinctions between life and art are broken."[3]

Throughout his career, Rosenberg insisted that the artist's true domain is not the expedient realism of "is," which deals in denotation, but the subterranean and sublime imagination that answers to the hidden causes of "seems." To quote the Hamlet essay:

> Since what we know must be, and is as common
> As any the most vulgar thing to sense,
> Why should we, in our peevish opposition,
> Take it to heart?

To seek to denote oneself truly is, from the point of view of the actor, a "peevish opposition" that interferes with playing one's part. Worse, it shows an intolerable contempt for the stage itself and everything that governs it.[4]

Weighing Shakespeare's meaning, he insists that the actor should zealously embrace the imagination as if it were true, not unlike Sartre's proposal that we should act as if we were free. Sartre may have distrusted the imagination, but Rosenberg, disgusted with the realm of spurious realism that politics traffics in, defended it as integral to art and art's contribution to the world. Rosenberg consistently went to extreme lengths in his art criticism to defend the aesthetic of imagination, without which, he contends, there would be no art at all.[5] Not only the artist but also the critic, Rosenberg believed, must give imagination priority over the realism that is given to "tracing out the fact." Rosenberg's achievement was to have defended the value of the imagination and the extreme ambitions of experimental art and literature in an era of cautious realistic values that opposed exclusively formal concerns. He tenaciously pursued the meaning of modern art using a method which, on the surface, seems like an argument but is best described as revelation strongly asserted, overthrown, and reworked. Constantly reformulating his thought about art and creation, milieu and culture, he construed art criticism as a defense of the creative imagination applied courageously and subtly to art and literature.

<p style="text-align:center">✳</p>

Emerging as a freelance thinker in the 1930s and as an art critic in the 1940s, Rosenberg was sufficiently cognizant of the world to note that American art lagged behind the brilliant products of the Euro-

pean imagination. His fierce loyalty to the individualism that pro-
duced experimental literature, however, made him quick to dislike
the regimentation of culture that was then taking place within the
individualist politics of the Left. In the 1930s many of the literary
intellectuals infatuated with communism submitted to the notion
that popular culture could express the dreams of an enlightened
socialist order or, at least, the enlightened socialist order to come. In
1934, *Partisan Review*, the literary journal of the John Reed Club,
appeared, supporting Trotskyite politics but condemning the prole-
tarian literature advocated by the Communist Party as ideologically
correct. As James Gilbert noted, both proletarian literature aiming
to recruit the masses and realist literature meant to speak clearly and
humanely about contemporary life were deemed artistically inferior
to the experimental literature being written abroad.[6] Awed by James
Joyce and T. S. Eliot, whose *Ulysses* and *The Waste Land*, respec-
tively, had been published in 1922, the staff of *Partisan Review* was
soon ostracized by the Communist Party for its literary allegiance to
Europe. In 1937, when the Moscow trials showing the repressive
nature of Stalinism caused many intellectuals to dissociate them-
selves from the Party, *Partisan Review* still advocated the intellectu-
als' hope for a Trotskyite version of communism – although with
increasing reticence. Depending on one's outlook, *Partisan Review*'s
steady emphasis on the literary avant-garde represented either a
commitment to liberated intellectual life or an escape from political
realities. Eliot saw fit to publish two sections of his *Four Quartets* in
Partisan Review. At the same time, from Mexico, Trotsky wrote to
Partisan Review that it was politically soft – that one needed to be
"fanatical" in one's beliefs if one was to succeed against totalitari-
anism.

George L. K. Morris, art critic for the *Partisan Review* from
1937 to 1942, advocated Mondrian in both his writing and painting
– and the mass media trounced him for doing so. Elsewhere, the
political dilemma over abstraction continued to trouble the most
thoughtful critics. In the inaugural issue of *The Marxist Quarterly*,
Meyer Schapiro used the occasion of the "great" exhibition at the
Museum of Modern Art, *Cubism and Abstract Art,* to write a cri-
tique of Alfred Barr's aesthetic assumptions, all the while scrupu-
lously justifying modern art to his uneasy political audience. He
disputed Barr's contention that now that the urge to explore the
natural universe, which had taken hold during the Renaissance, was
"exhausted," abstraction had become art's inevitable outcome, one

both subject to no aesthetic reversals and existing beyond history and time. Schapiro insisted instead that no art can be beyond history.[7] For his part Rosenberg was undaunted by the controversy. In his belief that abstraction rendered naturalism obsolete as a result of its culturally timeless and transcendent aesthetic, Rosenberg echoed Barr; in his belief that form is not immaculately conceived and sustained, he accorded with Schapiro. Aesthetic excellence, he maintained, can coexist with causal explanation; and, like Schapiro, he located the style of modernism within the individualistic, international, and "ahistorical" historical moment of Paris on the eve of the Great War. He agreed with Trotsky's cultural rationale to the extent that he became impatient with his irresolute colleagues. Still, his own halting diaristic thoughts show that Rosenberg was sympathetic to this protracted Hamletism within the intellectual socialist community.

Initially, Rosenberg appreciated *Partisan Review*'s editorial policy that held literature above politics. But in 1948, the year he launched *Possibilities*, he came to accuse the journal (and, later, *Dissent* and other politically enlightened magazines) of intellectual cowardice for censoring new literary experiments:[8] Any politics that encourages new content only to encroach on the "politically suspect" form by which newness declares its integrity – any politics which cannot accommodate the most advanced extension of humanity's creative and intellectual gifts – performs as a masquerade; and in these circumstances, it is the politics that is deficient, not the art. On this point, at least, Clement Greenberg (who, in 1958, became *Partisan Review*'s art critic) and Rosenberg agreed. Greenberg, however, who was more fanatical in his belief, insisted that form must be construed as a radical principle if it is to be aesthetically and thus historically compelling. Whereas Greenberg looked to make form his mission, Rosenberg, who was devoted to the mysterious plot of the unique imagination, clung to his mission of an open creative process.

Rosenberg came to resent being classified as a left-wing critic, because he felt that the assumptions of intellectual camaraderie that underlie the label foreclosed on the complex, untidy cultural nourishment that had determined his own creative possibilities. He had been influenced as much by "the Old Testament and the Gospels, Plato, eighteenth-century music, the notion of freedom as taught in the New York City school system, the fantastic emotional residues of the Jewish family" as by "the thirties."[9] To read Rosenberg is to

encounter an ongoing protest against any reductive, streamlined ideological grasp of the individual. He routinely met generalizations about individuality with an insistence that a human being is inconsistent and incomplete – and an expression of this formative impurity in conflict with itself and society. More than anything, he valued individual expression, and it is from this complex notion of the self that Rosenberg most frequently explained his rationale for art: It is precisely because individuality was so central to his aesthetic that we underestimate his career-long defense of the imagination.

Susceptible to literary influences ranging from Proust to Kafka to Wallace Stevens, he had a particular passion for Dostoevsky.[10] Certainly, the poetic and philosophical debates within the individual soul, the comatose contemplative mind that suddenly turns to fanatical action, the immanent truths that Russian literature addresses – all these literary dimensions Rosenberg evidently found irresistible. However, among the pantheon of influences on Rosenberg, the most unmistakably authoritative seem to have been Symbolist poet-critics Charles Baudelaire and Paul Valéry, who shaped not only Rosenberg's aesthetics but his sense of art's critical task as well. Rosenberg's view of journalism as a discredited form perfectly reflected Baudelaire's disdain for the minutiae of petty description in art and art criticism. In addition, Rosenberg's consistent and famous advocacy of existential spontaneity arose from the Romantic notion of imagination – sad, ardent, and forever in metamorphosis – that had, thanks to Baudelaire, installed itself in his mind: Transformation through subtlety or unexpected change or "the vision which arrives through intense meditation"[11] were values Rosenberg looked for in paintings.

Valéry's observations on art had produced no less an impact on Rosenberg's views. Observing Degas at work had caused Valéry to note that, unlike artists who codify and finish their work, "for Degas, a painting was a result of limitless sketches."[12] Rosenberg's thinking directly mirrored Valéry's induction – namely, the belief that the self-aware creative activity which brings art into being is itself. (But it must be added here that Rosenberg disapproved of the chastity that is its result in Paul Valéry's own poems.) Rosenberg held Valéry in high regard, for his privacy and for his example of the reflective intellect whose standards of excellence are limited only by what one can intellectually attain – an aesthetic pursuit not to everyone's liking. In 1931, when studying the luminaries of Symbolism, Edmund Wilson found a beautiful, abstruse world of language

relevant only to a former era (an era before World War I) that was caught in "the chambers of its own imagination."[13] According to Wilson, Yeats, Valéry, Eliot, Proust, Joyce, Stein, and Rimbaud relied too much on intimation and "on metaphors detached from their subjects."[14] "Though under the proper conditions," he continued, "these principles [of Symbolism] remain valid."[15]

European imaginative literature remained more compelling to Rosenberg than American realism. Journalism, a favored mode of writing in the 1930s, was of no interest to him, however intelligently pursued. Friends like Dwight MacDonald would get the back of his hand for joining the ranks of mass culture, whereas peers like Wilson, with their limited, albeit conscientious understanding of abstraction, who practiced reportage with a human face, were conspicuously ignored in the pages of Rosenberg's writings. Evidently, the documentary stance being adopted by writers was too ideologically foreign for Rosenberg to show any signs of graciousness to any of its practitioners.

To judge by the pages of *Art News* in the 1950s, abstraction got its revenge by virtue of the advocacy of sophisticated poet-critics. Even if, as Robert Goldwater maintains, his own *Magazine of Art* was the first to feature Abstract Expressionists,[16] *Art News* was the movement's most intensely literary and discerning champion. Its editor, Tom Hess, wrote criticism with unusual sensitivity. Reviews by poets John Ashbery, James Schuyler, Barbara Guest, Peter Schjeldahl, and John Perreault presupposed the meaningfulness of Symbolism and Surrealism now that there was a tradition of the mind's conscious meandering, its leaps into being, and its linked and floating metamorphoses of things, feelings, and thoughts. Such work, they said, is not meaningless, as often charged, but it is meaningful precisely because it is centered on the imaginative transactions that, as Rosenberg, quoting Rilke, wrote, "transform the earth."[17]

"A poet closely associated with New York artists,"[18] Rosenberg, too, wrote for *Art News*. It is within the context of his longstanding campaign for the acceptance of modernism, now conducted within a magazine friendly to the cause, that we should understand his provocative 1952 essay in that magazine. The essay was part Valéry's summits of thought and part Karl Marx's polemics urging Communards to turn their lost street fight into history. Rosenberg wrote,

The innovation of Action Painting was to dispense with the representation of the state in favor of enacting it in physical movement. The action on

the canvas became its own representation. This was possible because an action, being made of both the psychic and the material, is by its nature a sign . . . yet also exists as a "thing" in that it touches other things and affects them.[19]

It was not long before Rosenberg's term "action painting" became a debased conceptual logo for a public ignorant of or indifferent to the cultural history of abstraction. If, however, "action painting" came to seem an idiosyncratic notion pushed too hard, action had been an idée fixe of the twentieth century long before it became an obsession for Rosenberg. "A work of mind exists only in action," Valéry had written, drawing a clear distinction between the creative process and its pristine result, because "[o]utside of that act, nothing is left but an object which has no particular relation to the mind."[20] Defining art as an expression of an intuition, Benedetto Croce had reflected the modern impulse to escape from the sealed-off imagination that was characteristic of the previous, introspective era, and John Dewey's idea of art as experience had infiltrated contemporary thought until the passage of art into life and back again had become a stable aesthetic transaction in many people's minds. Finally, the rejection of contemplation had elevated action as an aesthetic idea with political momentum. Activism, with its capacity for turning metaphysical rumination into sudden mobilization for revolution, has driven the engines of a great deal of art in this century, fueling not only Russian Constructivists but the Dadaist gadflies as well. "The Dadaist should be a man who has fully understood that one is entitled to have ideas only if one can transform them into life – the complete active type."[21] Rosenberg admired the Dadaists in particular for the radical passion with which they fused purely aesthetic and purely political impulses. In general, he approved of action as a cultural locus that, if not logical, is nevertheless an effective working ontology which can yield results. He believed he could lean on the symbolism of action and even risk overemphasis, because, from behavioral psychology to existentialism to Zen, it represents the confluence of so many cultural longings.

For Rosenberg, action was the dramatic semantic core of a twentieth-century myth. Developed passionately but provisionally, his idea was subject to revision both in substance and style: from the groping consideration of action in Hamlet in the 1947 essay, to its 1952 presentation as an oracular spectacle in the action painting essay in *Art News*, to a stately proposition offered in a paper at an academic conference in 1965,[22] to a simple explanation in a 1967

Vogue article which portrayed "action painting" as an episode in the history of art.[23] This recycling suggests more than a professional obligation to suit writing to different audiences. In each instance Rosenberg adjusted his intellectual focus to implement the notion of action.

He wrote art criticism militantly but conditionally, reworking the ideas which were his medium the way he exhorted artists to work their paint. His criticism, then, does not lose touch with the notebook or laboratory, where hypotheses about action, the avant-garde, and other cultural notions spontaneously bubble. To locate our style is to locate the identity of our century, our distinctive cultural individuality, and Rosenberg identified our best self with the triumph of modernism.

Modernism was Rosenberg's ideology – a belief, he said, he would like to see enacted as law[24] – but an ideology whose terms are subject to dismantling, erasure, reassembly, augmentation, and transgression as the critical occasion dictates. Taken together, the diverse definitions of the terms of modernism occurring in his essays dare to provide an ongoing, open interpretation of modernism, a stream of intellectual "impressions," as Dewey said, in which conceptions, tested by experience, undergo revision. It is a practice that actively invites descriptions and creative speculation to collaborate with the intellect.

Rosenberg's criticism, however prescriptive and strongly voiced, revises its ideological position as it goes along, destabilizing its own fixed points of reference. Over the years, his continual restatement of "action" established a history of seeing art from different points of view and at different levels of generality, a precedent which, if prescriptive, was meant to be contested and to lead to additional intellectual litigation. In this sense, acknowledging the provisional status of his own analysis, Rosenberg offered us a theoretical work-in-progress, and although such an enterprise is not intellectually rigorous, there is more than poetic justification for it. Assuming that art is a product of imagination, not fact, Rosenberg opted for a kind of criticism that attempts to cope with a partial comprehension of art's ambiguous, multivalent meaning and the phenomenon of changing interpretations of its meaning over time. Some aestheticians consider this self-imposed intellectual openness to be a strength of Rosenberg's criticism, not a weakness. The interpretive model of criticism once advocated by Kant[25] also earned the approval of aestheticians. At least, according to aesthetician Joseph Margolis, "the

sort of rigor associated with determining matters of fact is flatly inappropriate in the circumstances in which interpretations are provided."[26] Rosenberg, who adopted a speculative, phenomenological–interpretive approach toward symbol, accepted – and even delighted in – the opportunity to rethink his own premises and ultimately fail at controlling the protean imagination.

To read Rosenberg defending the imagination – an imagination threatened on the one hand by both realism and fact and on the other by intellectualism and theory – is to see the strength of his commitment to the Romantic notion of the artist. Yet his defense takes paradoxical turns. He believed that keeping art new – imaginative, if not radical – depends on an imagination that strenuously makes compost of stale realisms. From this point of view, it may have struck many as surprising that Rosenberg accepted the terms by which Jackson Pollock managed, in Pound's words, to make it new. "The originality of Pollock," Rosenberg said, "lay in the literalness with which he converted theoretical statements into painting practice. What to others was philosophy or metaphor, he dealt with as material fact."[27] It was Pollock's conceptual breakthrough – translating metaphysical fantasies of action into physical movement – that redefined the meaning of paint. Pollock's action painting is a product of the imagination that offers a critique of the contemplative imagination by taking the moderns, with their urgings to activism, at their own word: following the trajectory of logic that Richard Huelsenbeck urges in *Possibilities* or that Dostoevsky's characters perform when they hurl themselves into action. In this sense Pollock's art is an unconditional and efficient modernist expression, so it is not surprising that Rosenberg embraced its originality.

He did, however, balk at Allan Kaprow's materialistic extension of Pollock's art into the actual world. Kaprow had written,

Pollock, as I see him, left us at the point where we must become preoccupied with and even dazzled by the space and objects of our everyday life, either our bodies, clothes, rooms, or if need be, the vastness of Forty-Second Street.... The young artist ... will discover out of ordinary things the meaning of ordinariness. He will not try to make them extraordinary. Only their real meaning will be stated.[28]

Notwithstanding Kaprow's grasp of the theoretical and ideological implications of Pollock, Rosenberg judged Kaprow's desire for sheer material existence as misguided. Had he been so disposed, Rosenberg also could have construed the cascade of recorded sound that

constitutes Kaprow's *Words* (1962) as a Pollock in poetry. There are two ways in Kaprow's production – the way of fully ramified sensibility, once Pollock becomes enriched by de Kooning, and the way of sensation, once Pollock becomes concrete and actual. But the actual *matière* of speech recorded in concrete poetry is not the sort of art-into-life that Rosenberg tolerated; he regarded *Words* as mass media. To remain art, he insisted, painting may approach life but must never reach it.

For Rosenberg, the crucial feature of Pollock's originality lay in his attention to the principle – the concept – of which style is the beautiful precipitate. Attending to action as an imaginative concept but manipulating its realistic sense, Pollock produced a skein of paint that fulfilled the requirements of modernism by coaxing a new all-over structure into being. In this instance, to translate virtual action into actual action leads to an innovative icon; to manipulate the literal meaning of action produces a drastic imaginative result.[29] Although Rosenberg reserved a special place for Duchamp's ready-mades because of their conceptual originality, when Neo-Realism came back as a reprise of Dada, he looked upon it as Marx had looked upon a replay of history: as farce. Or he threw it, along with Realism, down the black hole of "anti-art."

If real life was off-limits for the imagination, so too was the intellect demonstrated for its own sake. In his art criticism, Rosenberg brought up this issue when it was relevant – in discussing Hofmann and Klee, for instance, to determine how their art as thinking weathered the theory that informed it. Even so, he remained quite protective of the imaginative and symbolic nature of art and did not tolerate the probing of symbols of feeling with formal or semiotic instruments. In 1972 the exhibition *Joan Miró: Magnetic Fields* (co-curated by Rosalind Krauss and Margit Rowell) appeared at the Guggenheim Museum. It offered an unorthodox selection of Miró's sparest poetic paintings from the 1920s and 1960s; for Rosenberg, both the selection of works and the investigation of their meaning were suspect and an instance of the intellectual abuse of art. In his review of Krauss's catalogue essay, he condemned Krauss's formalist descriptions of Miró's poetic signs as a distortion of both the artist's intentions and of art. He writes,

For if there is one thing that should have been learned from Surrealism, as from Freud, it is that the antithesis consciousness/unconsciousness, or form/imagination upon which the Guggenheim exhibition is based, is unreal, and that it falsifies the manner in which original art is created.[30]

In fact, Krauss's essay is not the ruthless document that Rosenberg claimed it to be. Her description of visual elements explains how the animating space of painting creates the poetic ambiguity that distinguishes these ineffable works – among the very few truly Surrealist paintings produced – from the concrete poetry and forms they resemble. She uses her analytic tools delicately – and if she employs linguistic means to explain the mysterious signs in the *tableaux-poèmes*, which, as much as they are mysterious, are precisely ambiguous, what could be more relevant than a semiotic response to art whose meaning is simultaneously visual and verbal? Rosenberg, however, strenuously objected to this approach. Although he had read Suzanne Langer and absorbed her notion of the presentational symbol,[31] Rosenberg remained opposed to formalist or semiotic analysis on principle. He was further disturbed by what he construed to be the moral implications of art created or interpreted methodically. Wanting to protect Miró from an association with painters who, by solving visual problems, suggested Sovietlike engineers of the soul, Rosenberg became defensive. He wrote,

In art, however, it is always a mistake to push a concept to its logical conclusion. Art comes into being not through correct reasoning but through uniting contradictions of reason in the ambiguities of a metaphor. . . . [Art is the] action of living imaginations.[32]

These precepts, Rosenberg believed, should remain inviolate in the act of interpretation as well. Given Krauss's association with Greenbergian formalism, on the one hand, and his own almost superstitious fear of Stalinist "science" infiltrating art, on the other, Rosenberg was driven to condemn Krauss's analytic response to art as pernicious.

A limitation of Rosenberg's criticism is his frequent categorical dismissal of cognitive and intellectual tools in the interpretation of art, no matter how responsibly used, and even when this analysis does not preempt the imaginative speculation that he defends as most relevant to art. Because he wanted the tools to be integrated, Rosenberg adopted an extreme polemic stance. An intellectual who was wary of intellectual entrapment, he defended the imaginative domain of art against art history and disciplined philosophy, and artists or art critics who trespassed with unwanted aesthetic rigor or knowledge were condemned as self-consciously formal and for exceeding their roles. Even though art freed from the requirement of matching natural appearances inevitably "stresses the meaning of

the sign itself,"[33] this increased aesthetic emphasis, Rosenberg be-
lieved, is not what art is about. Insofar as preoccupation with the
material and formal language of paint is unfit for art criticism, he
maintained, concern with the metalanguage of style, genre, or his-
tory is illegitimate for art. For this foe of denotation and the declared
idea, the imagination was, at the least, a corrective for unassimilated
knowledge and, at the most, the means for significantly original
work. He wrote,

> Oh
> when a thing is getting ready
> for everybody there should be a halo
> of vigilance over the streets.[34]

Evaluating Rosenberg as an art critic necessarily entails impure
thoughts. He was a cultural ombudsman who refused to treat art
solemnly, with the result that political activists considered him too
aesthetic and aesthetes considered him too political, too sociological,
or too philosophical. He did not endear himself to political artists
by blessing Hans Hofmann with the Dionysian praise, "Not the
Muse of social consciousness but the ideologist of the picture plane
and the throbbings of space and color have been proven right about
the direction of painting."[35] Nor did his advocacy of the artisanal
handiwork of painting win him friends among those who considered
such painting to be pre-industrial and inherently servile, self-
indulgent, atavistic, and a futile escape into the realm of enchanted
introspection. That he championed abstraction, with its self-
sufficiency and artisanal devotion to the medium, places him in the
camp of aesthetes who, like T. S. Eliot, believe that the artist's task
is to excel at his or her medium and that improvements in the
world's conditions will come about by way of his or her example.
Rosenberg, who in fact seconded Eliot on this, would have added
that the artist is an instrument for the improvement of society to the
degree that he or she resists depersonalized, regimented artifacts of
society.

Neither did Rosenberg's hybrid philosophy entirely satisfy mod-
ernists. He outlawed both formal exploration, in which the intellect
is privileged, and the autonomous activity of play that feeds upon
the flux of calculated or unpremeditated sensuous differences. Like
the formalists he so often opposed, he did not hold that modern art,
whether painterly or flat, represented the triumph of ingeniously
exploited sensation through sheer material beauty.[36] He gave total

support to the ideology of modernism in its imaginative reaches but would not relinquish the panoramic cultural view that supplied, for him, the causal explanation for a painter's aesthetic criteria. The humanist as much as the Marxist in him forbade the aesthete from taking charge, and he pulled back from condoning the self-referring formal experiments of Valéry and Mallarmé, even though their art represented for him the total sovereignty of imaginative literature over realistic nonliterature. Modernists resented Rosenberg's insistence on interpreting modernism from the point of view of Romantic idealism. Form, they contended – not lofty or sinister temperament taken as an absolute – had determined the stylistic originality which civilization prizes above all. Were this not so, Manet would have been forgotten, tossed aside as an empty Delacroix.

Having invested in the artistic laboratory of modernism, Rosenberg nevertheless remained tied to a legacy of inherited meaning that rendered the principle of art-for-art's-sake to be ideologically unjustifiable in the twentieth century. He had been an early and militant champion of experimental form and language, but having witnessed the formalist implementation of self-awareness that came about in painting, he reaffirmed his own commitment to the metaphoric center of the artwork itself. Valéry had insisted that poetry justified its existence insofar as its language remained remote from prose and pursued a verbal materialism of sounds and rhythms in the symbolic and endlessly orchestrated meaning of words; but Rosenberg condemned this poetics. He recoiled from the art of the real unless it was attached to Hofmann's search for the real, with the emphasis placed on the search proven by work and transformation. Still, he revered that part of Valéry which accords with Kant and Heidegger – namely, that the hiddenness of art, however precisely approached, remains finally ineffable.

His defense of the metaphor harmonized his politics and his aesthetics, because both the dialectical Hegelians and the transfiguring Symbolists in whom he so strongly believed found partial truths and moral values immanent within sensation. Baudelaire's statement that "[i]t is imagination that has taught man the moral meaning of color, of contour"[37] calls to mind Rosenberg when he writes about Rothko. With the idea shining through sensation, a sensation that permeates both art and politics, Rosenberg came to defend abstract painting in the belief that the idea of morality is not dated and quaint but that it has general cultural validity. So if he defended modernism with a Baudelairean faith in German Romanticism, it is

because he felt ideologically secure in doing so. If he vociferously defended action, it was to put forth a metaphor that gave contemporary structure to artistic intention without circumscribing the possibilities for its imaginative realization. In any event, metaphor – something construed *as* something else – is the paradigm Rosenberg advanced as quintessentially cultural.

As formalism became entrenched, Rosenberg became correspondingly more hardened in his belief that creative imagination – not extravagant technique or the dogmatic assertion of the intellect – remained the overriding criterion by which art proves itself. In fact his visual acuity was sharper than his detractors cared to admit, yet he was dismissed as an art critic by those who did not appreciate the intellectual accuracy of his emotional response to sensory images. Had he been ideologically rigid in ranking art according to its adherence to immanent ideas and extra-artistic social forces, he would have been incapable of making reliable aesthetic judgments and could not have been counted on to winnow the significant from the trivial. But as his generous range of writings, which span Duchamp to Johns, shows, he was not coercive; rather, he was emotionally and intellectually responsive to stylistic criteria that the artists themselves imposed. Furthermore, despite the strong ambivalences around the fringes of his cultural values, he was a keener judge of vital beauty and form than several of his sensuously oriented colleagues.

✳

Whether an artist is foraging among styles or – more rarely – is in training to produce a full-fledged style remains a highly complex question that few critics engage. Aesthetic considerations alone are insufficient for criticizing a work of art; and, for the critic, knowledge of cultural context is imperative for determining a painting's meaning as well as its relative rank in history. Rosenberg was exceptional among his peers in his insistence on a truly comprehensive contextual view of modernism. Nevertheless, there was a history of art with which to contend, and Rosenberg addressed its stylistic concerns less well. Pollock's radical model of a post-Cubist space remains a landmark within this special history, and the fact that Rosenberg, with his semantic proclivities, would not culturally justify this syntactical breakthrough is an intellectual shortcoming that cannot be wished away. That said, however, we must add that his explanation of Pollock's originality is deeply insightful. In differen-

tiating Pollock from Miró by calling Miró's series of Constellations of 1940 to 1941 "a composition" and Pollock's works "an expression," Rosenberg forces us to attend to a crucial stylistic principle, one that distinguishes paintings of superficially similar appearance.

Rosenberg is constantly seeking out the axiomatic sense of things, and his analysis is characterized by its altitude – penetration and breadth of meaning that tolerate only basic issues. Indeed, his deep evaluation of twentieth-century art, seen from the long cultural perspective, explains his ceaseless defense of modernism. He is complexly motivated, and his reason for addressing individuality, action, and the avant-garde was not to perform a facile gesture of solidarity with Baudelaire's pronouncement that modern art and romanticism are synonymous – or even always to engage his deeply felt defense of the imagination. To be a worthy critic at the time he was writing, he rightly believed, is to investigate tirelessly the claim that what's current is significantly new and to question whether the art that is newly arrived presents an important advance over the revolutionary art of 1904–14 and not merely the slight rebuffs to it done the day before yesterday. To the extent that he interpreted the modernist adventure in a certain way does not diminish or falsify his sure sense of modernism's historical moment and scale.

Yet whether it was Baudelaire or Hegel that drove him, Rosenberg's achievement as a critic was to inspire American artists to do their most aesthetically ambitious work and then to defend them fiercely and intelligently when they most needed encouragement. Both resented and respected for his initiative, he was too ambitious for the Abstract Expressionists who, in the words of Tom Hess, were America's most important artists since Copley. Reviewing Rosenberg's book *The Tradition of the New* for *Dissent*, Paul Goodman wrote,

Harold made up their sense for them. He does not praise or explain the paintings, but he gives them a warrant to exist; and of course we have had the rich comedy of the painters disowning his names as they hew to his line.[38]

Goodman should have noted that, however strong a spokesman, Rosenberg demanded much less unanimity of style from the independent-minded European and American bohemians and exiles grappling with the possibilities of Surrealism than Clement Greenberg extracted from his disciples. Moreover, the exchange between Ro-

senberg and the Abstract Expressionists was two-way, and, as dominant as he was, Rosenberg constantly consulted with de Kooning, Philip Guston, and Saul Steinberg on artistic matters. Ultimately, the individuality of Abstract Expressionism proceeded less from an intellectual dependence on any one charismatic person than from an invigorating cultural unruliness that brought about a loose federation of ideas and attitudes.[39] Even as the heterogeneous band of French Surrealists who were exiled in New York promoted slippage between doctrine and the imaginative artistic result, they exerted a stronger influence on their American heirs than Rosenberg alone.[40] The strong art that resulted from this cultural agitation from Europeans – and then the subsequent rich, provocative, and at times significant painting and performance-, culture-, and site-art to which Abstract Expressionism gave rise – belies the artistic impotence Goodman ascribes to the movement.

Finally, the individual artists' successes and failures were their own, not Rosenberg's. The waves of bland, domesticated, and otherwise "safe" Abstract Expressionism that were soon saturating the market prove that, as much as he may have articulated sense, Rosenberg was not a guarantor of excellence. However, in hammering at salient cultural issues and values, he did keep the pressure on artists. He did not need a Plekhanov to tell him that artists must try to deal courageously and imaginatively with major contemporary issues if they hoped to do major work.

<p style="text-align:center">✳</p>

Vigilance is a function of habit. Having encouraged American artists to excel by competing with the best imaginative art of Europe, Rosenberg kept watch for signs of complacency. Once art has lost freshness and uneasiness with itself, he maintained, it is no longer art, however readily it may be collected and praised. (It is worth noting that in his writings, he does not blame the consumer society or the capitalist system for the commercialization of art. Instead, he believes that the artists themselves are responsible: It is the artists who delude themselves and the public by confusing superficial mimicry of energy with the genuine energy of metamorphosed work.) He could distinguish true from false vitality; his distinction between a successful artist and a successful careerist – and his constant vigilance on this point – is typical of the unintimidated moral stance he thought imperative for the role of art critic. His way of meting out

justice at the moment of Abstract Expressionism's decline combined flexibility with steadfast adherence to principles.

In 1958, ten years after Rosenberg worried over the distinction between "is" and "seems," the magazine *It Is* appeared. Angst is dead, Josef Albers announced. Rosenberg had meanwhile encouraged artists to move on, to take initiative in the search for something else – and at some point, he remarked that Abstract Expressionism had ended in 1952–53, the year, it should be noted, that the celebrated "The American Action Painters" appeared in print. More than most observers, Rosenberg knew when Abstract Expressionism had become fashionable. That is why, although not a fan of Rauschenberg, he sincerely deferred to him in calling *Factum I* and *Factum II* (1957) "brilliant." Even so, he maintained that for Albers to construe crisis content as a manner or look to be defended against as perennial renewal was to have missed the point of creativity altogether. The vigilance that the artist must practice to ensure his or her uniqueness looks like a bohemian stance; in Rosenberg's mind, however, it was not antisocial theatricality but moral rectitude that saved art from degenerating into fashion.

Harold Rosenberg was art criticism's valuable maverick. He cut across ideological lines and was worldly enough to remain unintimidated by the pressure to conform to either aesthetic or political doctrine. To the role of a loner he brought a complex intellectual apparatus, and throughout his career he reserved to himself the right to think complexly about rich and significant topics. For him art criticism entailed analytic thinking that was made no less strong by virtue of the fact that it accommodated a poetry of meaning commensurate with the workings of creativity and intellectual processing. To practice an imaginative interpretation of art's superabundant meaning allowed him continually to redefine a given topic and to feel it even as he came to know and debate it. He did continually debate and test the art world. He construed art criticism as intellectually braver than public relations, as more imaginative than journalism, and as more biased than history. Furthermore, he construed the critic to be in a privileged position, someone who was creative like the artist, with the wisdom of interpretation at his or her disposal – but also with responsibilities to judge and evaluate. A critic partial to Abstract Expressionism, Rosenberg, in true parental fashion, combined abiding love with deep concern and tough standards. He was capable of lecturing and scolding artists and intellectuals of

his own community, and he did so with more appetite and precise thinking than he did when he dealt with art that followed and responded to his own work. "To justify its existence, criticism should be partial, passionate, and political, that is to say, written from an exclusive point of view, but from a point of view that opens up the widest horizon":[41] Aesthetically committed and endlessly investigatory within that commitment, Harold Rosenberg fit Baudelaire's professional requirements perfectly.

The value of Rosenberg for today's critics is that he serves as a model of the independent, imaginative, and intellectual critic at a time when not only our politics and our art but also our art criticism has become conservative and self-serving. Whether politically right or left, cultural observers whose visual aptitude often is slight disavow abstraction for a return to content; but this is an unexamined herd response to art whose issues apparently elude them. Moreover, even today's informed, visually acute art critics seem incapable of making elementary aesthetic discriminations that would enable them to realize that the return to representation today is by and large not a return to content but a return to mere subject matter. A painting of studio nudes may be pornographic – a presumptive and fey misreading that reveals nothing so much as a misreading of the aesthetics of subversion. Likewise, abstraction is rich with meanings that reinforce or deny the assertion of heroic personal brushwork or the impersonal material presence: Black may signify tragedy or the fashion of tragedy. In any event postmodern appropriation of realism is potentially worthy but often irresponsibly employed, and critics remain lax in dealing with its presumed sophistication. Partisans once again tend to accept this return to the figure at face value. All too often, critics stand by as the figure is craftily transformed from reactionary figurative cliché to subversive political exposé of the reactionary values that are embedded in the cliché. What is needed is a debate on the uses and abuses of irony that the artists invoke – not a pseudo-intellectual smokescreen of irony's difficult and important rhetoric, or one that justifies its complicity with reactionary art.

Rosenberg would have goaded today's art critics into examining such unexamined issues. In one well-known essay that cited the Nazis' slick use of German Expressionist motifs, he discusses how styles in art are co-opted and become propaganda for political ends that are antithetical to their original intent.[42] It is a sobering discussion for critics who are complacent about their aesthetic or political immunity from cultural backlash. But it could well serve as the starting point

for a discussion about the criteria under which jejune parodies become persuasive cultural transgressions – and about the role of the imagination in keeping the content, if not the subject matter, beyond the reach of easy manipulation. For his part Rosenberg was ideologically opposed to making any concessions to popular culture – to a culture which he considered to be irredeemably simplistic in its grasp of things. With his complex cultural perspective, he would shame critics, those who were cloistered in strongholds of art or politics, into realizing that to claim a creative dialectical philosophy is presumptuous unless one practices it deeply and openly.

One should practice it most strenuously on one's pet notions. The excellence that Rosenberg defended is the contest between the individual artist and the conformist tendencies within him- or herself. Critics, too, should be aware of a deadness or coziness within themselves when, in the name of professionalism or ideological purity, they exempt their own presuppositions from critical discourse. Rosenberg's theatrical mode of writing derived from a style of criticism meant to refresh opinion, vocabulary, formulaic rehearsals, and similar indexes of false consciousness within one's own professional milieu. He was an exceptional critic because, although he held very strong views on art, his intellectual scruples and aesthetic discernment would not allow him the prejudicial narrowness that many critics, whether upholding Marx or Clive Bell, confuse with thinking. If we were truly brave, we would invite historians and aestheticians who are disciplined in anthropology, philosophy, and the history of ideas into the pages of our magazines to implement the genuine self-critical attitude we pretend to have – but do not. Such an attitude is largely absent from the dogmatic rehearsal of power, desire, or form that suffices for art criticism today. After all, rigid attempts to advance ideas are not a sign of intellectual toughness but of doctrinaire softness, and only by sustained internal debate may we experience the necessary self-criticism that leads to consciousness.

11

The Art of Philip Guston

UNDERWORLD OVERCOAT

Once upon a time but not so long ago, it seemed that one arts panel in every three was dedicating itself to considering The Individual in Society and brooding long – and if not hard, then vociferously – on the role of the creative outsider. Today it is often argued that the tension between individuality and conformity is gone. Now that the individual and society are synonymous, one wonders, may we feel nostalgic for alienation?

A retrospective consideration of Philip Guston's drawings[1] raises that question. His work from the 1930s to the 1980s clearly shows his swing from depicting the neurosis of alienation to depicting the neurosis of consensus – and back again.

Like others of his generation in the arts, Guston spent his formative years in the 1930s trying to give Neoclassic validity to relevant social and political issues. But it wasn't until the 1960s – when he could rely on the accrued wisdom of Abstract Expressionism – that his most excellent work evolved out of these overtly political labors. In my view the aesthetics of Abstract Expressionism helped his politics. Subjective and touched with a vigilance that borders on theory, these palpitating abstractions (to paraphrase Goethe) conveyed more content – more political awareness, if you will – than any of the ideological murals that had preceded them; and throughout his career, Guston's drawings always anticipated and defined each stylistic phase.

Yet before and after his Abstract Expressionism, Guston evidently remains attached to – and informed by – the rhetoric of oppression that is associated with the art and literature created between the two world wars.

Biographers have mentioned Kafka as among the literary influences on Guston's art;[2] but his works also have an affinity with those of Ernest Hemingway's, an affinity which, to my knowledge, has not yet been mentioned (see Figure 17).

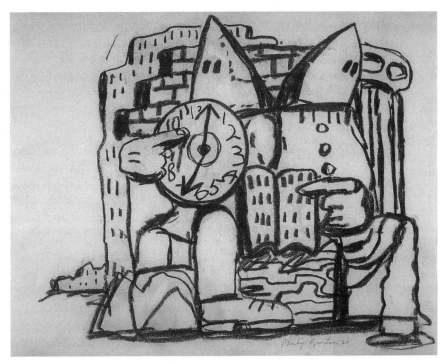

Figure 17. Philip Guston, *Untitled* (drawing). 1968. Charcoal on paper, 17⅞ × 22½ inches. Photograph by Sarah Wells, courtesy of the David McKee Gallery, New York.

Hemingway, a master at using farce as a blunt instrument, begins his story "The Killers" thus:

The door of Henry's lunch-room opened and two men came in. They sat down at the counter.

"What's yours?" George asked them.

"I don't know," one of the men said. "What do you want to eat, Al?"

"I don't know," said Al. "I don't know what I want to eat."

Outside it was getting dark. The street-light came on outside the window. The two men at the counter read the menu. From the other end of the counter Nick Adams watched. He had been talking to George when they came in.

"I'll have a roast pork tenderloin with applesauce and mashed potatoes," the first man said.

"It isn't ready yet."

"What the hell do you put it on the card for?"

"That's the dinner," George explained. "You can get that at six o'clock."

George looked at the clock on the wall behind the counter.

"It's five o'clock."

"The clock says twenty minutes past five," the second man said.

"It's twenty minutes fast."

"Oh, to hell with the clock," the first man said. "What have you got to eat?"[3]

From props to affective tones, the scene drawn by Hemingway here and those drawn by Guston in his first late figurative drawings and paintings both suggest a rhetoric of oppression. Sublimity of space and time are shorn of consoling metaphysics: Space is claustrophobic, and time is impoverished by petty displacement onto clocks and feeding schedules. Free will becomes trivialized through shortsighted goals – what's to eat, and when?

As the fracas over the lunch menu in "The Killers" heats up, so does the disarming vaudevillian routine. The scene continues:

"I'll take ham and eggs," the man called Al said. He wore a derby hat and a black overcoat buttoned across the chest. His face was small and white and he had tight lips. He wore a silk muffler and gloves.

"Give me bacon and eggs," said the other man. He was about the same size as Al. Their faces were different, but they were dressed like twins. Both wore overcoats too tight for them. They sat leaning forward, their elbows on the counter.[4]

Examining these literary types ultimately leads us to their source in politics. In works by both Hemingway and Guston are creatures filled with suspicion and identified as thugs by virtue of their not being characters so much as schema with flat affect. Myopic, literal-minded maneuvers finesse terror and the implication of unmotivated violence. Hemingway, as a modernist, supplies no cause, no explanation for a death that will arrive inevitably and soon. Acutely aware of the fictive possibilities in a reality already made grotesque and irrational, Hemingway the novelist drew on what he had seen firsthand of politics when he had written as a journalist. Already in 1922, as an American newspaper columnist covering political events in Italy, he had written "Mussolini, Europe's Prize Bluffer," an article in which he described the Fascists as "a sort of Ku Klux Klan" and encapsulated their threat to the world in Mussolini's sartorial faux pas of wearing a black shirt with white spats.

Like the twinned dumb executioners in *The Trial* who come to get K and, without a word, escort him to his death, the tyranny that Guston personifies in his paintings and drawings is cousin to an ethos as capricious and absolute as Kafka's and Hemingway's. Hence Guston is presupposing a scenario found not only in the kind of hard-boiled fiction that enlists the documentary realism of reportage; he is presupposing as well a world that equates objectivity with materialistic vice – the vision of Expressionist drama. More than a shared vocabulary, this assumed topos of the underworld constituted a legacy of a politically Left bohemia that was vital in both Europe and the United States in the 1920s. But what I want to note here is Guston's bonding with this period and its sordid aftermath.

Later, in response to American political hubris in Vietnam – and to assassination and violence at home – Guston sought some contemporary expression of actuality for the 1970s. Yet he chose for that reality an amalgam of a settled progressiveness of Synthetic Cubism and the conservative but unsettling idiom of de Chirico.[5]

So although much has been made of the *au courant* relevance of Guston's political statements of the 1970s, he was actually more profoundly historicizing and literary. In his late Hemingwayesque romance with the period between the two world wars, he was doubtless sincere, but it must be admitted that he produced better statements of conscience – and much better art – after he left explicit social comment behind.

The personal magic of Abstract Expressionism had worked well for him, and although he rejected it in order to communicate, as he put it, "a deeper meaning," Guston was mistaken if he thought his dehumanized cartoons of Klansmen were necessarily deeper than his Abstract Expressionist gesture. Only when he finally pressed beyond an historicism populated with Klansmen and easy existential paraphernalia did his subject matter give way to the deeper meaning of content, the very existential content of his previous Abstract Expressionism: vigilance, mortality, and beyond – an eternity of feeling in which, as in Hemingway as well as in Kafka, guilt is a given.

The wonder of it all is that once beyond the set-pieces of alienation, in his best still-later works (*Friend – To M.F.* [1978] and *Web* [1975], for instance), even a slight period cast does not cushion the anxiety that these works reflect and evoke. Nor is their agonizing nakedness a bit diminished by their association with an ethos of the familiar past.

I CONFESS

If, as Ingres says, drawing is the probity of art, it must also be true that Delacroix and the romanticists may register as much probity in their spasmodic mark as do the suave classicists in their controlled, sinuous line. For Philip Guston, at least, drawing evidently informed the romanticism of the Abstract Expressionism and Neo-Expressionism by which he is best known. In drawing incessantly, he taught himself art and interrogated style, and when things were rough, he consoled himself with drawing even as he negotiated the difficult passage to the next phase of expression. Although a truant from academic drawing himself, he later insisted to his own painting students that they give priority to drawing – drawing from life.

So integral was drawing to Guston's developing a cultural worldview, one might reasonably argue that draftsmanship and touch – not color – best articulate his paintings.

A survey of Guston's artistry as a draftsman – from 1930, with his formative Neoclassical visual politics, to 1980, with the Neo-Expressionism which he fathered – conveys the genuine adventure of an artist trying to bend the idiom of his times to his own heartfelt concerns.[6] If not all of the phases of this adventure are compelling, in some sense this is to Guston's credit. His was not a prepackaged career free from mistakes – and also growth. Artists ambitious for their art rather than their careers will find a study of Guston's complete oeuvre most rewarding, because it both teaches visual mastery and exemplifies the subsequent intentional sabotaging of control.

<div align="center">✳</div>

The campaign to clean up a society troubled by war and violence with which Guston's career began in the 1930s and 1940s is one of the problematic phases of this artist's adventure. By this time he had mastered drawing, principally as a rebellious autodidact, and he was entirely fluent in Neoclassicizing idioms that had been adopted by artists to valorize social comment through myth – or rather, the *mannerisms* of myth, since for all the earnest propaganda against moral decay, *The Conspirators* (1930) and *Clothes Inflation Drill* (1943) are aesthetically minor. No distinguished, coherent style governs these works.

An exciting transitional piece is *Tormentors (Drawing No. 1)* (1947). With it – as if anticipating what would in three years become

his new direction – Guston almost entirely shed the etiolated Neo-classicism and refreshed the theme of violence through seismic and tentative automatic contour drawing. Conspicuous for its stylistic re-move from his classicizing work, this drawing's broken calligraphy enhanced what Kenneth Burke calls the "disorders of the polis."[7] The troubles plaguing society are made real enough through the sugges-tion of an armored silhouette studded at the neck and seamed at the leg – a telling detail of which Guston would make horrific use again and again. Here, scattered in modernist shards of surreal Neo-classicism, is a quieter rhetoric of battle that is equally effective at im-parting a dignified tragic cast to the vernacular of contemporary life.

*

Drawings from the 1950s, which sputter with scratches and bits of calligraphy, announce Guston's alliance with Abstract Expression-ism.[8] But the telegraphic notation is not just a "look." Reductive yet by no means impoverished, the agitated mark characteristic of his Abstract Expressionist paintings creates not an unfocused "busting out" but a highly discriminating permanent revolution. In contrast to these great paintings, one must admit, his drawings are merely a blueprint of the expressive experience. For this very reason, the drawings make explicit certain compositional strategies.

Critics have remarked that Guston's drawings are about location, and it is true that placement of marks to enhance the feeling of variable, contingent existence does indeed preoccupy his work. Yet the nature of the mark itself is an additional concern. As the decade wanes, the drawings reveal an intense absorption in creating a mark that is expressive of both assault and wound. Intent on exploring the lineaments of vulnerability as much as on displaying the formal possibilities inherent in an all-over structure in this period, Guston seems now to dwell on the meaning of the mark. It is fascinating to see how fissures developing from architectural sketches will appear to be furrowing both the bedclothes and the brow of the protagonist in the drawings from the 1950s. In *Head – Double View (Drawing # 20)* (1958), orifices puncture a shape, an image which presages the theme of the confessing self that came to dominate Guston's late figurative phase.

*

Rather than a dense field of marks, Guston's drawings in the early 1960s reveal line enclosing and enfolding spaces (*For M* [1960]) (see

Figure 18). This is the period when he began to incorporate, rather than agitate, space, a development which allowed him to create images that were part organic objects and part inchoate stuff, a sort of primal material that retains its rudimentary force even as the images grow identifiably concrete. By the middle of the 1960s, these objects define themselves.

The proliferation of images in Guston's work in this period is evidence of his tendency to play off the inherent ambiguity in things gross and dense. In *City* (1968), physicality conveys emotional heft: Quality wrestles with quantity – and loses. Wounds in the facades of buildings reappear, this time as slits such as de Chirico might have rendered. Early on in his career, Guston had lifted de Chirico's vision and employed it in statements about the politics of "the state" – and now, once again, he utilizes this urban stereotype. With an image unmistakably suggesting a fortress, Guston's representation of the city as a suspicious, "guarded," collective entity is unmistakable.

By day abstract and by night representational, Guston's work in the 1960s suggests a desire to develop a generic iconography that is nonetheless charged with personal feeling. Curator Magdalena Dabrowski has remarked that the abstract drawings evince the artist's cognizance of Minimalist art – however he may have denied it[9] – and also seem determined to recall the abstract symbolic essences in the earliest Expressionism developed by Kandinsky. Popularized in the 1940s in handbooks on emotional composition, Kandinsky's form language was translated by Guston into illustrations of such affective abstractions as *Parting, Joining,* and *Domination and Fear.* His drawings from the early 1950s bear such titles as *Downward* and *Ascent,* but in the late 1960s, in addition to *Stone* and *Book,* there are such titles as *Edge, Haven,* and the deceptively neutral *Mark. City,* with its multiple marks simultaneously signifying orifices and scarification, represents yet another pictograph of feeling. Although he began this phase by drawing reductive abstract and figurative elements, he groped toward creating an aesthetic of empathy in which the symbolic ambiguity of abstraction presents itself with the legibility of representation.

What one sees in the many quick sketches of this period, then, is the result of a self-imposed refresher course on signs – a prelude to the reassembly that would become his new symbolic style.

Biographers have suggested reasons for this change to figuration. In her book on Guston, Dore Ashton has suggested that the reason for this change to representation lies in Guston's wish for direct

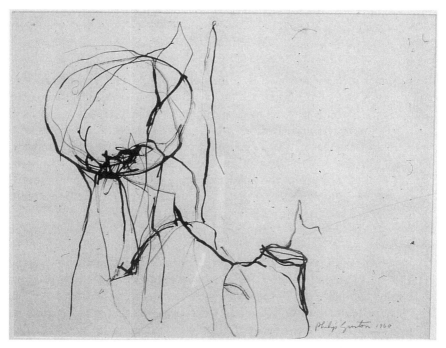

Figure 18. Philip Guston, *For M* (drawing). 1960. Ink on paper, 18 × 24 inches. Photograph courtesy of the David McKee Gallery, New York.

statement, because he did not want "emotion of ambiguity to stick to me like seaweed."[10] Curiously, however, according to Robert Storr, it had been his dream of "a direct expression"[11] which had caused Guston to switch from representation to abstraction two decades before. But if his desire for direct expression caused his transition to Abstract Expressionism, and if his desire for unencumbered expression resulted in his transit back to figurative art, then the implication would seem to be that it's not the art but Guston's attitude toward it that wanted periodic renovation.[12]

Whatever he said in theory, the fact is that until the late 1960s, in practice Guston's personal idiom closely mirrored the style of the day: A more direct expression coincided with the prevailing style. Although Dabrowski notes that it was part of Guston's temperament to meet success with a sense of failure, depression, and an impulse to flight (changing his residence, changing his style),[13] his flight manages to incorporate at least some mainstream values. Even in the final phase, as he fled worldly success, he returned to conservative

figural compositions while the art scene shifted to the recuperation of easy-to-read styles.

*

A major theme revealed by a long view of Guston's career is confession. Others have noted the theme of violence, and, indeed, violence by the state as well as by despotic individuals does prevail in both his figurative and abstract phases. Early on, Guston's obsessive theme was war in all its guises, from street games to armed combat, all ritualized with appropriate Neoclassical decorum. But his portrayal of violence in the postwar culture is tantamount to an admission of guilt, whose purpose was to align political content with personal pain. Guston's postwar vocabulary of self-inflicted violence expresses both the damage and reparations that are borne by the body. Early in his career, the theme of confession took the form of someone assuming the burden of political guilt on behalf of the polis. (Late in life, after another go at political art, Guston passionately unburdened himself and, however reluctantly, portrayed the individual admitting to sin. This time, dropping the signifiers so specific to the Klan, he needed only to display street armor as vulnerable to pain to refer back to an ethos retrieved from modernist abstract forms.)

Meanwhile, the year 1968 shocked Guston and informed the visual black comedy that emerged from his politicized pen. Upsetting to him were the U.S. political policies in Vietnam and the radical politics causing self-determination to self-destruct at home. Appalled by hysteria from radicals as much as by violence from reactionaries, he effected an aesthetic retreat and chose thereafter to privilege the rhetoric of communication over the rhetoric of expression. "Synthetic Cubism and Metaphysical Reality Go to Camp" might have announced the coming attractions of Guston's new idiom.

Added to this was an existentially infused cartoon that now offered Guston an interesting mode of social comment. He had been an early admirer of both Krazy Kat and the commedia dell'arte, but it was not until the late 1960s that he utilized low art to address ethical issues. In contrast to his former mannered academic manipulation of the grand Neoclassical idiom, existential comics offered him a shrewder way to deliver a serious message about terrorism using doll-like figures whose malice was offensive yet – because they were mere schema – nonthreatening.

The apparatus of alienation – a clock, a city, a smoked cigarette,

a lone lightbulb – along with the props of art-making – paintbrushes, tacks, canvases, and plaster casts – fashion Guston's grim allegories of the self toying with a confession of responsibility for its own condition. The iconography, culled from the West's cultural supply cabinet, once again cites de Chirico, appropriating that artist's *Portrait of Guillaume Apollinaire* (1914) for props, including a plaster cast wearing shades – an appropriation that turns the symbols of the artist-seer on its head. In Guston's profanation of the artist-seer, however, what were once instruments of probity have become weapons among thugs, and an untitled charcoal from 1968, showing a pair of Klansmen sitting face-front, is really Picasso's *Three Musicians* (1921) redone for morally instructive purposes. This drawing shows that, once again, when Guston returned to making political art, he became enamored of heavy-handed political signifiers. Dabrowski points out that, more often than not, Guston's fistlike hands from this period are used for attack as much as for defense.[14]

<p style="text-align:center">✳</p>

The reception given to this cartoon phase of Guston's art was bound to be favorable. Thanks in part to the cultural normalization of Pop Art, viewers were now in the habit of responding to cartoons as they would to art. Moreover, given the negative publicity surrounding the Museum of Modern Art's 1984 *"Primitivism" in 20th Century Art* exhibition, with cartoons and popular bases of modern art elevated even as the notion of primitivism became discredited, there was no doubt that Guston's choice of idiom would be praised without hesitation.

Nonetheless, the quality of Guston's late drawings should lead to a different judgment.

Only after violence became confession in paintings and drawings that dropped the Klansman mask and reassimilated Expressionism did Guston truly succeed in transforming ethical subject matter into ethical content. Internalized as self-inflicted violence, his psychopolitical cartoons are more potent than the earlier finger-pointing works of an explicitly political nature, works in which the shock of the KKK registers but in which the leverage for consciousness is small. A 1947 Herblock cartoon showed an atomic bomb measuring the girth of the world upon which sat men at a conference table; the cartoon bore the caption "Don't mind me, just go on talking." If, from 1968 to 1973, Guston seemed to be a failed Herblock, it may have been because the vaguely humanistic finger-pointing lacks the

specificity of sharply focused, issue-oriented cartoons. On the other hand, if in this phase of his art Guston also seemed to be a failed Goya, it may have been because too much is invested in the mere sign of racism – the KKK hood. Guston's attempt to synthesize the political cartoon and fine art ultimately cheated both idioms. If there is a general misperception that subject matter and content are synonymous, Guston's late political paintings reveal that he is fooled by this counterfeit too, confusing the impact of KKK furnishings for the value of horrific ethical presence.

At any rate, the paradox is that once Guston neutralized his subject matter, the terror his art imagined escalated.

Certainly, to judge by the imaginative, intense late canvases, Guston was more inspired as a sinner than he had been as a moralist who was hiding his feelings of guilt behind self-righteous indignation. Once he dropped his own defenses and openly portrayed the self as defenseless against the vice and moral decay he had ascribed to the Other, he allowed an unconventional approach to his topic; and only after he exploited the liberated forms of estrangement did he release the full agonized grandeur that had lain latent within the image. His response in 1974 to a review of Nadezhda Mandelstam's book *Hope Abandoned* declares that intention. He wrote,

> To justify existence . . . Russian literature has done more than any other, and if a Russian writer says today that we are all criminals, it pays to listen carefully. When a Russian refuses consolation, it means that things are bad, it means that there really is no consolation. This is a book about how to live without consolation. Without consolation, one can live only on love, memory and culture. . . .
> I feel such identity with this – I feel this is what my paintings are about in a way.[15]

If, in contrast to the agonized authority of Guston's last works, the political works seem unfulfilled, this fact only points to the belated realization that, throughout his career, whatever the ostensible subject matter, "his art is always about himself."[16]

The ashamed self as subject does not warrant automatic cachet. But it does seem to have brought out some of the best in Guston. In the painted versions of *Head and Bottle* (1975), *Friend – To M. F.* (1978), and *Web* (1975), cartoon schema are motivated and sustained by deep and problematic attachments. Although these works are essentially about mortification, the red that floods them and his great Abstract Expressionist canvases express all subjective feeling.

Touch substitutes for palette in these canvases, and this substitution is wholly adequate.

In their own right, the last drawings reveal truly intense (not merely emphatic) artistic power. His ink sketches from this period, for example, are not dutiful studies for a final painting but explorations of the expressive possibilities inherent in a theme. In the drawn variations of *Web* – as in the painting – the sexuality of hair, the fatality of spidery filament, the immutability of law all pull together in an unconsoled constellation of feeling. A more formal unburdening is evident in *Three Heads* (1975) (see Figure 19). Three rectilinear heads are linked by outer arcing hands which form a proscenium for the central head that is smoking a cigarette and also turning to kiss the head on the right. As William James would remind us, the image is not in a thing but in the relationship the common border expresses. Here, figures have a joint boundary, eye riveted to eye, mouth sharing mouth, and arms encircling each other. The common border is violated, with the cigarette on the assault, admitting, how-

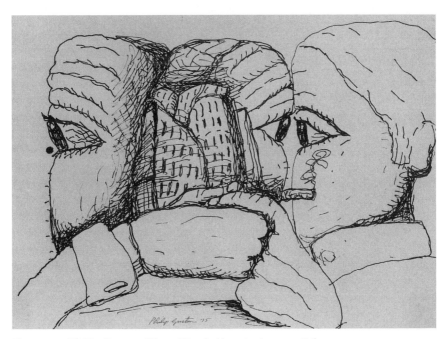

Figure 19. Philip Guston, *Three Heads* (drawing). 1975. Ink on paper, 19 × 25 inches. Collection Diane Shearman. Photograph by Steven Sloman, courtesy of the David McKee Gallery, New York.

ever reluctantly, a sadomasochistic content that betrays the intimate gesture of a kiss. One is reminded of the extensive tradition of the kiss in art, such as Brancusi's rudimentary essentialist sculpture. Surely too, Guston was familiar with Giotto's fourteenth-century painting *Kiss of Judas*. Confessed betrayal within the family, complicating intimacy and trust, comprises the content which suffuses and enriches the apparently inarticulate subject matter.

Having rendered his content subjectively, Guston was free from the illustrative constraints of the object. It is as if he finally had taken Kierkegaard's lesson to heart: that truth can be illuminated by creating concreteness and subjectivity together, for concreteness by itself is mere literal-minded representation. Perhaps, at last, he also learned Kandinsky's lesson of inner necessity. Kandinsky, who believed the object to be distracting and crossed the threshold into nonobjectivity (but placed limits on pure form), urged that we press toward abstraction as far as great feeling will take us. "We may go as far as the artist is able to carry his emotion," he wrote, "and once more see how immense is the need for cultivating this emotion."[17]

Guston's last literary phase, undoubtedly an artistic retreat from pure abstraction, was boycotted by both critics and artists as a sellout. Then, once his work began to be accepted, it was accepted uncritically – it became fashion. But whether his work was figurative or abstract, once he let himself be vulnerable to subjectivity, his art showed that his real strength lay with Expressionism. As he slowly arrived at a complex psychopolitical portrait of himself, with painting and drawing both reflecting a magical, not imitative theory of representation, the art sped away, leaving mere ideological illustration in the dust.

Gestural Aftermath

WORRYING MAN (JONATHAN BOROFSKY)

Expressionism may be violent; or, as the art of Jonathan Borofsky demonstrates, it may worry. By 1983 Borofsky had counted 2,845,323 sheep, and his drawings, sculptures, paintings, and other imaginative extrusions ambiguously situated between self-expression and art had quickly surpassed that number.[1]

With Borofsky, counting is obsessive rather than soporific. His installation from the accretion of drawings from notebooks (some writ large on actual walls), *Counting from 1–* (1969–present), for one example, may have begun as a Conceptual work, but over time it moved further and further away from the metronomic ticking of artistic productivity to signify something richer.

Borofsky's practice of counting is a reminder that creativity is sleepless and elemental and takes places at a level that is antecedent to artistic shaping; and it is here that the Conceptual side of Borofsky joins up with his primitivism. Where Conceptual art is ideational, primitive art is spiritual and emotional. But at the heart of both tendencies is the belief that true art lies in processes anterior to the triumphant artifacts themselves. Ultimately, however, Borofsky has a genuine gift for locating psychic distress. He may constantly refer to the intellect, but he is quite at home in psychological uneasiness, the uneasiness that causes creative expression in the first place – the uneasiness that distrusts too much artistic control.

The wayward visual stuff that Borofsky installs in exhibitions descends from an aesthetic lineage that typically gives anxiety priority over art. Historically, anxiety has decidedly informed much modern art in general – it nourished the action painting of Abstract Expressionism, fed the vitality of *art brut*, proved to be the rationale for Surrealism, and eroded social conformity in German Expressionism. *Matière* may not be found in Borofsky's paintings and drawings, but the free and neurotic individualism that inspires artists

certainly is. Curiously, it is not his few rabid Neo-Expressionist canvases of the 1980s that seem authentically psychological; rather, it is the continual stream of his stark dream paintings. Lucy Lippard once found these paintings "too inept to be naïvely 'good' ";[2] but I find them too truly simple – too precisely located in nonliterary pain – to be inept. These drawn paintings are convincing precisely because there is nothing to look at.

As with the willed primitivism of the Fauves, the Expressionists, or, for that matter, the technically impoverished Symbolists, Borofsky's dream images have a greater psychological impact by virtue of being vague and chilly schemes of figures; the very remoteness of the figures intensifies the feeling of doom or guilt expressed in the scrawled captions – words suggestive of something less visual than aural, the exteriorized voice-over which dreams often supply.

Flagrantly indifferent to perceptual correctness, Borofsky assiduously locates the feeling that lies vulnerably within art and its making. Subjective thought is what his art is about. "My thought process is an object,"[3] Borofsky once said – and, indeed, his oeuvre offers no comely artifacts to satisfy an audience's thirst for beauty. Rather, it provides a visual chronicle of a busy terror.

In the mid-1970s, however, partly through personal conviction and partly through the strong aesthetic direction indicated by his contemporaries, Borofsky began to introduce the worldliness of both politics and postmodernism into his art. With this avowedly public art came a diminished psychological content (although the gritty contours expressive of moral outrage in the political wall drawings of the 1970s manage to convey a sense of personal urgency and bitterness). Borofsky's shift toward public art recalls the one that took place at the turn of the century, a shift that, as Werner Haftmann says, renovated the image of the artist from that of a Symbolist introvert producing a body of work in withdrawal from the world to a youthful, aggressive man of action ready to engage in critical polemics.[4] It would be an exaggeration to say that Borofsky turned to Expressionism; yet his increasingly pluralistic embrace undoubtedly began to incorporate its outward-directed violence.

Although at first glance it may not have appeared so, some of his installations in the 1980s were quite polemical (see Figure 20). There was, of course, the wonderfully messy gallery installation of 1980, a work that included strewn litter and the contemptuous slogan "Littering is the product of a sick mind" and that climaxed in a game of Ping-Pong. This was one of Borofsky's most masterly displays of anarchic intelligence ever. But more apropos was the show of 1983

Figure 20. Jonathan Borofsky, Installation, Paula Cooper Gallery, New York. October 18–November 15, 1980. Photograph by Geoffrey Clements, courtesy of Paula Cooper Gallery, New York.

that was presided over by a giant clown/ballerina and that was awash in the embarrassing bathos of local carnivals. Comprised of canvases that were both hung on the wall and free-standing, as well as of sculpture and drawing in willfully impure hybrids, this installation first seemed to want to establish an ingratiating homage to amateurism. Harmless enough at first glance, it nevertheless revealed the not-so-innocent carnival of art that was being so avidly produced in the late twentieth century: documentary photography, feminist exposés of advertising, Neo-Expressionist paintings, postmodern appropriation of images, and – through his perpetually motorized clown – performance art.

If Borofsky's Neo-Expressionist canvases are not as psychologically compelling as his dream paintings were, it is because – as done with this installation – he wanted to produce a sign in the mode of this style. The impact of the motorized clown installation indeed hinged on being filled with stock types of art, each faced by the stock

critical response which the Chattering Men's grinding mouths supply.

Intellectually, the motorized clown installation was pat, as polemics typically is, and it exposed Borofsky's weakest flank: forming a mature intellectual statement by rational means. Yet by rendering each stock artistic idiom in the fretful eccentricity of his own style, he managed to put the burden of intellectual glibness back onto the shoulders of the individual artist. As the mouths ground away and the cassette tapes sang their silly songs, so Borofsky's menagerie of art styles strutted pathetically within the semiconscious terror that haunts the artist when doing art – alone.

The strength of Borofsky's work is in its insistent, exasperating edginess – an edginess that is fashioned from cultural overload. It is in this realm of personal uncertainty that he remains authoritative.

FOOD FOR CENTAURS (TOM NOZKOWSKI)

Whereas many painters profess a return to content, few realize this project as anything more than a return to subject matter, the dreary recapitulation of appearances of which, it is alleged, an image comes into being. An image, however, is not an object; the image is rather more like Pound's "mental event thrown upon the mind."

An uproarious exception to this literally construed image may be found in the oeuvre of Tom Nozkowski, who has for the last fifteen years unleashed upon the world his mania for the vexed silhouette. Usually pinned in the center of a canvas board is a flat shape that the artist has worked arduously and taken to the mat. Through a process of revision that is often long and deliberately tortuous, an adventure that often includes superimposing an incompatible silhouette over the first or inscribing it with spatial torque and wresting cohesiveness – or at least détente – from the struggle, the image emerges, abstract and eluding known categories. This is so despite Nozkowski's resistance to applying the term "abstraction" to his art – "because," as he told me, "my art is about things seen, read, or done that exist in some way in the real world." Thus abstraction is resisted, the artist might well protest, given that the source of his art is neither ideational nor indefinite but found, for instance, in the specific visual response to architectural drawings – or has been

provoked to counter the notion (believed by his mentor and friend, the sculptor Ruth Vollmer) that ideal geometry is a kind of truth.

Empirical experience, then, locates Nozkowski's penchant for the geomorphic curiosities that comprise the sort of world most real to him. Beyond this justification is the artist's sense of reality. Thanks to his deep skepticism toward generalization and his allergic reaction to theoretical text and agenda, Nozkowski puts as much distance as he can between his art and intellection.

Idiosyncrasy is Nozkowski's most comfortable mode. Utterly banished from the art is anything that might appeal to the corporate mind (see Figure 21). The svelte and unruffled surfaces of painting so often seen today will not be found in this artist's work; and if a painting is finished before it's resolved, that finish is destroyed and destroyed again until the image emerges satisfactorily. (As a result canvases from 1975 are still in the hopper despite the fact that others begun well after this time reached completion long ago.) From

Figure 21. Thomas Nozkowski, *Untitled* (4–91). 1984. Oil on canvasboard, 16 × 20 inches. Collection Emily Fisher Landau, New York.

among a bunch of works prompted by reading about "Tun-huang" – certain eighth-century Buddhist cave paintings, the meanings of which were lost and then reinterpreted by monks centuries later – emerged an image that, according to Nozkowski, inadvertently recapitulates the process of meaning lost and found over time. Although suffering is not the aim, Nozkowski's procedure does share with that of the Abstract Expressionists a commitment to visceral process that is sustained until the content of the (often) surrealistic image becomes inevitably elusive. Merchandising plays no part in these epiphanies nattered into being.

Furthermore, because forms that derive from universalizing principles suggestive of high art are suspect, the regularity that inheres in simple geometric figures is kept at bay. Other than decidedly lumpen, doggedly made circles, as well as rectilinear shish kebabs unearthed in Flatland, geometric elements appear something like the dross of light manufacturing formerly found on the cobbled streets of Soho – templates in negative, perhaps from leather key cases once die-cut and dumped to dribble out of bales at day's end. However Nozkowski's bollixed silhouettes seem nonideological in the extreme, they nonetheless reveal intellectual links with ideological critical theory sportively defended now in many quarters: A distrust of the grand theme and the big idea is steadfastly maintained in Nozkowski's improvised scheme of things. In effect, what is revealed is a stubborn skepticism toward abstraction as a rational institution. In contrast to the norms imposed on modernist picture-making, Nozkowski's art insists on just the peculiarity – meaning both the particular and the curious – that was formerly rejected out of hand. Even by the Romantic interpretation of modernism, which draws on an historical plot that justifies the principle of individuality, the curios born of willful obstreperousness that Nozkowski proffers might seem beside the point. Nevertheless, the undermining of abstraction as an institution pervades his image. In Nozkowski's hands the image is anti-establishment with a vengeance, and it may be said to support the idea of an emancipatory art.

Eccentricity in this work, then, is symptomatic of an ongoing stylistic rebelliousness and cultural orneriness. Yet as the ten-year survey of his work at Beaver College (September 16–October 27, 1991) and of the more recent art at Max Protetch prove, it's the coherence of this stance that prevails despite apparent visual differences from work to work. Further coherence is obtained through fixity of format, placement, and gestalt. Absent is the mere consis-

tency of most art shows these days, which are stocked predictably with identical items turned out in small, medium, and large. Present here is the perversity of choosing canvases identical in format and size (the size of a drawing pad, 16 × 20 inches), all harboring a single – and singular – painterly abnormality that is suspended against an inchoate yet sensitized field. Color that is intuitive, not intellectual, is decidedly freewheeling, as a palette shifts reference rather than modulates tastefully within a fixed spectrum. Yet the morphology of the floating image remains fairly constant. The motivation may be toward anarchy, yet the creative undertaking centers on bringing the freakish and the free into line through good-natured chastisement. The earlier work may be intuited, the latter work a rationalized version of instinct, yet altogether, stylistic coherence manifests itself through the extremes of fixity and freedom bound together.

If tormenting a silhouette reveals Nozkowski's drive toward the deflation of noble forms, it also reveals a drive that positively wills a way to unique abstract imaginings. Despite the artist's disclaimer about abstraction, impressive, both first and last, is his consistent urge toward metaphor. In contrast to what once was called New Image painting, the art Nozkowski brings about is not a simplistic act of stylized representation made to serve as abstraction but rather a process of intensive labor that substitutes unknown ingredients for known ones, resulting in a gastronomic entity to be named later – a metaphoric je ne sais quoi wherein the content of art is situated firmly and very concretely yet is utterly transformed. Noskowski recalls being impressed by Robert Graves's book of essays *Food for Centaurs*; in that book Graves tells of Alexander Pope's defense of poetry for posing questions for which there are no answers, but he rejects that position, claiming instead that the the truth is very different: Poetry poses questions which it answers imaginatively all the time. Centrally placed and floating against an indeterminate ground, the vivid and savory silhouettes that Nozkowski presents are like "food for centaurs." Imagine Picasso stuffing dumplings to tempt our palate. . . This would not be cuisinely cooking, to be sure. Grisly, unidentifiable bits – or even "naughty bits," in the words of Monty Python – put Nozkowski's images in league with primitivistic tropes. With an early modernism as his basic inheritance and with the semantic sweep through Cubism, Surrealism, and beyond, Nozkowski's bonanza of tropes counts among the few truly abstract marvels currently to be found in the art world.

STYLE MAKES THE MARK
(JONATHAN LASKER)

Style as a concept in art history has little in common with style in the media. In art history style is a culturally embedded form; media "styling," when not merely flair, connotes angle or attitude. As when a song stylist impersonates a standard rendition, so too art stylists skim off phenomenal appearances of art for impromptu visual pleasantries that entail little cultural memory.

For Jonathan Lasker, however, styling is camouflage for style. Pretending to be merchandise sporting attitude, his work betrays by its styling a savvy historical concern for that essential instrumentality of style: the mark.

<center>∗</center>

The mark of recent art-historical privilege is the calligraphic gesture born of Abstract Expressionism. It is not too much to say that in Jackson Pollock's or in Willem de Kooning's hands, the seismic mark defined and articulated a culturally embedded form. Drawing liberated from description and smears rescued from paraphrase embodied a creative process that was difficult to originate yet deceptively easy to copy. Indeed, an Abstract Expressionist style sprung up by the late 1950s, because, as the Romantic poet Samuel Taylor Coleridge might have said, artists were then imitating appearances, not principle.

Then there is the linguistic grip of gesture once it surfaces as code. Crucial to the history of style because profoundly strategic, Robert Rauschenberg's *Factum I* and *Factum II* (1957) put forth twinned drips on canvases that also featured duplicate pasted newspaper images, and in doing so – in doubling the gesture of spontaneity – Rauschenberg raised the issue of resemblance in an aesthetic committed to uniqueness. In re-creating accident, Rauschenberg wondered in effect, "How does presentation alter through representation?" Despite the artist's stated intention (Rauschenberg insists that he wished that his painted doublet of a drip would reveal the irreducibility of difference), his semantics of similarity revealed gesture to be vulnerable to imitation and pedagogy. The accidental drip or urgent brushstroke once signifying individual expression now yielded a pedagogy of the same thing – a kind of school of calligraphy having set in.

Roy Lichtenstein's strong misreading of Rauschenberg's probing

of Pollock's style has found a home in Lasker's translation of a private expression into public pedagogy (*Standards of Expression* [1989]). Given that a standard of expression is a figure of speech compounding criteria with norms, style that is epitomized may have settled into second-hand reduction: This at any rate is the assumption. The Pop Art reception of Abstract Expressionism indeed assumes that an application of standards enforces a routine view of matters – and certainly the stencil that Lichtenstein typically employed in his manufacture of the brushstroke in the 1960s calculated that sense of standards exactly. But whereas Lichtenstein wielded a stencil of the gesture, Lasker prefers his "standards" to be hand-painted in order to reassimilate generic and mechanical technique into the manual. Culturally, too, Lasker's standardized gesture is proof of a complicated semiotics that has worked on the gesture as received idea. The hand-painted *sign* of the mark can actually and adequately notate a codified style that is stylized via the nondescript and narcoleptic public media.

In any number of Lasker's paintings, uniformity of the mark suggests Lichtenstein's early image of a ball of string unraveled from figure into field. Or, rather, the graphic notation for the string's shadow has reached its full insubstantial extension across Lasker's painted surfaces insofar as it is physically sealed and psychically impervious to expressivity (*Cosmic Self-Evidence* [1989]) (see Figure 22). Feigning obliviousness to the implications of style, Lasker's sign of the mark nonetheless counterfeits the stylistically burdened gesture as scrupulously as possible. Pollock through Lichtenstein, as Lasker tells it, the automatic drawing in columns or boxes manifests an automated accumulation that mimics the syntax of bookkeeping, in which only quantitative, not qualitative, notations register (*Invective Decor* [1990]).

Looking back over his career so far, we can say that Lasker's decision to differentiate material from graphic aspects helped clarify his semiological purpose. In the early 1980s, with canvases pastily thick, the gawky stuff of pigment emphatic throughout, his paintings tried out a neoprimitive art moderne (*The Trophies* [1983]; *Cave Painting* [1984]), showing solidarity with the then-widespread artistic resistance to high modernism. Then, retaining thick paint for the topmost layer, Lasker reduced, compressed, and quarantined physicality; and his dissociated historicism of art moderne assumed a conceptual aspect: The sign for painting and the sign for drawing are established through the isolation of material from graphic impulses.

Figure 22. Jonathan Lasker, *Cosmic Self-Evidence*. 1989. Oil on canvas, 100 × 135 inches. Courtesy of Sammlung Goetz.

Meanwhile, because oil sketches are where he works out his ideas, Lasker's preliminary studies for paintings revealed that polarizing tactics worked well. In these studies, the emergence of the sign for painting in harlequinade stuffs, excessively marked in both color and physicality, promotes the slang of painting as distinct from that of drawing. A lexicon of form arises from what Roland Barthes once called "the segmentation of content"[5] – and with that dissociated vocabulary, a commedia dell'arte of style.

Translating Abstract Expressionism into a set of visual givens by means of carnivalesque counterfeit now enables what was once gesture to keep pace with shifts in cultural intention.

BODY'S SURPLUS (DAVID REED)

A living figure, grown
Largest wherever rock has grown most small.

Just so, sometimes, good actions
For the trembling soul
Are hidden by its own body's surplus, . . .
Michelangelo, *Rime* 152

What if a brush dragged along canvas, a brush that was to be lifted once the load of paint had exhausted itself, became unstoppable? And what if in its wake, an ever-renewing ribbon swirling across space, compounded by standing waves of another, superimposed, ribbon of paint, spread out? What if, in other words, in place of the natural material constraints of the brush there appeared licentious limitlessness?

This is exactly what has happened to the art of David Reed – or, rather, what Reed has allowed himself. After a decade of lean painting, in a practice that emulated the profound and reductive approaches of Robert Ryman, in the early 1980s Reed underwent an aesthetic conversion to "fat" matter and process; rich and hyperbolic, his once procedurally driven painting is entirely recast.

<p style="text-align:center">✳</p>

Reed's early brushstrokes displayed their material integrity. Because the physical nature of paint deposited through a single brushstroke was exactly commensurate with the meaning of this brushstroke, the act of painting bore a decided iconic relation to itself. The origin of the stroke coincided with the initial contact of brush to canvas, the coagulated red or green of that contact remaining intact as it was set down. To follow the course of the brushstroke, to watch the paint draining through bristles, was, of course, to apprehend the phenomenon of beginnings, middles, and ends in physical self-sufficiency. The brushstroke, then, spelled out the mechanics of the nature of liquidity.

The immediate context for this approach to painting was the transition from the Minimalism of gestalt to the minimalism of procedure. The simple, deliberate, repetitive laying down of one brushstroke after another in the manner of Ryman's covering a small unprimed canvas laterally in white, the brush entirely instrumental in governing the unit of paint laid down, or of Carl Andre's placing copper squares side by side on the floor to form a grid, or of Jackie Winsor's hammering nails into a wooden beam to exhibit the studded results – these workmanlike actions superseded the "action painting" of the late 1960s and early 1970s, and David Reed partic-

ipated in this concrete aesthetic in which materials and procedures of making were launched.

<p style="text-align:center">✳</p>

In contrast to this severe self-evidence of materials, Reed's recent paintings indulge a theatrical sleight-of-hand. Here is a thoroughgoing change from an aesthetic of the quotidian to an aesthetic of spectacle. As before, Reed's preference is for supports of extreme proportions, but now these wide, narrow canvases serve to crop a field of compound painterliness rather than to provide a neutrally appropriate frame for the exhibition of a brushstroke. Although gesture is uniform, scale is made strange through montage of rhythm and hue. In *No. 229* (1986), for instance, a kind of salmon bisque strip in regular folds interrupts an indigo-into-black field set flashing by a pale citron corner. In *No. 275* (1989), a spatula swept through alkyd pigment, working wet-in-wet and swirling gold through black, provides a writhing ground for a similar sweep in chartreuse – which, in turn, provides a platform for a single yellow brushstroke (see Figure 23).

Like Baroque drapery animated yet suspended in a kind of lethargic excitement of momentous occasion, Reed's brushstrokes half enact, half depict the action they are meant to display. This calligraphic taffeta introduces a complexity of rhetoric – more accurately, a conflation of rhetoric – that Reed hadn't risked before. The modernist loyalty to the medium and the specific adherence to the brushstroke as self-sufficient are here combined with a postmodern historicism of style.

Reed is, moreover, studiously working out a vocabulary of illogic that might organically proceed from the self-conscious attention paid to the painterly brushstroke. That is why his art seems to expand on the integrity of the brushstroke even as hyperbolic illusionism achieved by wielding spatulas could be said to be in patent violation of this integrity. The perfect vehicle for extending the materiality of the brushwork beyond its functional clothing of torso and limbs, drapery – especially according to the conventions of the Baroque era – enacts a flight into emotional life independent of the figure swathed in it. Whereas in the Renaissance, Gabriel's clothing, rushing upward in a wake behind the descending messenger, enacts the excited urgency of Mary's pregnancy and fate, in the Baroque era cloth itself is impregnated with vitality and heft. Drapery bulks out; it materializes space. Reed's canvases have taken all of this into account. His

Figure 23. David Reed, *No. 275* (detail). 1989. Oil and alkyd on linen, 26 ×
102 inches. Photograph by Dennis Cowley, courtesy of the Max Protetch
Gallery.

currently fleshed-out strokes, mediating between the calligraphic
brush to which Abstract Expressionism has accustomed us and Ba-
roque drapery's palpable yet arbitrarily animated exuberance, create
a disembodied embodiment of this stuff. The substantial transpar-
ency of his pigment plays up the paradoxes, furthermore, of this
sliding scale of stylistic referentiality. Although Michelangelesque

theory viewed painting as additive at the same time that it viewed sculptural carving by nature as subtractive, Reed has sought to create an effect of subtractive painting of brilliant strokes carved away by the dark ground. The individuality of Reed's painting, then, lies in his reinterpretation of the New York School's formalism as a species of Baroque action at once overextended and undercut.

Like Frank Stella yet independent of him, Reed finds the Italian Baroque painters to be inspiring in their energetic piling up of forms in space. In the Norton Lectures given at Harvard in 1983 and 1984, Stella flaunted his recently acquired enthusiasm for Caravaggio's deep space, which helped him justify his own extravagant decorative overload in his current relief paintings. Proceeding progressively from the interlace of complex virtual space to the constructed relief incorporating actual space, Stella has hoped to install a logic of decoration by which to retain his position as a modernist; and to the extent that his art is a strategy of the decorative, he may indeed succeed. Retaining reference to actual brushstroke in his current opera of illusionism has enabled Reed, meanwhile, to locate a more convincing way of justifying his embrace of a set of terms apparently antithetical to the straitened, formalist vernacular from which his generation emerged.

Once when Reed and I were in Soho looking at gallery shows, we stopped at the Paula Cooper Gallery, which then had on view small – and compressed – polychrome constructivist reliefs. Reed, containing his distress, asked, "Do they seem to you arbitrary or inevitable?" "Both," I said. Since then, Reed's own art has welcomed into its domain the principle of arbitrariness. But at the same time, the cohesiveness governing the principle by which the brushstroke assumes its historicizing mantle seems inevitable as well.

13

Contesting Leisure
Alex Katz and Eric Fischl

Both Alex Katz and Eric Fischl dwell on the world of leisure in the postwar era. But the attitudes of the two artists toward these homes and vacation spots and toward their inhabitants diverge sharply. When Fischl's works from 1979 to 1985 are seen in tandem with Alex Katz's from 1950 to 1985, Fischl assumes the role of a kid brother teasing his older sibling in an attempt to antagonize him; viewing selected works of the two artists together allows one to glimpse what might be described as a strong rivalry of values behind their shared figuration.[1] (See Figures 24 and 25.)

In reaction to the extraordinary situation central to Abstract Expressionism, Katz developed a style of painting conspicuously centered on ordinariness. Like Fairfield Porter, from whom Katz learned much about neutrality, and like Frank O'Hara, who wrote poems about his lunch hour, Katz has thought seriously about the link between leisure, ordinariness, and the daily life celebrated by modernism. In modernism, the emphasis is on the medium, the materiality whereby paint, not flesh, engenders the world. But throughout his career, in contrast, for instance, to Willem de Kooning, who painted women as a pretext for fleshliness in paint, Katz – a major contributor to the post–Abstract Expressionist style – has devoted himself to expressing the neutrality of paint. Consequently, his work from 1950 to 1985 is spread with portraits one can barely identify as actual poets, painters, and art critics because of the deliberate physiognomic blandness and sheer size Katz has given them. These are portraits conceived as color-field panoramas.

In a certain sense Fischl paints as if Abstract Expressionism had not taken place. In Fischl's realistic pictures flesh is subject matter projected as literal nakedness and sex; for the most part, paint shifts for itself, reflecting transient stylistic influences. Perhaps the core of Fischl's art lies in vulgarity. In his work from 1979 to 1985, not only is the barbarism of sex present; so too is the obscenity of racism, which scares up as much fear, desire, and misunderstanding as sex does in our modern world. Blatant, obnoxious, trading in

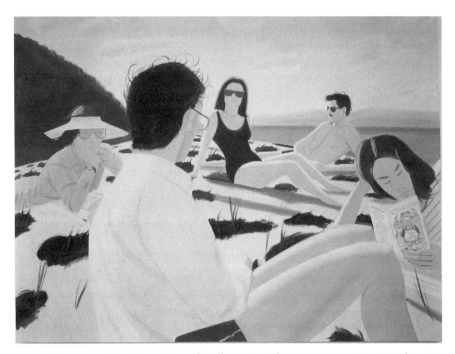

Figure 24. Alex Katz, *Round Hill.* 1977. Oil on canvas, 72 × 96 inches. ©
Alex Katz/Licensed by VAGA, New York. Courtesy of Marlborough Gallery,
New York.

innuendo, many Fischl paintings read like ethnic jokes on canvas.
To relate this world of frustrated, unconscious behavior to the lei-
sure of the 1950s – the decade of his boyhood – Fischl transforms
suburbia into a lurid soap opera, at once self-indulgent and emotion-
ally starved. It is the 1950s, perhaps, but seen as if the sensationalism
of the 1980s' Neo-Expressionism were retroactive.

The realism that Katz utilizes derives from a style concerned
more with medium than with subject. His stylistic sources lie most
immediately in Fairfield Porter, from whom he learned that paint is
both concrete and generic and that it is applied to canvas to locate,
not to describe, the scene before one. Location is the inevitable, not
the ineffable, topic of Katz's work. Although one can see that a
certain consciousness of shape is derived from Milton Avery, the
Romantic ineffability of light is rarely seen in Katz's work; rather,
he favors the Realism of opacity. More than any other phase of his
career, the early paintings manifest this opacity and ordinariness.

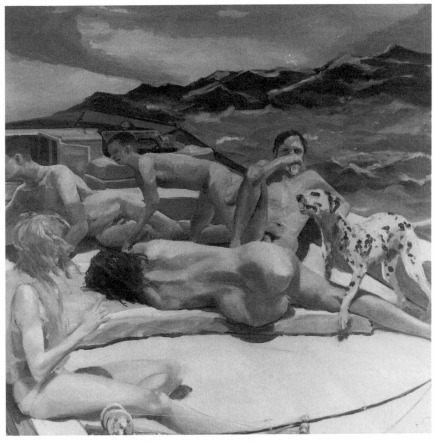

Figure 25. Eric Fischl, *The Old Man's Boat and the Old Man's Dog.* 1982. Oil on canvas, 84 × 84 inches. Photograph by Zindman/Fremont, courtesy Mary Boone Gallery, New York.

Plugged into the center of these smallish easel paintings is a single figure – or a pair seen as a unit – who is standing, not at rest but optically flat, stiff, affixed to the page as a postage stamp to an envelope. Many of Katz's papiers collés and wood and aluminum cutouts reinforce his deemphasis on personality by emphasizing the opacity and the subtle anxiety of the medium. Derived from the awkward dolls which Manet (after Velásquez) contrived from real life, these single figures pay further homage to Manet through their location: distanced in the middle ground, surrounded by paint that ambiguously and not very convincingly delineates studio or land-

scape – or an uneasy amalgam of both. Later canvases are more beautiful but not more significant. In the early work we see Katz arrive at a formula for the weight of the figure – its size, its location – that will establish the aesthetic of middle distance. It is a formula that he will maintain throughout his career no matter what the actual size of the figures.

With Fischl, realism is patently tied to social issues and to expedient psychological storytelling. Fischl came to attention in 1981 with his notorious *Bad Boy* (1981): As a woman sleeps, exposing if not presenting her genitalia, a boy stealthily takes money from her purse. Naughty subject matter combines with studio Realism to capture the attention of the public. *Bad Boy* was Fischl's accessible entry into the realm of the more challenging, if more problematic, "bad painting" pursued by a diversity of artists at the time. But he was also painting beach scenes in a coarse, libidinous manner reminiscent of the Ashcan School, especially its Fourteenth-Street division (as represented by Reginald Marsh). Recall the jostle of Marsh's shoppers and beach-bathers signaling to us with their inadvertent sexuality, the vulnerability lurking within violent glances, the other signs of social uneasiness, and you have some of the same sensational matter of the human circus that Fischl is after in his 1950s period pieces.

Edward Hopper, too, figures prominently as a source of subject and style for Fischl. To my mind, the ready reception of Fischl's paintings had been prepared at least as much by the return to the life and truth of American Scene painting as by the narratives of exploitation of David Salle, Robert Longo, Nicholas Africano, and Ida Applebroog.

<p style="text-align:center">✳</p>

Ultimately, Katz and Fischl are as different as the paradigms of the medium and of the self. These are the positions held by their advocates, Robert Rosenblum and Donald Kuspit, authors of the catalogue essays on Katz and Fischl, respectively.[2] Concluding his essay on Katz, Rosenblum writes,

What may finally be most remarkable about Katz's achievement is the way in which he has taken the stuff of daily living and loving we thought suitable only for an uneventful diary entry and transferred it, without manifesto, to the grand-scale arena of American monumental painting today.[3]

Contrast this with what Kuspit writes on Fischl:

Fischl's pictures are about the failure even of bohemian, punk, or whatever culture to offer an adequate support system for the individual suffering from a narcissistic feeling of helplessness, worthlessness, or sheer uncertainty of self.[4]

These statements represent a major antagonism within the idea of the modern.

For Rosenblum, the eventlessness of our lives transferred into the eventfulness of the medium remains central to our notion of modern art. Finally, it is not leisure but the sufficiency of doing nothing that comes to prevail in the paintings of Alex Katz. Nothing picturesque is offered to hold our interest. As with amateur snapshots, painted close-ups of people we do know only underscore the flatness (uneventfulness, neutrality) of the scenic view in the background that ostensibly inspired this picture in the first place. When Katz's paintings are effective, as in *Self-Portrait with Sunglasses* (1969), they succeed in holding our attention even as they eliminate interesting sights to see.

Parenthetically, Katz is by no means the only one of his contemporaries to employ the device of sunglasses as a way to insist that we attend to the impersonality of his subject. In a 1966 production of Stravinsky's oratorio *Oedipus Rex*, the set and costume designer Larry Rivers placed the chorus on bleachers, a perch from which they commented on the drama clad in T-shirts and with sunglasses entirely masking their eyes – or, rather, both enlarging the eyes and rendering them grandly impersonal as masks do. As shown by Rivers, impersonality is employed for symbolic ends, the sunglasses urging that we take notice of this archetypal crowd of witnesses. As rendered by Katz here, the impersonality of the medium leads us not to indifference but to a Kantian disinterestedness that takes note of an imposing, if not intimidating, aesthetic surface. When Katz's small figures grow large, entirely filling the canvas with their heads, what has taken place is the *confirmation of the ordinary*. I believe Rosenblum implies this sense when he speaks of the monumentality of Katz's larger-than-life compositions.

In Kuspit's view of Fischl, however, a culture aimed at shoring up the self is inadequate, puny compared with humanity's psychological turmoil. Even our so-called neutral acts of perception, wherever "transgressive of expectations," are "morbidly fascinating

[and] voyeuristically engaging."⁵ That is to say, even matter-of-fact realism carries a psychological valence. In Fischl's *Time for Bed* (1980), the postures we assume may echo African sculpture in form, but the content is of our unfulfilled – and thus, in some real way more fascinating – selves. Kuspit interprets the vulgarity of Fischl's pictures as a measure of the self under siege. In an interpretive catalogue essay on Fischl, Jean-Christophe Ammann focuses on a consideration of puberty; in contrast props and roles, and how to interpret them, are the subject of another essay, this one by Bruce W. Ferguson.⁶

If *Time for Bed* seeks to demonstrate that our vulgarity is a primitive force truly more compelling than the sublimated sculptural form that art takes, Fischl's *A Brief History of North Africa* (1985) brings fascination with the primitive self up to date. On a beach, ostensibly in the context of a game of riding on shoulders, white and black figures stack up powerfully, if uneasily, to form a totem pole which opposes an elongated figure apparently swathed in a beach towel so that only the head is showing. Really a disembodied head atop a towel, this spectral figure is counterpoised by the first set of figures, who are also not what they seem – they form a totem pole only by virtue of the illusion of an imagined viewer sitting on the sand. Subjectivity is thus introduced from within an objective situation; perception is an investment in point of view. What this exposes is our own irrationality, the irrationality that informs our notion of the primitive and is inextricably attached to it – the term "attached" meaning "fond of" it. Fischl's fondness for painterliness in his current work may be his way of showing he can compete on a technical level with European artists. (Where his academic Realism exposes anatomical ineptness, Fischl's expressionist realism postpones the issue of technique by virtue of the fact that its more rudimentary means greatly enhances the emotional punch of the work.) But it is also meant to entice us – to engender our own fondness for taboo subject matter – just as Lovis Corinth (whose painterliness Fischl's *Africa* recalls) entices us with the head of Salomé through painterly seduction.

∗

To what extent are Katz and Fischl exemplary of the paradigms of medium and self? In his 1979–85 works, Fischl, gaining painterly confidence and with catch-up technique, was also still locating his

subject matter. He was not as committed to the psychological con-
tent of the self as he was to tracking the then-current debate on
primitivism within the art world. If not in art exhibitions, then in
some art magazines, primitivism had been called on the carpet as the
palliative of modernists. Prompted by the Museum of Modern Art's
1984 display of African, Native American, Melanesian, and Micro-
nesian tribal objects[7] that were paired with early modernist art from
Europe and contemporary works influenced or inspired by these
Third World artifacts, art critics challenged curators to a highly
partisan debate. Conducted in *Artforum* and *Art in America*, this
debate was one of the highlights of the 1984 season, and although it
told us much about the shift in cultural trends, it clearly laid bare
the cultural assumptions of the proponents of both content and
form. With the basic premise of form and medium severely ques-
tioned, it was not hard to tell which cultural perspective had
currency. So if the paintings of Fischl from that period possess
topicality, it is in large measure owing to the artist's shrewd handling
of the issue of primitivism and of its relation to the libidinous self
that is frustrated both in bed and on the political stage.

Katz's early work is tough and important. It penetrates the mean-
ing of the medium in a way that is authoritative even as it remains
outside the prevailing abstract practice. In his later work from the
1970s on, the intention changes, and what was once careful adjust-
ment of the notion of the medium shifts to design and, all too often,
to an embrace of its fashionable forms. Symptomatic is his use of
pattern. The rhythmic pattern of limbs in *Private Domains* (1969) is
exemplary, one of the very best canvases Katz has produced. It is at
once a group portrait of the Paul Taylor Dance Company and a
forest of limbs in vertical near-repetition whose tense design is en-
tirely distant from stylishness. In later paintings, such as the multi-
paneled *Pas de Deux* (1983), movement is a function of decor – the
decor of patterned, modish clothing. Pattern, not weak in itself, here
trivializes the rhythmic structure that is Katz's concern. His intention
clearly is to impart balletic structure to the quotidian world of heads,
hands, hair, and clothes with as much consequence as he can man-
age. He has allowed the idiosyncrasies of costume to substitute for
the richness of formal rhythm extended across space; but only when
he neutralizes some of the interesting fashion and metes out his
rhythmic changes as infrequently as he does in the simple group
portraits will the ordinariness of rhythm become momentous.

＊

Schematically stated, we can say that the paradigm of the medium presupposes that life is inadequate to art; whereas the paradigm of the self holds that art is inadequate to life. Surveying the paintings of Katz and Fischl together, one can see how figurative painting that is similar in subject matter and locale can diverge enormously in content – that is, in the meaning that its figures readily enact.

But in Katz and in Fischl, the armed camps of the medium and the self are not so staunch after all. Although the medium is certainly the province of Katz, the self is not absent; it is indeed present, if only through the tradition of portraiture in which an individual calls to us through his or her heroic types. Fischl, on the other hand, though he trades in the psychological implications of nakedness, finally may be less psychological than playing at transgression; there may well be aesthetic irony, not agonistic struggle, in the figural juxtapositions rampant in his paintings.

These cross-overs of meaning notwithstanding, a coupling of Katz's and Fischl's works sets the defense of the medium against the defense of the self; and at this moment, nothing could be more pertinent.

Ideas of Order

14

Indeterminacy Meets Encyclopedia

Kestutis Zapkus

Indeterminacy, an ancient idea that abounds in potentialities for modernity, translates subatomic uncertainty into potentialities manifesting stylistic order. The physics of particles changing their positions in space and time has prompted metaphors realizing the various possibilities inherent in a visual structure, and it has done so in styles which suggest that no definite or single solution will exhaust the legitimate implications of the structure.

Cubist aesthetics, for instance, centers on such spatially indeterminate occurrences. Cubism is constituted in the spatial fluctuation of what remains of objects once they are analyzed into their essential aspects – all aspects relating to the canvas's frontal plane. No fixed viewpoint and no precisely measurable position describes an object; rather, constitutive relations, subject to interpretation and reinterpretation, embed epistemological approximations. Once the notation for natural space becomes that of purely abstract constellations of formal relations, then the deep cultural configuration that art historians call style can be said to have changed, and from Cubism, Suprematism, De Stijl, and the Minimalist modes of ordering, the grid thereafter comes into play. Modernity presupposes the cumulative history of orders and the necessity of taking indeterminacy into account.

The art of Kes Zapkus orders visual space in exact uncertainty. This Lithuanian-born American citizen of the world came of artistic age presupposing the certitude of atomic point, line, and plane. Early in the 1950s – yet after his ambitious modified Cubo-Suprematist restatement of Baroque masterworks – a kind of virtual kinetics characterized the abstract incident. Environmental in scale relative to the viewer – a grid to indicate exact *positions* albeit relative *relations* – these works revealed a space suggesting the potentiality of unstable, incessant change.

By the late 1960s, the proportion in Zapkus's work alternates between fixed and free structure, with planes reduced to infinitesimal size, in order to agitate the otherwise stable homogeneity of hue in

his color-field painting. Then in the late 1970s, a period of journalist incident embeds the abstract field: Stylistic cataclysm takes over, and grids become one of many formal relics within a supercharged expressive montage of styles. By the mid-1980s, all phases combine in a stylistic synthesis and consolidation. Shifting angles, scales, and viewpoint proliferate and pile up.

Peculiar to the aesthetic of Zapkus is the crowding of contingency in his work. Philosophically, contingency is that sort of indeterminacy that settles on accident and the unpredicted event that is happening yet seized upon. Contingency entails choice, not foregone conclusion. It posits an empirical, not logical, reality for which no one solution necessarily completes circumstances, however it might condition them. Poetically, contingency is that sort of indeterminacy that lends cosmopolitan agitation to modern life – or so thought Baudelaire, who wrote, "Modernity is the transitory, the fugitive, the contingent, the half of art of which the other half is the eternal and the immutable."[1]

Indeterminacy at great pitch, then, characterizes an oeuvre for which the work-in-progress is the goal. Here is another sense of Zapkus's aesthetic that is now accounted for: the fascination with – indeed, the commitment to – the inconclusive, necessarily imperfect knowledge of the world, the encyclopedia rather than the *summa*.[2] James Joyce, whose writings Zapkus admires, makes exemplary use of the paradigm of encyclopedia: Bloom's peripatetic adventures in *Ulysses* provide him with a complex yet accumulated knowledge – and a knowledge subject to conditional encounters and digressions creates a form of august deferral and open-endedness toward outcomes.

In Zapkus's large canvases, inclusiveness rather than comprehensiveness characterizes his encyclopedic visual knowledge. They are informationally dense with planar and linear elements in combination; yet the incessantly imaginative practice compensates for the rational device of the grid. In consequence the entire visual field registers specificity – specificity of experience and vigilance, point by point. Inclusive because they absorb event and then transform event into visual knowledge, Zapkus's canvases suggest, as Henry James writes somewhere, "experience never limited, never complete."

Although the modern ideology that Zapkus has valued argues for a progressive vision of art, the practice – being worried, obsessive, and faithful to indeterminate complexity – puts the givens of abstraction into creative doubt. The complacency or certitude that

often attaches to reductive modernity is not tolerated in this aesthetic.

A century after Baudelaire noted the contingent nature of reality, Umberto Eco wrote his essay on the aesthetics of indeterminacy. In his view the unfinished work as an end in itself, as evinced by the encyclopedia, is paradigmatic of modern art and literature. Complexity and ambiguity, possibility and interpretive thought are integral to modernity. Although openness may be ascribed to artifacts throughout cultural history, Eco observes, modern art deliberately exploits this value and converts it into an aesthetic field of possibilities. Preoccupied with the unfolding of indeterminacy in the maturing poetics of James Joyce – an indeterminacy that necessitated engaged interpretation by the reader – Eco wrote the lengthy essay that became *The Open Work*,[3] which he published in 1962.

*

Inclusiveness on a grand scale had entered Zapkus's art early. Recalling his student days in the late 1950s, the artist remembers being filled with ambition for the art he had hoped to do himself because

the school [the Art Institute of Chicago] was in a museum, and to get to class you had to go through it, which means past Poussin, Titian, Veronese, Vermeer, *La Grand Jatte* – the works. I was very interested in what was sometimes called "the grand tradition" in painting. . . . [which means] very ambitious painting. In the past, of course, it meant many figures – a multi-figure composition.[4]

The greater the potential interaction of parts, the better. For Zapkus complexity brings with it a richness of visual conception, and, indeed, the compositions which brought him attention early in the 1960s are richly tectonic. A photograph accompanying an article by Franz Schulze in the journal *Lituanus* shows Zapkus posing in front of *Two Half Circles* (1962), a piece of planar virtuosity set in a compound format as grandly orchestrated as a religious altarpiece or a socialist tribute to the apotheosis of labor. Having admired the compositional ambition of Michelangelo's Sistine Chapel ceiling, Zapkus, at twenty-four, was evidently capable of imagining its abstract counterpart.

Sixty-part Fugue (1964) reflects Zapkus's visual experience in Paris, where he had lived on a travel grant that he had won in 1960. Bright planes proceed across a field becoming endlessly trans-

latable, and their Cubist repositioning demonstrates that no single perspective or foundational order has a permanent hold on all the relationships; in lieu of system, an endless sequence of alternative choices establishing provisional "solutions" composes the field.

All this destabilization is taking place at the expense of a static, unyielding system. As against traditional academic painting that is rendered from preparatory cartoons, Zapkus's grid, thoroughly integrated into the composition, supplies the modern composition with structural fixity that is antagonistic to the relatively more freely ordered mark and the improvisatory nature of *passage*. In just this way Zapkus will allow the regulatory force of the grid to enter as an order subject to modification.

Remarkable beyond this inclusive indeterminacy is the intensity of Zapkus's work. Like the art of Willem de Kooning, it presupposes a labor-intensive, open process – intensive because it is crammed with visual acuity. What is at stake is more than mere stamina, although that is amply demonstrated. Rather, neither early on nor more recently in his career does Zapkus ever abdicate responsibility for visual intelligence on a point-by-point basis. Indeed, he has said, "The 'presence' (Art Quotient) of much contemporary art is generally presence as object; in my work it is presence as articulation."

Or, as Umberto Eco wrote on Joyce,

This radical conversion from "meaning" as [the] content of an expression, to the form of the expression as meaning, is the direct consequence of the refusal and destruction of the traditional world in *Ulysses*. When a "lump" of experience is dominated by a univocal, stable vision of the world, it can be expressed by words that are explicit judgments on what is said. But when the material of experience assails us without possessing its interpretive framework – when we notice that the codes of interpretation can be different, more open, flexible, and full of possibilities, and yet we still don't have the key for using them – then experience *must show itself* directly in the word.[5]

The experience that shows itself in Zapkus's art is not, of course, centered in the *word*; nor does it drive the brushstroke, that smallest unit of meaning in Abstract Expressionism. It shows itself in the plane or, perhaps, in the microplane, shorn at an angle to introduce a diagonal Suprematist thrust or doubled back on itself as though to fuse multiple viewpoints within this transistorized form.

All in all, Zapkus assesses his own early intentions in art school

when, in *With Paint on Canvas*, a 1980 film about his art made by Jerry Gambone, he recalls that early ambition to bring out the "richness of Cubism."

*

It is curious to consider Zapkus's adaptation of serial orders once he returned to the United States from Paris in 1965. In this phase of his work, predetermined yet arbitrarily sequenced colors placed in strictly patterned cells propose an alliance with serial music.

At the time of his death in 1945, Arnold Schönberg's twelve-tone structure had inspired an even more thoroughgoing and normative plan for serial music. According to the radical implication of the thinking, not only pitch but also rhythm should be fixed (as his students John Cage, in the United States, and Pierre Boulez, in France, understood independently). Subsequently, music grew entirely serialized (or else entirely aleatory, as with Cage) – creativity being strategic, and radically so (see Figure 26).

The art confronting Zapkus in the United States when he returned deployed logical tactics (Sol LeWitt, Mel Bochner, Bruce Boice) or nonlogical yet predetermined series (Agnes Martin, Frank Stella) or the patterned implications of decoration, whether hard-edged or painterly. Zapkus resolved to distance himself from what he would later call "the conceptual game plan." If a prefabricated look seemed to control art's lyricism, doubtless this look derived from the postwar dissemination of information-processing technologies, which, among other programmed forms, already were producing light spectacles from Canada to Yugoslavia. Ever since Norbert Wiener had ushered in cybernetics in 1948, it had been understood that any network of events in time that develops through an order of any kind reveals the plausibly creative extension of the complex logic of organization; by the mid-1960s, a systems approach to art was commonplace. Although thoroughgoing self-regulating sets were rarely implemented in the art of that period, permutation and combination were the generative principles that frequently put the process of translation at odds with the traditional forms of transformation. In this sense series – that is, either repetition or simply derived succession – is antiformal, ergo conceptual. Among these last series is the sort of serial imagery that posits composition in terms of a predetermined spectrum or a continuum in simple expansion. "Serial imagery," then, is defined as

a style of repeated form or structure shared equally by each work. . . . Neither the number of works nor the similarity of theme in a given series determines whether a painting or sculpture is serial. Rather, series is identified by a particular interrelationship, rigorously consistent, of structure and syntax. . . . There are no boundaries implicit to Serial Imagery: its structures may be likened to continuums or constellations.[6]

But Zapkus, who trained to become a violinist before he settled on painting, has insisted on using "seriality" in its seminal musical sense. He writes,

I used the term ["seriality"] in my studio from 1965 on, regarding the work I was doing, to various studio visitors. An artist, writer and an organizer of *Systemic Painting* at the Solomon R. Guggenheim Museum in 1966 was one of the visitors in my studio. . . . If he got the term from me, he misinterpreted and misappropriated the term to imply works done as a series and of *some* components: like [Frank] Stella's "Protractor" series, his own group of plastic panels, or [David] Novros's L shapes. I remember arguing with him about the term because I was using it in the serial music – 12-tone row – sense. I was then forcing my visual material through systematic 12-sequence modes.[7]

An untitled painting from 1966 provides an example. In counterpoint to notched bands that are shaded gray-into-white is a diagonal array of multihued bands of augmented and diminished widths, bands that are exactly in the sequence of the twelve chromatic tones. In music there is an inherent antagonism between a polyphonic structure that is ordered and grounded through a key, on the one hand, and serial music that is arbitrarily yet exhaustively sequenced in registers of pitch, on the other – a conflict, by the way, that was noted disparagingly by the structuralist Claude Lévi-Strauss – for a variety of resolutions through differing interpretive interventions. In Zapkus's art, a polyphony of a sort is created by placing a gray scale against a nonchromatic sequence of hues. Zapkus says, "Everything, including *Blue Diptych* (1968) (the first silkscreened image for me), was oriented that [serial] way."[8]

Yet by 1972–73, Zapkus had adapted the modular unit of a bit of screen together with gesture – or rather, the rhetoric of these marks in literary reference – to photomechanical silkscreened images. Amiably cybernetic, this yoked pair of elements registers certain implications of serial thinking already being used in music (in his *Second Sonata* [1948], Boulez had atomized the series into rhythmic dyads, ignoring pitch).

Figure 26. Kes Zapkus, *Raceway*. 1976–77. Vinyl screen, acrylic, oil on canvas, 84 × 84 inches. Photograph by Geoffrey Clements, courtesy of Paula Cooper Gallery, New York.

"Rhythm . . . is the first formal esthetic relation of part to part in any esthetic whole or whole to its parts . . . ," says Stephen Dedalus in *A Portrait of the Artist as a Young Man*.[9] It was Joyce's desire, Umberto Eco contends, to express the aesthetic commonality between medieval and modern sensibilities. In music as well as in literature, medieval operational schemes underpin the modern interest in essential elements. (It is well known that operational games with serial rhythms, which Webern first wrote, matured with Schönberg after he had studied the rhythmic works of the Renaissance composer Heinrich Isaac.) Given Zapkus's musical past, it is no wonder that the idea of rhythm inspired his art at this time; even as

the phased rhythms of Minimalist music were in the air, Zapkus tended to produce art that preserved the analogy of musical series.[10] In this inflection of structure by means of rhythm, he sought to exploit an expression of "a stasis provoked, protracted, and dissolved" with what he calls the "rhythm of beauty,"[11] as Joyce might have said – that sort of animated stasis which is barely perceptible within a monochromatic field.

By the mid-1970s, this steady state of indeterminacy led to art that Zapkus played out phenomenologically. From the distance needed to take in the full extent of its thirty feet, the viewer finds that the prevailing sensation on seeing *Homage to H. M.* (1974–75) is that of gazing at pietist blankness. Only up close – so close that an atomized adjustment of marks renders the white panoramic field intelligible – can the viewer detect the uncertain machinations of the hand notating mark and screen against a penciled grid. A stasis provoked, protracted, and possibly enriched is decidedly the form that Zapkus has attempted here.[12] Polarizing the extremes of near and far visibility from works of art helps to create an internal scale of environmental dimension. The sense of indeterminacy, then, lies in the atomized minutiae which are seen up close but which are revealed to be integrally ephemeral from afar. It was at this time that phenomenally extreme art environments abounded with (as Frank Popper noted of the music of Boulez) "perpetually changing microstructure within a stable macrostructure";[13] and in such canvases as *Homage to H. M.*, Zapkus perfects the contest in such a polarized field. "Who anywhere will read these written words? Signs on a white field?"[14]

This he pursues without neglecting the formal aspect of art. Interviewed by Robert Sterns, then head of the Contemporary Art Center in Cincinnati on April 27, 1978, Zapkus commented,

Mondrian simplified, reduced, distilled representation – through his own personal evolutionary process – until he was satisfied that it wasn't referring to anything else except internal relationships. I think that his classical period was an attempt to feel comfortable with a purely visual language.

The ten-year retrospective of paintings prompting this statement shows Zapkus's passion for the modernist language of reduction, which is uncompromised by pictorial impulse. But his is the sort of De Stijl–like adaptation of visual necessities to the verities of indeterminacy: a brilliantly hued field excited by subtle, atomized contingencies. With Zapkus, who was seeking Pollock's information but was expressing it with Mondrian's clarity, essentialized relational

form is palpably decision-intensive. Characteristically interested in inclusiveness, Zapkus had created, by the end of the 1970s, a chromatic pointillism that also elaborated a range of facture (from hard-edge to brushy) and density (from translucent to opaque), while at the same time ensuring that the color too engages a range of reference (structural, optical, and decorative). "When is a painting finished?" Zapkus asks rhetorically. "When all the possibilities are exhausted."

This mania for exploiting structural possibilities served the artist well. By submitting to the discipline of permutational procedures, Zapkus increased his repertory of visual expression; and insofar as he acknowledged seriality as a special paradigm of thought, his art of indeterminacy only benefited. Nonhierarchical in the extreme, seriality augmented the possibilities inherent in atomized all-over space. Essentially different from tonality, the most illustrious music utilized seriality imaginatively as a language to engender music, not as an absolute orthodoxy. The use of increasingly operational procedures opened – rather than closed – an organizational depth. Similarly, Zapkus's imaginative heft gave his art high-quality rhythmic drive across its vast surfaces, surfaces that were excited fields of position and energy incarnate.

<p style="text-align:center">✳</p>

Indeterminacy meets encyclopedia in the politically inflected art of the decade that followed. By adopting the grid early on, Zapkus had already achieved a democratic disbursement of formal information across the surface of the canvas, but what he sought now was the figurative enrichment of this network.

Reflecting back on his own motivation for change, Zapkus recalls the initial phase. He says,

From the start, I have always wanted my work to be inspirational and reasonable on the humanistic level. At that time, it seemed to me that to add to the body of knowledge the semi-science of visual art was a worthy pursuit in itself. The implied purpose of that kind of contribution would have been to somehow elucidate, specify and enrich humanity's life experience. . . . I felt a tenderness towards the plight of the consciously human, wishing to help augment life experience rather than illustrate it, comment on it, or negate it. . . . Hence followed my involvement with a search for a visual form to parallel music.

This comment reflects an attempt to express beliefs about abstract art commonly held by generations of modernists. After completing a

magnum opus, *Traffic* (1974), Zapkus felt he had achieved all he wanted from intensively hermetic visual notation. Like many of his generation, he felt dissatisfied with public art and, at the same time, he wanted the public to attend to serious art. As Lucy Lippard writes in a 1982 article, after Zapkus had gone through a period of refining abstract notation, "Now he longed to share his experience. With a new, participatory motivation, he began to stress the importance of crossing barriers, communicating more directly through his art."[15]

Zapkus's art suddenly burgeoned with passages that were implicitly if not explicitly referential. Conventional wisdom has it that the more explicit and expressive art is, the more political it is; opposing this is the view that art is radically political only insofar as we banish reference to popular culture from it (after all, we do not tell our surgeons to lighten up because their knowledge and procedures are too obscure for common understanding). Prior to the 1980s, Zapkus had been acting on the assumption of the latter view: that the undertaking of art should be fully charged with serious knowledge and ability.

Abstract artists' participation in political actions is not a contradiction. To recall the 1960s is to acknowledge that, from the assassination of John F. Kennedy through the Vietnam War, politically aggravated violence helped to pressure the art community into acts of conscience. The Artworkers Coalition, for instance, in which Zapkus participated from 1969 to 1971, put political frustration to use in public actions that included antiwar demonstrations, protests in support of striking museum workers, and white papers on fair-use standards of art in museums and galleries.

Throughout the 1960s and 1970s, acts of conscience realized through radical experiment inspired some of the most worthy art, as the landmark 1967 exhibition *Arte Povera: Earthworks, Impossible Art, Actual Art, Conceptual Art* (organized and anthologized by Germano Celant, among others) amply demonstrated. Some of the works in that exhibition exemplified what Lippard would emphasize as the "dematerialization" of the medium in her well-known 1973 chronology (which itself remains a minor masterpiece, at once history and artifact).[16] It can be argued that even as the Situationist movement in Europe utilized popular culture for political protest and even as such organized actions in the United States took cognizance of the Situationist movement, a quietist form of resistance persisted in an art that was devoted to manifesting the indeterminate orders which were lodged in the use of certain materials and procedures.

Meanwhile, Zapkus was pursuing his own form of political consciousness-raising. With his own commitment to an aesthetic toughness and with abundant stamina for the long substantive haul, Zapkus, who often works on paintings for four to six months or longer, conducted his artistic affairs in a way that showed he was protesting against certain institutional practices in museums and galleries.

To renounce abstraction as trivial – or as somehow dispensable – must seem excruciatingly effete to those who do not have the luxury even of social debate. Yet Zapkus, whose career had so far remained staunchly political in this sense, became persuaded that doing abstraction was narcissistic. He writes,

That function for art appears self-serving and narcissistic to me now and not at all as generous, nourishing, and egalitarian vis-à-vis the quest for life's meaning. Curiously, J.F.K.'s example and leadership threw me into a realization that my country was not a place, nor a physical, nationalist, or ideological grouping, but humanity itself, in which I and all are bound by our common drive for life experience. Unfortunately, civilization does not uphold an existentialist point of view, and, even less [does it assure] every individual his right to life experience. Perversely, civilization has created elaborate control systems which give control wholly to some, partially to others, and . . . take control totally away from still others. I was astonished to understand that civilization is manipulative and exploitative: governments, ideologies, religions, organizations, sciences, arts, wealth, causes, history, fashions and schools all function to separate and distinguish people's needs and opportunities.

How was he to sustain allegiance to abstraction even as his art infiltrated that world with reference and allusion (see Figure 27)? The question now takes on an urgency, and it is answered through his reliance on eliding juxtaposition and breaking contours, as well as on montage – if not collage – in a composition that welcomes a superfluity of reference. Figurative elements from popular magazines enter the paintings scrambled, nearly obliterated, or deformed, and they are overwhelmed with painterly incursions. These figural elements, secreted within the maelstrom of paint, are subject to the same lawlessness that governs the composition as a whole. The notion of encyclopedia obtains because the word "encyclopedia" derives from the sense that basic knowledge is put into *circulation*. In Zapkus's paintings, however nonhomogeneous the space, the commonplaces of experience and innocence illustrated by armaments and toys, for instance, circulate freely. These are expressive paintings, and they favor circulatory patterns of racing visual information. (Were it not for the thoroughness with which Zapkus meta-

morphoses cultural givens, one could argue that these political paint-
ings demonstrate not visual understanding but the lack of
information and a redundancy only masquerading as political en-
gagement. Speaking cybernetically, we might say that redundancy
informs the encyclopedia.)

Dreams of Patriotism (1981) is "about the endless conflict in
Northern Ireland." Thanks in part to the fact that maps were the
artist's inspiration, compositional tactics are constantly changing
throughout the work rather than being consistently maintained.
Range applies to every aspect of this painting: from color to facture,
from scale to viewpoint (and onward to modes of representation),
from illusionist to schematic to abstract. This is an inclusive visual
adventure, concretely rendered throughout. It is, Lippard reports the
artist as saying, "art . . . as a meaningful activity, a private investi-
gation, a simultaneous conglomerate of all experience, not just indi-
vidual, but social too."[17]

The Children of War series, begun in 1982, is the most explicitly
social art Zapkus has attempted. In a recent recollection of his
childhood experience, Zapkus writes,

I was brought to the U.S.A. as an eight-year-old directly from the battle-
fields of Europe. While American children looked nourished, protected,
happy, and not older than their years, I felt strange and old. I found it
difficult to understand or empathize with their lightness of mind and
cheerfulness, having felt the full throttle of adult vengefulness. My eight
years had seen bombed-out cities and had experienced bombing raids,
wounded and scattered human bodies, hurt and bleeding animals, scream-
ing, moaning sirens, tears, and terror expressed in many foreign lan-
guages. . . . It's amazing to me how a war experience totally twists a
person, yet the warring instinct and preparation for war are considered
perfectly normal to the human condition.[18]

Roger Rosenblatt's *Children of War*, a book about the impact of war
on children's psyches, revived Zapkus's own wartime impressions,
and from his boiling stew of cultural artifacts, we can infer an ency-
clopedia of dislocation lodged within a complex formalist vision. In
the postmodern world of Zapkus's canvases, there now obtains a cul-
tural quotation spelled out, one pitting adult fantasies against each
other in a furious contest in which perfectly normal cultural elements
are engulfed. Zapkus conflates armaments and toys in a poetic subjec-
tivity meant to correspond to his own childhood trauma. The public
aspect of the breakup of the world reveals a topos of modernity made
postmodern via the use of encyclopedic information.

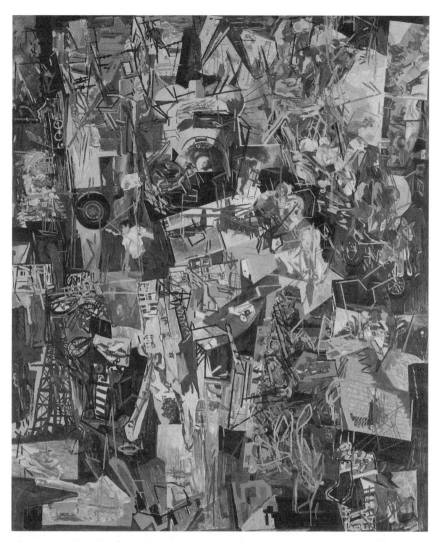

Figure 27. Kes Zapkus, *Rations*. 1984. Oil on canvas, 72 × 60 inches. Photograph courtesy of John Weber Gallery, New York.

Unabated is the steady stamina in painting of which Zapkus is capable. Sheer extension coupled with diligent research into figural possibility soon led him to acquire a fund of visual impressions he could plunder for metaphoric purposes. In notes written in 1983, he makes mention of Mahler's *Kindertotenlieder;* but if this late Romantic work remains compelling as a social statement, it is by virtue

of its abstraction insofar as it stylistically centers on an atonality that extracts harmonic adventurousness from melancholic chromaticism. Doubtless, the stylistic adventurousness that marked Zapkus's work at the opening of the decade depended on a fresh appreciation of metaphoric possibilities.

In retrospect this period of overtly politicized painting, which indeed, in 1984, served to prepare Zapkus's imagination for the visual and cultural data that were soon to be metamorphosed into the socially augmented abstraction that would follow, was a period when he truly practiced the inclusiveness he espoused, a period of research into social idioms and their application.

*

"A period of glasnost," Zapkus jokes, closed out the 1980s. This comment is his way of acknowledging his response to a changed world, and indeed, the repertory of munitions and instruments symbolic of institutional control either disappears or becomes integrated into a lexicon of abstract reference in the paintings he created at this time.

In reinvigorated shaped canvases, his work becomes more eccentric than ever before. A heterogeneous cluster of variously sized canvases, decidedly not comprising a single gestalt, presents the idea of the unification of a material discombobulation as a near impossibility.

More significantly, the new diversity of format is symptomatic of a thematic and stylistic range which he had not permitted himself before (see Figure 28). In *La Farge and the Chlorinated Pool* (1988–89), for example, erratic blocks of bright color enliven the gloom of this visual reference to the stained-glass Victoriana of the American painter John La Farge. Brilliant, too, are the subterranean links between painting and title. (Zapkus at this time showed a genuine aptitude for titling works to bring out their latent poetic content; he seemed to understand that poetic meaning could be released if the title proffered a separate creative act, a verbal domain interacting with a visual domain to produce a whole creative event.)

Taken together, accident and contingency inform both theme and structure in this body of work. Accident renders unintentional and random order intelligible. Contingency welcomes the prospect of alternative solutions to creative problems, whether in art or in the human sciences. It is indeed the fate of humans to have to grapple with indeterminacy, which, to some degree, is inherent in most

Figure 28. Kes Zapkus, *Residual Plans*. 1986. Oil on linen, 72 × 48 inches. Photograph courtesy of John Weber Gallery, New York.

situations. Still, indeterminacy is a function of meaning, Zapkus now concludes, not meaninglessness. As he once said, he wants "to have painting become a convincing substitute for the transient chaos that life is all about." *Cage and the Wetlands* (1987) and *Fugue for Hieronymus Bosch* (1987) exemplify two of many approaches to contingent – though not aleatoric – layering and circulation.

Meanwhile, as the artist wrote in 1989,

[My] preoccupation with an inclusive, complete kind of painting continues. The layering of elements, themes, and concepts persist [sic] but often congeal into larger forms. [My] visual vocabulary is now much more wayward than restrictive, a rigorously non-referential language the artist was committed to ten years ago. Now everything may enter this abstract and structural attitude.

Residual Plans (1986), *Improvisation on a Shrill Sound* (1987), and *Reappraisal of the Algarve* (1988–89) are especially fine examples of, as it were, holding a mirror up to indeterminacy.

Neo-Expressionism had been the adopted style of many painters responding to European trends since the late 1970s. In Italy and Germany, the poetics of pastiche and excess seemed a way to represent cultural overload with energetic irony. For Zapkus, too, idiomatic abundance began that decade. Expressionistic license gave rise to compositions that were either impacted, relentlessly dense, or furiously and exquisitely ungovernable. By decade's end, however, a less tumultuous form of thematic and structural inclusiveness was evident in his work: Stately patterns of exposition sustain lyric passages of color while architectonic elements are apt to nestle harmoniously within the canvases' framing edges.

∗

"Of what use is history? Why study history?" John Cage was once asked. His profound answer: To thicken the plot.

It is startling to hear this from a musician we thought was hopelessly in love with atemporality, but Cage's answer reveals his reverence for the dimension of time. Implicit in his comment is his respect for certain narratives that lend sense to the haphazard chronicle of our days. As we have learned from semiotics, history reconfigures chronicle into a compelling plot, the design of which allows for cultural self-scrutiny.

To speculate on this further: One could consider that Cage, the author of *Williams Mix* (1952), could well appreciate that the aural

splicing of sound sources is not meaningless – but that it is meaning-ful precisely because it agglomerates reality. All that occurs in it pertains to the nature of sound. "City sounds . . . country sounds . . . electronic sounds . . . manually produced sounds, including the literature of music . . . wind-produced sounds, including song . . . and small sounds requiring amplification to be heard by others" – this batch of sound does collage cultural reference.[19] The cacophony of historical experience contributes to a sampling of culture from which, once a temporal selection has been made, some narrative comes into being – not an absolute narrative but a provisional one. No less compelling for being one of several alternatives, no less compelling for being contested, this "plot" gives substance to style.

Here, perhaps, is what Zapkus has gained for his enriched pas-sages of broken and reconfigured planes. Having passed through a period of contemporary history painting, his proclivity for perusing cultural information has led to a refreshed encyclopedic visual knowledge. Never one to disallow cultural insight, Zapkus is never so intellectually self-satisfied that he produces what critics might call "ideological commodities." Within the essentializing model of mod-ernism, his criticality takes the form of a rebellious perplexity besieg-ing predetermined or determinate assertion of form.

So Zapkus's "period of glasnost," convulsive again in more cur-rent works, cultivates unrest. At least a *mal de siècle* discernible in *Liberation of Past Tense* (1991) suggests that the artist is not op-posed to the stance of postmodernity (see Figure 43, p. 283). Se-creted with "pictorial and stylistic truisms,"[20] this all-over field of shifting gray, sparkling here and there with hue, recalls paintings created by the artist thirty years earlier, before he went to Paris as a student. Tondo-shaped images of globes of available international styles – from Baroque to Constructivist to Abstract Expressionist – embedded in the field suggest the personal theme of macrocosm-within-microcosm, again as before. Fading out at the periphery – as with many of the Cubist *passages* – these globes suggest a Neo-Romantic nostalgia for the long-ago-and-far-away of modernity that is glimpsed from a fictive perspective. A painting about the historicist stance toward modernity, *Liberation of Past Tense* presents an inter-esting holding pattern on current period values.

Since collage had effected an epistemological shift from acciden-tal to premeditated indeterminacy, postmodernity has revealed the problematic nature of styles seen historically. Now Zapkus offers a spatiotemporal paraphrase in this canvas of prospect, vista, and

aerial view. If his is a metanarrative, he says, it is a provisional metanarrative,

like a universe where there are many elements in intimate interrelationship with one another, relating the whole history of my past and of art. So it's a kind of universe of my thoughtful past.

15

A Greenberg Retrospective

By all rights a retrospective exhibition of an artist's career is selectively comprehensive. Chronicling the artist's oeuvre from start to finish, such a retrospective argues against years of received opinion handed down by critics speaking on the artist's behalf. Fifty years after his first articles in *Partisan Review* catapulted him to instant notoriety, Clement Greenberg himself got to see a full-scale retrospective of his complete critical writings – and with it the opportunity to have matters restored to fullness and perspective.

But not quite. Published so far are two of the four volumes projected in the series, those covering the years 1939–49, the first formative decade of Greenberg's criticism.* Neither of the other two volumes are soon forthcoming; because of previous commitments by his editor John O'Brian, the remainder of Greenberg's retrospective will have to wait at least until the early 1990s.[1] In plain view, however, is Greenberg's sense of modernism, honed to a radical instrument of culture. The formalism Greenberg contrives continues to remain one of the most penetrating interpretations of modernism by which we understand the inner structure and goals of advanced art created in the twentieth century.

Fifty years after the fact, when art historians and critics target Greenberg to prove either how right or how wrong he was, the essays to which they most often appeal are "Avant-garde and Kitsch" (1939) and "Towards a Newer Laocoön" (1940). The main reason for this focus is their perception that Greenberg's intellectual center coincides with his literary origins. "Avant-garde and Kitsch," Greenberg's entry into the discourse of the anti-Stalinist avant-garde intelligentsia, voiced support for artistic resistance. No compromise and no rapprochement with commercial mass culture was allowed if the modernist artist was to be worthy of the avant-garde. Kitsch, whether promulgated by totalitarian propaganda or by democracies'

* John O'Brian, ed., *Clement Greenberg: The Collected Essays and Criticism*, volumes 1 and 2 (Chicago: The University of Chicago Press, 1988).

regional notions of art, was seen as both politically and aesthetically noxious. With World War II in the wings and with Trotksy exiled and sending *Partisan Review* cultural bulletins from Mexico, Greenberg's contribution to the discussion initiated by William Phillips, Philip Rahv, and Dwight MacDonald, as editors of this journal, was not idle chatter but decidedly activist. Neither was the notion of the avant-garde an abstraction, given that Greenberg was writing even as Eliot's "East Coker" and "Dry Salvages," published in 1940 and 1941, respectively, appeared in *Partisan*'s pages. The avant-garde was happening in the present.

Announced in "Towards a Newer Laocoön" and argued in essays thereafter is Greenberg's contention that whatever purists may say, we do not need to resort to their metaphysics to see that abstraction is the best of today's visual art. Greenberg is not being coy when he says that the excellence of abstraction can be apprehended directly. But neither does this suggest he is incapable of employing certain privileged ideas for preemptive metaphysical strikes. An idealist right from the start, he insists on identifying canonical art with the most advanced expressions of culture in order to distance himself from what he might call the lesser talents. The short honor list that Greenberg compiled over the years is well known. Matisse, Picasso, Mondrian, Miró, and Pollock manage to enter his canon of painting. Willem de Kooning's first abstractions earn the highest praise. The early Cubists Alberto Giacometti and David Smith form the short list of indispensable sculptors.

"Indispensable" is the operative word. If more and more people wield pigment-laden brushes, this fact does not make them all painters. Neither does it make all their products paintings – at least in anything but a technical sense. According to Greenberg's interpretation of Wölfflin, pictures may come into being but remain irrelevant for the history of painting unless they originate in or bring to fruition a major spatial paradigm. They will prove their worth definitively, as modernist history since Courbet has shown, by intensifying those plastic and flat qualities unique to the visual medium of painting.

For Greenberg, Cubism remains the most significant style of modern art because it invented a truly new visual structure, one, moreover, offering a pictorial rebuttal to Renaissance illusion. So strong is this belief that Greenberg tends to be prejudicial, sometimes ignoring a valid stylistic lineage competing with the Cubist genealogy he derives for his artists. (Pollock, one may argue, is essentially Impressionist in syntax, Expressionist in semantics.) In this retro-

spective of collected essays, however, one reads Greenberg's radical view of modern art as it unfolds with unexpected and ramified thoughtfulness. Here is no piece of legislation upheld without exception, and typically Greenberg will award partial favorable judgments when considering lesser talents and problematic careers. Despite himself, Greenberg's practical criticism is more forgiving than his systematic aesthetics.

In any event, ideology has not been the stumbling block for Greenberg that it has for some art critics. John Berger, for instance, believes that art for art's sake is mere entertainment – its aesthetics, an unconscionable detachment from politics and society. He is thus forced by his ideological stance to elevate Fernand Léger above Cézanne, making the former the superior artist. Greenberg does not fall victim to this sociological ploy. Refusing to lead with his ideology, Greenberg rightly maintains that Cézanne is the superior artist because of a style implemented more radically and strenuously, his avant-garde painting totally beyond the appeasement of culture even today. In contrast to Cézanne, by courting accessibility and communication with society, Léger compromises his so-called radical position. Then, too, entertainment descends on Léger in another way. In a 1941 review of Léger, Greenberg sadly ruminates on the truth that it is difficult for an abstract artist to keep fresh. "By force of repetition," he wrote, Léger's work has become "facile and empty. . . . When the abstract artist grows tired, he becomes an interior decorator – which is still, however, to be more creative than an academic painter."[2]

Consciously or not, Greenberg assumes the position of art historian Henri Focillon, who believed in the soundness of structure, with the concomitant decadence of ingratiating substitutes and their merely decorative effects. To Greenberg, an artist becomes merely decorative as a result of a failure of visual nerve or the attempt to ingratiate him- or herself with society. Flash forward twenty years later: Will Greenberg have the gumption to say these words to color-field artists whose work has grown soft from facile rehearsals of spatial ideas? Will Greenberg turn from this gentrification of art to at least some of the works of Minimalism by Donald Judd and Sol LeWitt, works that at once extend David Smith while returning to Constructivism's genuinely radical conception of sculpture? How Greenberg copes with radical art unforeseen by him is beyond the historical frame of this part of the retrospective. What is immediately pertinent is that Greenberg does not confuse the abstract concerns

of art for art's sake with entertainment; art is not entertainment for the sighted. Greenberg was to write years later that Trotskyism turned into art for art's sake, a position that prepared the ground for heroic aspirations in art to come.

Adversaries of Greenberg protest that his emphasis on the formalist implications of modernism is advancing an ahistorical point of view, yet even though anyone scanning these volumes of collected essays will note that a contextual approach to art is indeed notably absent, such an objection to his approach by no means invalidates it. In actuality, giving formal priority to art does not so much register Greenberg's particular choice as it does a widely held period assumption. In the 1920s, when Greenberg went to school, formalism was in vogue throughout Europe, and it was utilized by a contextual art historian like Erwin Panofsky as much as by critical upstarts like Greenberg, not because it was fashionable but because such sustained formal analysis was tantamount to a demonstrable visual literacy. It is no wonder that armed with his analytic skills, plus native perceptivity, Greenberg spotted the work of Pollock and Smith and confidently championed their art, as unintelligible as it may have been to others at the time. With both social history and biography ancillary to informed sight, this significant art did not get lost in the welter of contemporary artifacts that were plea-bargaining their way into history, but it was appreciated for the definitive achievement it was. Stringent though Wölfflin may have been, his idea of pure visibility has prevailed for reasons more valid than proponents of pure contextuality would like to concede.

Greenberg's radical, formalist interpretation of modern art can still teach history. In a recent interview William Lieberman told me that his title suggests that he is curator not of "modern art" but of "twentieth-century painting and sculpture." Even so, the logic of this statement does not disguise what amounts to an aesthetic policy statement: Now that the Metropolitan Museum of Art maintains that modernism should be relegated to a small aesthetic inflection in the history of twentieth-century practice – and to the walls of the vast halls of the Lila Acheson Wallace Wing – we do indeed see evidence of Lieberman's decision to support an untheoretical chronicle of painting in its many current idioms. At the Museum of Modern Art, meanwhile, where Kirk Varnedoe is about to succeed William Rubin as chief curator of the department of painting and sculpture, we can speculate about a shift in policy already discernible in this longtime enclave of modernism. In response to pressures to

open up the Modern to art of political protest and to a broader demographic spectrum of artists, solo shows and group shows alike are reflecting a shift from aesthetic to sociological values. As is usually the case, this sociologically "enlightened" art entails waffling on aesthetic quality.

For Greenberg, art history is not to be confused with current events. Such history is rather a plot to interpret this sort of quotidian story, a plot whose design enacts an advanced notion of visual structure. His radical sense of modernism surely offers such a plot – yet it offers more. The general lesson to be learned from his formalist approach is that though art history may potentially take in all man-made things, the plot – our interpretation of its history – must adhere to a significant theoretical foundation. Greenberg's own position shows, furthermore, that under whatever cultural aegis we determine our interpretation of history, there can be no aesthetic backsliding. As color was to Matisse, the formalist avant-garde is to Greenberg: a way of defining culture by its most advanced expression. If our society is capable of only enfeebled, if well-intentioned, art, he maintains, then that's what all of us – not only critics – should be unafraid to say.

16

Abstractions

Barnett Newman and James Turrell

Barnett Newman's art is often presupposed even where it goes unmentioned. A somber or brilliant expanse of paint masterminded by this giant of the New York School underlies the technical experiments in ambient light by Californian James Turrell a generation later. Formally, Turrell's choice to identify art with big blank spaces presupposes Newman's example. Philosophically, Turrell subscribes to the belief held by Newman and others of his Abstract Expressionist angst that aesthetics is not pulchritude; art, whatever else it is, is essentially not beauty insofar as its source lies anterior to beauty in human experience. Sensory perception leading to awareness as such has a prior claim on aesthetic meaning.

Perception and beyond – this topic underlies these two books that are otherwise different in type.* The *Selected Writings* of Barnett Newman allow us access to this artist's voice in pungent words spoken extempore as he strode through a museum or declaimed more deliberately in manifestoes, appreciations, and tactical complaints directed toward aesthetics, artists, and the art world. Arranged thematically and contextualized with an introduction written by Richard Shiff, this selection provides a charming album of opinion and observation to those already familiar with Newman's art. This lively firsthand glimpse into the artist's intention is decidedly improvisatory compared with the sober, comprehending gaze and reflective yet unpetty scholastic study that Turrell inspired in Craig Adcock. But both anthology and monograph remain dependent on the reader's prior knowledge of the paintings and the installations respectively.

Newman's mission, driven by an ethos rare today, was to make American art competitive with the European avant-garde, and it is his lasting achievement that along with Pollock he accomplished this

* John P. O'Neill, ed., *Barnett Newman: Selected Writings and Interviews* (New York: Alfred A. Knopf, 1990); and Craig Adcock, *James Turrell: The Art of Light and Space* (Berkeley, CA: University of California Press, 1990).

end. Born in 1905 in New York of Russian Polish parents and majoring in philosophy at CCNY (only to spend a decade salvaging his father's menswear business at the time of the Depression), Newman brought to his study of art a sense of the importance of principled reasons for action. As he learned from exiled Europeans fleeing Europe with the advent of Nazism, it was crucial to understand what one does, why one does it, and how it advances human understanding. To further artistic modernity, it was not enough to adorn canvas with illusionistic, if writhing, wheatfields in celebration of regional "isolationist art," as he put it, or even to stylize such scenes further to gain a semi-abstract purchase on this subject matter; such pictorial art was clearly inadmissible. Until he or she had produced a major critical response to abstraction, Newman believed, the artist had not earned the right to consider him- or herself the painter of an opus; much less could the artist expect a place in future world-art history. The problem with which Newman wrestled, then, was the following: Given the modern necessity of abstraction, what alternative to Cubism could be posited that respected yet did not illustrate content? Oil sketches done in the 1940s show seismic indications of pods, sprung seeds, and other notations for germination that had been learned from Surrealism – elemental forms gradually reduced in number, simplified, and made abstract. The abstract symbolism Newman sought to advance was the feeling of an idea (*pace* Langer, to whom he had hurled a famous epithet about aesthetics being mere ornithology). Arriving at this solution took years.

Given his commitment to the artistic breakthrough, it is not surprising that Newman's *Onement I* (1948) – a paradoxical content, in which a vertically divided field could raze yet give birth to space – came only after an ordeal of three years' self-imposed exploratory drawing; it also followed an eight-year hiatus in painting during which time he searched for "something to paint."[1] (The drive to create significant abstraction was cultural, a period value. So it is not a coincidence that after two decades of struggling with Baroque and Expressionist antecedents, Jackson Pollock produced his opus one, a work that he was pleased to name a radical synthesis of all expressiveness that combined into rhythm sustained infinitely through dripping and pouring paint [*Number 1* (1948)]).

Meanwhile, throughout the sabbatical from painting, doubtless fueled by frustrated action, Newman wrote several polemical articles. Among them are the more celebrated of his writings: "The Problem of Subject Matter" (1944–45), an article on a topic that

also concerned the influential painter-in-exile Hans Hofmann; "The Plasmic Image" (1945), Newman's term for plasticity; "Northwest Coast Indian Painting" (1946); "The Ideographic Picture" (1947), which concerned the meaningful nonverbal character of a symbol; "The Sublime Is Now," which was written in 1948, the year Newman came upon the germ of the idea for his mature painting (birth-in-death, at-one-ment, expressed through a thin line, or "zip," cleaving an otherwise unbroken space). As Richard Shiff observes, Newman "used his writing to instruct himself in the issues that he knew he had to master."[2] Linking modernity to archaic content – indeed, making the modern a function of the archaic – was a Nietzschean proposal that Newman gladly took up.

Newman's achievement, then, was to employ a discretionary visual intelligence for radical expression – specifically, managing to achieve the sheer scale of color without loss of passionate force. (Imagine, if you will, Matisse's *Red Studio*, the cadmium red laced with indications of the white canvas; now imagine the cadmium red expanse uninterrupted, save once or twice.)

Newman's importance may be further measured in the turf wars his art and polemics inspired in subsequent generations of artists, and his uncompromising example continues to chasten art making decades after his death in 1970. Donald Judd, whose famous white paper, "Specific Objects" (1965), which emphasized the perceptual aspects of Newman while ignoring Newman's spiritualized content, provided the world with a strong misreading of Newman's uniform, or nonrelational, compositions. This misreading was advantageous to Judd's own modular industrial sculptures even as it reinforced Greenberg's bias toward formal essentials. For an alternative response to the art of perception, however, Robert Irwin, James Turrell, and other West Coast artists have provided bodies of work at once more technological and more ethereal.

Newman's legacy to Turrell is indirect and diffused through Ad Reinhardt and others. (A fine, definitive retrospective of Ad Reinhardt's introspectively optical painting could be seen at the Museum of Modern Art, New York, June 1–September 2, 1991.) Nevertheless, presupposed by both Newman and Turrell are certain notions of aesthetics. Both thought, for instance, that art does not center on beauty (nor on ugliness), because art's aesthetic basis lies elsewhere: For Newman, amazement toward abstract ideas was engendered through form – for Turrell, through consciousness of perception. With Newman, the means is dramatic, a virtual wall of vivid color

broken only by a vertical disturbance running through it; for Turrell, the means may be sharp or subtle to the point of being perceptually subliminal, an irradiating light inducing phenomenological experience of walls and rooms. Whether by the metaphysically tendered bias of the sublime or else by the phenomenologically inclined frame of mind, a markedly subjective response to fields of brilliant color or to dim light is what these artists hope to induce.

To accomplish this, Turrell typically prepares a light chamber into which the viewer enters to see the work. Promoted as much by the New York School as by West Coast holistic uses of light, the manipulation of a total visual field – the phenomenon that perceptual psychologists call *Ganzfeld* – is an approach to concentration that artists who came of age in the 1960s have taken for granted and have tried to perfect. Whereas, for instance, the dark visual environment within the Rothko Chapel is (by virtue of unruly natural light and shadow or steady gloom) only partially effective as a meditation chamber, Turrell's sustained artificial control over light effects results in a predictable immersion of the viewer into the subjective aspects of the physiological process of seeing. Staring hard into dim space and perceiving only the blue streaks of one's own neurons firing within the disorienting weightlessness induced by a specially sealed, raked approach by ramp – this experience can result in somatic effects as intense as the retinal experience is subtle.

The question remains whether all this is art or an especially etheral form of special effects. Dr. Edward Wortz, the scientist with whom Turrell and Irwin collaborated in the late 1960s while members of the Art & Technology experiment, considered these projects art. In contrast to the laboratory uses of *Ganzfeld*, Turrell's Skyspaces, a series created from 1970 on, which incorporated the temporal spectrum of night, are less scientific than they are poetically framed natural observations. Turrell himself insists he has taken pains to avoid spectacle, and both in his long-term diligent studies in perceptual psychology and in his secreted and modest application of technology, he has, indeed, acquitted himself: The sensory aura of his installations is almost always more potent than one's curiosity about how the aura is produced. Turrell's installations together with Irwin's light objects, initially coincident with the trendy interest in Op Art, have decidedly surpassed Op Art and other glib misconstruals of pure visibility.

From the viewpoint of contemporary art history, however, Turrell's poetically framed nature has often been judged to be scientistic,

even though it is nonmaterialist and interiorized, even though it logically realizes the predictions of his mentors' concerns.

In 1966, the year Turrell sealed a room to create his first documented light piece, Newman himself told Andrew Hudson of the *Washington Post*,

The scale of a painting in the end depends on the artist's sense of space, and the more one succeeds in separating the painting from the sense of environment. People always keep talking about "enviromental art." I hope my work is free from the environment.

That is why in my mind's eye I have always been fascinated by the tundra, where the feeling of space involves all four horizons. That is why I have described my idea of space by calling it the "space dome." After all, when you are driving through the mountains you feel the environment. You feel locked in. You are where you are, and the mountains which create the environment give you the impression of no space at all.[3]

Noting the perceptual flattening seen from within a vast yet imprisoning space, Newman had anticipated Turrell's experiments – most uncannily, his recent Roden Crater Project, near Flagstaff, Arizona. Here embedded chambers are intended to enhance nature's volcanic amphitheater, both its sky dome and astronomical spectacle.

Fashioning such a geologic prospect from which to gaze at nature recalls the early Romantic impulse for the fusion of artistic and scientific endeavor – both led to similarly problematic results and a mixed response. Wordsworth did not get rave reviews with his call for the poet to ready him- or herself for "carrying sensation into the midst of the objects of science itself. The remotest discoveries of the chemist, the botanist, or mineralogist will give us proper objects of the poet's art. . . ."[4] Newman's ability to see nature from inside out stopped short of co-opting it as "creative." His own canvases argue for the felt, symbolic re-creation of nature as integral to artistic experience.

As Adcock puts it, the light induced by Turrell "has epiphanic intensity, but no symbolism. . . ." If art is involved, it is in the finesse of orchestrating a directedness of attention so far as "the simple act of looking [is] highly compelling."[5] Once one disallows spectacular effects and novelty, there is, as well, ingenuity required to make people remain visually vigilant once habituated to the ambient light and space. Even if Newman would resist Turrell's manipulation of space as art, he could admit they share many of the same assumptions of art's relation to human behavior.

During World War II, skywatchers trained to scan for enemy

planes succumbed to the wearying and hallucinatory effects of habituation well before the crucial need for vigilance came to an end. Artists after the war, who attempted to prolong this sense of crisis, met with resistance and ridicule in prosperous times. What we are witnessing in the legacy of Newman is that passage from existential to phenomenological consciousness which assumes that the human viewer is responsible for bringing meaning to seeing – and for sustaining that effort.

17

A Literature of Silence
Nancy Haynes

Silence

Her paintings neither rest nor sleep but are decidedly devoted to an aesthetics of, as she says, "emptying out."

Certainly, in physical appearance, paintings by Nancy Haynes take heed of black. Black is the modernist sign of the radical. A utopian shade, black further entails the rhetoric of the tabula rasa – and indeed, the clean slate as support for painting once provided Haynes with the objective correlative she needed to make manifest her modern position.

Fundamentally, then, hers are black paintings – but with their black articulated in material and formal terms. Emptying out implies a withdrawal from color, the purpose being to concentrate the attention on the interior of the surface of the painting, where there is much going on. Removal of any possibility of pursuing coloristic passions and attractiveness leaves these paintings understated yet not reductive, because frequently visible is an aurora borealis of gray. Indeed, a spectral range of black through white introduces a tonal chromaticism into the extremity of black, and into this modified contrast is further added a subtle play of warm into cool.

Black may be characterized as absence, the absence that results as a consequence of all colors mixed in pigmented confusion – or in consequence of the withdrawal of light. Revealing optical as well as pigmented qualities, Haynes allows for the possibility that her gray paintings are those black canvases to which visibility has been brought. Interested in differences of factual light, Haynes started using luminous paint about fifteen years ago. *Third Rail* (1984), for instance, displays four material differences of pigment, two of which – gold leaf and luminous paint – flank painted (black) and unpainted (linen) surfaces. Contrasting structural features were thus enhanced through the surface's severely polarized material differences. Technique has remained a preoccupation ever since then. Yet the materialism of support-surface has also since entered and been absorbed

into a visibility more fluid, more yielding, than before. Sensually nuanced black readies the intellect for articulation. Putting it another way: With Haynes's spectral grays at her disposal, black is relieved of its dogmatisms. Just as light and dark interpenetrate in these recent works, so too does material and metaphysical content couple and uncouple freely (*Once* [1990], Metropolitan Museum of Art). Now one sees that the utopian state of Not Yet has been handed over to an Adornoesque measure of tangling with unfulfilled possibilities.

<div align="center">✳</div>

Culturally, Haynes may be initially situated where Ad Reinhardt triangulates Theodor Adorno and Samuel Beckett (*Untitled* [1986], Brooklyn Museum). Ad Reinhardt's Idealist belief in painting-about-painting was manifestly heroic, and long after Suprematism had abandoned subject matter and anecdote, decoration and ingratiating incident, his abstraction bore the conviction that only form is relevant. Haynes follows in this lineage. The tonal, textural epidermis of her paintings is not at all the same as drab decor; it is dedicated to creating visual stringency.

For Reinhardt, like Adorno, a concerted negativity in theory and practice is a decidedly positive advocacy of resistance: resistance to interpretation, resistance to commodification. For Haynes, as well, an aesthetics of negation and negativity expresses an ardent resistance to taste. In her work no renditions of brushwork appease an audience new to the tradition of modernity, because the burden is on the viewer as much as it is on the artist to become visually literate if the pursuit of art is desired.

This cultural consciousness of war or other catastrophe internalized, which is advanced by the most stringent members of the New York School, informs Haynes as well, even though her work does not manifestly express such concerns (see Figure 29). Newman's *Onement I*, Reinhardt's cruciform compositions, and Mark Rothko's liminal spaces didn't just inscribe existential extremity in material and formal terms; they also established a standard of seriousness analogous to the seriousness of their cultural situation. Silence and self-discipline in art characterized these men's style. The "withdrawal of recluse, *rebirth* in seclusion" was Ad Reinhardt's comment about the symbol of black. His diaristic notes see the symbol as spiritually commodious. In this sense he is more generous to its expressive possibilities than Beckett. In perpetually subjective

encounter with catastrophe or with matter catastrophically apprehended, Beckett recalls Pascal: Nothingness is the lived proximity to death one sews into one's clothing.

Irritability

No less real for being silent, the physicality of Haynes's painted surface is no mere universal category as a result of its becoming marked, textured, and distressed, as Adorno might appreciate. The surface of silence is both structured and inflected. In *Untoward* (1991), for instance, nebulae of marks distinguish themselves into particularity, so that what results is calligraphy suggestive of, as the artist says, the East and the West on either side of a central spasmodic episode like Tourrette Syndrome. Handwriting through which (psycho)somatic disarticulation always threatens to come about agitates the visual field.

Haynes's mark is the mark of the infinitesimal sensation. With surfaces so inflected, Haynes's art reveals the visual precision we associate with an etcher's mentality. Pitted surfaces vexed with all manner of painstaking decisions point to a scrupulousness of inscription. Haynes's visual fields, then, reveal the irritability by which one comes to understand expressive gesture at its most sensitized (*Fort-Da* [1990–91]).

Between Irritability and Iterability

A mark is a gesture at its most minutely signifying. Reliance on the singular seminal nature of the mark, touch, or brushstroke is at least the radical assumption of New York School artists and their latter-day material proponents. Reinhardt's carefully adjusted early brushwork is a forerunner of even more carefully situated later planes within black. The painstakingly adjudicated atmospheres of Arshile Gorky, Cy Twombly, and Mark Rothko all suggest that in the best artists, sensitivity of surface corresponds to closer and closer approximations of an issue, a question, an articulation of structure.

Slow apprehension of an integrally indiscernible space of painting may be seen in Haynes's work. Given the half-erased space being articulated, the brushiness seems to be procreative of as many doubts as clarifications (*Naming* [1991]; *The Painting in Question* [1991]). Whatever else it is, the mark is surely not in Haynes's art a

Figure 29. Nancy Haynes, *Situate*. 1992. Oil on wood, 16 × 20 inches. Private Collection.

conspirator of decor, something merely habitual in its facility to render a surface intelligible. Similar to the divisions within Barnett Newman's visual fields, Haynes's mark or brushstroke signifies the artist's location of an abyss and, so, a condition of a distant "there" against which the mark establishes a conditional "here." (With the psychoanalyst Jacques Lacan advancing the notion of the subject caught between mark and a void, perhaps the Heideggerian coefficient of Newman's "zip" is the quality of the mark Lacan had in mind [*Brushstroke* (1991)].)

The structure of iterability may, in painting, take the form of a mark scratching that which can be said nonverbally – and repeated, tracing a regressive chain of nuanced incertitude. So in Haynes's work, the internal frames that indicate the inflected void of the canvas are themselves inflected and adjusted reiteratively. One way or another, the visual intelligibility of field voices its hesitancy:

Shades of gray worry, apologize after the fact, speak in wistful self-address, manifest tendencies of approach-avoidance and scenarios of revision (*Referent* [1992]; *Revisionist History* [1992]).

The Literature of Silence

Nancy Haynes has produced a series of breathtaking mono-types inspired by the work of Samuel Beckett. That her admiration for him is longstanding comes as no surprise to those viewers famil-iar with her painting. She is aesthetically in accord with Beckett's assumption of "the divine aphasia in an excess of speech and want of reasoning" – or speechlessness, against which mark-making is inadequate (*That Which Memory Cannot Locate* [1991–92]).[1] She evidently admires that same impulse toward (the Heideggerian) in-adequacy of language in art other than her own (Robert Ryman's own homage to Beckett's "Ill Seen Ill Said," with its barely voiced "th" inscribed in illustration, for instance). Cognizant of Vladimir and Estragon's cosmic fretfulness, she conducts her own forays into elegant stuttering on the visual plane.

Haynes is by no means alone in remaining riveted by the para-doxical nature of black to express meaninglessness and meaning, both at supersaturated strength (*Seppuku* [1991]). From Beckett's bleak spirituality to those Reinhardt studies of spirituality that in-form Thomas Merton's silence, and from the West's fascination with the religions of the East, those religions that place positive value on negativity to existential void, the literature of silence remains a mat-ter of conviction for a generation of artists. Certainly its terms of imploded bereavement yet also its positive valence define a domain familiar to Nancy Haynes. She has not been content to rest here, however, and among the artists working now she is unique in dem-onstrating a visual intelligence that will not allow her to content herself with the habit of silence but that instead leads her to excavate it more and more inquiringly.

18

Boulders from Flatland

Jene Highstein

> "Pardon me, my Lord," replied I; "but to my eye the appearance is as of an Irregular Figure whose inside is laid open to view; in other words, methinks I see no Solid but a Plane such as we infer in Flatland; only of an Irregularity which betokens some monstrous criminal, so that the very sight is painful to my eyes."
>
> *Flatland*, by Edwin A. Abbott (1884)[1]

To us, the inhabitants of Spaceland, viewing perspectival renderings of the innards of cubes is not a horrific experience, because we have become accustomed to the conventions of this drawn space. Similarly, from our third-dimensional vantage, drawings related to sculpture may not be painful to the eyes – even though the shift in seeing them as distinct from the sculpture may require us to adjust to the learned conventions of seeing flat. Whereas drawings are optical experiences, sculptures are tactile. Then, too, drawings are often only approximately analogous to their sculptural counterparts. Free drawing, which has no model, requires that we forget the relation of drawing to sculpture altogether, because some drawings do not correspond to three-dimensional things.

Jene Highstein's drawings reveal an approach to shape approximately analogous to the morphology of his three-dimensional things. A Flatlander would be relieved to know that the conventions of perspective are noninvasive in Highstein's drawings and do not penetrate flat forms to show the intestines of a cube's or ovoid's interior. Almost all of Highstein's forms remain densely opaque silhouettes. Matte black pastel or watercolor fills the shape entirely; little if any modulation of surface reveals itself (see Figure 30).

On the other hand, the contours reveal an irregular geometry. Approximating ovoids and polygons, Highstein's hand-hewn shapes, although not quite rustic, identify an intuitive approach to shape meant to produce simple, nameless things. Large spots or areas, many taut with respect to the negative field they occupy, sit in space.

Among the most tantalizing of them are drawings in which the so-called positive figure and negative ground assume the status of a paradox: the black figure apparently a black hole of absorptive power; the white ground engulfing the black hole. Formally, these drawings shift in weighted and weightless paradoxical equilibrium. Like lumps and mounds in section, these positive areas are not so shaped, however, as to refer to actual objects. That is to say, in ways that language philosophers would note, a number of Highstein's images depict decidedly general shapes – shapes that are perceptually distinct but referentially elusive. Among the most compelling of all his works, such images retain their namelessness and neutrality. Ultimately, Highstein's work reveals its strength in drawn and sculpted lumps and mounds that are rudimentary without being primordial.

Highstein's sculpture can be identified with fundamental things – a sort of nature on the cusp of acculturation. Whether Highstein's choice of material has been bronze or wood or stone, the phenomenological content of his boulderlike mounds seems coincident with a Heideggerian "setting forth the earth." Made of stone, yet less monumental than most cultural presences, Highstein's sculpture challenges the assumption that sculpture is necessarily macho. Whereas boulders and stone in nature express the entire range of phenomenological presence, Highstein's preference is to construe both large and small works recessively, passively – innocuous to the eye, more like stones in the road than like the peasant's sabots.

The cultural equivalence of modesty applies to the drawings as well, but the drawings are unlike the sculpture. Highstein models the surface of his sculpture with point-by-point care, honing the entire three-dimensional shape, but he reduces the drawings to silhouette, and so shaping them requires care applied primarily to the silhouette's boundaries. It is there that Highstein's hand may be found, as Heidegger would say, to be tuning the contours.

With his simple shapes adjusted edge to edge, Highstein's drawings relate stylistically to modern American functional abstractions done in midcentury. A comparison with the American artist Myron Stout comes to mind. With their graphite deposited and accreted in a slow synthesis of form, the drawings of Stout share with Highstein's an aesthetic that values morphological modesty and presence through attuned form. Work is less intensive in Highstein's unprepossessing form, however; struggle is not the issue. In this sense the two-dimensional lumps and mounds that Highstein draws occupy

Figure 30. Jene Highstein, *Flying Saucer* (drawing). 1977. Dry pastel on etching paper, 60 × 84 inches.

space, but they do not overwhelm it. Highstein seems more interested in keeping matters on an even keel.

✳

Highstein's sculpture is stylistically linked with early modern art; its visual language is entirely at ease. The aesthetics of positive and negative interpenetrating form, the equilibrium induced through the asymmetry of modified geometric shapes, the presence of nameable imagery even as abstraction is advocated, the reductive visual language – these modern traits are as characteristic of Highstein's sculpture as they are of sculpture from Brancusi to Hepworth and Moore.

It is in this sense that Highstein's work is minimal. As John Graham defines it, minimal art arrives at essence through a process of the gradual distillation of manifest material. Whether mere "thing" or refined and abstracted actuality, Highstein's images are minimal because they emerge gradually, having been shaped into simplicity. Brancusi would recognize them as essences. The truncated ovoid in Brancusi's *Torso of a Young Girl* (1918), for example, is

fundamental to the form vocabulary of Highstein's boulders and mounds. Brancusi's *Flying Turtle* (1940–45) wittily defies the viewer's expectation of sculptural gravity, poised as it is on its curved – not flat – side. Highstein's *Flying Saucer* (1977), too, balances on its curvature. Highstein's drawings reveal the imagery and devices of early modern thought.

In style, then, Highstein's work has much more in common with intuited essences than with the intellectual rationale for renovating sculpture as an art-historical category. The later Minimalist art of the 1960s, arguing for an intellectual renovation of art history, displaced Graham's earlier notion of minimalism, and the Minimalism of Donald Judd's logically generated volumes or even of Robert Morris's phenomenologically calculated slabs and enclosures exists in an entirely different realm from the sort of shaped essences that Graham had noted in 1937. Highstein emerged as an artist in the early 1970s, at a time when, on the one hand, Minimalism had already ceded its vocabulary of perception to the next generation and, on the other, artists' on-site interventions were conspicuously understated. Instead of logical constructs or heroic objects, the protagonists were now space and environment and milieu.

Highstein's drawings from the early 1970s reflect the collective wish for such a deliberately understated intervening presence. In an untitled drawing, two vertical lines occupy the diagonal axis of the page. (Coincidentally, a Highstein sculpture that merely occupied a vacant garage situated vertical poles at either end of the space. Less aggressively than Richard Serra, who would have worked precariously situated lead or steel material into the piece, Highstein offered poles that were concerned with adjusting the already available space for perceptual visibility – and so, with cultural reclamation.)

Some of Highstein's line drawings are passive in this way. Others deploy line differently, including an early drawing in the collection of Richard Nonas. Splayed from a rectangle are lines we infer as depicted planes, and these simultaneous views of top and bottom help to describe the Cubist illusion implicit in an ensemble of lines.

By the late 1970s solid planar mounds that derived in part from early modern geometry and in part from anonymous sculpture that was found in the country and city preoccupied the artist, and his drawings reflected these preoccupations. Anonymous forms attractive to Highstein include such urban features (in this case, commonplace in Italy) as granite mounds set at discrete, regular intervals that close a street to vehicular traffic. These barriers to all but

pedestrians articulate the street by indicating permeable boundaries. Once adapted as sculpture by Highstein, these mounds could be considered to be some of the artist's contribution to Minimalist art's prefabricated functionalist logic, except for the fact that Highstein shapes them by hand and so reclaims them for attuned essentialist form. *Totem*, the title of a drawing of such a mound from 1979, for instance, submits Minimalism to the aesthetic of modern minimalism.

Large untitled drawings from the mid- and late 1980s engender forms growing out of the shape's internal diagonal axis. These ovoid densities hold the flat space with palpable authority. Perhaps because the dynamic diagonal activates the ground yet is buried within the image's irregular mass, the resulting drawings seem to manifest sculptural possibility. They are certainly among the most various Highstein has so far produced.

The 1990s have yielded, in Highstein's words, drawings that issue from sculpture – yet in themselves, they are fantasy. For the waiting room at Grand Central Station in New York City, Highstein has projected a hollow cone large enough to walk into. Not yet built, this proposed structure has provoked drawings which, he has told me, imagine "what looking up from within the interior feels like." What it feels like to Highstein is a linear drawing in negative: All space on the page is black except for the delineated outline at the top. For a creature from Spaceland, the psychoperceptual field seen from below may be disorienting, because viewers have acquired the habit of seeing Highstein's drawings as elevations or plans (when they see them as transcribed from reality at all). The illusionist space is, however, not so much as to seem to be intestinal – and, indeed, the most immediate impression is that of two-dimensional space – made into sensuous fact.

19

Box, Aspects of
Donald Judd

At some point in his quest for sculptural necessity, Donald Judd settled on the box. Why? Or to put it another way, what was the question to which the morphology of the box was an answer?

As is often true of the artist mindful of modernity, the question to which "Box" is the answer concerns definitions and narrations that are indispensable to thought – and so it was true of Donald Judd. What is sculpture? This question, raised by the theoretically minded witnesses of art circa 1950, seemed to Judd particularly urgent given that the definitive post-World War II art, modernity's most innovative art, was that of painting. In contrast to the radical manifestation of line and plane in the New York School paintings by Jackson Pollock and Barnett Newman, pictorial sculpture seemed woefully retarded. Under the spell of Surrealism, sculpture was still caught in the process of abstracting symbolic content from nature rather than of thinking with the medium to advance an hypothesis about the nature of sculpture itself. This familiar story of the situation as Judd saw it explains his art-historical sources and the ratifying ethos that drew Judd to define sculpture as he did. The point in noting it again is to establish the cultural motivation for subjecting sculpture to what is no less than an aesthetics of definition.

"What is necessary and sufficient to sculpture?" That, in effect, is how early modern artists had phrased the question, and for reasons I shall discuss later, to another question – "What is sculpture?" – Constructivists had answered, "Volume" (or, alternatively, "Materials articulating actual space").[1] If sculpture is an object occupying three dimensions, then mass is not needed to establish the concept; mass is, as it were, superfluous to the definition of this category of object.

To the same question at midcentury, Judd initially put forth artworks at odds with the very Minimalism that his work would later typify. In view of the peculiar works he did contrive, the question posed might have been closer to the following: "What radical paint-

ing done at midcentury is the sculpture most answerable to?" This is the question that is called to mind, given that the artworks he produced labored, on the one hand, to translate the optical nature of color into tactile surfaces and tactile surfaces into reliefs and, on the other, to transfer reliefs from their rightful place on the wall, which was the domain of painting, to the floor, the conventional place for sculpture.

Before 1964, then, Judd resisted sculptural self-evidence. A rigid flocked red surface into which a metal wedge had been stuck is one such object. An inclined plane, also red, on which a grille stood vertically, is another. The first is a painting by default, because it hangs on the wall; the second is a sculpture by virtue of its standing on the floor.

Verbal descriptions such as these reveal how much Judd was thinking about hybridizing the nature of aesthetic categories. These descriptions also demonstrate to what lengths he would initially go to circumvent self-disclosing self-evidence, the objects being contrived to resist any familiarly named thing.

Descriptions can render these objects more familiar only by relating them to formal, stylistic, and art-historical niches. Given that surface is decidedly one formal dimension deemed essential to painting, a reasonable description of an early Judd "painting" might read: "an entity that willfully 'triangulates' the opticality of Barnett Newman's virtually uninterrupted red color-field expanses with the tactility of Yves Klein's flocked monochromes to acknowledge the dichotomous resolution proposed in the surfaces made deep in Jasper Johns's series of 'Flags.' " What Judd meant by the term "specific object" may be a compound of philosophical simples, yet certainly in the aggregated whole, neither the term nor the object it indicates is culturally simple.

Again, compared with the categories of aesthetic knowledge that teach us to respond, say, "equestrian figure," to certain conventions in sculpture, these entities by Judd are other. Early works by Judd are calculated to defer recognition of the given and to call forth an experience of a different sort: notice without a name. At any rate, if one assents to encountering a sculpture by Judd prior to 1964, it is toward no familiarly named thing. Considering the runged inclined plane, corner piece, or dentilated relief, one notes only, "What is it?" That is to say, these objects are peculiar and unhomely in shape despite their use of materials that are commonplace. By pointing and asking, "What's that?" the bemused spectator prompts an ostensive

definition by way of response. To this question, a legitimate answer might be: "I don't know, it's a thing. A thingamabob."

Meanwhile, the species of thing Judd is laboring over is very different from the sort of thing respondents to the New York School – conspicuously Jasper Johns – put into play. Recall Johns's *Target with Four Faces* (1955). Here is an object that violates the principle of aesthetic integrity by bifurcating painting and sculpture – the latter represented by a series of casts of sightless faces. On this aesthetic enigmatic entity about the yoking of antagonistic activities in art, a piece of Heideggerian thought may be brought to bear:

No matter how sharply we just *look* at the "outward appearance" of Things in whatever form this takes, we cannot discover anything ready-to-hand. If we look at Things "theoretically," we can get along without understanding readiness-to-hand. But when we deal with them by using them and manipulating them, this activity is not a blind one; it has its own kind of sight, by which our manipulation is guided, and from which it acquires its specific Thingly character.[2]

An artifact rich in implication, *Target with Four Faces*, together with its companion *Target with Plaster Casts* (1955), urges an interpretation accommodating this Heideggerian view of things. The very constructed aspect of these paintings, which promotes the notion that making a painting (being more than a pun) actually entails physical work and the handling of materials in ways accountable to the medium, has been said to be ironic because it is literal rather than metaphoric in nature; but these works by Johns sustain both metonymic and metaphoric readings at once. As Johns will argue through these and later works – works to which a hammer, ruler, paint, brush, and "turp" can are attached – the immanence of the art object depends on the artist's cognizance of the physical nature of the medium of the thing that is redescribed for this purpose as "the work" or "the work-in-process." The embedded nature of work is not always ironic in Johns, whether the work takes the form of physical activity or mental cognition.

Without resorting to the mysterious or the dreamlike symbol, an artist may conceive a semantics of artifactual content that is no less present in the world for being between categories or genres – or for being known in its parts yet elusive in its totality. Rauschenberg's assemblages would qualify[3] – so too, at his formative stage, would Judd's artifacts. This is precisely strategic on Judd's part, even if the artistry of materials is crude, because installing such a (nameless)

object where a sculpture should be compels the viewer, whether critic or connoisseur, to resort to description.

Description in lieu of a name accomplishes several aesthetic and philosophical goals. Description insists on the material or structural foundations of form; not being taken for granted, description sets forth the meaning of the work in terms of a direct experience. Then, too, rendering an object by reducing it to phenomenological description postpones that sort of classification through language that would substitute for engaging with the palpable object itself.[4] In fact, Judd's material description of early artworks says as much. "Light cadmium red on wood with black enameled metal pipe," he said, identifying a work from 1962 (see Figure 31).

Let us substitute this description: "Wooden angle painted cadmium red supporting an opposing black pipe." This description also allows the possibility of fixing a reference where "Untitled" and even the single convenient name or concept "volume" or "sculpture"[5] is insufficient to fix a reference. Common building materials in simplistically concrete syntax manifest a rude actuality that the Productivist Vladimir Tatlin and his Constructivist nemesis Naum Gabo could both appreciate. In contrast to Tatlin's *Corner Counter-Relief* (1914–15), Judd's piece may be reconfigured verbally as follows: "a structural reduction in answer to Tatlin." (See Figure 32.) This analytic description of Judd's work posits stylistic context as content. At any rate, art-historically grounded works by Judd lend intention to Judd's form language, however naïve at this point. One thinks of Gabo and his allusion to the definition of sculpture: "It [i.e., 'abstraction'] is always stated as a reproach that we form our materials or abstract shapes. The word 'abstract' has no sense, since a materialized form is already concrete. . . ."[6] Sets of descriptions concerning the peculiar objects that Judd has put in place, then, reveal the common ground of meaning through certain properties: three dimensions implicating volume arrived at through construction.

A three-dimensional entity general enough to be considered an object like any other undergoes conversion to specificity when actually built, and it is meant to frustrate an essentialist reading of squareness or redness – or even of volume. Even when sculptural definition is at stake, "the art of three dimensions" is an ontology the generalizing essence of which, Judd hopes, must be apprehended in actuality. Even when definition is at stake, the sculptural entity that Judd has contrived as a way to sabotage definition calls forth descriptions that labor to name a definitive ontology – and fail.

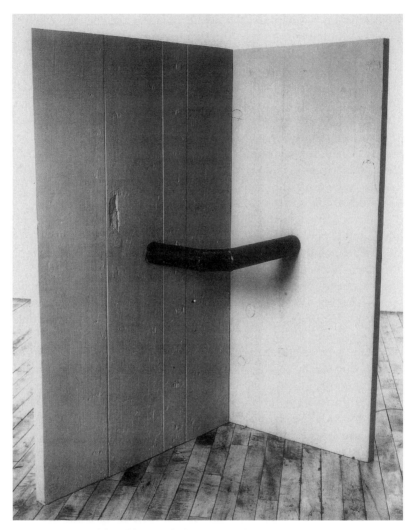

Figure 31. Donald Judd, *Untitled*. 1962. Light cadmium red on wood with black enameled metal pipe, 48 × 37⅛ × 21⅜ inches. © Estate of Donald Judd/Licensed by VAGA, New York. Courtesy of the Donald Judd Estate.

In 1964, the not-yet-boxlike thing soon undergoes a conversion to the standard form of itself. Replacing the unhomely morphology of early work is the shape of a box, one specified through industrial materials and manufacture. Aluminum, Plexiglas, and plywood – the materials are intended to qualify the general and universal shape:

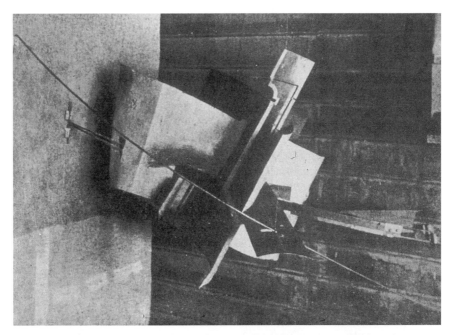

Figure 32. Vladimir Tatlin, *Corner Counter-Relief.* 1914–15. Mixed mediums. (Whereabouts unknown.)

Materialism adjusts Idealism, and the ordinary language of manufacture qualifies the language of form. In contrast to Judd's earlier works, the box is conspicuously commonplace. Indeed, this neutrality is the point.

What the box loses in interest, however, it gains in a paradoxical aesthetic indifference (see Figure 33 on p. 233). Initially, a box that elicits mere notice helps neutralize the aesthetic encounter, and the Minimalist box obliges the viewer wandering through a gallery to cope with this sort of aesthetic. To cover for concepts arrived at experientially after the fact, the viewer assents to the three-dimensional item by virtue of having named it. "Cube!" she says – or "Box!" – remarking that it is like a container of some sort.

Perhaps because all "cubes" and "boxes" tend to be treated as though the meanings of these words are interchangeable, the language employed to represent the cube that Judd constructs is carelessly applied even though volumes of precisely cubic dimension rarely appear in his oeuvre. The word "cube" or "box" may suggest itself because these names are handy. Then, as Quine says, since the

universals of language when translated into things become essentials,[7] we might carelessly assume that by naming the thing we are free to manipulate language to ascertain and investigate the essential nature of the thing. Words replace objects of experience; and with Judd's objects, which feign synonymy with the "cube," words replace objects readily. Thus, to frustrate this synonymy, Judd adjusts the proposed object so that it falls between names and categories of reference. Put another way, as in Adorno's cultural theory, the irreconcilability of concept and object is integral to art; and thus deliberately exploited by Judd is the dimensional conundrum of the not-cube and the unboxlike box relative to the essentializing words of "cube" and "box."

"What is sculpture?" Fundamentally speaking, this is the question to which Minimalism gives no simple answer. If Minimalism addresses the issue of definition and supplies a consideration of the essential and minimal condition for some thing's being an artifact, then Judd addresses the essential condition that is at once more general and more specific than sculpture traditionally speaking, and he builds a three dimensionally constructed entity, one concretized precisely by virtue of the fact that it is formally and materially at odds with the type of object this entity is most like. His box is coded as a sign, a sign that signifies what the ordinary box has in common with the essential sculptural object from which utility has been withdrawn. Furthermore, despite being simple in shape, these works of Minimalism are not simply shaped: They are not carved or modeled toward an emerging unity.[8] They are constructed – indeed, they are often fabricated – according to plan. The content of the form is informed through this material difference. It is what separates Minimalism and its concern for definition from Minimalism and its pursuit of revelation.

<p style="text-align:center">✳</p>

Speaking conventionally, we might say that functional relations assume the constitutive link between part and whole. As the doctrine emphasizing the practical utility of the necessary relations in form, functionalism has had a long and aggravated role in the history of art, yet it is no less significant for all that. Its topics include form well adapted to use, the contest between rationalism and empiricism, the compelling idea of the architectonic, the critical impact of industry on technology, and the language of design. These topics, among others, are perennial concerns of the cultural history that would investigate the practical dimension of art.

Aesthetics has a long tradition of favoring utility over beauty, a

tradition that dates back to the Greeks – most notoriously, to Socrates. As the story goes, Socrates, who was stupefyingly ugly, was prepared to argue that he was more beautiful than Critobulus by virtue of the utility of his features. Once Critobulus established that, like a sword or a shield, features are beautiful insofar as they are fit to their purpose, Socrates maintained that he himself was much more beautiful than his adversary. His reasoning: Whereas Critobulus had eyes that looked only straight ahead and a nose whose nostrils were directed down, these features were, evidently, less well adapted to their purpose than his own, because his eyes could scope from side to side and because his nostrils turned upward to take in all smells.[9]

That the dialogue instigated by Socrates was mischievious matters less than the agreed-upon presupposition that utility could rival beauty on its own ground. The significance of this position for Minimalism eventually is the assumption that function is good and worthy even as mere beauty is to be disdained – or, rather, that functionalism assumes that beauty should not impede function. Function determines the condition of beauty attained in an artifact.

Functionalism informs a narrative that gives privilege to engineering and to industry – and ultimately consecrates industrial design. From a certain perspective, then, the history of technology coincides with the history of utility as a Minimalist alternative to that of biology that the early modern artists had found adaptive to sculptural definition. As brought into prominence through Roman engineering and passed on subsequently as a value during the Industrial Revolution, functional use informed the aesthetics of modern Constructivism – and especially the Productivism that is antagonistic toward making art that is not immediately useful. Whether or not Judd's personal account of his coming of age acknowledges it, a collective history of functionalism's fascination with tectonics constitutes a compelling cultural antecedent for Minimalist materials, procedures, structure, and symbolic form.

Elementary procedures constituting an elementary form of language of tectonics had already been proposed in the mid-nineteenth century, when Gottfried Semper laid out a materialist theory of meaning. With his taxonomy of material, technique, and function, Semper shows constructive principles at work, just as carpentry discloses the form of its making in structures rigid yet moveable, or as weaving reveals its constitutive element of knots in series.[10] In this sense, handicrafts are generative technologies.

Transposed to the Industrial Revolution, technology became a

value – and, perhaps, an end in itself. Under certain favorable circumstances of history, unadorned industrial technology proved to wield more aesthetic purpose than much of the fancy Victorian painting and sculpture that had been made for the purposes of beauty. It is in this spirit that the Crystal Palace of 1851 suggests itself as an antecedent representative of the vernacular of utility put in play as industrial design and adapted a century later by Minimalism.

The beauty of the Crystal Palace aside, the sheer concentrated practical inventiveness remains culturally significant. Architectural historians note that Paxton's design won the patronage of Prince Albert because it proposed that building in glass and cast iron "required no massive foundation,"[11] while its pioneering prefabrication allowed for the erection of the exposition hall with all due speed. Preconceived rather than constructed on-site, modular prefabrication expedited matters even as the process shifted from creativity on the site to creativity on the drawing board. To put it another way, we can say that the augmentation of the greenhouse to the size of the exposition hall did not take place by rote scaling up but by reconceiving the procedures that could allow for the timely appearance of a credible public structure.

"What is a form of sculpture rendering function transparent to perception?" To ask this question is to appreciate that volume – not mass – will suffice as an answer both perceptually and analytically. Aside from exploiting the functional potential of material, the functional suasion of the assembly line made possible through reliance on the template and module has implications for functional procedure. Utilizing the module of common construction and prefabricated parts to construct a sculpture surely indicates Judd's intention to align his artifact with the history of ideas that attaches the modern to mechanical and architectural form. For Judd's work, as for Minimalism in general, the first machine age of 1900, with its "predisposing causes,"[12] allows us to speculate on the relation of material to procedure as well as on the relation of both of them to intended cultural meaning. With what tradition would the Minimalist artifact find the best fit? The answer: the tradition to which aesthetic functionalism (formalism) is determined in alignment with the history of the idea of utilitarian functionalism. This formulation does, at any rate, suggest a plausible answer.

The question of whether utility should be actively promoting aesthetic or practical ends reached an ideological crisis in Soviet Russia, with Constructivists and Productivists staunchly dialectical

on this issue. Constructivists believed that a form of liberated work must accompany the aesthetics of utility. The engineer Naum Gabo recalls shouting matches between those like himself, who believed that aesthetic and practical forms of utility should be kept distinct,[13] and others representing Tatlin's Productivist view, who wanted them merged.[14]

(The implications of literal and phenomenal materials and their construction are exemplified in the notion of transparency. Glass displays its quality of transparency and promotes the value of self-evidence in formalistic structures built by the former engineer Naum Gabo. Edge disembodied in a sculptural line and planar transparency answered in opacity both emphasize the design of an implied volumetric – not massive – three-dimensional space. Or should one say, a three-dimensional visualization of what [Gabo hoped] would be understood as constructing mathematical surfaces? Line developing into curved surfaces meant to be analogous with topological space distinguished the utopian aesthetics of Gabo, his brother Alexander Pevsner, and El Lissitzky from the utopian utility defended by Tatlin, Rodchenko, and Stepanova. Contesting the territory of transparency for rational or, alternatively, empirical, ends remains an ideologically freighted theme of the era. Meanwhile, transparency as a problem of knowledge manifests itself in the Cubist superpositions of transparent planes.[15] This Cubist method is directed toward creating ambiguity, not self-evidence,[16] despite structures that open the interior to view. Interior on a par with exterior formal structure will, however, promote a formal clarity not only in Picasso's paper construction of a guitar, the "sound box" of which is open to view, but also in Tatlin's constructed reliefs for which the Picasso had been a provocation.)

Whether functionalism should be purely aesthetic and kept remote from matters of utility or rather the opposite – a manufacture that advocates no art but that which aims at utility – inspired many manifestoes and urgently proclaimed calls for action in short-lived magazines. *Veshch/Gegenstand/Objet*, initiated by El Lissitzky and Ilya Ehrenberg in 1922, promoted a theory of art for the new Constructivist object that did advance an international discourse on languages of functionalism at the expense of mere utility. One of its editorials proclaimed,

Objet will take the part of constructive art, whose task is not to adorn life but to organize it. . . . Obviously we consider that functional objects turned out in factories – airplanes and motorcars – are also the product of genuine art. Yet we have no wish to confine artistic creation

to these functional objects. Every organized work, whether it be a house, a poem, or a picture – is an "object" directed toward a particular end. . . . Primitive utilitarianism is far from being our doctrine.[17]

To gauge the meaning of Minimalism years later, one looks to how the artist or his or her artifacts weigh in on this issue. Indeed, in the 1970s, although he had set out to design furniture in a domestic habitat that he controlled, Judd himself would legislate against exhibiting his sculptural objects together with his applied objects. But the ideological content of aesthetics does not resolve itself here: Of chief importance in understanding Minimalist form is noting Judd's struggle to synthesize aesthetic and practical traditions within the object. How a box can be made to signify varyingly weighted practical – then rational – content is something that qualifies the object throughout Judd's career. A formalism that produces an empiricism in tension with rationalism is decidedly the energizing, creative content animating Judd's work.

The significance of recalling the above episodes from the history of the idea of functionalism for Judd is decidedly this: To see indicated relevant episodes from this history is to appreciate a notion of functional form that is antecedent to Judd's, one that will come to supersede the artist's own immediate actual history (with its exposure to Johns's work), and to which his aesthetic more and more conforms.

<p style="text-align:center">✳</p>

What was the question to which the morphology of the box was an answer? Can the functionalism of form find a vernacular? More precisely, we can ask, "Can the functionalism of form find a vernacular grammar both worthy of yet resistant to utility?" (See Figure 33.) If restating a problem causes alternative solutions to emerge, perhaps, then, restating the terms reserved for geometric figures would disclose a vernacular domain in which modern functionalism would remain uncontradicted.

A sculpture, then, might be described as an object drawn from daily experience, one distinguished through its relation to function. A box appearing under this pragmatic auspice satisfies the required vernacular contextualization. An artifact of basic construction, a box represents a piece of fabrication well within reach of common skill, and this elementary handicraft lends further vernacular reference to the sculptural form chosen by Judd. (The relation of the way

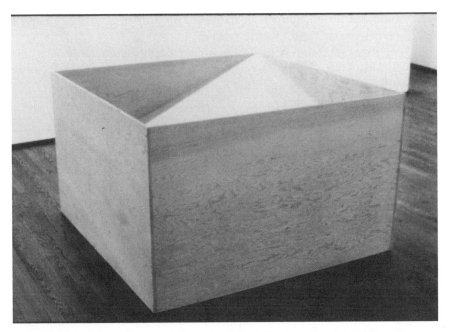

Figure 33. Donald Judd, *Untitled*. 1976. Plywood, 5 × 3 × 5 feet. © Estate of Donald Judd/Licensed by VAGA, New York. Courtesy of the Donald Judd Estate.

something is made to the function it serves will be an aesthetic that is self-consciously adopted by Minimalism and exploited by the procedure-driven post-Minimalist artist throughout the 1960s and 1970s. Immediately, those forms that are transparent to their production will favor materials and procedures associated with building construction. This is what Judd had done when he elected to make a corner construction of wood connected by pipe in order to make manifest the "arts" of carpentry and plumbing. Consistent with this emphasis on the building arts are works by the Canadian artist Jackie Winsor, who has shown nails driven into stacked laminated plywood, board bound and repeatedly wound with hemp, and other works that display work rather than craft.)

Finally, the vernacular may be said to reside in the synthesis of skill for practical ends associated with the philosophy of American pragmatism (and John Dewey in particular, whom Judd had read with interest). Not to lay too much emphasis on this aspect of the vernacular, given that his studies in art history at Columbia University would emphasize European tradition; nevertheless, the artifacts

Judd did produce invoke a nativism, the sort of industrial design a homespun carpenter would produce.

Relocating to Marfa, Texas, in 1971, and subsequently designing furniture gave Judd the opportunity to investigate prototypes of vernacular volumes and their manufacture.

Later on, he recalls,

In the middle eighties I wrote that in the middle sixties someone asked me to design a coffee table. I thought that a work of mine which was essentially a rectangular volume with the upper surface recessed could be altered. This debased the work and produced a bad table which I later threw away. The configuration and the scale of art cannot be transposed into furniture and architecture. The intent of art is different from that of the latter, which must be functional. If a chair or a building is not functional, if it appears to be only art, it is ridiculous. The art of a chair is not its resemblance to art, but is partly its reasonableness, usefulness and scale as a chair. . . . A work of art exists as itself; a chair exists as a chair itself.[18]

Conspicuous here is Judd's initial impulse to derive specifically functional objects from a kernel of function, however estranged from literal instrumentality that functional design might be. Also significant is his subsequently learned insistence that the aesthetic and practical ends for objects be kept distinct. Like the Constructivists rather than the Productivists, Judd comes to define the aesthetic object in terms of functional resistance – that is, intelligible construction in tension with mere use.

Once Judd begins to design furniture, he still exercises a form of language derived from deploying horizontal and vertical elements that describe some version of a volume. Meanwhile, table, chair, bench, and bookcase – all invite a consideration of the vernacular volume familiar enough to be taken for granted, functional enough to entail use, and formal enough to perpetuate a lexicon of relations (open and closed, left and right, top and bottom). Whether or not Judd ever was an interesting designer of furniture, he showed a studiousness toward the box both as a reduction and for its structural potentiality. Implicating a life-world if necessary, the basic rectangular volume may move into a pragmatic set of relations, for example, simply by lengthening a vertical surface to articulate the back of a chair.

It is interesting in this regard to consider the furniture manufactured under Judd's direction as the pragmatic function in objects against which the boxes – specifically, the plywood boxes with de-

pressed and/or angled "lids" – are containers rendered unpragmatic. Functionalism for nonfunctional ends defines aesthetic function in Russian Futurism and the formalisms it continually inspires, so that the functional lid rendering the container opaque once it is disposed diagonally seems to be a stylistic and historical homage to the early Russian visual language even while exercising its structuralist prerogative. In 1976, when Judd put on exhibition the first group of his plywood boxes, he announced not simply a change in material but a lucid configuration of Constructivist structure by which the recessed surface made opaque the transparent instrumentality of the box as practical container.

(Doubtless, the formal logic of structuralism aided the semiotics of reference embedded in the common type. In Le Corbusier's concept, the *object-type* resides in the "classic" status attained in design through which the designer recuperates a lost vernacular. Conferring the status of *object-type* on machine-made objects of daily use that have become commonplaces would seem to have little in common with Judd's furniture except insofar as the ordinary cardboard box or plywood crate or air-conditioning duct informs fundamental material and formal conditions in vernacular volumes of tables, chairs, and bookcases.[19] The standard in furniture seems to be Judd's goal: "reasonableness," as he calls it. Even so, Judd is not alone in his interest in the type; during the 1960s, notes Alan Colquhoun, the type as preexistent form was a preoccupation of Neo-Realist architecture.[20] Meanwhile, Minimalism in general tried to understand the principle of standardization and other aspects of functional form in order to criticize modern art from within [since, as Colquhoun argues, the rote application of modernism had left modern art vulnerable to postmodern critique from without]; structuralism provided that means of internal critique.[21] Given an interest in the vernacular, Minimalism favors the "box" rather than the "cube." At least, the modernist "box" would accommodate the requirements of sculpture better than the new-fangled postmodernist "shed." Throughout his career, Judd seems determined to resist postmodern revisions of objects.[22])

If a sculptural object is to be deemed transparent to what it contains, then what does the box transparent to sculptural function contain? A self-displaying thing, the box manufactured according to Judd's wishes becomes, during the 1960s, a sort of container for hue and light; then, in the 1970s, the box becomes occupied with structured relations.

Since Reinhardt, Newman, and Klein had each proposed a material condition for the sheer optical intensity of light – a phenomenon reconceived with industrial means by Dan Flavin and others a decade later – and demonstrated the implications of chromatically saturated environments to advantageous ends, Judd could hardly be expected to ignore these strong exemplars of the art of three dimensions in his own research. Color-field and Minimalist artists alike could take advantage of environmental color that, nonetheless, did not owe its structuring of transparency to Cubism.

That is to say, during the 1960s, when light fixtures articulated the corners of rooms and otherwise augmented the palpably environmental possibilities inherent in color-field painting, the interiors of Judd's boxes, selectively articulated in color, also sought to create light-filled space. Conspicuous in this way are the wall Stacks, a vertical series of cantilevered frames mounted on the wall, their interior shafts of light initiated from the gallery lights above. Optimally a column of hued light apparently binding the physically discrete series of boxes cantilevered from the wall, this colored ether, a surrogate for painting in the industrial age, displays properties that dramatize the normative polarity between optical painting and tactile sculpture within a single artifact.

Then, in the 1970s, Judd's boxes began to demonstrate another sort of self-disclosure. Functionalism under the structuralist aegis shows itself as a display of opposing relations of the series' interior elements. Returning to the arithmetical order he had been using, Judd now extracts from it a formally plotted composition consistent with the cultural moment. Internally partitioned in simple series to reinforce this logic were boxes mounted on the wall that were preoccupied with relating variable orders within the interior of the box to the fixed modular exterior. A logic of operations guides the sequence introducing the parts of the interior: An internal partition first installs a median, then a second partition (oblique or not) placed right of it establishes itself as half as much, and a third partition (oblique or not) left of the median establishes itself half again in the last box in the series to reveal a division into fourths. A kind of *brise-soleil* for structuralists plays itself out in conceiving form. The assumption that there exists a reality born of a logical structure may be seen throughout Judd's oeuvre yet is particularly pronounced in the 1970s when binaries of tilted and untilted louvers partition his plywood boxes. Judd has said, "Take a simple form – say a box – and it does have an order, but it's not so ordered that that's the

dominant quality. The more parts a thing has, the more important order becomes, and finally order becomes more important than anything else."[23] In 1964, when Judd made this comment, his concern was to avoid those kinds of compositional orders suggestive of the figure. By the time he died in 1994, Judd had allowed a variety of alternative sources for ordering parts to wholes into his constructed work: from industrial design to a "linguistic" object.

What is the question for which the articulated box supplies an answer? What sort of construction will allow for reference to normative structures in discourse redeployed intelligibly for art? In Judd's late work, function has become tempered with the logic of formal and informal operations of all kinds. Note the contemporary milieu of conceptual artifacts advancing syntactical arguments ranging from randomness in heaps and scatterings, to literal arithmetic measurement, to the logic of groups. All this experimenting in intelligible structure suggested modes of ordering the interior of the rectangular volume.

Meanwhile, by shifting from color to rational measurement, Judd is able to accomplish a dematerialization of the box's interior by converting aesthetic to cognitive structure. At least, he brings these aspects into equilibrium. Late series feature boxes hung horizontally so that the interior rear lapidary surfaces can be seen past the structurally deployed partitions (or viewed even as the partially open front surfaces expose the interior to view). In this way, measurement and proportion can retain their rational content, satisfying the aesthetics of Classicism[24] while bringing the functional nature of use into the domain of a functional language.

20

Quality Through Quantity
Donald Judd

Together with Robert Morris early on, Donald Judd was long set on reallocating aesthetic content toward the radically commonplace. In this particular yoking of opposites, Minimalist art declared for extremity and neutrality at once, even as it sought to clarify the language of abstraction through ordinary form. Theoretically, both Morris and Judd put modernity at the service of the vernacular. In the spirit of the age, Morris's "Notes on Sculpture"[1] engages the definition of sculpture, and within an orderly historical and theoretical approach, it lays out the minimal analytic conditions under which sculpture exists. Judd, in his position paper "Specific Objects,"[2] is severely oracular rather than systematic, and as art critic, he gives judgments.

Reviewing Robert Morris's work in the 1964 group exhibition *Black, White and Gray* – a theme he finds dubious – Judd shows respect for Morris's aggregate of gray blocks (see Figure 34). Of these elements, which roughly approximate a portal, open square, column, and slab, he writes,

Morris's pieces exist after all, as meagre as they are. Things that exist, exist, and everything else is on their side. They're here, which is pretty puzzling. . . . Things exist in the same way if that is all that is considered. . . . Everything is equal, just existing, and the values and interests they have are only adventitious.

Morris's objects seem to express this flat, unevaluating view. Western art has always asserted very hierarchical values. Morris's work and that of the others in this show, in different ways, seem to deny this kind of assertion. This attitude has quite a few precedents in this century, but this work is the most forceful and the barest work so far. This is all good, but these facts of existence are as simple as they are obdurate – as are Morris's objects. I need more to about and to look at. *Slab* is the only one interesting to see. It is about eight by eight feet across and a foot thick and is supported a few inches off the floor. The space below it, its expanse – you are displaced from sixty-four square feet, which you look down upon – and this position flat on the floor are more interesting

238

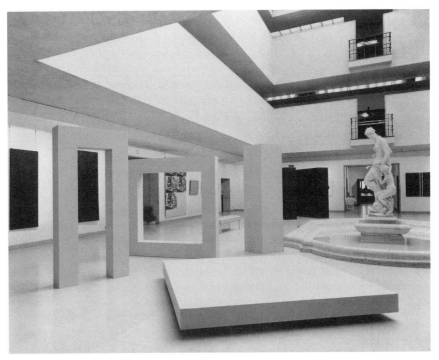

Figure 34. Installation photograph of *Black, White and Gray* at the Wadsworth Atheneum, Hartford, Connecticut. January 9–February 9, 1964. Photograph courtesy of the Wadsworth Atheneum Archive, Hartford, CT.

than the vaguely sculptural and monumental upright positions of the other three pieces. Most of the things in Morris's recent show were more specific and complex as ideas. This made their scant appearances more relevant.[3]

At least in the context of an emerging Minimalism, Judd's review of Morris's work is instructive to the extent that it reveals the values that attach to a description of the commonplaces of form. On two counts, then, the issue of quality enters into Judd's criticism: The nature of aesthetic resistance to the known category of sculpture may be gauged through decisions that are made concerning an object's primary and secondary qualities, and the fact that this resistance is meritorious. Moreover, a sort of ordinary language inhabiting three dimensions, Morris's pillar, slab, and portal support Judd's interest in the fundamentals, as well as an objective formalism shorn of subjective phenomenal perception and taste.

Meanwhile, Morris may well have had behavioral ambitions for his objects. As though drawn from a Wittgensteinian lexicon of forms, "slab" and "pillar" are names of objects that accord with those constructed entities that Morris had fabricated for the exhibition, entities that were initially reviewed by Judd in 1964 for the periodical for which he was an art critic, *Arts Magazine*.

Wittgenstein's ruminations on elementary language seem particularly apt for the task Morris is setting out to accomplish. Wittgenstein wrote,

Let us imagine a language for which the description given by Augustine is right. The language is meant to serve for communication between builder A and an assistant B. A is building a building with building stones: there are blocks, slabs and beams. B has to pass the stones, and in that order in which A needs them. For this purpose, they use a language consisting of the words "block," "pillar," "slab," "beam." A calls them out; – B brings the stone which he has learnt to bring at such-and-such a call. – Conceive this as a primitive language.[4]

That is, "slab" and "pillar" are names for those basic linguistic morphologies corresponding to things, things now static yet potentially activated should there be a need for them. Indeed, the sort of artifact Morris soon pursues is a behavioral extrapolation of elementary language. By the late 1960s, as an initiate in a world of performance already exploring a language of actions and comprehensively about movement as such, Morris performs a basic protocol. As early as 1961 he does induce simple actions: On stage, a pillar falls.

Judd's critical writing on Morris is striking. If Minimalism intends a leveling of sculptural meaning toward elementary propositions of unevaluative existence, on what grounds do some "minimalities" do it better – or how are their pieces more interesting? If all boxes demonstrate self-evidence, why should some be more transparent than others – and in some instances be more compelling – whereas with others that are opaque in regard to the self-evidence of the box, their very opaqueness or obliqueness seems worthy? Certainly, if all Minimalism is treated alike (as it is by some critics), then the issue of merit should not matter. But according to Judd, some art is interesting and some less so. However committed to the principle of economy, Judd is dissatisfied with art that merely acquits itself as good gestalt. Unless matter finds a form that

speaks to a conceptual framework for the already colonized history of sculpture, he seems to say, even a low geometric volume deviating from sculptural habit does not present itself with sufficiency.

<center>∗</center>

What I want to propose is that quality plays a decisive role in determining the calculated neutrality of quantity at work in Minimalist objects. However flat and unevaluating, the content of a form we recognize as a box by Judd comes about through the superimposition of rival orders in one object. By inserting unlikely arithmetic sequences into geometric shape or by prolonging the fascinated courtship of utility by beauty, Judd introduces complexity, and the caliber of the aesthetic engagement with modern sculptural theory is raised as an issue. Inexpedient yet constitutive form results from the effort to import structural and functional formalisms from nonaesthetic sources. In other words, by defining contemporary sculpture by what it is not – it is not statuary – Judd accomplishes something else: Through the tactical friction of cognitive contents and aesthetic expectations, Judd proposes that neutrality can be arrived at positively, through what sort of three-dimensional proposition sculpture *is*. At least in Judd's scheme of things, sculpture is an object for which extension and number as primary qualities obtain yet for which secondary qualities – such as color, light, and texture – are brought forth in subordinate roles. How the extension of space shows sculpture that aspires to the condition of an object is our concern here.

The cognitive inference patterns that result from superimposing arithmetic number and order on geometric volume serve not only to locate Judd's sculptural contribution art-historically, but they also serve it categorically, for quality abides in the significant strategy and tactics deployed in the name of sculptural definition.[5]

<center>∗</center>

Minimalism conducts itself with urgency. It finds the question "What is sculpture?" to be a pressing art-historical issue with which the artisan has no choice but to engage, leading him or her to commit to an answer. As with the theoretical-minded New York School, which took a retrospective glance at the twentieth century to see what could plausibly follow Cubism, Minimalism, in turn, takes issue with the art of the New York School. Minimalism is an

agonistic enterprise, then, precisely because it cannot conceive of being indifferent to modern art. Yet Minimalism is traditional in its aesthetics as well. Starting with the integrity of an object – in its distinctness from its surroundings whereby "your mind first of all separates the basket from the rest of the visible universe"[6] – Minimalism shows itself to be pressing for the implementation of a certain classical intelligibility. Even so, Minimalism is progressive, because it looks for significant plot lines in the modern era and attempts to follow these consequentially with regard to sculptural definition and necessity; Minimalism is also essentialist, less for what it can strip away through a process of intuitive streamlining than for what it proposes to be intrinsic to sculpture *qua* sculpture.

Judd's hypothesis is that before all else – before being a nude, a battlehorse, or an anecdote – a sculpture is a *thing*. The idea of the artifact as obdurate thing is, for Judd, a far more interesting claim than the notion of simplicity that most viewers believe Minimalism to be about.

Once boxes appear numerous from 1964 on, it is as though the unevaluative were being offered as value, the box being the scheme for the ordinary content. The functional bias in Judd would cue us into discerning a shift from the earlier work, work featuring shape as interesting (thanks to its nonstandard features), to the shape neutralized to allow materials, size, and noncompositional order to assert themselves. It should be repeated that variety in shape is soon eliminated, uniformity is enhanced, and morphology in Judd's art is an issue only to the extent that it abides in the choice of the box. The box is a constant in Judd, whereas shape as a variable aspect of gestalt remains exploratory in Morris.

Dissonant intentionalities reveal themselves in Morris's and Judd's early position papers on the new aesthetic. In the first of his "Notes on Sculpture" (1966), Morris assumes that a definition of sculpture is still possible – that sculpture separates itself from things in extension by virtue of an essentially three-dimensional space, because two-dimensional surfaces in color remain the distinct and separate domain of painting. That the contemporary moment derives its aesthetic from Constructivism, specifically that of Naum Gabo and Vladimir Tatlin, is, to Morris, obvious. Morris's principled stylistic history seems intended to answer Judd even as it is meant to remind the public of the ground rules of modern art. Meanwhile, in "Specific Objects" (1965), Judd advocates those contemporary objects that, against proscription, attempt to combine

painting and sculpture; for this example he is grateful to Barnett Newman and Jasper Johns – yet also to Yves Klein. Although Judd himself may have denied owing anything to Europe, his art is already entailed in an aesthetic dialogue with industrial engineering and functional formalism. With major works of Cubism, Constructivism, and De Stijl on view at the Museum of Modern Art in New York, an institution frequented by Judd while he studied art history at Columbia University, access to the comprehensive principle of design and the ethos of constructed volumes entailing surrounding public space could be obtained with ease.[7] Judd eventually does art directly acknowledging stereometric and other rationally built objects – primarily from Constructivist sculpture. That is to say, the sequence progressions within partitional boxes for which Judd will be known are demonstrably attempts to organize space rather than to express a form. The boxes will show themselves to be built of uniform size, within which a sequence of partitions refuses to attain to dynamic architectonics. Vitalism is not the point.

Modular, anticompositional, and – arguably – holistic, Judd's boxes provide a Constructivist alternative to Cubism by carrying the analytic force of a fundamentally different conception of space. Yve-Alain Bois contends that "Judd's notion of space here is very close to that of Polish Constructivist Katarzyna Kobro."[8] This is a comment he had argued at length: that even as sculpture occupies and shares "the space of ordinary objects," it seeks an aesthetic "union with space" by equalizing (colored) interior and exterior surfaces – the synthesis of painting and sculpture sought by Judd.[9] Structurally direct, sculpture is to realize a unity (rather than a duality, one attained by opposing Baroque forces, say these Polish artists), and this precept also suggests to Bois the compatibility of Władysław Strzemiński's and Kobro's theory of Unism and Judd's doctrine of nonrelational unitary form.[10] Yet if Kobro's works achieve a sculptural union with the surroundings through an open cube given to plasticity, Judd's boxes in series, whether on the wall or floor, separate themselves from their surroundings. Neither do they compose the architectural space of their surroundings; rather they insist on remaining physically distinct. They impose themselves on their surroundings. Again, even assuming that the modern idea of space is arrived at through construction rather than by disclosing a form, we find that the quality of space defined by Judd is neither the *raum* nor that space that the open plan intends to counteract. The entity devised by Judd contains space as an object rather than as a work of

architecture – yet it exists as a sculptural infinity extendable by virtue of the module, with its grammar of "structural homogeneity."[11] Depending on the phase, Judd's objects variously construct arithmetic or logical schemes put forth as direct, materially experienced relations. Relative to Kobro's, Judd's boxes are calculatedly intellectualized.

This said, we may add that a progressive attitude further relates Minimalism to Constructivism and modernity at large. Strzeminski writes,

A new form does not spring from itself, but appears thanks to a modification of objective conditions. Hence the necessity for the artist to recapitulate the entire trajectory of the evolution of art, so that he will be able to elaborate in full consciousness the form appropriate to our own time.[12]

This world-historical realism presupposed by Kobro and Strzeminski in the 1920s and 1930s identifies the purposive mission advanced in the writings and art of Judd and Morris alike and renders them answerable to the history of the avant-garde, a movement that emerged in the 1960s. Encapsulating Strzemiński, Bois quotes, " . . . What this evolutionary conception of history legislates is the *quality* of the work of art," for, as the artist says, "it is the quality that is crucial not the quantity."[13] Quality here is *thought relative to the history of ideas*. Whereas Judd's personal history reflects the challenge to synthesize painting and sculpture, the collective history challenged him to define sculpture, and so came up with a working definition of sculpture as a thing comprised of an inside and outside, something ordered intelligibly.

✳

In Judd's enterprise, one, four, ten, or one hundred elements display the material idea of number; and true to this idea, the actual number of elements in Judd's work can be verified – by counting. Qualitatively put, they may be said to translate into the valued concepts of single, several, or many; and where the vocabulary is affective, they can be translated into the concepts of singular, unique; a great number, abundance; quantities. Consider the sheer spatial extension of the works by Judd. It is a striking instance of number being exploited qualitatively.

In any given "Stack," a number of wide shallow boxes mounted high allows a view from within thanks to lighting typically from above. Many rather than few boxes in the stack are necessary, then,

to convey the sense of extension and unity (of boxes that are in actuality separate yet bound optically through an extended inner core of light, a light that tints the wall). Emphatically, the degree of extension, not merely the fact of it, directs attention to the nature of the piece beyond the height (or length) that is needed to establish that the color reflected off top and bottom surfaces is the painterly stuff that allows the discrete sculptural elements to cohere. That is to say, the shallow boxes must be sufficiently numerous to display the arithmetic or geometric progression ordering them. (In the kinds of distributed order in art that came after Minimalism, the spatial extension of materials takes the form of a heap, a mound, or scattering. In Minimalism, the ordering principle for spatial extension is linear if not in an array.) In any event, order, not as refinement but in the sense of a crucial logic informing actual things or the aspects of form seen to be universally derived from the rapprochement of the sciences, is the crucial concept here.[14]

In Judd's sculpture as with Minimalism in general, the basic formal grammar is serial (see Figure 35). The commitments of Post-Impressionist color schemas, the Cubist analysis of an actuality that is manifest in formal elements and redeployed space, and the Constructivist attempt to concretize mathematical equations in actual space – all are perceptual contents made conceptual. Minimalism, by way of contrast, put forth counting or simple measurement, and, as Mel Bochner has written, simple progressions that did not pretend to be mathematics.[15]

Number and order constitute a merely arithmetic tactic meant to overhaul and renovate geometric formalism. *Untitled* (*To Susan Buckwalter*) (1964) shows Judd's intention extremely well. A wall relief of four galvanized iron boxes hanging from a horizontal bar that is painted blue establishes a series; four here is one more than the minimum required to verify a series as arithmetic fact. Why the artist selected four and not three may be a question whose answer can reinforce the serial order and make it emphatic. In a larger sense, this question may further allude to the essential arithmetic operation of counting which, together with correspondence, constitutes basic number sense.[16] (Whether there are more seats than people in an auditorium is easily grasped, and this is an instance of primitive number sense.) Against this bar, Judd has placed boxes in evident noncorresponding formal relation. He has apparently calculated that in its essential discontinuity, number (of boxes) will show itself as a discontinuous flow – thus the presence of the linear blue element,

the manifest *continuity* of which is shown together with the manifest *discontinuity* of the four elements beneath.[17]

A continuum compounded of discontinuous points is among the most persistent of serial forms in Judd's career: Exploiting the notion of graduated sequence is less common. Progressively diminishing lengths of bars (or of hemicylindrical elements) in inverse relation to the progressively increasing gaps between them undo the geometric harmonies by which the West recognizes the presence of beauty, substituting instead that which is unfamiliar. Put qualitatively, the ordering principle is that of interpenetrating "gyres" (the structure ordering Yeats's poem "Sailing to Byzantium").

✳

The occult implication of numbering systems aside, the modular series appeals to artists looking to give palpable, experiential form to a reductive logic of relations. Sculpture, usually a categorical embarrassment to the theoretical-minded in art, may pride itself on being a demonstrable constructivism, because it seems to posit that "every abstract object is specifiable."[18] This, at any rate, would allow for Judd's peculiar term "specific objects" to coincide with the mathematical sense that ranges over numerals, numerals to which specific numbers belong. Red is an abstraction that ranges over cadmium red pale and madder lake, and once Judd determined that selecting particular colors for his objects would not recall the unspecifiable hues expressive of the indeterminacy of Symbolist states of affairs, the general color category was abandoned for specified color. Perhaps the domain of the functional connection in the serial object, indicated by "and," can be so specified.

Pragmatic philosophy provides Judd with another way of thinking about series – to the advantage of sculpture. Two boxes are a set unless the notion of repetition is rephrased in terms of conjunctive relations; then, as William James puts it, their arrangement is characterized as that of "with" or (qualitatively) "withness."[19] In his understanding of Hume's empiricism, James argues that explanatory privilege is given to parts and to particular facts, and he constructs a philosophy from them: "For such a philosophy, the relations that connect experiences must themselves be experienced relations, and any kind of relation experienced must be accounted as 'real' as anything else in the system."[20] Real conjunctive relations treat the notion of "and" as admitting of a gamut of experienced perceptions

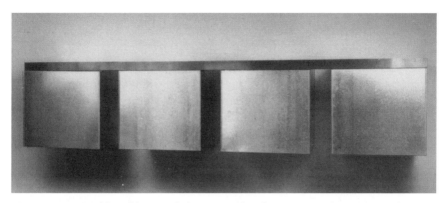

Figure 35. Donald Judd, *Untitled.* 1964. Blue lacquer on aluminum and galvanized iron, 30 × 141 × 30 inches. © Estate of Donald Judd/Licensed by VAGA, New York. Courtesy of the Donald Judd Estate.

that interpret series. To understand Judd's Minimalist syntax for the official material description of an early work, one which reads, "Light cadmium red on wood with black enameled pipe," we find it instructive to follow James further. He writes, " . . . Merely to be 'with' one another in universal discourse is the most external relation that terms can have, and that seems to involve nothing whatever as to further consequences."[21] "With" is the flat and unevaluating term that Judd seeks, unevaluating because most general, relative to which other relations are more specific, in placement, and, perhaps, in value. Or as James puts it,

Philosophy has always turned on grammatical particles. With, near, next, like, from, towards, against, because, for, through, my – these words designate types of conjunctive relations arranged in a roughly ascending order of intimacy and inclusiveness. *A priori*, we can imagine a universe of withness but no nextness; or one of nextness but of no likeness, or of likeness with no activity, or of activity with no purpose, or of purpose with no ego. These would be universes, each with its own grade of unity.[22]

Here lies a justification for Judd's productive "universe" of series expressive of "withness" even as there comes about a universe of sequences expressive of "nextness." Phenomenological intimacy and foreignness will appear in the torqued steel environments of Richard Serra, for instance; and the installations of Dan Graham continue to construct transparent yet reflective domains of personal and public

space to be explored both behaviorally and phenomenally. In contrast to these investigations of the gamut of "withness," Judd's sculpture remains a set of objectified relations. Even so, considering the gamut of conjunctive relations helps to clarify why certain works by Judd seem definitive of their situation while others do not.

Placing one thing after another may be a conceptual machine for producing art whose pulchritude is independent of the eye, but it cannot guarantee perfect results – or rather, its perfect results may not be adequate (see Chapter 22, "Ideas of Order"). Facing a wall with the sculptural equivalent of a grid has been problematic for Judd, as instanced by the installation at 142 Greene Street in 1981; by that time inflected order had been common in his work for a decade. If the point of the piece was to display the idea of a syncopated switching between perpendicular and angled planes, then (however the span may have justified the numbers) the installation of louvered plywood modules seemed excessively extended. To put it another way, we might say that the perceptual difference overall swamped the signifying degree of difference within the boxes – boxes that, not incidentally, were literally contiguous. The optical flicker was devastating to the larger structural order.

Paradoxical though it may seem, this installation raises the issue of the *quality* of the repetition. Almost all works supposedly designed for that same site merely filled it – two exceptions being the inaugural installation by Dan Flavin and the terminal installation by James Turrell. Both men addressed the problem of the gallery's sheer size – the sheer volume of the gallery – by inundating it with light (or the absence of light). Vaporous particles rather than solid planes proved articulate. (Parenthetically, the problem of public sculpture comes to mind. Sculptural things set in public plazas tend to be defeated by scale and by bounds, whereas water and light, the mediums of fountains and street lamps, are not consigned to a diminutive condition.) At any rate, merely filling space does not prove site-specificity; but in Judd's installation, in this case optical where it should have been logical, qualitative issues are raised as a result of the want of reasoning. (Or as Hume might have said, much reasoning is required to find the proper *sentiment*.[23]) Color, materially suited to be pervasive, can easily unify large space (for, as Dewey assumes, what is sought is the intuitive grasp of unity, a "permeating quality" of seamlessness).[24] Significant for the issue of conjunctive relations is the fact that without decided intervals separating the boxes, Judd's constructive intention was lost to trivial effects. Per-

haps learning from this experience, Judd rarely attempted physically contiguous "nextness" and typically mounts an installation of modular boxes with space between them to render the interior structural grammar intelligible. Bringing the principle of repetition into focus evidently requires him to become acquainted with the subjectivity impinging upon objective serial display.

Quality as a measure of intellectual focus or diffuseness comes into play when Judd merely fills an available space – or otherwise permits repetition alone to justify the extent of a piece. The virtue of remaining distinct and intelligible under changed operations is, at least, taken for granted in this account of the philosophy of science. Peter Caws writes,

The possibility of doing this kind of thing [addition, multiplication] depends on the fact that most objects of everyday experience preserve their properties unchanged over reasonably long periods of time (without breaking into parts, for example) and can be put in groups together without reacting upon one another (coalescing, for example).[25]

Although the secondary qualities of color may leave the cube elusive, it is assumed that number, manifested either as a notion or a thing, rarely is. Caws continues,

. . . [D]isputes might arise as to whether the cubes were really green (whether they might not be bluegreen, whether the light might not be deceptive) or as to whether they were exactly cubes, but, assuming that they were distinct and able to be examined closely, a dispute could hardly arise as to whether there were two of them, whatever they might be called.[26]

If the aim of Minimalism is a studied neutrality, one for which Judd's objects assent to the condition of things with insides and outsides that are intelligibly ordered, then the presence of color raises the issue of lucidity as the category of painting fuses with the category of sculpture, even as color remains a (secondary) quality to be exploited for its material difference from the (primary) quality of number. Relative to number's fixity and distinctness, color is free and indistinct, properties available for orchestration where traditional means of whole-to-part composition have been eschewed. Yet, again, color introduces secondary qualities that complicate the object's stylistic connotations, for, if nothing else, elusive chromaticism may have already been claimed by Symbolism, and plangent hues may have already become markers of Expressionism. (Color, flat

and unevaluating, represents a calculated decision to signify systems not already occupied by style.) Perhaps because Hume provoked Judd to attempt a Constructivist Minimalism meant to establish a sensible presence in a logic of compositional relations, these matters enter into the qualified object – qualified both in the sense of critical modification having been applied to measure and order and in the sense of evaluation in consequence of artistic decisions having been made.

∗

The flat, unevaluating quality of the sculpture that Judd hopes to attain cannot be achieved without cultural reckoning. Freighted prior cultural associations, conveyed through the proportion and orientation of the boxes in series and through the qualities of materials and color, impinge upon the sought-for neutrality of the artifacts.

A thing nonfunctional and general enough to be understood as a sculptural idea yet made particular to the senses, Judd's box-as-artwork keeps its distance from the literal object. Constructed and hollow, the boxes give palpable concretization to extension, number, and ratio. Furthermore, tinted plastic reflects color off the top and bottom surfaces of the boxes and onto the walls, and it can also articulate the insides of things. Indeed, its contrasting properties allow color to serve as a necessary sculptural element in the sense that both Malevich and the Elementarist Constructivists would approve.[27]

Even so, Judd's "bookshelves" from the 1980s have been derided, in effect, for being too functional. (Since the open harlequin-colored structures were made to double back on themselves, no problem of functional punning occurs.) Then, too, with cultural references skewed toward functionalism and the vernacular of industrial engineering, Judd puts his boxes in jeopardy on those occasions when he opts for beauty and taste. Indeed, the reference to the industrial aesthetic is so prevalent in Judd that, when lustrous copper and brass make an appearance in the specific objects of the 1970s, charges of "deluxe" came down.[28] Although copper may be justified because of its traditional use in plumbing and electrical fixtures (and surely is base relative to gold) – that is, as a large floor piece of quality merchandise – copper, being much less commonplace than plywood, is subject to the connotations of ostentatious display usurping the intended industrial reference. For the most part, how-

ever, Judd avoids those industrial materials with expensive conno-
tations. Steel, aluminum, plywood, and plastic are his materials of
choice. The issue of consequence here is semiotic – to ignore these
socioeconomic references of formal functionalism is perilous for the
meaning of the object. The strength of Minimalism lies in its ability
to define the sculptural object in terms of engineering and industry –
and especially with regard to basic artisanal construction. To shift
material and formal signifiers is to invite cultural reference which is
perhaps unwanted – and certainly quite different. A box built under
auspices other than these might implicate commerce, rather than
industry. (And as we all know, commerce is the domain of Pop Art.)

In any event, arranging parts in series may be free of value in
nature, but art is challenged to acknowledge the value that attaches
to, say, left rather than to right in symmetrical composition.[29] It is
precisely the pervading bias toward associating bilateral symmetry
with human form that prompts Judd to avoid the principle of reflec-
tion and to organize his sculpture on the principle of invariant
translation. The high degree of symmetry informing Minimalism at
the outset later admitted solutions to the problem of composition
that allowed for the partitioning of a box, and so in the newly
expanded scheme of things, a row of of boxes in relief provides an
occasion both for tallying the number of partitions as they increase
(or decrease) from box to box and for comparing sets of distributed
formal relations. A culturally opportune moment for the construct
occurred to help matters along. Thanks to the emergence of structur-
alist logic, which had become popular in the 1960s, a coded formal-
ism of left and right, together with a set of perpendicular and oblique
relations, provided Judd with compositional antinomies sufficiently
abstract for his purposes.

Structuralist order provides a mode of composition favored by
Minimalism because it introduced a disconcerting binary logic into
a staid practice of formal relations that had seen the art world
become complacent. Yet it remains to be claimed by the many styles
constituting rationalist modernity in general in periodic rebirth
throughout the century. (The qualities of repetition as well as its
relative merit are then more readily disclosed in programs antitheti-
cal to one another, with partisans of *idealist* mathematical structures
arguing for functional relations that are very much at odds with the
practical functionalism advocated by the materialist utilitarians.)
Now we learn that not only do the Constructivist and Productivist

theories of art advance very different contents for the structure of repetition,[30] but also that Minimalism has inherited the debate over structure as well.

Discussing the quality of repetition is not meaningless, then. Although sheer quantity may fall into redundancy, it may not do so if the conceptual or methodological purposefulness of series, sequence, or permutation is made vigorous. Certainly, enlisting the principle of repetition as such does not foreclose on conceptual discrimination within a program: Principles of repetition include seriality, in which relations within series determine the relative place of an element; transformations of a group; and strict duplication extended indefinitely – this last being a specialty of Minimalism.

<div align="center">*</div>

Perhaps quality through quantity can be so demonstrated. It certainly goes a long way in explaining why, given the fact that the principle of sheer repetition governs so much of Judd's art, that relatively little is routinized or slight. I would maintain that the key to this substantial achievement is Judd's critical and (eventual) art-historical acumen toward a syntactical investigation of sculptural form.

21

Maquettes and Models
Siah Armajani and Hannes Brunner

Things made of cardboard and little else suggest an undertaking both provisional and hypothetical. As temporary structures readily dismantled, cardboard cartons produce boxes into which we drop, move, and store those possessions we have accumulated; they even shelter the homeless inside their unprepossessing fabric.

Once made into houselike constructions on a smaller than human scale, cardboard puts us in mind of the architectural maquette, a kind of graphic analogue – in structural if not material terms – to the habitable form it proposes. Subject to revision, cardboard (whether or not strengthened by wooden rods or lath) allows the artist to visualize in a relatively impromptu manner the end product of a creative process of which the maquette may be only a viable stage. Even so, the maquette hypothesizes a palpable and permanent state of affairs that its creator intends to realize.

Sketchy as they are, Models for the "Dictionary for Building" series (1974–78) are indeed models (see Figure 41, page 279), with their structural design in miniature predicting fairly enough the set of articulated relations Siah Armajani will realize full-size in 1979 (see Figure 42, page 280).

Yet what Armajani will realize faithfully will have already called into question the fondest preconceptions that sustain our beliefs about what houses ought to look like. Taken apart and put back together, that architectural commonplace we know as a house reveals and renews itself. For the scales of part to whole and of relative placement are upset: What was a minor feature is now a major structure, what was above is now below, what was continuity is bereft of transition. Free to circulate, door, wall, window, closet, dormer, roof, and stairwell recombine, repositioned in permutational free-fall. In *Open Window, Open Shutters*, for instance, the "standard" screen covering the window extends beyond it, exceeding the window's width and length. The structural mismatch continues as the shutters, whose normal position would be flanking the window, double up on one side. Depending on our prior knowledge

of architectural convention, Armajani leads us from the natural meaning of the window's being open to a cultural sense of openness once the normal tectonic syntax is liberated from its well-behaved referential function. The rhetoric of material nonchalance and structural anarchy may suggest dissolution, the art out of control. But for Armajani, who is inheriting the aesthetic ideology of Constructivism, these uncosy modes are calculated to thwart our desire to find small things cute – the peril of miniature models everywhere.

Frustrated in these matters, we are thrust back to considerations of structure, and so with the prototypical image of a house in mind when viewing his radical inventions, we are prepared to surrender our prejudice against so-called arbitrary form. With Armajani, the arbitrary is not meaningless: It is a search for meaning in the commonplace vernacular of architecture as we take it for granted.

Through the ongoing process of reimagining the house, we find that the identity of the house returns. The tectonics of structure are not fixed, but they are decidedly an instrumentality for the fluid contemplation of a domestic dwelling. Incorporating real space, the architectural fragments that Armajani lets stand as complete in themselves actually integrate the open plan into the material scheme. Moreover, there is further evidence of fluidity in Armajani's interest in the cultural *gesamtkunstwerk*. With literary correlatives to his projects always close at hand, it is appropriate to enlist the aid of the poet Wallace Stevens, who has inspired Armajani with an idea of changed yet reconstituted identity of place. Stevens wrote,

> A tune beyond us as we are,
> Yet nothing changed by the blue guitar;
>
> Ourselves in the tune as if in space,
> Yet nothing changed, except the place
>
> Of things as they are and the only place
> As you play them, . . . [1]

How can the commonplaces, the topoi, the given forms of life be redeemed? The answer well might be this: Creative process renders product afresh. Continual recombinatory fingering animates and re-images the structure at hand so that whatever had been merely thing is reconceived through the imagination as itself. Manipulating the order of the house is Siah Armajani's way of reminding us that order reinvented is structural design liberated. The house as normative structure is thus released into potentiality.

Hannes Brunner is a fabulist working in three dimensions. *House of Thieves* (1993) is his current project. Built of cardboard and lath, this house is small enough and ephemeral enough to propose itself as an imaginary arena, yet it is sufficiently large and realistic for passersby to enter.

Although suggestive of models, in a certain sense *House of Thieves* is not an architectural model; it has the actuality of a playhouse. It teases us with the possibility of materials suggestive of a kit to be scaled up, but this is not the case. Brunner's smaller-than-life world remains diminutive even though it is raised on tables; being raised on stilts, the house shows itself as "an exhibit" – evidencing itself as both conceptual and perceptual realization. Insofar as it is conceptual though material, *House of Thieves* is a notional scheme for pretending, for supposing a state of affairs. Provisional and hypothetical though it may be, however, its improvised state is not a step to further permanent architectural realization; it is an end in itself. Hannes Brunner says, "As a stage house, the *House of Thieves* is a house which is loaded with expectation and tension already before one really knows what is going to happen with it. The wheels of fantasying can turn wild. . . ."[2]

What is the state of affairs that *House of Thieves* evokes? Brunner says that the guilty – or those who believe themselves to be guilty – exist in a space isolated from society. They are special and their space is the focus of special attention.

Illustrative of the psychodynamic of thieves is the fable "The Musicians of Bremen," which tells the story of outlaws who, on hearing one animal after another braying and cawing in the night, suppose a giant has come after them. The *House of Thieves* turns the commonplace house into a figure of speech, a topos into a trope for the place the guilt-ridden might occupy.

So outfitted with surveillance periscopes and furnished with apparatus appropriate to a self-sufficient work station, the *House of Thieves*, teasingly complicated, takes a capricious view of such defensive attitudes. Complicating a simple structure indeed results in an architectural caprice, one by which we locate ourselves in an imaginary world. The aesthetics of the picturesque informs this artist's adventure with ready-made and homely materials. The exquisite realization of the assembled cardboard and lath elements reveals Brunner's emphasis on finish and perfection in craft – and his attentiveness to detail in the mechanism of our fantasy.

Different in the extreme are Brunner's and Armajani's senses of

the poetics of space. Brunner responds to the affective suggestiveness of the house "under bad aspect." Whether outlaw or delusional cult figure retreating to a house, something imagined to be a fortress against the world, the psyche Brunner imagines occupies the house subjectively. Armajani, however, responds to the cognitive intimations of the house under linguistic analysis. Sometimes as a structuralist, other times as a structuralist who is daydreaming, the grammarian Armajani imagines parsing the mental construct known as a house, all the while preoccupied with its demonstrable objectivity.

Myth and fairy tale inform the mythopoesis of Brunner's *House of Thieves*. The logical symbolism that exercises options of closed and open form reveals that a notional theory of discourse informs the cultural project of Armajani's Models for the "Dictionary for Building" series.

In such ways does the fabrication of a house give rise to the occasion for thought.

Ideas of Order
Sol LeWitt

> Order is not repetition. It is a central idea.
>
> Louis Kahn[1]

Order in Plan

Even the most casual inventory of the works of Sol LeWitt discloses the patient repetition characterizing virtually all his art. The ceaseless ganging of cubic modules shows only an aspect of the formidable body of repetitive structures that he conceived. In whatever medium – sculpture, wall drawing, or printed matter – the evidence of repetition is unavoidable. So it would seem perverse to deny the importance of repetition for LeWitt.

But in a certain obvious sense, repetition is of little concern. Especially for LeWitt but also for other Minimalist artists with whom he is loosely associated, repetition is a tactic in a larger aesthetic strategy of questioning and reshaping our definition of art in the latter half of the twentieth century. Minimalism takes an especially tough stand on sculpture, and LeWitt for his part takes a tenacious one that, like water influencing rock, is no less strong for being gentle. Eroding the art object of its physicality, LeWitt becomes a Conceptualist insofar as the object is now a constructed artifactual scheme conveyed through language.

This chapter will argue that we are mistaken when we try to trivialize the notion of order into mere orderliness in LeWitt's work; his art does not concern visual neatness. Rather, his attention to order is something shared by most serious artists of all genres who realize that to create major art is to engage a major paradigm or idea; to create major art, moreover, is to engage the mind through the cultural values informing any given style. These kinds of order, if not unique to LeWitt, are important to consider when reflecting on the meaning of his crisp diagrammatic structures, both sequenced and arrayed, as well as the formal repetition that characterizes them. How LeWitt's art disengages repetition from both notions of plan and the rules of composition will be sketched below.

*

When artists order the world, they not only compose it – they also conceive it. This conviction of LeWitt stems from the year he spent as a graphic artist in the office of the architect I. M. Pei, from 1955 to 1956. A formative experience, his job made evident that despite all the cooperative work needed to erect a building, the author of the project remains the architect, the person ultimately responsible for the thought that went into the structure's artistic conception. The beaux-arts tradition of architecture taught LeWitt that painters and sculptors bestow too much respect on artifacts when artifacts are often only the physical precipitates of creativity. Because true creativity lies in conception, he believes, perhaps the artist should keep the notions of conception and execution distinct, reserving the term "art" for everything in the generative process up to and including the articulated plan.

Yet if creativity and conception are so allied, why would LeWitt disavow theoretical intention for his Conceptual art? He says, "This kind of art is not theoretical or illustrative of theories; it is intuitive, it is involved with all types of mental process and it is purposeless."[2] Disentangling the several thoughts in this statement, it is possible to say that Conceptual art centers on a plan or scheme but cannot claim to be a closely reasoned set of propositions derived from evidence that, as in science, are intended to explain an established group of phenomena.

*

Conceptual art is not a body of knowledge; neither, strictly speaking, is it necessarily rigorously systematic. In a narrower cultural sense, too, LeWitt does not claim to be doing ground-breaking research. Arnold Schönberg's disposition of twelve tones in relation to one another *was*, however, a conceptual framework that led to a theoretical overhaul of music and a revolutionary shift in our understanding of what's possible. Like collage, like *matière*, the twelve-tone series was a radical invention of its age. Rare is the artist who can do innovative art with conceptual frameworks of such importance. In effect, LeWitt is confessing this in his own disavowal of theory. He is saying that his own intellectual claims are modest when he employs arithmetic to extend his art, serial fashion, across the floor or wall. What LeWitt does claim, however, is the need for art to reinvent itself, and he hopes to revamp abstraction, redefining our

experience of sculpture by giving us structures developed from non-visual form.

For LeWitt, art is in the plan. Included is the sense of method, a way of doing things arrived at in consequence of thought – the plan of structures forming in the mind. Art abides then in the deliberation leading to the final conception. Further included is the notion of preconception, for which the former architectural draftsman concurs with the architect as constructor in believing that art is completely conceived in the mind in advance of its execution. It is no secret that after World War II, the art world on both sides of the Atlantic sought a way to subvert Abstract Expressionism's putative trial-and-error approach to creativity.

Again, music can be used to illustrate the cross-disciplinary, international currency of this idea: With his own twelve-tone music indebted to Schönberg, Pierre Boulez realizes both the originality and the imaginative potential of systemic structure; neither is he afraid to create music by a systematic method, which is not the same approach at all.

<p style="text-align:center">✳</p>

Actually, Boulez's *Penser la musique aujourd'hui*, first published in 1963, just as Minimalist and Conceptual art gained strength, is an analysis of pitch, rhythm, dynamics, and timbre, one proposing creative systematic methods for thinking about serial composition.[3] Introducing this sober analyis is a deliberately melodramatic "interior-duologue," one in which Boulez anticipates any objection raised by readers about mind control: He won't tell composers what to think, just that they should think. Assuming that hit-or-miss intuition is no more authentic than deliberate thought, Boulez does not romance suffering for its own sake.

As removed as this analytic procedure of music is from the Minimalists' visual concerns, Boulez and the Minimalists share a common respect for the preconception of art. LeWitt observes, "There are several ways of constructing a work of art. One is by making decisions at each step, another by inventing a system to make decisions. The system may be structured as logical or illogical (random)."[4] For instance, a single ordering principle generates either regimentation or scatter in Carl Andre's conception of art. The deductive structure so basic to the Minimalist preconception of art – and conscripted by Frank Stella to produce not only single paintings but entire series – can yield surprising irrationality, as his Protractor

series demonstrated. LeWitt admits to all kinds of mental processes, including the intuitive, and, indeed, a retrospective glance reveals as much associative evolution as consistent logic in his choice of permutations for sculpture.

LeWitt addresses a prejudice against cerebration in the art community, one in which art is by definition imaginative, whereas mathematics is intellectual, and crossovers are unthinkable. LeWitt posits an art of mental forms, sometimes reasoned, sometimes not. Meanwhile, if not among those rare artists to produce a theoretical breakthrough, LeWitt *does* participate significantly in the discourse that ponders the question, "What is the art object?"

✳

LeWitt may be an idealist for believing that one can be an artist by concentrating on form as conveyed through diagrammatic schemes that are derived from math – and doing so without depending on the usual materials of art – but, in practice, LeWitt allows a palpable realization of his plan (see Figure 36). Such a form is exemplified in *Modular Cube/Base* (1968), a seminal work. Precisely because the lattice sits condensed in the center of a flat grid much larger than it itself is, at once implying a field of maneuverability, development via nonhierarchical growth, and investigation revealing the reciprocal relations found in groups, *Modular Cube/Base* announces that it is about nothing less than organization – organization in potential. The open cube upon a grid reveals the conceptual power to imply transformation.

Modular Cube/Base is a blunt post–Abstract Expressionist prescription for dealing with illusion: Juxtapose three-dimensional and two-dimensional structures but do not reconcile them. Regard the flat grid on which the lattice rests. Primarily spatial organization, it also realizes order as an end itself.

For its effective articulation of its mental status, *Modular Cube/ Base* is a truly conceptual work. The size of the piece (cube: 49.9 × 49.9 × 49.9 cm; base: 2.5 × 148.6 × 148.6 cm), although signaling its affinity with the maquette, decidedly reinforces the sense that this work is not design but idea. (It differs, then, from Daniel Buren's definition of a conceptual object, which is to say, "a general mental and abstract representation of an object."[5] A cube for LeWitt is not a thing but an organization made manifest.) Giving privilege to the "creative notion that constitutes its own object"[6] here, LeWitt

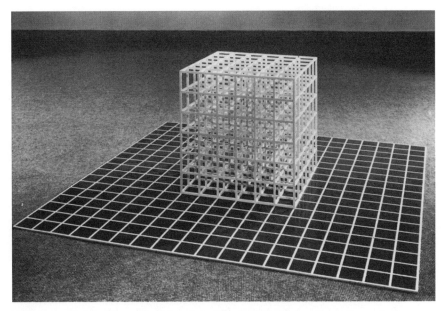

Figure 36. Sol LeWitt, *Modular Cube/Base*. 1968. Painted metal: 15¼ × 15¼ × 15¼ inches (49.9 × 49.9 × 49.9 cm); grid system: 45¾ × 45¾ inches (148.6 × 148.6 cm). Private Collection. Courtesy of Sol LeWitt. Photograph courtesy of John Weber Gallery, New York.

broadcasts *concetto* rather than *disegno* and so estranges form from sculptural cliché. Sculpture is, in effect, reinvented.

This said, we have to add that LeWitt's open modular structures manage to finesse a literal perspectival actuality. Some modernists claim that the grid is the quintessential twentieth-century perspectival scheme by virtue of the fact that it lends nonhierarchical order to the dimension of space.

(Thus the emergence of the grid may involve not a rejection of illusion so much as a reappraisal of spatial organization other than the one proposed by the Italian Renaissance – that is, one in which subordination and hierarchy constitute the ordering principle. Subordination of figures to each other as a way to accomplish a unified conception of space made the Italian perspective persuasive; but, says Svetlana Alpers, this is a convention to which only the Northern Renaissance, with its coordination of figures, evidently did not subscribe.[7] Perhaps the modern order, then, may be seen to reconcile the spotlit intensity obtained through the local coordination of fig-

ures with the need for global consistency. Imagine a trio of key players [say, the Magi] or a choir [as of angels] as modules available for infinite extension in space.)

Whether or not we do accept the grid as quintessential modern order, the grid does satisfy the imaginative extension of the notion of perspective by which we obtain both intellectual and spatial maneuverability in horizontals and verticals that, in Mondrian's words, cross but "do not cease to continue."[8]

To break stale and obsolete visual habits is the intention of all artists associated with Minimalism, but LeWitt is more obsessively arithmetical than, say, Stella or Flavin – whose work *the nominal three (to William of Ockham)* (1963–64) was a key influence on LeWitt's work. His is a search for an order of abstraction different from the creative mathematics that the theosophist M. Schoenmaekers advertised as the key to transcending the depiction of nature. Through geometry, contended Schoenmaekers, the artist can reach a real, because eternal, form. Spiritualist content aside, the reality of abstraction is similiar for Constructivism as for De Stijl. Within the context of these styles, LeWitt's open cube defines a parcel of space in a way that recalls Constructivist sculpture, because his modular structures are transparent except for their edges; and like the work of certain mathematically inclined advocates of Constructivism, his open cubes and their derivations may stand as mental visualizations of structure rather than as sculptural things. In this sense, therefore, they are to be understood as plans. Geometric though they may be as extensions in space that comprehend a form of pure relations, LeWitt's structures sample mathematical orders ranging from the arithmetic to the serial in order to theorize the given volume so closely identified with the essence of sculpture.

Early on, LeWitt declared that his art does not concern primary forms. Furthermore, much of the art attests to the fact that although his work may be read as spatial manipulation, perceptual gestalt is an effect, not a cause, of form's compositional rules; rather, straining to overcome our dependency on images, LeWitt often sacrifices simplicity of shape and rather projects the notion of organization as such (see Figure 37).[9] LeWitt's "sculptures" proffer organization in all its permutations and in all its ceaseless industry. Borrowing freely from both mathematical and linguistic logic, LeWitt is intent on reinforcing his distance from perceptual models of art, and in this sense he is very much of his time, if one recalls

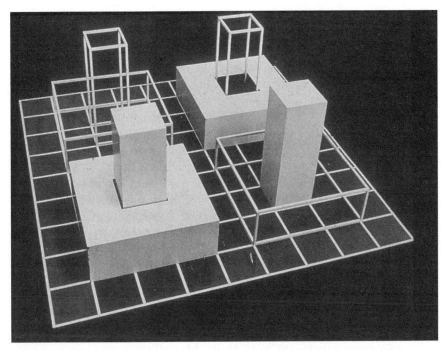

Figure 37. Sol LeWitt, *Untitled 4-Part Set ABCD*. *1966*. Powder-finish aluminum, 19½ × 57 × 57 inches. Courtesy of Sol LeWitt. Photograph courtesy of John Weber Gallery, New York.

that in the 1960s laws of analysis in art were sought outside the discipline.[10] Lucy Lippard recalls that LeWitt, on learning of Jean Piaget's theory of cognitive psychology, which argues that formal/operational intelligence supersedes perceptual intelligence, felt vindicated in his own ideas.[11] (As his career unfolds, LeWitt's early complete disavowal of perception is to be taken lightly, because his oeuvre shows he weaves back and forth between both conceptual and perceptual concerns.)

As a realization of permutational operations, LeWitt's work is resolutely static except in implication. Neither does it envy the kinetics of the actual world. It is thus distinguished from the kinetic constructions of Victor Vasarely and the Groupe Recherche d'Art Visuel of the post–World War II period, which it in some ways resembles. Beyond this, it is decidedly opposed to research of materials and technique, let alone the technology of optical and kinetic

phenomena that facilitates pure perception. Neither is LeWitt's art about communication; despite the collaborative nature and the intent to democratize art through its free dissemination, popularization of meaning is not LeWitt's goal. Indeed, in this resistance to popular culture, LeWitt is arguably closer to the hermetic practice of Ad Reinhardt and Agnes Martin than to the laboratory either of optical art by Vasarely or of algorithmic drawing by François Morellet, an artist to whose researches LeWitt is nonetheless indebted. If LeWitt is indebted to concrete art, it is to the studies of Josef Albers, who first created serial compositions in 1926. At any rate, what interests LeWitt is not kinetic movement but potential movement – and whatever can be gained through mental visualization.

Exemplary here is the series *Cube Structures Based on Nine Modules* (1976–77), which is painted wood (109.8 × 109.8 × 109.8 cm). Its title is a little misleading; there are not nine modules but one unit of 9 × 9 × 9 external modules whose interior is excavated for potential embedded structures. Unlike the variations of *Incomplete Open Cubes* (1974), in which the concept of subtraction holds sway, governing all variations that occur when a cube is deprived of one or more edges, *Nine Modules* only *alludes* to thoroughgoing permutation (see Figure 38). As in the tradition of classicism, total enumeration is implied, and LeWitt chooses to realize only some sequences of subtraction.

In this transistorized version of a life-size predecessor made in 1969, intensity combines with delicacy to give the work a kind of spectral trepidation. Anticipated by the insistent wall-to-wall sensation of Barnett Newman's red, the sheer quantity of LeWitt's built structure compels attention, and so it may be argued that here, where decided optical intensity is enlisted to compensate for the loss of variety, LeWitt has made perceptual effect part of his rule of composition. These effects in *Nine Modules* find an analogue in the sensation brought about by the early additive music of his friend Philip Glass – and by such downtown works as Steve Reich's *Violin Phase* (1967), in which seven notes played over and over, slightly off-register, induce an aural trance. Following in the gigantic wake of the New York School, artists of all genres learned to instill an aesthetics of quantity as compelling as the quality valued previously.

But optical effects in LeWitt's artifacts may be said to serve to compel attention to a cognitive scheme rather than to urge on the viewer a sensory content as such.

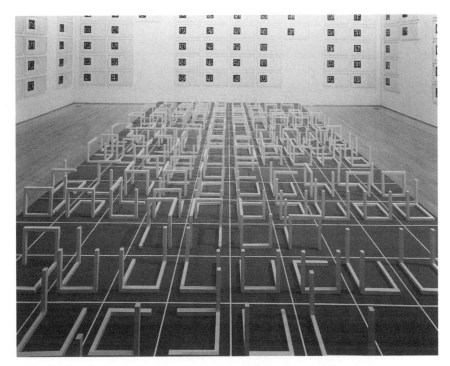

Figure 38. Sol LeWitt, Installation of *Incomplete Open Cubes*. 1974. 122 painted wood structures on a painted wooden base and 122 framed photographs. Each sculpture measures 8 × 8 × 8 inches. The base measures 12 × 120 × 216 inches. Each framed work on paper measures 14 × 26 inches. Collection of San Francisco Museum of Modern Art: Accessions Committee Fund purchase. Courtesy of Sol LeWitt. Photograph courtesy of San Francisco Museum of Modern Art.

Order as Style

In LeWitt's undertakings, then, order is both an articulated plan and a rule of composition. Conceived to be executed in accordance with his directions, the executed plan, then, may be reconstituted from the realized sculptural work, and in that there is a reciprocity between idea and object. Can this plan and notational result be said to reveal a style?

Starting in 1975, *Art in America* ran articles on LeWitt by Donald Kuspit and, in response, by Joseph Masheck that discussed LeWitt's art in relation to style.[12] Kuspit wrote that LeWitt's intention is to search beyond art history for a stylelessness based on

universals drawn from mathematics. Masheck contended that everything from LeWitt's preoccupation with order to the choice of white borne by his structures shows not stylelessness but cultural contingency, with style as a kind of culturally informed morphology. LeWitt's art, Masheck said, is indeed abundantly marked by classicizing tendencies that range from Constructivism back to Neo-Classicism. Ultimately at issue for these critics was not the Platonic–Aristotelian debate that rose up but rather the place of style in culture. Whether style is the parochial obsession of art history (and so a specialty of culture) or whether style embraces culture is a presupposition that decided these critics' respective arguments.

Their arguments may be reconciled in the following way. Style in art history is a collective phenomenon, and so an epochal style may obtain for stylelessness in a set of assumptions about the sort of neutral order admissible at any one time. Classicizing rules for composition appear cyclically, and yet they are marked with period values and an ideology that identify the style of objectivity under consideration. Thus, although his constructed versions of nonhierarchical order are not uniquely modern, yet together with the kind and degree of abstraction assumed to be possible, LeWitt's stylelessness is historically limited to the period when procedures presented in writing become an end in themselves – that is, an artifact is identified with the procedure for its making. A stylelessness of an art-historically restricted sort informs LeWitt's work, then. His style is culturally consonant with an epoch that takes its modernism for granted, an epoch that not only Neo-Plasticism but also Abstract Expressionism has passed. In addition, thanks to a Conceptualism that rationalizes procedures and methods, LeWitt's so-called stylelessness can be seen to have benefited from a "dematerialization of the art object" such that ordering space in a nonhierarchical pattern can be accomplished through the plan to do so.[13] So if asked to speculate on the date LeWitt's works came about, our stylistic analysis suggests we are more likely to guess 1968 than 1948 or 1928.

It can be argued, however, that LeWitt extends Abstract Expressionism even as he reacts to it (best seen in his wall drawings), but this argument is allowed precisely because certain modernist cultural assumptions inform prior appearances of the grid or its equivalent: an equalizing coordinate system of space.

Whether the key feature of Abstract Expressionism is vital gesture or autonomous drawing remains crucial to discussions of style, and forty years after the fact, strong partisans of either view would

cheerfully send opponents into exile. By addressing the nature of both gesture and all-over composition, LeWitt neglects neither. For the gesture, LeWitt supplies the instructions for a mark; for the all-over composition of Pollock's continuous thread, LeWitt supplies a discontinuous, yet even, field of space. However opposed to the priority of feeling, LeWitt presupposes both gesture and field to be fixed aesthetic entities in art of the twentieth century, because he has gone to the trouble of neutralizing taste by dissociating himself from it. Meanwhile, he has reserved judgment for himself.

LeWitt assumes that the all-over composition is a pictorial syntax that Minimalism must perpetuate; and to this end, his serial drawings may be seen as a metamorphosis of Abstract Expressionism. First executed in pen and ink, *Lines in Four Directions, Each in a Quarter of a Square* (1969) displays vertical, horizontal, and diagonally placed lines in isolation, all orientations combined by superimposition. Here is a landscape, so to speak, a landscape in disorder, revealing hidden geological relationships; but whether or not we resort to a structuralist metaphor for syntax, this reductive structure as much as Abstract Expressionist structure gives priority to that "nexus of relationships" which, as Octavio Paz says somewhere, is Claude Lévi-Strauss's key insight into the form by which meaning in culture establishes itself. The currency of structuralist thought cannot be overlooked when considering the analysis of directions and their synthesis as gathered in LeWitt's wall drawings, the commonplace of the 1960s and 1970s being the linguistic assumption of equating syntax with style. But this is a detail in the epochal concern with the notion of organization as such.

In reaction to Abstract Expressionism, LeWitt plans drawings in which, as Roland Barthes would say, inscription replaces expression. But in May 1970, in response to the death of the artist Eva Hesse, there appears the first instance of "lines, not straight" in homage to Hesse's irregular, erratic gesture, recalling her rooms hung with actual string that themselves recall Pollock's painted networks. If Abstract Expressionism ordains that art tell of feeling, in his drawings LeWitt responds to Hesse's friendship and artistic influence with the rhetorical code for feeling; and this code differs from the mere look of feeling, with drips and splatters done in bad faith. Rauschenberg's celebrated *Factum I* and *Factum II* (1957) exposed the fact that gestural spontaneity can be faked;[14] in the art of Jasper Johns, gestural rhetoric is acknowledged as such; but in LeWitt, we see rhetoric of feeling and of thinking utilized in structuralist antino-

mies. Grasping the implications immediately, Lawrence Alloway noted that "though skeptical of Abstract Expressionism, LeWitt nonetheless produced in his wall drawings a brilliant reconciliation of the notion of drawing as graphological disclosure and as intellectual content."[15] LeWitt assimilates the concept of expressivity to articulated rule from this point on.

For some partisans of modernism, organization, not gesture, is privileged because of the tendency of drawing to structure space. Roger Shattuck writes, "The air is full of infinite, straight, radiant lines crossing and interweaving without one ever entering the path of another, and they represent for each object the true FORM of its cause."[16] As noted by Shattuck, these observations by Leonardo da Vinci inspired Paul Valéry in 1894 to advance the idea that da Vinci anticipated Maxwell's recently published field theory, thus revealing a modernist bias for visualizing space as distributed uniformly "all-over."

Striking – even startling – is the congruity between da Vinci's description of the structure of electromagnetic space and LeWitt's descriptions of his invented rationality. Consider, for example, the piece dedicated to Hesse: "Lines, not straight, not touching, drawn at random, uniformly dispersed with maximum density, covering the entire surface of the wall." These verbal twins, however, differ greatly in meaning. Leonardo da Vinci is attempting to understand the world; LeWitt is attempting to create composition in the abstract. He builds on the early modern concern for organization – and for abstract relations that can be introduced into the world of art to vouch for phenomena as simultaneously necessary and arbitrary, essential and accidental. However, he then departs from the need to explain things. Perhaps, then, LeWitt derives an imaginary universe parallel to the scientific realm as da Vinci conceived it, one realizing "erudition plus logical method."[17]

Appropriating the notion of logic to finesse an imaginary world has enjoyed cultural currency for more than a century. The notion that reality consists of relations – that it does not exist in things – influenced the modern emphasis on syntax in art, and late modern art presupposes this notion as well. For LeWitt, composition is a logic that creates a world, whether or not it explains the world of nature.

LeWitt has given radical prominence to the concept of organization, taking a crucial topic of modernism and elevating it as the first principle of his art. Lending self-conscious structuralist status to

order and modes of ordering only reaffirms LeWitt's strategic affiliation with the radically homogeneous space found in Abstract Expressionism, however Conceptual that strategic relation to the exemplars of all-over composition. (In the New York School, it is a disputed truism that the figure is a throwback to things, unless it is totally dismantled and scattered, Osiris-like, within fields of paint to become an atomized portrait-landscape; Willem de Kooning's late fleshly fields come readily to mind as a recent practice of this inherited truth.) Then again, much Abstract Expressionism takes from Impressionism the conviction that to distribute content across a surface is not to lose the intelligibility that this composition had when corseted in subject matter. Taking a broad look at this century's visual history, we readily see artists of both so-called logical and illogical styles of modern art who presuppose that whatever the content, it is to be distributed more or less evenly throughout an imaginary space. LeWitt's strategic relation to all this is to have taken the preconceived constructed object and, in line with his architectural assumptions, reinterpreted as Conceptual art strategy, redefined object as plan – and plan as that which can generate an ensemble of possible states of affairs. There is no contradiction in saying that the objectivity sought here is at once styleless and historically contingent – and that this particular avatar of stylelessness manifests itself late in the twentieth century.

Order and/or Repetition

Order is a comprehensive term inclusive of structural arrangements of all kinds. A gamut of functionally integrated to chance-induced compositions has attained the status of paradigmatic order and thus great cultural significance. The assumption here is that paradigmatic order is significant because analysis is inherent in creativity – indeed, analytic thought is inherently creative in itself. It is in this paradigmatic sense that repetition may be deemed creative.

Nonhierarchical composition is the sort of arrangement LeWitt favors, and toward that end he writes a set of instructions that constitutes a rule. Unlike some articulated plans, however, the instructions LeWitt sets out demand a recurring activity.

The repetition required to fulfill the obligations set out and the conception of the artwork itself have, perhaps, a modern epochal necessity – or if not necessity, then a collective style. As discussed

earlier, a certain acknowledged mentality that accords to the grid
the status of a symbolic form is commensurate with a formalism
inspired by evenhandedness in physical law and logic at the turn of
the nineteenth century and perpetuated thereafter. What art inherits
from science is the value placed on analytic thought itself, the search
for logical atomism being accorded early modern privilege. I take
LeWitt's instructions as the analogic model for a culturally privi-
leged concept of order – namely, repetition.

That the instructions regulate the artifactual results through con-
ceptual preordination is another matter.

All of these signifying senses of order to which LeWitt subscribes
do not in themselves commit him to what will be identified as the
issue of postmodern repetition, for which replication and simulation
contrive an order of an entirely different kind.

<p align="center">✳</p>

Thanks in part to a scientific attitude toward industry and work,
there is by now a longstanding tradition of mechanism adapted to
art theory and practice. While visiting America in 1934, Gertrude
Stein declared that her writing displayed not repetition but insistence
inflected by emphasis. She said,

> If this existence is this thing is actually existing there can be no repetition.
> There is only repetition when there are descriptions being given of these
> things not when the things themselves are actually existing and this is
> therefore how my portrait writing began.
>
> So we have now, a movement lively enough to be a thing in itself
> moving, it does not have to move against anything to know that it is
> moving, it does not need that there are generations existing.
>
> Then we have insistence insistence that in its emphasis can never be
> repeating, because insistence is always alive and if it is alive it is never
> saying anything in the same way because emphasis can never be the same
> not even when it is most the same that is when it has been taught.[18]

"When the things themselves are actually existing," they are not
copies of nature. They regenerate themselves formally by means of
rhythmic emphasis, all the while vital, because "beginning again and
again" entails an entry-level energy that is sustained. In Stein's rules
of composition, recurrence in accumulation is sufficient to compel
interest in mechanized nature. Along with Eadweard Muybridge's
studies of motion that were so fascinating to LeWitt and his genera-
tion, Stein's enactment of actions is both demonstration and proof
that absorbed repetitive activity can be engaging.

Underlying LeWitt's instructions to be executed as drawings is an assumption of the essential validity of repetition as a paradigmatic structure that nonetheless need not be repetitious in method either through a trancelike motor automatism that inclines toward submission to perpetual writing or through concentrated vitality that recreates beginning. Add to this the methodology that lends this practice self-conscious strategy, and the comprehensive assault on the ideas of order that galvanized the arts as a whole early on in this century is readily appreciated for the significant achievement that it is. Revisited in the 1960s, the systematic reduction of automatism undergoes transformation. Owing to the fascination with the information feedback systems of cybernetics and the real-time systems that call for process or procedure to occur automatically once initial decisions of conception are in place, we prefer a certain mechanical processing of nature to an expression of subjectivity. A legacy of the positivist and mechanical treatment of psychology in Stein (known to us through her earliest published writings, "Motor Automatism," a study in sleep research that was conducted while she was under the tutelage of William James at Johns Hopkins), is, perhaps, *Sleep*, a film made by Andy Warhol in 1963. This film gives real-time status to six hours of his sleeping subject.[19]

Postmodern attitudes toward repetition, however, revise the conception. In part thanks to trading in second-hand "originals," Pop Art posited that reproductions of all kinds be given serious consideration, and it further proposed that the notions of replication and the copy, once considered reprehensible, be taken as a challenge to the presumed ideal of originality. Given the culturally extrapolated post-structural interpretation, meanwhile, that all is second-order discourse – a sign of a sign, not a sign of an original reality – now is an opportune moment to reconsider LeWitt's idea of order.

"Repetition as Originality," the topic of a symposium conducted by Rosalind Krauss, dominated the Summer 1986 issue of *October*.[20] Benjamin Buchloh, writing on the neo-avant-garde, observed that it was the practice of artists after World War II – Yves Klein, Lucio Fontana, and Robert Rauschenberg – to inscribe in their art a recognition of their belated position in relation to the avant-garde of 1910–25. Repetition is the very "historical 'meaning' and authenticity" of the neo–avant-garde, Buchloh wrote.[21]

LeWitt's art, however, is not repetition in this sense. For one thing, like other Minimalist and Conceptual artists, he is not sociologically or historically ironic. His attitude, a continued faith in the

avant-garde, necessitates belief in the significance of creating – or at least, attempting – radical art. This is not to claim that LeWitt is literally the first to do a certain kind of art but rather to claim the sense that sustains the notion that strategic thinking in art is as much originality as is necessary.

The discussion of repetition in *October* defined the topic variously. Steven Z. Levine, in "Monet's Series: Repetition, Obsession," referred to the duality fastened on by Gilles Deleuze when he wrote about "[the] distinction between what he calls Platonic repetition, or the allegedly self-same reinstantiation of an original identity, and Nietzschean repetition, or the persistent deferral of similitude in the face of inevitable disparity."[22] The claim that sensations can be painted directly is scrutinized and found to be other than it is, for, with his Monet, studies in nature copied from other artists were subject to being processed in the studio. Yet even so, even if his method remained more *plein-air* than Impressionist, Monet's studies at Etretat or his earlier series of cathedral facades dissolved in light may be seen in a Nietzschean sense, Levine wrote, as the elusive capturing of an impression in a succession of canvases – and it is by successive ephemeral renderings by draftsmen of his idea that LeWitt and his art may be profitably linked to this notion of impressionistic repetition. Certainly impressionist in this sense are the performances by draftsmen of LeWitt's written plans. Furthermore, the written instructions comprising his plan may be the point of creative inception, but they are no origin that is cut off from both the artist's creativity and from the subsequent artisanal realization in an actual drawing. To put it another way, we might say that the authority of the artist, the authority of the art, and the authority of the artisan represent a dispersal of origin.

Even so, the Minimalist contemplating necessary and sufficient conditions for the object of art, someone who derives the object from the idea to conceive it, is not concerned with the fleeting impressions destined to become material inadequacy, because the plan, blueprint, or predetermined order may be replicated many times without the loss of intellectual originality. As a score is to its performances, the plan is to be realized rationally and so comprehends any number of empirical actualities and finds them adequate. Each wall drawing, each variation in a series of modular sculptures, then, is a repetition in both a Platonic and a Nietzschean sense. Whereas a drawing may be an imperfect copy of a lost original, it is an adequate presentation and re-presentation of a way of doing

things. A set of instructions entails latitude in realization, each one realization of which, if done by hand, is, as Deleuze says, a phantasm promising to be identical but revealing itself as different. Meanwhile, an argument may be made that a closed system of exhaustive permutation and operation is holistic and so does not suffer the stigmatization of repetition. At least, permutation is adequate to symbolic operation even though an optical impression may not be deemed adequate to perception; the criterion for rationalism is the same as for empiricism. "It is difficult to bungle a good idea," believes LeWitt.[23]

Formal repetition in LeWitt's art is, of course, a characteristic trait. However, few viewers bother to make a distinction between repetition intrinsic to the artistic conception of scheme, rule, and method, on the one hand, and mere repetitiousness, on the other, and it doesn't matter whether the conception is informed by a rule of recurrence or not.

Mere repetitiousness in LeWitt's art was exemplified by a show in 1977, one featuring wood reliefs in area or outline that depicted figures of plane geometry. Despite the morphological variety, this materialized alphabet of signs was intellectually tedious. At once clumsy and facile, the set seemed to be fulfilling a prior obligation; and indeed, I later learned these rote constructions were a reprise of a much earlier conceptual moment in the artist's career. Far more effective intellectually were his isometric drawings intended for books and subsequently exhibited as enlarged wall drawings in 1981; they were effective possibly because they made evident their status as diagrams mediating between the physical object and idea. (Repetition that almost never comes across as repetitiousness occurs in LeWitt's three-dimensional works. His open cube structures hold up with each chance encounter. When one comes upon one of them twenty years after creation, still aesthetically unassimilated and tough, they are surprisingly free from the sense of being designed. This is an achievement, especially since good design has gentrified all housewares, with so many artworks seeming to have been "accessorized" after the fact.)

This having been said, I nevertheless dispute LeWitt on his point that "it is difficult to bungle a good idea."[24] His art is good because it is about clarifying the meaning of an artifact in relation to the conception of organizational structures, which themselves stand in relation to conventional sculpture. A mediocre realization, like a mediocre performance, could distort intention beyond recognition

and destroy the art's conceptual authority, as it did when geometricizing shaped canvases led to inert reification of signs. (The repetitiveness is not in the sign itself any more than it is in the notation for the circle and the triangle – or for that matter, the point, line, and plane. It is rather that LeWitt miscalculated the material as such: The stretchers rendered the concept literal rather than symbolic.) Then, too, amorphous and confused realizations of LeWitt's meaning by assistants in the "shop" may contribute positively to the ideology of democracy, but they detract from the creative intelligence of the order, despite the fact that the authority for the abstract order written into the score – or script or plan – that dictates performance is LeWitt's.

A complicated originality characterizes his work. With his belief that creativity lies in the mind, LeWitt subscribes to the notion that works of art possess theoretical and symbolic autonomy, an autonomy that such works of art share with concepts of science presented in thought, even as the artistic constructs so produced mimic the scientific constructs of explanatory force. Insofar as he repeats known orders, LeWitt sustains (as Deleuze refers to it) a duplicative sense of origin; then again, this origin is of forms held in the common domain. Arithmetic or serial in initiative, LeWitt's rules of composition participate in a styleless universality of syntax that can nonetheless be dated culturally, for to propose that the order (the essentializing strategy of art) is identical to that order (the rules of composition) conveyed in planned procedure (the written instructions), a procedure that is to be executed methodically, reveals a modern mentality as it dedicates itself to repetition as an idea displaying the differences in sense between conception and execution. The originality may well be expressed in the will to logical stratification. His ceaseless effort to devise rules of composition in the abstract, then, may stand as the original practice of that symbolic adventure.

Is it therefore false to reconcile LeWitt's conceptual origin with that kind of beginning that extends itself again and again through intention? The creativity of original ideas or of symbolic activity that is the source of our ability to imagine and think abstractly is less a Romantic truism to be discarded than a source of value we have neglected. Still, what is significant about LeWitt's art, beyond the value he places on the idea of organization itself, is that he does not integrate the authority of conception and the author of the actual works. The verbal plan announces the end of LeWitt's creativity.

Defining by limits, the plan also declares that art ends where the production of finished artifacts begins. Where they do not locate their meaning as anticipatory, drawings done on behalf of the idea signal that they are supplementary, an expression of truth in which idea is everything, with visual impressions at once creatively superfluous yet pragmatically appropriate for articulating the potential of the creative organizational idea.

23
Contextualizing "The Open Work"

The history of art is not mere chronicle. Then again, significant histories of modernity other than the one that essentializes surface may be told. Among the most respected alternative histories of modernity are those of order and especially, among these, an order given to unpredictable outcomes or variable degrees of freedom within a system has come to define modernity in the artifact. Long before the phrase "complexity and contradiction" became a commonplace of postmodernity, figures no less than Pablo Picasso and James Joyce took up its theory and practice in their singularly open and encyclopedic projects, and notions of recombinatory order and ambiguous sense have for nearly a century anticipated the revival of cultural openness. "The open work," a phrase that the literary theorist Umberto Eco applied to the art of Joyce in an essay that appeared thirty years ago, has prompted the title of this exhibition of art devoted to visual means of drawing inspiration from the unfixed, unsettled, and uncertain structures that characterize artistic indeterminacy (see Figure 39).

Indeterminacy concerns the potential that realizes an order and so gives promise to surface. In an all-over order the indeterminate form is without center, constantly reorienting itself in sequential, if not serial, fashion. Whatever else can be said about the art of our century, nonhierarchical sequencing of marks has remained a commonplace of modernity.

All-over order can be seen in the crosshatch paintings created in the 1970s by Jasper Johns (b. 1930, Augusta, Georgia). Mark rather than gesture characterizes Johns's pictorial field. One kind of mark-making throughout establishes an all-over uniformity within which subtle contingencies occur, for there are material differences in facture that are applied to the constant change of slanting hatched marks as they occur across the surface in a series of visual transitions comparable to *passage* in Cézanne's work. Then, mirroring hatch-work across internal seams to induce embedded patterns, Johns permits us to see "figures" perceptible within the ground: *of* the

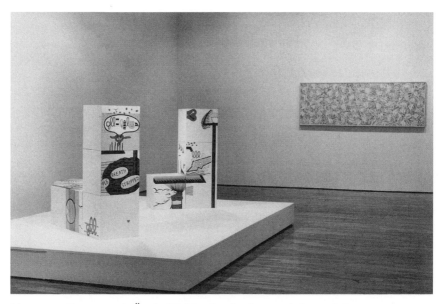

Figure 39. Foreground: Övyind Fahlström; background: Jasper Johns.

ground which gives rise to them. This work from 1979 is preceded by *Corpse and Mirror* (1974), with its inscribed negation, and it is followed by two works entitled *Dancers on a Plane* (1979 and 1980), both with competing patterns of provisional organization emerging from an overall field.

Like Johns, Kes Zapkus (b. 1938, Vilnius, Lithuania) creates works with an all-over structure in which are secreted figural events (see Figure 43). Scattered throughout a decentralized (though not totally homogenized) field are intense, apparently abstract markings, some of which, on examination, are figurative – images, a few years ago of artillery and evidence of war, recently of pictorial and stylistic truisms. Meanwhile, beyond this semantic ambiguity, Zapkus's open, labor-intensive compositional process favors results that are deliberately inconclusive. Chosen for this exhibition is *Liberation of Past Tense* (1991), a fourteen-foot gray encyclopedia of discontinuities that is inflected with color and with fugitive incident (such as horizons of landscape and architectural plans). Most conspicuously, four schematic globes, each surfaced in a different modern style, occupy the canvas's center, and it is this that suggests the painting's paradoxical thematics: the macrocosm of dominant worldviews engulfed by a provisional and relative microcosm. *Improvisations on a Shrill Sound*

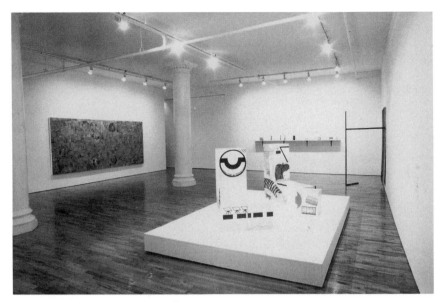

Figure 40. Foreground: Övyind Fahlström; background, left to right: Kes Zapkus, Siah Armajani, Jim Hyde.

(1987), *Flight into Arid Zone* (1988), and *LaFarge and the Chlorinated Pool* (1988–89) are recent works of dystopia in style.

Is structural contingency the result of a kind of mind-wandering? Not really, for to proceed through the world of the contingent is not to engage in daydreaming; it is rather to enter into the realm of the conditional (rather than causal) visual structure: if . . . , then . . . , if . . . , then . . . Under such conditional circumstances, accidental or apparently mistaken thinking animates necessary considerations of art. Some artists, such as Siah Armajani (b. 1939, Teheran, Iran), force the issue into prominence. If, for instance, in Armajani's series Models for the "Dictionary for Building" – fabricated from 1974 to 1978 and realized full-scale in revised form during the 1980s – we note a house excerpted for our appreciation, then the windowed walls, floors, and staircases present themselves as details in a normative vernacular of architecture (see Figure 41). If, however, we see a house becoming dysfunctional thanks to the presence of a casement from which a window has slipped, or a wall hoisted and angled upward and so made dormerlike, or Dutch doors rendered ambiguously windowlike, then we are apt to consider Armajani's project as sculpture taking no fixed form, loyal only to an ongoing

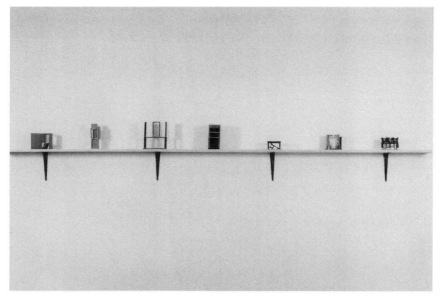

Figure 41. Siah Armajani.

recombinatory argument about the uneasy relation of function to structure. Examples of fully realized work are *Basement Window Under Front Door Steps* (1985) (see Figure 42) and *Closet Under Landing* (1985). Reference to a Russian Constructivist radio tower suggests utopian motives at the heart of Armajani's project. Indeed, throughout his career freedom and openness of information have pervaded his choice of commissions, which include reading rooms and reading gardens executed for American universities, where, Armajani maintains, reading is an expression of individual choice.

Similarly, James Hyde (b. 1958, Philadelphia, Pennsylvania) builds art that puts categories in relative and hypothetical adjustment. His recollection of the antiformal drift between categories of painting and sculpture, set in motion by the early modernists and recalled cyclically thereafter, raises questions: If this is painting, then what is it doing occupying the floor? If this is sculpture, then why is color broadcast? Here, indeterminacy assumes the logic of relative solutions. A second-generation post-Minimalist, Hyde otherwise conflates the so-called *a priori* categories of painting, drawing, and sculpture. By bulking the surface of paint into a materially dense slab of fresco, he creates a painting that also acts as a support for a sculptural element; the steel bracket in turn defines an immaterial

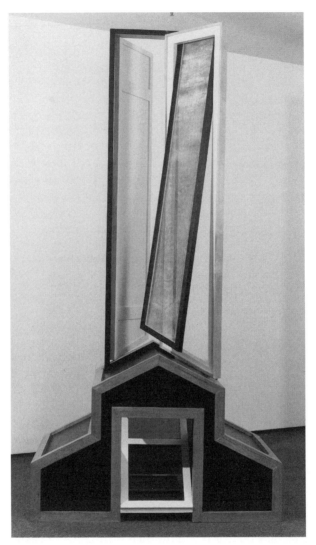

Figure 42. Siah Armajani, *Basement Window Under Front Door Steps.* 1985. Painted wood, stain, screen, and Plexiglas, 104½ × 51½ × 38 inches. Courtesy of the Max Protetch Gallery. Photograph © 1985 by Ellen Page Wilson.

plane and volume from wall to floor. This work, called *Suit* (1991), is typical of Hyde's thwarting of material and categorical self-evidence. Other works of similarly confounded structure include *Resign* (1991), *Wake* (1991), and *While* (1991).

With Ron Gorchov (b. 1930, Chicago, Illinois), shaped canvases may be taken either as a structural anomaly or as a willed rebellion against the doctrine of flatness, by which one kind of modernity has been defined (see Figure 43). If his work is seen as a structural anomaly, the cursive painting across the surface may be construed as fanciful calligraphy. If, however, the support, with its paradoxical convex concavity, is seen as a willed misreading of flatness, then the torus and Möbius figures painted on the surface may be acknowledged to represent the topological analogue to this support, parading their own illusionist riddles by eliding or opposing virtual and actual space and viewpoints. This saddle-shaped topology, realized topographically, puts considerable English on spatial clarity. Topology, the mathematics of the continuities invariant under deformation, appears here in a metaphoric form to suggest that not all is well in Flatland. Chosen for the exhibition is *Zoology* (1990), which is from a group of works that includes *Tempest* (1989) and *Zephyros* (1989).

As often noted, indeterminacy in form and content elicits interpretive and interactive engagement. The intepretive process as such becomes highly evident once an intense simultaneity of visual events presented in the artifact forces the viewer to wrest sense from apparent busyness and volatility – or, alternatively, from visual events apparently static and thus uneventful in the extreme. Furthermore, this status challenges the viewer to combat his or her own indifference and to locate sense in the oceanic order of things. Johns is notorious for making art that taxes the interpretive resources of the viewer, and Armajani's destabilized house invites active speculation about norms. Övyind Fahlström seizes the same prerogative.

Övyind Fahlström (1928–76) was born in São Paulo, Brazil, of Norwegian and Swedish parents. Subsequently sent by them one summer to visit grandparents in Scandinavia, Fahlström found himself suddenly cut off from home by the start of World War II. As Fahlström's widow says: Imagine the worldview that might emerge from the seminal experience of a Portuguese-speaking nine-year-old knowing no word of Swedish, who grew up in the household of grandparents whom he had never met, in a country where night reigns most of the year. Even without this testimony of trauma, one

can see that situations of weak causality were Fahlström's specialty. In his mature art Fahlström realized world-political board games wherein life's unpredictability is administered only through operational contingency: If x happens thanks to a specific political interest, then y will occur in response; no master plan governs clear hierarchies of value: His end games without goal tease forth the active or imagined intervention of the viewer in this virtual world of cultural politics. The frustration level is high – as it is meant to be. On exhibition is *Sitting . . . Six Months Later* (1962). In manipulating its modules, Fahlström has made it possible to see that continuity of visual language from face to face can be achieved only at the expense of discontinuity elsewhere. Paper dolls and other improvised game structures by Fahlström include *Eddie in the Desert* (1966) and *Column No. 1 (Wonderland)* (1972).

Order – both provisional and relative – suggests a modern state of affairs that was known to the Impressionists and Cubists and was reworked continually thereafter. In this view, the object disappears. It becomes instead an object dissolved in a field of relations.

Epilogue

As far as I know, reception of "The Open Work" was largely positive, yet at least one negative response was extreme. Of the favorable responses, an artist not included in the exhibition has since said repeatedly that whenever he despairs about the situation in the art world, he recalls the exhibition, rereads the statement, and feels he can sustain himself again. Indirectly, I learned that one dealer, impressed by the show's significance, sent the editor of an art magazine to see it, although no artist of hers was represented. An art writer was kind enough to call the selection of work in its entirety as revealing "exquisite intelligence." These reactions, in addition to the positive responses from two veteran art critics, one formalist, another psychoanalytic, were reassuring. Art critics assigned the exhibition to classes of their students. The show received mention in the press.[1]

Given the muddle that usually suffices for a realized thesis in group shows, I had expected "The Open Work" to be received warmly, yet more than this I had expected a good measure of comprehension. Indeed, my only worry throughout the process of preparation was that the lesson of the show would be too obvious, and so I had decided to cast my gallery statement indirectly, with impres-

Figure 43. Left: Ron Gorchov; right: Kes Zapkus.

sionistic, glancing blows. But one negative response startled me into realizing that, even beyond the rote interpretations typical of much social art history, the irrelevant formula is a given indulged in by critics all too often.

Susan Sollins, the director of Independent Curators Incorporated (ICI), was – what? irritated? appalled? by "The Open Work," a show she called "incoherent." This comment surprised me because I felt that the principle of structural contingency was extremely pronounced, and so I asked for her criterion for coherence. "Medium," she said. Indeed, ICI has funded a drawing show entitled "Drawn in the 80s," but however commonplace is this topic in the curatorial repertory of ideas, medium or technique is precisely the measure of a show with the least *stylistic* or *cultural* coherence. As I sought to explain this, I realized that Sollins's literalist taste was offended by being confronted with the need to comprehend this abstract point. The more our dialogue progressed, the more entrenched in our views both of us became. In desperation, I reminded her that the title "The Open Work" (a direct quote from the essay by Umberto Eco) was intended to signal the commonplace nature of the thesis of the synonymy of indeterminacy and modernity in our age. "You know," I began, "Eco even initiates his discussion of indeterminacy in the arts

with mention of the music of Karlheinz Stockhausen and Lucio Berio, associates of that great composer, Earle Brown."

Suddenly, our confrontation underwent a conversion. "He should hear that," Sollins said quietly. "Earle Brown is my husband."

We were both stupefied. That we could find commonality at all, given our mutual repudiation of each other's views, seemed amazing.

For my part, I continue to wonder on what basis does communication between Sollins and Brown take place. Brown, an associate of John Cage, has devotedly pursued an open compositional strategy in music throughout his career. As with certain Europeans, such as Stockhausen, Brown's notion of form is decidedly given to performed contingency (so that if a certain musical event arises, then, in consequence, interventions by the performer result); performance choice is hard-wired into his compositional strategy. Whereas some interventions rely on contingency, others that are improvisatory rely on chance. Improvisatory choice in sequencing the piece, guiding tempo, and so on, informs Brown's *Available Forms* (1961–62), as it had in Stockhausen's *Grüppen* (1955–57) (a work also featuring the aleatory decay of sound).

Variable and elastic duration was a factor of indeterminacy that Brown had already explored in the early 1950s, when, in an express avowal of the principles informing the art of Pollock and Calder, he began his exploration of different kinds of indeterminacy in music.

Several possibilities remain: Sollins may not understand Brown's music; she understands his music yet may be unwilling to generalize the principles of indeterminacy beyond the practice of her husband; she accepts musical forms of the open work but not the visual equivalents; she can comprehend it either if confined to the 1950s, the period most closely identified with indeterminacy in the critical literature; she appreciates all of the above yet believes that coherence breaks down if intellectual imagination, rather than technical consistency, is required.

Many laypeople are reassured by consistency, and for this reason subject matter or technique still provides ready, although for the most part bogus, themes for art exhibitions. In the disciplined study of art history, undergraduates learn early on to spot the deceptive nature of subject matter; for, given any two flower paintings, one may parade botanical and documentary information, whereas the other reveals religious encoding; we look to latent content, not to overt subject matter, as a determinant of meaning – and so style.

(Meyer Schapiro defines style as constant form – that is, as culturally entailed form.)

Despite this elementary training in our liberal-arts education, a willed obliviousness to events of the last one hundred years persists in some quarters, and with it the presuppositions of 1827, 1855, 1890, 1913, 1948, and 1968, even by those who profess knowledge of these nodal cultural points in the history of the open work.

Notes

Chapter 1: Pail for Ganymede

1. Walter Hopps, *Robert Rauschenberg: The Early 1950s* (Houston, TX: The Menil Collection, 1993), p. 156.
2. As Jack Burnham reminds us, volume is not more spatial than mass, because space is the constituent medium of both (Burnham, *Beyond Modern Sculpture* [New York: Braziller, 1968, 1973], p. 313). But physics loses out to the aesthetic nomenclature in conventional parlance.
3. André Corboz, "Modern Architecture and the Japanese Tradition," in Tomoya Masuda, ed., *Living Architecture: Japanese* (New York: Grosset & Dunlap, 1970), p. 4.
4. "... [T]he very word architecture is nonexistent in Japanese tradition. There is 'zoka,' which concerns the construction of houses, and 'fishin,' which concerns the collection of funds for the building or rebuilding of temples; these are not abstract terms, but words denoting precise acts, as in medieval Christendom" (Corboz, "Modern Architecture," p. 5).
5. Mel Bochner, in conversation with the author (June 14, 1994).
6. Burnham's *Beyond Modern Sculpture*, for instance, begins its account of modern sculpture with a chapter devoted to this topic.
7. Burnham, p. 20.
8. East meets West in Rauschenberg's practice. But it should be noted that the floor plane has been a horizon of expectation for millennia in Japan. Human activity within the home transpires on or close to the ground, as is revealed, for instance, when gift boxes are placed upon the floor while host and guest exchange bows.
9. Sometimes indifferent to orientation, Rauschenberg will say of a particular work that it may either attach to the wall or rest on the floor. Further complicating the precision of intention is institutional practice. For security reasons or for the sake of intelligibility, curators may raise floor works onto plinths; meanwhile, art photographers will take their own measures of precaution. Note, for instance, the plates in Hopps's *Rauschenberg: The Early 1950s*. In them the viewer sees that, by resting the object on paper that curves upward to fuse wall and floor plane, the photographer has preempted the decision of the artist.
10. Johns counterfeited painting through sculpture in his *Painted Bronze* (Savarin) (1960).
11. In Heidegger's "The Origin of the Work of Art," stones (the "things" of the earth) together with hammers or peasant shoes (the tools of the earth)

give rise to form yet remain distinct from form. (Heidegger's essay is reprinted in Albert Hofstadter, trans., *Poetry, Language, Thought* [New York: Harper & Row, 1972], pp. 15–88.)

12. Richard Wollheim, *Art and Its Objects* (Cambridge, UK: Cambridge University Press, 1980), p. 43. Wollheim credits the "striking comparison made by [Claude] Lévi-Strauss of human culture to a bricoleur or handyman, who improvises only partly useful objects out of old junk...." (p. 43).

13. Ibid., p. 61.

14. Claude Lévi-Strauss makes this argument.

15. W. K. C. Gutherie, *The Greek Philosophers from Thales to Aristotle* (New York: Philosophical Library, 1950), p. 129. (Thanks to Joseph Masheck for this reference.)

16. In his preface to *Essays on Assemblage*, the publication of the proceedings of the symposium, John Elderfield summed up Seitz's definition of assemblage:

> The word was chosen by the show's curator, William C. Seitz, in order to cover "all forms of composite art and modes of juxtaposition." Thus, its reference is, on the one hand, broader than that of the word collage, in including fully three-dimensional as well as planar works, and, on the other hand, more specific than that of the word construction, in stressing the accumulation of found elements in such a way that they remain separately recognizable" (Elderfield, "Studies in Modern Art 2," *Essays on Assemblage* [New York: The Museum of Modern Art, 1992], p. 7).

17. Robert Rauschenberg, in conversation with the author.

18. In the symposium, Roger Shattuck points to the evolving notion of collage as crucial. Whereas in Cubism, the theme of still life unified collage, he argues, with the advent of Surrealism, heterogeneity in theme and material prevailed. Dadaism had meanwhile intervened.

19. Dickran Tashjian, *Skyscraper Primitives: Dada and the American Avant-garde, 1910–1925* (Middletown, CT: Wesleyan University Press, 1975), p. 55, citing "Buddha of the Bathroom," a 1917 article by Louise Norton published in the Dadaist journal *The Blind Man*. The occasion for Norton's article was a defense of Duchamp's *Fountain*, which had been submitted to and rejected by the Society of Independent Artists early that year. Duchamp's belief that the inverted urinal typified plumbing and bridges, which were "the only works of art America has given," encouraged, I believe, Rauschenberg and later generations of independent artists to further the formal and expressive objectivity of barbed wire, ventilator ducts, and the auto body. The artist as mechanic who improvises solutions reinforces Rauschenberg's unironic identification here.

20. See Elderfield, *Essays on Assemblage*, pp. 148–9.

21. William Tucker, *Early Modern Sculpture* (New York: Oxford University Press, 1974). Tucker devotes a chapter to seminal sculptural objects and objectivity.

22. The verbal wit and poetry playing over Rauschenberg's sculpture and painting alike encode the art with literary content. Erotic puns on the syllabic "can" hoisted into the blue "yon" (der) reveal links between *Canyon* and *Pail for Ganymede*. See Kenneth Bendiner, "Robert Rauschenberg's Canyon," *Arts Magazine* 56 (June 1982), pp. 57–9.

23. See Burnham, *Beyond Modern Sculpture*. His book argues for the evolution of sculpture toward systems and away from objects.

24. Kendall L. Walton, "Categories of Art," *The Philosophical Review* 69 (1970), pp. 334–67, reprinted in Joseph Margolis, ed., *Philosophy Looks at the Arts* (Philadelphia: Temple University Press, 1978), pp. 88–114. Walton's essay considers the slippage of genre in the arts to be affected by a variety of aesthetic and nonaesthetic factors. For Walton, Rauschenberg's drawing *Erased de Kooning Drawing* (1952), in particular, and his collages and kinetic sculpture, in general, exemplify "contra-standard" practices that lead either to the coining of new categories or to an expanded field.

25. For further consideration of the artist's high- and low-tech practices, see my "Imagination Without Strings," in *Robert Rauschenberg* (Hiroshima: Hiroshima Museum of Contemporary Art, 1993), pp. 24–35.

Chapter 2: Texas, Japan, Etc.

1. Robert Rauschenberg, in an interview with the author (December 22, 1985).

2. Ibid.

3. The Rauschenberg exhibition is best understood in the context of TexArt/150, a gala promotion of Texas that also included the exhibitions *Handmade and Heartfelt*, an exploration of contemporary folk art in Texas that was organized by the Laguna Gloria Art Museum in Austin; *Honky Tonk Visions* at the Museum of Texas Technical University in Lubbock, which explored through works of artists and musicians the influence of West Texas music on popular culture; and *The Texas Landscape* at the Museum of Fine Art in Houston, which was intended to show the ways artists have related to the Texas landscape through their work.

 According to Ron Gleason, director of the Tyler Art Museum and coordinator of TexArt/150, this explosion of arts events arose out of conversations between Linda Cathcart, director of the Contemporary Arts Museum, and Peter Marzio, director of the Museum of Fine Art, then expanded beyond Houston to include arts institutions statewide.

4. Interview with the author (December 22, 1985).

5. Ibid.

6. More intuitive than intellectual, the improvisatory method of Rauschenberg nonetheless shows a formal rigor that prompts the comparison with what Eliot called "sensuous thought": "The quality in question is not peculiar to Donne and Chapman. In common with the greatest . . . they had a quality of sensuous thought, or of thinking through the senses, or

of the sense thinking, of which the exact formula remains to be defined" (Eliot, "Imperfect Critics," *The Sacred Wood: Essays on Poetry and Criticism* [London: Methuen; New York: Barnes and Noble, 1970], p. 23).

7. Interview with the author (December 22, 1985).

8. Indeed, Linda Cathcart's and curator Marti Mayo's motivation for scrambling all the series in the 1985–86 installation at the Contemporary Arts Museum resulted from their perception that there was a stylistic unity binding Rauschenberg's "travelogues."

9. See Jean Piaget, *Play, Dreams and Imitations in Childhood* (New York: Norton, 1951).

10. Donald Barthelme, in Joe David Bellamy, *The New Literature: Interviews with Innovative American Writers* (Urbana: University of Illinois Press, 1974), pp. 151–2.

11. See *Rauschenberg, Work from Four Series: A Sesquicentennial Exhibition* (catalogue), appreciation by Donald Barthelme, essay by Linda Cathcart (Houston, TX: Contemporary Arts Museum, 1985).

12. Interview with the author (December 22, 1985).

13. Wallace Stevens, "Notes Toward a Supreme Fiction," *The Collected Poems of Wallace Stevens* (New York: Alfred A. Knopf, 1964), pp. 397–8. Copyright 1954 by Wallace Stevens. Reprinted by permission of Alfred A. Knopf, Inc.

Chapter 3: The Art of Cy Twombly

1. *Cy Twombly: Fifty Days at Iliam* (New York: The Lone Star Foundation at the Heiner Friedrich Gallery, November 18, 1978–January 20, 1979); and *Cy Twombly: Paintings and Drawings 1954–1977* (New York: The Whitney Museum of American Art, April 10–June 10, 1979).

2. In conversation with the curator.

3. Roland Barthes, "The Wisdom of Art," *Cy Twombly: Paintings and Drawings 1954–1977* (New York: Whitney Museum of American Art, April 10–June 10, 1979).

4. See Heiner Bastian's monograph, *Cy Twombly, Bilder/Paintings, 1952–76* (Berlin: Propyläen Verlag, 1978).

Chapter 4: The Art of Being Sparse, Porous, Scattered

1. Roland Barthes, "The Wisdom of Art," in Annette Lavers, trans., *Cy Twombly: Paintings and Drawings 1954–1977* (New York: Whitney Museum of American Art, 1979), catalogue for the exhibit of the same name, April 10–June 10, 1979.

 Unless otherwise stated, all quotations of Roland Barthes are from this essay.

2. See Chapter 3 of this book, "The Art of Cy Twombly: A Discourse on Twombly," which originally appeared in *Art in America* 7 (September 1979), pp. 81–3.

3. In phenomenologically keyed interpretations, Barthes takes pains to record primordial experiences for primordial forms.

4. Barthes dwells on the issue of names. Preoccupying Barthes, I believe, is not only the painting *The Italians* (1961) but the name "The Italians," for as a name it recalls "Italianicity" from earlier writings on advertisements in which the name suggests inflated value and cultural priority. Italy as connotative of cultural priority over the French haunts Barthes still, even as the uncertain calligraphy of Twombly's inscription of the name deflates its "nominalist glory" and calls into question its "pure" value.

5. The unmotivated signifier of the title throws the abstract nature of the composition into relief. Beyond the scope of this paper is a discussion of "possible worlds" that names in Twombly's art evoke. The mythological or legendary status of certain names is particularly provocative: "Homer" represents that cultural entity indicating the collectively authored oral epic poem *The Iliad* that is recited over time. Barthes, fascinated with designation as well as meaning, might well have been drawn to Twombly's art for the enigmatic modalities of naming as much as for the codes inscribed in the gestural calligraphy.

6. As Annette Lavers reminds us, style for Barthes is the instrumentality of the imagination, not of the social sphere (see Lavers, *Roland Barthes: Structuralism and After* [Cambridge, MA: Harvard University Press, 1982]).

7. During Twombly's formative years, the idea of history that was advanced in the United States by New Critic Kenneth Burke was one suggesting a metaphoric notion of dramatism, a notion crucial to the advancement of the aesthetic and ethos of "action" painting. Antithetical to New-Critical practice, the revered Chicago Aristotelian Richard McKeon developed thematic typologies for philosophy, history, rhetoric, and poetry.

8. See Lee McKay Johnson, "Baudelaire and Delacroix: Tangible Language," *The Metaphor of Painting* (Ann Arbor, MI: UMI Research Press, 1980).

9. See Barthes, "Cy Twombly: Works on Paper," in *The Responsibility of Form* (Berkeley: University of California Press, 1991), p. 160.

10. The exhibition *Picasso and Braque: Pioneering Cubism,* organized by William Rubin for the Museum of Modern Art in 1989, depended on an almost forensic patience for day-by-day evidence of the collaborative effort in evolving the Cubist style. Temporal and material positivism here proves strategic.

11. Seymour Chatman, "The Styles of Narrative Codes," in Berel Lang, ed., *The Concept of Style* (Ithaca, NY: Cornell University Press, 1979, 1987), p. 239.

12. Placing creative expression at the putative poetic origin of human utterance is a cultural phenomenon that Barthes ignores, but in the 1940s Vico's translated writings encouraged the identification of behavioral and evolutionary linguistic development in primitive vocal practices.

13. Martha Nussbaum, *The Fragility of Goodness* (New York: Cambridge University Press, 1986), p. 20.

14. See Chapter 3 of this book, "The Art of Cy Twombly: Early Paintings," pp. 35–8, which originally appeared in *Art in America* 67 (September 1979), pp. 80–3; also as an untitled catalogue essay in *Cy Twombly: Paintings* (New York: Stephen Mazoh Gallery, 1983), unpaginated (catalogue for the exhibition of the same name).

15. The history that may have subconsciously formulated these "random" questions possibly centers on Mussolini's advance on Africa. My thanks to Joseph Masheck for the suggestion.

16. See Chapter 3, "The Art of Cy Twombly: A Discourse on Twombly."

17. See ibid. In a *New York Times* review of the 1983 exhibition *Cy Twombly: Paintings* at the Stephen Mazoh Gallery in New York, art critic John Russell denied the possibility of ratiocinative processes and intentions in the intuitive art of Cy Twombly. His response is typical.

18. See Lavers on poetic coinages, in *Roland Barthes: Structuralism and After*, pp. 42–3.

19. Richard McKeon, *Thought, Action, and Passion* (Chicago: University of Chicago Press, 1954, 1974), p. 204. Expression of essences throughout Twombly's art from the 1960s onward would seem to cast it in this vein. Meanwhile, as Twombly's figural manipulations simplified, Barthes's were prefigured to be growing more complicated. Gerard Genette had already noted in 1964 that Barthes was preparing to deal with free variants of constants (see Gerard Genette, "The Obverse of Signs," *Figures of Literary Discourse* [New York: Columbia University Press, 1982], pp. 27–44).

20. Lavers, in *Cy Twombly* (p. 37), notes Barthes's admiration for Bachelard's definition of an image as a set of potential transformations.

21. Once "postulating . . . that any process presupposes a system," Barthes would seem now to believe that any system presupposes process (Lavers, *Cy Twombly*, p. 53). Whereas once "the effects" of happenings were doomed to trivialize confrontational dialectic, Barthes now prefers the former for its nonauthoritarian stance (see Lavers, p. 79).

22. Barthes's writerly symbolist correspondence to Twombly's style recalls a similar impulse not so long ago in art criticism, criticism that agitated on behalf of that sort of Abstract Expressionism known as "action painting." Well known is the fact that in 1952, when support for abstraction was at best precarious even among the well-intentioned art public in New York, the poet and cultural critic Harold Rosenberg tried to mobilize the public with a passionate partisanship, one inspired by Baudelaire in essays on European abstraction in exile. "The American Action Painters," notorious then, has subsequently moved through the status of celebration back to notoriety, as younger critics, siding with Greenberg's color-field formalism, declared Rosenberg's essay to be both ill-conceived and unreadable. What is less well known, yet which I maintain elsewhere (see Chapter 10, "Harold Rosenberg: Transforming the Earth," on pp. 127–45 of this volume), is that the charge that Rosenberg "made up" the term

"action" so that artists would rally around him demonstrates an igno-rance of the traditions of Romanticism and of revolutionary activism, both of which informed Rosenberg's choice of slogan; at the very least, the spirit of Vorticism informing Rosenberg's first and only book of poetry, *Trance Above the Streets*, which was published a decade prior to his art essay, shows the poet-critic promoting a culturally embedded metaphor wrested from Aristotelian poetics and reconfigured "dramatist-ically" for a variety of modernisms. As for being unreadable, "The Amer-ican Action Painters" is, like Barthes's essay on Twombly, an enactment in the style of the message he is advocating, and, as such, in its aphoristic performative mode, it is perfectly readable – this last point remaining undetected even by the progressive wing of art writers who profess to advocate style as content.

Chapter 5: Narrating the Hand

1. A commonplace of modern poetry and art alike is the preoccupation with calligraphy as a material sign embodying both verbal and visual contents. The spatialization of the page, the image and other topics, and the mate-rial residue marking a page – all entered the poetics of modernity a century ago.

2. Jack Burnham, *Artforum* 7 (April 1969), pp. 49–55.

3. First exhibited in 1976, *Post-Partum Document* by Mary Kelly was pub-lished in London by Routledge & Kegan Paul in 1983.

4. Jurij Lotman, *The Structure of the Artistic Text* (Ann Arbor, MI: Univer-sity of Michigan, Michigan Slavic Contributions No. 7, 1977), p. 65.

5. Jean Piaget, on Mach and the empiricists, "The Myth of the Sensorial Origin of Scientific Knowledge," in *Psychology and Epistemology* (New York: Viking, 1974), p. 63.

6. The poetic index of the cry, the stuttering, or the babbling of children taken up by Romantic poetics and intermittently supposedly thereafter as in, say, Wallace Stevens (an admirer of Vico) and in Joan Miró and Paul Klee in the 1920s, also has haunted visual artists inclined toward the expressivities of Bataille and Artaud. In the 1950s, Nancy Spero, a con-temporary of Twombly, had registered existential complaints scatologi-cally even before converting these expressions to specifically political outrage.

 Presupposed is the Nietzschean claim that the archaic cultural expres-sions are superior to the rational expressions in their vitality in the crea-tive work – superior if for no other reason than the status of interiority imputed to archaic artifacts. Charles Baudelaire's modernism underes-teemed rationalism in favor of both the raw and the decayed expressivity; Bertolt Brecht, the crude, and Walter Benjamin, the refined, intellect ele-vated archaic art for its power to revitalize rationalism. The poetics of origins persists (even as the multiplicity of historical origins is acknowl-edged), at least in both Twombly and Kelly. For they both voice origins through temperament – that is, the French sense of the particularity of the

person, the historical specificity of the particularity of the person, and the historical specificity of the particular set of marks constituting that individuality. Thus, individuality – not so much individualism – instructs the idea and shapes it into a realization through experience.

7. Miriam Lindstrom, *Children's Art* (Berkeley: University of California Press, 1957), p. 18.

8. Ibid., p. 19.

9. Ibid., p. 18.

10. Ibid., p. 19.

11. Ibid.

12. Kelly, *Post-Partum Document*, p. 45.

13. Ibid., p. 77.

14. D. S. Clarke, *Principles of Semiotic* (London: Routledge, 1987). Clark is restating Willard Van Orman Quine's notion of stimulus sentences, which appeared in Quine's *Word & Object* (Cambridge, MA: MIT Press, 1993), p. 33. Understanding a sentence means utilizing it, as Quine notes approvingly of Wittgenstein. One of Quine's chapters, which is entitled "The Ontogenesis of Reference," opens by observing that the operant behavior of children's babbling has come to a close once emitted behavior becomes elicited behavior, one marked by assent (initially) and dissent.

15. Kelly, *Post-Partum Document*, p. 165.

16. More precisely, as Cook wrote, "Beginning with the point, Klee aims for a direct and energetic local effect while at the same time leaving uncertain the viewpoint – and the dimensions – within the work" (Al Cook, "The Sign in Klee," in *Dimensions of the Sign in Art* [Hanover, NH: University Press of New England, 1989], p. 131).

17. Kelly, *Post-Partum Document*, p. 167.

18. Among other modern writers, James Joyce sought to inscribe in his own stratified text Vico's model of the development of language. In contrast to Joyce's superabundant imagination, Kelly's pedagogy keeps imagination at bay.

19. Lotman, "Text and System," in *The Structure of the Artistic Text*. Lotman's consideration of poetry and prose in a later chapter ("Elements and Levels in the Paradigmatics of the Artistic Text") is relevant here too. In Kelly's text, the expectations of poetry for expressing so-called affective writing are met with prose, albeit prose co-opting poetry's artifice.

20. "We improve synonymy by socializing it," says Willard Van Orman Quine in *Word & Object*, p. 66.

21. Curious here is Mary Kelly's inconsistent transcription of her son's deviant letters. According to Piaget, the logical operation of reversibility takes hold at age seven. This may explain Kelly Barrie's consistent "error" in gestalt (and orientation) even as his judgment in locating intersections is consistently accurate.

22. As Vico would have it, naming synthesizes self-definition and character.

23. See "A Discourse on Twombly," *Art in America* 67 (September 1979), pp. 80–3, discussed in another context in "The Art of Being Sparse,

Porous, Scattered," a paper I delivered at the symposium "After Roland Barthes" that was held at the University of Pennsylvania in 1994. This paper was subsequently published in the volume by Jean-Michel Rabaté, ed., *Writing the Image* (Philadelphia: University of Pennsylvania Press, 1997), pp. 201–16.

24. In Gerald Prince's anatomy of text, "[a] topic is either the most prominent element in a text, the element associated with the most numerous of salient predicates, or else the class or aggregate of which this most prominent textual element is a member or constituent. Finally, a symbol, as opposed to a theme, is what it is as well as what it represents (it is the very conjunction of a motif and the theme concretized by that motif)." From Prince, *Narrative as Theme: Studies in French Fiction* [Lincoln: University of Nebraska Press, 1992], pp. 4–5.)

25. Piaget, it must be said, does not subscribe to the logical positivist view of things, and his own scheme for the epistemological development of a child proposes that from the outset, the capability for sensation is accompanied by that of perception and implies a logico-mathematical schematization of perceptions as well as actions exercised on the object. See especially Chapter 4, "The Myth of the Sensorial Origin of Scientific Knowledge," in Jean Piaget, *Psychology and Epistemology* (New York: Viking Press, 1972), pp. 63–88.

26. Giorgio Tagliacozzo, ed., Hayden V. White, co-ed., *Giambattista Vico: An International Symposium* (Baltimore, MD: The Johns Hopkins University Press, 1969).

27. Tullio de Mauro, "From Rhetoric to Linguistic Historicism," Tagliacozzo and White, pp. 293–4, *passim*.

28. Ibid., p. 295.

29. The intensity of the then-current discussion on historicism may be gauged through Hayden White's "Historicism, History and the Figurative Imagination," in his *Tropics of Discourse: Essays in Cultural Criticism* (Baltimore, MD: The Johns Hopkins University Press, 1990), pp. 101–20. In this chapter, White distinguishes definitions by Karl Popper, by Georg Iggers on Meinke, and by Maurice Mandelbaum. Striking as well is the historiographic overhauling of history by White, whose tropological model demonstrates how thoroughgoing the linguistic framework had become. The priority given to poetry and the metaphoric basis of discourse for history may be cited as predicting his interest in resuscitating Vico as a credible historian of the figurative imagination. In addition to his own contribution on Vico to the symposium "What Is Living and What Is Dead in Croce's Criticism of Vico," he has written "The Tropics of History: The Deep Structure of the *New Science*," in Giorgio Tagliacozzo and Donald Phillip Verene, eds., *Giambattista Vico's Science of Humanity* (Baltimore and London: The Johns Hopkins University Press, 1976). All essays are collected in White's *Tropics of Discourse*.

30. Lucy Lippard, ed., *Six Years: The Dematerialization of the Art Object 1966–1972* (New York: Praeger, 1973). Itself a catalogue of Conceptual

works, this work assumes the format of chronicled information and the stance of described objectivity. It is an exemplary artifact of the directed intentions of the age. Typical of the entries are these from early in 1970:

> Gerald Ferguson. Proposal: *A Dictionary for Concrete Poets*: twenty-eight sections, each section devoted to words (alphabetized) of the same length. Halifax, January 28, 1970. January 12–29, School of Visual Arts, New York. Sol LeWitt directs an exhibition in which he asks Hollis Frampton and Michael Snow to record separate sequential studies of dance motion; homage to Muybridge. . . .
> *Art-Language* No. 2, February 1970, Coventry. Contributions by Kosuth (American editor), Atkinson, Bainbridge, Baldwin, Barthelme, Brown-David, Burn, Hiron, Hurrell, McKenna, Ramsden, and Michael Thompson, "Conceptual Art: Category and Action." . . .

Chapter 6: When Is a Door Not a Door?

1. Johns, in conversation with the author (February 22, 1990). Unless otherwise noted, all quotations of Johns are from this interview.
2. Sketchbook notes in Trevor Winkfield, ed., *Julliard* (Leeds, UK: Winkfield; 1968–69), quoted in Richard Francis, *Jasper Johns* (New York: Abbeville, 1977), p. 110.
3. Marcia Epstein Allentuck, *John Graham's System and Dialectics of Art* (Baltimore: The Johns Hopkins University Press, 1971), p. 6.
4. Frank O'Hara, "Skin," quoted in full in Roberta Bernstein, *Jasper Johns's Paintings and Sculptures, 1954–1974* (Ann Arbor, MI: UMI Research Press, 1985), p. 85. "Skin" was published originally in Frank O'Hara, *Collected Poems* (New York: Alfred A. Knopf, Inc., 1971), pp. 475–6. Copyright © 1971 by Maureen Granville-Smith, Administratrix of the Estate of Frank O'Hara. Reprinted by permission of Alfred A. Knopf.
5. Mary Ann Caws, *The Art of Interference* (Princeton, NJ: Princeton University Press, 1989), p. 6.

Chapter 7: Jasper's Patterns

1. Ludwig Wittgenstein, *Philosophical Investigations*, 3rd edition (New York: Macmillan Publishing Company, 1968). Throughout his writings, Wittgenstein considers the discreteness of spots, areas, or patches to be sufficient even as the objects the patches described remain dispersed in touches and so unperceived as a whole. Insufficient with regard to use, moreover, these impressions may be sufficient to perception.
2. Leo Steinberg, "Jasper Johns: The First Seven Years of His Art," *Other Criteria: Confrontations with Twentieth-Century Art* (New York: Oxford University Press, 1972), pp. 17–54.
3. Investigating the material world through perception is the subject of Svetlana Alpers, *The Art of Describing: Dutch Art in the Seventeenth Century* (Chicago, IL: University of Chicago Press, 1983, 1984). In Johns's art,

the empirical impulse is insufficiently realized to satisfy those looking for actuality in this way, yet it is sufficient to illusion's composite aspects. By exploiting the referential difference between word and object both in illusion and in representation, Johns manipulates aspects to make sense in formal and logical terms, requiring active interpretation (not passive description) of the signs the object has become. Imitation as such is the major project undertaken and scrutinized symbolically: In Johns's art, representation is insufficient to traditional representational art, with objects appearing in sketch, diagram, or other notational deviation from likeness. For matters of notation, see Nelson Goodman, *Languages of Art: An Approach to the Theory of Symbols* (Indianapolis, IN: Hackett Publishing, 1976, 1988).

4. Michel Foucault, *Death and the Labyrinth: The World of Raymond Roussel* (New York: Doubleday, 1986), p. 23. Foucault mentions the impediments to representation in reproducing the world chosen by Roussel.

5. See Craig Adcock, *Marcel Duchamp's Notes from the Large Glass: An N-Dimensional Analysis* (Ann Arbor, MI: UMI Research Press, 1981, 1983), p. 192.

6. Adcock, pp. 192–3.

7. Steinberg, *op. cit.*, p. 31.

8. Richard Shiff, "Anamorphosis: Jasper Johns," in James Cuno, ed., *Foirades/Fizzles: Echo and Allusion in the Art of Jasper Johns* (Los Angeles: Wight Art Gallery, University of California, 1987), pp. 147–66.

9. See Thomas Kuhn, *The Structure of Scientific Revolutions* (Chicago, IL: University of Chicago Press, 1962). On the issue of problem-solving arising from apparent contradictions in knowledge, see the discussion of the wave-particle phenomenon in David Park, *Contemporary Physics* (New York: Harcourt, Brace and World, 1964).

10. Johns, *Scrap*, no. 1 (December 23, 1960), p. 4, cited in Roberta Bernstein, *Jasper Johns' Paintings and Sculptures 1954–1974: "The Changing Focus of the Eye"* (Ann Arbor, MI: UMI Research Press, 1975, 1985), p. 114.

Chapter 8: Frame of Mind

1. See Leo Steinberg, "Jasper Johns: The First Seven Years of His Art," *Other Criteria* (New York: Oxford University Press, 1972), pp. 17–54.

2. Max Kozloff, *Jasper Johns* (New York: Harry N. Abrams, 1967), p. 38.

3. Ibid., p. 41.

4. Joshua Taylor, *Learning to Look* (Chicago, IL: University of Chicago Press, 1981), p. 150.

5. Max Kozloff, "Jasper Johns," *The Nation* 197 (December 28, 1963), p. 462.

6. Max Kozloff, *Renderings* (New York: Simon & Schuster, 1968), p. 10.

7. Kozloff, "Robert Rauschenberg," in *Renderings*, p. 212.

8. Kozloff, "Jasper Johns," in *Renderings*, p. 206.

9. See Donald Kuspit, "A Phenomenological Approach to Artistic Inten-

tion," *Artforum* 12 (January 1974), p. 50; and Joseph Masheck, "Sit-in on Johns," *Studio International* 77 (November 1969), pp. 193–4.

10. See Max Kozloff, "The Trouble with Art-as-Idea," *Artforum* 11 (September 1972), pp. 33–7; and "Kozloff's Criticism in Absentia," *Artforum* 11 (June 1972), p. 36 (Kozloff in reply to Preston Heller and Andrew Menard).

11. David Shapiro, *Jasper Johns Drawings 1954–1984* (New York: Harry N. Abrams, 1984).

12. Translated by Shapiro in *Johns Drawings*, p. 48.

13. Paul de Man, quoted in Richard Unger, *Hölderlin's Major Poetry: The Dialectics of Unity* (Bloomington, IN: Indiana University Press, 1975), p. 238.

14. Shapiro, in an unrecorded conversation with the author.

15. Unger, *Hölderlin's Major Poetry*, p. 217.

16. Harold Rosenberg, "Jasper Johns: Things the Mind Already Knows," *The Anxious Object* (New York: New American Library, 1966), pp. 142–3.

17. Ibid., p. 144.

18. Charles Baudelaire, quoted in Harold Rosenberg, "Twenty Years of Jasper Johns," *The New Yorker* (December 26, 1977), p. 42.

19. Ibid.

20. Ibid., p. 45.

21. Ibid.

22. See Lawrence Alloway, *American Pop Art* (New York: Collier Books, and Whitney Museum of American Art, 1974), pp. 52–75.

23. Barbara Rose, "The Graphic Work of Jasper Johns: Part I," *Artforum* 87 (May 1970), p. 39.

24. Roger Shattuck, *The Innocent Eye* (New York: Farrar, Straus & Giroux, 1984), p. 232.

25. Rose, "Graphic Work," p. 42.

26. Ibid., p. 43.

27. Ibid., p. 39.

28. Ibid., p. 41.

29. See, for example, James Gibson, *The Senses Considered as Perceptual Systems* (Boston: Houghton Mifflin, 1966).

30. See Barbara Rose, "Jasper Johns: Pictures and Concepts," *Arts Magazine* 52 (November 1977), pp. 148–53.

31. Rose, "Decoys and Doubles: Jasper Johns and the Rationalist Mind," *Arts Magazine* 50 (May 1976), p. 72.

32. Ibid., p. 73.

33. Rosalind Krauss, "Jasper Johns," *Lugano Review* 1 (1965), pp. 84–113.

34. See Rosalind Krauss, "Jasper Johns: The Functions of Irony," *October* 2 (Summer 1976), pp. 91–9.

35. Ibid., p. 98.

36. Ibid., p. 95.

37. Rose, "Graphic Work," p. 39.

38. Rose, "Decoys and Doubles," p. 69.

39. See Rose, "Jasper Johns: Pictures," p. 159.

40. Rose, "Decoys and Doubles," p. 69.

41. For instance, Wayne C. Booth challenges Cleanth Brooks's assumption that all poetry containing incongruities and qualifications is ironic. See Wayne C. Booth, *A Rhetoric of Irony* (Chicago: The University of Chicago Press, 1974), p. 17.

42. Octavio Paz said that Duchamp is profoundly ironic precisely because he is critical. See Octavio Paz, *Marcel Duchamp: Appearance Stripped Bare* (New York: Viking Press, 1978).

43. See Hayden White, *Metahistory* (Middletown, CT: Wesleyan University Press. 1980), p. 375.

44. Ibid., p. 434.

45. The assumed linguistic model of art is examined by Frederic Jameson, in his *Prison-House of Language: A Critical Account of Structuralism and Russian Formalism* (Princeton, NJ: Princeton University Press, 1972).

46. See Charles Harrison and Fred Orton, "Jasper Johns: Meaning What You See," *Art History* 7 (March 1984), pp. 76–101.

47. See Joseph Masheck, "Cruciformality," reprinted from *Artforum* (Summer 1977), in his *Historical Present; Essays of the 1970s* (Ann Arbor, MI: UMI Research Press, 1984), pp. 145–8. Masheck's other discussions include "Sit-In on Johns" (a review of Kozloff's *Jasper Johns*), *Studio International* (November 1969), 193–5; "Rembrandt X-Rayed" (note), loc. cit. (November 1970), 169; "Jasper Johns Returns" (in *Art in America* [March–April 1976]), 65–7, reprinted as "Coming to Terms with Later Johns," *Historical Present*, pp. 109–13; and, supplementing "Cruciformality" (in *Artforum* [April 1978]), also reprinted in *Historical Present* as "Hard-Core Painting," pp. 159–60; "Iconicity" *Artforum* (January 1979), 221.

48. See Joseph Masheck, "Two Kinds of Monk: Reinhardt and Merton," in Masheck, *Historical Present*, pp. 91–6.

49. See Donald Kuspit, "Personal Signs: Jasper Johns," *Art in America* 69 (Summer 1981), pp. 111–13.

50. Rose, in an unrecorded conversation with the author.

51. Claude Lévi-Strauss, *The Savage Mind* (Chicago, IL: University of Chicago Press, 1962), p. 21.

52. John Cage, quoted in Krauss, "Jasper Johns," p. 86.

Chapter 9: The Specter of Art Hype and the Ghost of Yves Klein

1. For the idea, expressed as "The possible rises on the ground of the nihilation of the for-itself," see Jean-Paul Sartre, chapter IV, "The For-Itself and the Being of Possibilities," *Being and Nothingness: A Phenomenological Essay on Ontology* (New York: Washington Square Press, 1956), p. 147, and following.

2. *Yves Klein 1928–1962: A Retrospective* (Houston, TX: Institute for the Arts, Rice University, 1982), p. 349.

3. Nan Rosenthal, "Assisted Levitation," in *Yves Klein 1928–1962: A Retro-*

spective (Houston, TX: Institute for the Arts, Rice University, 1982), p. 126.

4. This is a rephrasing of Rivers's extended statement in "Blues for Yves Klein," *Art News* 65 (February 1967), pp. 32–3, 75–6. In the original statement, Rivers said,

> [Barnett] Newman came to reduced means through some personal response to painting and painting history, and Yves through Zen and Judo. It took Yves twelve years to become the most naturalistic and elemental artist of our time. I mean that he used the elements. If it was raining he would spread some of his blue pigment on a sheet of Kraft paper and stick it out the window for a few minutes. Whatever happened, happened. Other times he would tie some canvases to the top of his automobile, go scooting along a road accepting the results of the wind as it whipped the pigment across the surfaces (p. 75).

Chapter 10: Harold Rosenberg: Transforming the Earth

1. As well as containing Rosenberg's essay, the first issue of *Possibilities* included an article on Dada by Richard Huelsenbeck and two key statements on painting by Mark Rothko and Jackson Pollock.

2. Harold Rosenberg, "The Fall of Paris," *The Tradition of the New* (New York: Grove Press, 1961), p. 209. "The Fall of Paris" was originally published in *Partisan Review* in 1940.

3. Harold Rosenberg, "The American Action Painters," *Art News* 51 (December 1952). This piece also appeared in Rosenberg, *The Tradition of the New*, p. 28.

4. Harold Rosenberg, "The Stages: A Geography of Action," in *Possibilities* I (Winter 1947/48), p. 50.

5. Although he distanced himself from them, Rosenberg remained indebted to I. A. Richards and the formalist literary theorists of the 1920s for supplying him with clear semantic categories, especially the distinction between instrumental language, which is denotative, and aesthetic language, which is connotative and uniquely distinguished by imagination. See, for instance, the synoptic discussion of literature and "nonliterature" in René Wellek, "The Nature of Language," *Theory of Literature* (New York: Harcourt, Brace & World, 1956), pp. 20–8.

6. See James Burkhart Gilbert, *Writers and Partisans: A History of Literary Radicalism in America* (New York: John Wiley & Sons, 1968), especially chapter 13, "Revolution and Renaissance," pp. 88–117.

7. See Meyer Schapiro, "Nature of Abstract Art," *The Marxist Quarterly* 1 (January–March 1937), pp. 77–98.

8. See Harold Rosenberg, "The Herd of Independent Minds," *Discovering the Present* (Chicago, IL: University of Chicago Press, 1973), pp. 15–28.

9. Ibid., p. 25.

10. In fact, Rosenberg did start to write a biography of Dostoevsky, but he could never sufficiently distance himself from the topic to finish it (Dore

Ashton, in conversation with the author). For Ashton, Rosenberg's motivation and major theme are individuality. See Dore Ashton, "On Harold Rosenberg," *Critical Inquiry* 6 (Summer 1980), pp. 615–24.

11. Charles Baudelaire, *Curiosités Esthétiques* (Paris: Crepet, Conard, 1923), p. 50 (author's translation).

12. Paul Valéry, "Degas, Dance, Drawing," *Degas, Manet, Morisot* (New York: Pantheon Books, 1960), p. 50.

13. Gilbert, *Writers*, p. 99.

14. Edmund Wilson, *Axel's Castle: A Study in Imaginative Literature of 1870–1930* (New York: Scribner's, 1931), p. 21.

15. Ibid., p. 25.

16. See Robert Goldwater, "Reflections on the New York School," in *Quadram* 8 (1960), p. 29.

17. Harold Rosenberg, "Oh This Is the Creature That Does Not Exist," *The Tradition of the New* (New York: Grove Press, Inc., 1961), p. 121.

18. William C. Seitz, *Abstract Expressionist Painting in America* (Cambridge, MA: Harvard University Press, 1983), p. 63. Rosenberg earned that appellation by having produced a volume of poetry, *Trance Above the Streets* (1942), as well as by having written many probing articles on literature (including a review in *Poetry* 47 [March 1936], p. 347, of Kenneth Burke's formative *Permanence and Change*, in which he quotes Burke's Heideggerian conclusion that "the ultimate metaphor for discussing the universe and man's relations to it must be the poetic or dramatic metaphor" [p. 347]. *Art News* did not eschew journalism, of course, but its editorial latitude allowed for a sophisticated response to nonrepresentational art – from argument to oratory, from impressionist to the sort of speculative criticism that asks not only, "What do I think?" but "What is there to think?"

19. Rosenberg, "The American Action Painters," p. 27.

20. Paul Valéry, *The Collected Works of Paul Valéry* (Princeton, NJ: Princeton University Press, 1956–75), p. 100.

21. Richard Huelsenbeck, "En Avant Dada," *Possibilities* I (Winter 1947/48), p. 42.

22. ". . . [C]reation of art within the twentieth century is an activity within the politico–cultural drama of a world in the process of remaking itself" (see Rosenberg, "Criticism and Its Premises," *Art on the Edge* [Chicago, IL: University of Chicago Press, 1975], p. 136).

23. See Harold Rosenberg, "Movement in Art," *Art and Other Serious Matters* (Chicago, IL: University of Chicago Press, 1985), pp. 10–21.

24. Rosenberg also stated, "Aesthetic programs have replaced regional masterpieces as authority and inspiration. 'Every modern activity,' says Paul Valéry, 'is dominated and governed by *myths* in the form of *ideologies*' " (his italics) (Rosenberg, "Criticism and Its Premises," *Art on the Edge* [Chicago, IL: University of Chicago Press, 1975], p. 138).

25. "By an aesthetic idea I mean that representation of the imagination which induces much thought. . . . In a word, the aesthetic idea is a representation of the imagination, annexed to a given concept, with which, in the

free employment of the imagination, such a multiplicity of partial repre-
sentations are bound up, that no definite concept can be found for it"
(Immanuel Kant, quoted in Tzvetan Todorov, *Theories of the Symbol*
[Ithaca, NY: Cornell University Press, 1984], p. 190). Explaining Kant's
aesthetic, Todorov says that, incapable as language may be of exhausting
the meaning of art, a critic is in the "enviable" position of never running
out of material to interpret.

26. Joseph Margolis, "The Logic of Interpretation," *Philosophy Looks at the
Arts* (New York: Charles Scribner's Sons, 1962), pp. 116, 118.

27. Harold Rosenberg, "The Mythic Act," in his *Artworks and Packages*
(Chicago, IL: University of Chicago Press, 1982), p. 63.

28. Allan Kaprow, "The Legacy of Jackson Pollock," *Art News* 57 (October
1958), pp. 56–7.

29. Prejudiced against structure, Rosenberg virtually ignores the organizational
originality of Pollock's all-over canvases. Instead, with the intuition-
expression of automatic writing in mind, he discusses the notion of expres-
sivity. The origins of gesture as feeling, not physical action, come by way of
the artistic legacy of Expressionism: "The scars of such a revolution in ex-
pression are, however, those blots and specks which as emissaries of the id
resist the conscious will of the artist in both painting and music alike, which
mar the surface and can as little be cleansed away by later conscious correc-
tion as the bloodstains in fairytales" (T. W. Adorno, on Arnold Schönberg's
Expressionist *Verklaerte Nacht*, quoted in Frederic Jameson, *Marxism and
Form* [Princeton, NJ: Princeton University Press, 1971], p. 27).

30. Harold Rosenberg, "Miró," *Art on the Edge* p. 29.

31. See Rosenberg's review of Suzanne Langer's *Feeling and Form* (1953) in
"Virtual Revolution," in *The Tradition of the New*, pp. 50–7. Rosen-
berg's predisposition toward ambiguity did not preclude him from using
fruitful semiotic terms himself. His use of the term "sign" in defining
action painting apparently derives from the language analysts, particu-
larly from Langer's notion of the presentational symbol. Art, as distinct
from everyday discursive language, cannot represent; it can only express,
involved as it is in a simultaneous integral presentation of meaning.
Having written for *Kenyon Review, Poetry, Symposium*, and other liter-
ary magazines, Rosenberg might well have noted the discussion of lin-
guistic formalism in their pages. For instance, it is likely that he noted the
publication of Philip Wheelwright's celebrated "Semantics of Poetry" in
Kenyon Review 2 (Summer 1940), which discussed his specialized notion
of the "plurisign" – "semantically reflexive in the sense that it is part of
what it means. That is to say, the plurisign, the poetic symbol, is not
merely employed but enjoyed; its value is not entirely instrumental but
largely aesthetic, intrinsic" (p. 270).

32. Rosenberg, "The Concept of Action in Painting," *Artwork and Packages*
(Chicago, IL: University of Chicago Press, 1982), pp. 226, 228.

33. Wellek, *Theory*, p. 23.

34. Rosenberg, "Snow on the Aerials," *Poetry* 54 (May 1939), p. 77.

35. Rosenberg, "Hans Hofmann: The 'Life' Class," *The Anxious Object* (New York: New American Library, 1969), p. 120.
36. For Robert Goldwater, by contrast, the meaning of Abstract Expressionism originates in pure sensation and beauty. See Goldwater, "Reflections," p. 30.
37. Baudelaire, *Curiosités*, p. 274.
38. Paul Goodman, "Essays by Rosenberg," in *Dissent* 6 (Summer 1959), p. 306.
39. See Goldwater, pp. 33–4.
40. See Stephen C. Foster, *The Critics of Abstract Expressionism* (Ann Arbor, MI: UMI Research Press, 1980), p. 92.
41. Baudelaire, quoted in "The Salon of 1846," *Art in Paris: 1845–1862* (Oxford: Phaidon, 1965), p. 44.
42. See Rosenberg, "The Politics of Art," *The Anxious Object* (New York: New American Library, 1969), pp. 173–80.

Chapter 11: The Art of Philip Guston

1. *The Drawings of Philip Guston* (New York: Museum of Modern Art, September 8–November 1, 1988). This retrospective included 151 Guston drawings on paper, from 1930 to 1980.
2. Dore Ashton, *Yes . . . , But: A Critical Study of Philip Guston* (New York: Viking, 1976). In this book she discusses the Kafka influence.
3. From "The Killers," in *Men Without Women* (New York: Scribner Publishing, 1927), pp. 78–9. Excerpted with permission of Scribner, a Division of Simon & Schuster, from *Men Without Women* by Ernest Hemingway. Copyright 1927 by Charles Scribner's Sons. Copyright renewed 1955 by Ernest Hemingway.
4. Ibid., pp. 79–80.
5. Guston was not alone among his generation in reverting to a former period during the twentieth century for a contemporary political statement. For instance, in the decade that saw the publication of *The Organization Man*, Lester Johnson created phalanxes of electric-blue, bowlered silhouettes marching across yolk-yellow space to imply that a gangland mentality may be the unwanted obverse of individual anonymity.
6. The Museum of Modern Art's retrospective exhibition of Guston's works (see Note 1) offered an opportunity for just such a survey.
7. Kenneth Burke, "Form and Persecution in the *Oresteia*," *Sewanee Review* 60 (Summer 1952). This essay also appeared in Burke's *Language as Symbolic Action: Essays in Life, Literature and Method* (Berkeley: University of California Press, 1973), p. 126.
8. With his all-over composition indebted to Pollock and with his points of sensuality suggestive of Gorky or Grosz, his notation for feeling is succinct and clear – and entirely abstract. It is as if the facades of buildings he had sketched in Rome in 1949 (while on an American Academy fellowship) had redefined themselves as inscapes less material than in-

tensely sensible. Perhaps the strong Italian light – or even the sharply punctuated line-and-dot shorthand with which Ingres had noted the ur-ban views – had informed this new succinctness. In Guston's art of the late 1950s, there may well be a tradition of graphic probity reinforcing the abstract vocabulary of Abstract Expressionism.

9. Magdalena Dabrowski, *The Drawings of Philip Guston* (New York: Mu-seum of Modern Art, 1988), p. 29.

10. Ashton, *Yes . . . , But*, p. 155.

11. See Robert Storr, *Philip Guston* (New York: Abbeville Press, 1986), p. 25.

12. An impulse to purge himself may have led Guston to overstate the case – as Ashton suggests when she terms his temporary disavowal of feeling as "hyperbole"; and, indeed, his late art shows his immersion in "emotional seaweed" – ill health having refreshed his psychic material with sure-fire urgency.

13. See Dabrowski, pp. 28, 37.

14. Ibid., p. 38.

15. Quoted in Ashton, pp. 177–8.

16. Ibid.

17. Wassily Kandinsky, *Concerning the Spiritual in Art* (New York: Witten-born, 1947), p. 69.

Chapter 12: Gestural Aftermath

1. Of these millions, fifty items selected from a fifteen-year period were on exhibit in 1985 at the Philadelphia Museum of Art. The exhibition traveled from Philadelphia to New York, Berkeley, Minneapolis, and Washington, D.C.

2. *Artforum* 13 (November 3, 1974), p. 63.

3. Similiar statements abound in a transcript of Borofsky's unpublished 1984 interview with Mark Rosenthal.

4. Werner Haftmann, *Painting in the Twentieth Century: An Analysis of the Artists and Their Work* (New York: Praeger, 1968), p. 317. As events would have it, Borofsky's installation at the Paula Cooper Gallery in Oc-tober 1980 would incorporate "life action." With a Ping-Pong table invit-ing participants to play by putting creativity in centrifuge, the installation made the subjective world of thought and association into an introspective street-theater. In his interview with Rosenthal, Borofsky puts it this way:

> Two sides of a table with a net in the middle, not unlike other sports, signify the division. The net is the symbol and is the center of activity. So it was logical to make it into a painted sculpture that one could actually use and play. It would incorporate life action, as well as sound, into this set – or this three-dimensional painting – that I created; and people could not only walk through it (this installation) which they had done up to then, but also take part in it, and at once, point: be the action as someone else watched. They'd be the actors in this set.

Borofsky's stated intention only reinforces the intentionality in his work: to transfigure existential engagement in a way commensurate with play and with social action, both tendencies that animated the international world of art actions throughout the 1970s.

5. In Barthes, stories become texts subjected to analysis in discontinuous units of reading. So, too, is this true with Lasker. No longer spontaneous, the so-called automatic gesture that Pollock once knew is now depicted as a semantic coding of gesture, and it is referential rather than expressive. Drawing and painting are distinct citations.

Chapter 13: Contesting Leisure

1. By a stroke of wayward luck in 1986, New York's Whitney Museum of American Art brought about just such an opportunity to view these artists' works at the same time. The Whitney had already scheduled a midcareer retrospective of Katz when Fischl's planned show at the Broida Museum was canceled abruptly due to the Broida's closing. The Fischl show had been traveling through Canada and Europe and, suddenly, it was in New York with no place to go. Fortunately, the Whitney Museum picked it up and scheduled it simultaneously with the Katz retrospective, thereby bringing about an intriguing coupling of wills in a pair of exhibitions that was far more stimulating than either would have been if seen in isolation from the other. *Alex Katz* (New York: Whitney Museum of American Art, 1986) and *Eric Fischl Paintings* (Saskatoon, Canada: Mendel Art Gallery, 1985).

2. Donald Kuspit and Robert Rosenblum also squared off in a debate at the School of Visual Arts in New York in November 1985.

3. Robert Rosenblum, "Alex Katz's American Accent," *Alex Katz* (New York: Whitney Museum of American Art, 1986), p. 31. The essay was revised and expanded from a piece accompanying a Katz exhibition at the Fresno Arts Center and Museum in 1977.

4. Donald Kuspit, "Voyeurism, American Style: Eric Fischl's Vision of the Perverse," in Bruce W. Ferguson, ed. and curator, *Eric Fischl Paintings*, (Saskatoon, Canada: Mendel Art Gallery, 1985), pp. 9–17.

5. Ibid., p. 9.

6. Bruce Ferguson was the guest curator of the 1986 Fischl exhibition at the Whitney Museum, and he also organized the Fischl show for its opening at the Mendel Gallery in Saskatoon, Saskatchewan, Canada.

7. *"Primitivism" in 20th Century Art: Affinity of the Tribal and the Modern* (New York: Museum of Modern Art, September 19, 1984–January 15, 1985).

Chapter 14: Indeterminacy Meets Encyclopedia

1. Charles Baudelaire, "The Painter of Modern Life: Modernity," in Jonathan Mayne, trans., *The Painter of Modern Life and Other Essays* (London: Phaidon, 1964), p. 13. This translation was originally published in *Le Figaro* (November 26 and 28, and December 3, 1863).

2. This point is raised by literary theorist and semiotician Umberto Eco in *The Aesthetics of Chaosmos: The Middle Ages of James Joyce*, trans., Ellen Esrock (Cambridge, MA: Harvard University Press, 1962, 1989).

3. Reissued as Umberto Eco, *The Open Work* (Cambridge, MA: Harvard University Press, 1989). The notion of indeterminacy – crucial to modern aesthetics – was, as Eco sees it, a crisis of medieval thought once interpretive signs implied loss of control over the administration of meaning. Joyce's tortuous development from a medieval to a modern believer gives Eco the occasion to speculate on the changing nature of semiotics in Joyce's aesthetic.

4. Kestutis Zapkus, in correspondence and conversation with the author. All subsequent citations of the artist are from these contacts, unless otherwise noted.

5. Eco, *Chaosmos*, p. 37.

6. John Coplans, *Serial Imagery* (Pasadena, CA: Pasadena Art Museum, 1968), pp. 10–11.

7. The curator in question is David Lee.

8. Zapkus, in a statement to the author. Zapkus sees seriality as belonging to early modern cultural heritage and resents the recent appropriation of the systems of De Stijl and the serial music of Schönberg, which were developed before and after World War I. For an analysis of organizing principles that bring tonal structure and serial music into opposition, see Schönberg, "Serial Composition" (1923) in Leonard Stein, ed., *Style and Idea: Selected Writings of Arnold Schoenberg* (Berkeley, CA: University of California Press, 1984), pp. 207–8.

9. James Joyce, *A Portrait of the Artist as a Young Man* (New York: Viking, 1960), p. 206.

10. "In his introduction to *The Raw and the Cooked*, Claude Lévi-Strauss examines the differences between two cultural attitudes which he terms 'structural thought' and 'serial thought.' By 'structural thought' he means the philosophic stance that underlies the structuralist investigation in the human sciences; by 'serial thought' he means the philosophy that underlies post-Webern musical aesthetics – in particular, Pierre Boulez's poetics" (opening paragraph from Eco, "Structure and Series," in *The Open Work*, p. 217). Eco's essay examines the opposition to the analytic principles fundamental to the conflict between structural and serial thought.

11. Eco, "The Early Joyce," *Chaosmos*, p. 18. Eco comments that in early Joyce, a Pythagorean order of rhythm qualifies the modern order.

12. Eco (*Chaosmos*, p. 28) quotes from *A Portrait of the Artist as a Young Man*: "[T]he silent stasis of the aesthetic pleasure."

13. Frank Popper, "Poetry and Music," *Art-Action and Participation* (New York: New York University Press, 1975), p. 146.

14. Eco, in "The Early Joyce" (*Chaosmos*, pp. 58–9), is referring to William T. Noon, *Joyce and Aquinas* (New Haven, CT: Yale University Press, 1957), p. 113. Even here, Zapkus's autonomous art object is not, strictly speaking, Minimalist. The canvas of pictorial quantum energy is not without an imaginative consideration (and reconsideration) of the notion of intelligibility as it appeals to the barely sensible.

Borofsky's stated intention only reinforces the intentionality in his work: to transfigure existential engagement in a way commensurate with play and with social action, both tendencies that animated the international world of art actions throughout the 1970s.

5. In Barthes, stories become texts subjected to analysis in discontinuous units of reading. So, too, is this true with Lasker. No longer spontaneous, the so-called automatic gesture that Pollock once knew is now depicted as a semantic coding of gesture, and it is referential rather than expressive. Drawing and painting are distinct citations.

Chapter 13: Contesting Leisure

1. By a stroke of wayward luck in 1986, New York's Whitney Museum of American Art brought about just such an opportunity to view these artists' works at the same time. The Whitney had already scheduled a midcareer retrospective of Katz when Fischl's planned show at the Broida Museum was canceled abruptly due to the Broida's closing. The Fischl show had been traveling through Canada and Europe and, suddenly, it was in New York with no place to go. Fortunately, the Whitney Museum picked it up and scheduled it simultaneously with the Katz retrospective, thereby bringing about an intriguing coupling of wills in a pair of exhibitions that was far more stimulating than either would have been if seen in isolation from the other. *Alex Katz* (New York: Whitney Museum of American Art, 1986) and *Eric Fischl Paintings* (Saskatoon, Canada: Mendel Art Gallery, 1985).

2. Donald Kuspit and Robert Rosenblum also squared off in a debate at the School of Visual Arts in New York in November 1985.

3. Robert Rosenblum, "Alex Katz's American Accent," *Alex Katz* (New York: Whitney Museum of American Art, 1986), p. 31. The essay was revised and expanded from a piece accompanying a Katz exhibition at the Fresno Arts Center and Museum in 1977.

4. Donald Kuspit, "Voyeurism, American Style: Eric Fischl's Vision of the Perverse," in Bruce W. Ferguson, ed. and curator, *Eric Fischl Paintings*, (Saskatoon, Canada: Mendel Art Gallery, 1985), pp. 9–17.

5. Ibid., p. 9.

6. Bruce Ferguson was the guest curator of the 1986 Fischl exhibition at the Whitney Museum, and he also organized the Fischl show for its opening at the Mendel Gallery in Saskatoon, Saskatchewan, Canada.

7. *"Primitivism" in 20th Century Art: Affinity of the Tribal and the Modern* (New York: Museum of Modern Art, September 19, 1984–January 15, 1985).

Chapter 14: Indeterminacy Meets Encyclopedia

1. Charles Baudelaire, "The Painter of Modern Life: Modernity," in Jonathan Mayne, trans., *The Painter of Modern Life and Other Essays* (London: Phaidon, 1964), p. 13. This translation was originally published in *Le Figaro* (November 26 and 28, and December 3, 1863).

2. This point is raised by literary theorist and semiotician Umberto Eco in *The Aesthetics of Chaosmos: The Middle Ages of James Joyce*, trans., Ellen Esrock (Cambridge, MA: Harvard University Press, 1962, 1989).

3. Reissued as Umberto Eco, *The Open Work* (Cambridge, MA: Harvard University Press, 1989). The notion of indeterminacy – crucial to modern aesthetics – was, as Eco sees it, a crisis of medieval thought once interpretive signs implied loss of control over the administration of meaning. Joyce's tortuous development from a medieval to a modern believer gives Eco the occasion to speculate on the changing nature of semiotics in Joyce's aesthetic.

4. Kestutis Zapkus, in correspondence and conversation with the author. All subsequent citations of the artist are from these contacts, unless otherwise noted.

5. Eco, *Chaosmos*, p. 37.

6. John Coplans, *Serial Imagery* (Pasadena, CA: Pasadena Art Museum, 1968), pp. 10–11.

7. The curator in question is David Lee.

8. Zapkus, in a statement to the author. Zapkus sees seriality as belonging to early modern cultural heritage and resents the recent appropriation of the systems of De Stijl and the serial music of Schönberg, which were developed before and after World War I. For an analysis of organizing principles that bring tonal structure and serial music into opposition, see Schönberg, "Serial Composition" (1923) in Leonard Stein, ed., *Style and Idea: Selected Writings of Arnold Schoenberg* (Berkeley, CA: University of California Press, 1984), pp. 207–8.

9. James Joyce, *A Portrait of the Artist as a Young Man* (New York: Viking, 1960), p. 206.

10. "In his introduction to *The Raw and the Cooked*, Claude Lévi-Strauss examines the differences between two cultural attitudes which he terms 'structural thought' and 'serial thought.' By 'structural thought' he means the philosophic stance that underlies the structuralist investigation in the human sciences; by 'serial thought' he means the philosophy that underlies post-Webern musical aesthetics – in particular, Pierre Boulez's poetics" (opening paragraph from Eco, "Structure and Series," in *The Open Work*, p. 217). Eco's essay examines the opposition to the analytic principles fundamental to the conflict between structural and serial thought.

11. Eco, "The Early Joyce," *Chaosmos*, p. 18. Eco comments that in early Joyce, a Pythagorean order of rhythm qualifies the modern order.

12. Eco (*Chaosmos*, p. 28) quotes from *A Portrait of the Artist as a Young Man*: "[T]he silent stasis of the aesthetic pleasure."

13. Frank Popper, "Poetry and Music," *Art-Action and Participation* (New York: New York University Press, 1975), p. 146.

14. Eco, in "The Early Joyce" (*Chaosmos*, pp. 58–9), is referring to William T. Noon, *Joyce and Aquinas* (New Haven, CT: Yale University Press, 1957), p. 113. Even here, Zapkus's autonomous art object is not, strictly speaking, Minimalist. The canvas of pictorial quantum energy is not without an imaginative consideration (and reconsideration) of the notion of intelligibility as it appeals to the barely sensible.

15. Lucy Lippard, "Art Tranquil, Art Defiant: Kes Zapkus," *Art in America* 70 (Summer 1982), pp. 132–8.
16. See Lucy Lippard, *Six Years: The Dematerialization of the Art Object from 1966–1972* (New York: Praeger, 1973).
17. Lippard, "Art Tranquil," p. 33.
18. Zapkus, "Harmonized Chaos," a memoir, in manuscript.
19. George Avakian, quoted in Richard Kostelanetz, ed., *John Cage*. Documentary Monographs in Modern Art, Paul Cummings, general ed. (New York: Praeger, 1970), p. 109.
20. Marjorie Welish, from a statement for *The Open Work*, an exhibition organized by the author for the John Good Gallery, April 2–May 2, 1992, and published as "Contextualizing 'The Open Work,' " in *Sulfur* 32 (Spring 1993), pp. 255–69.

Chapter 15: A Greenberg Retrospective

1. Volumes 3 and 4 were published in 1993.
2. John O'Brian, *Clement Greenberg*, Vol. 1, p. 64, originally published in *The Nation* (April 19, 1941), p. 843.

Chapter 16: Abstractions

1. Often attributed to Newman, this phrase appears in his hithero unpublished essay "The Problem with Subject Matter," *Barnett Newman* (New York: Alfred A. Knopf, 1990), p. 80.
2. Richard Shiff, "Introduction," in O'Neill, ed., *Barnett Newman*, p. xiii.
3. Ibid., p. 242. Originally published as "The Case for 'Exporting' the Nation's Avant-garde," *The Washington Post* (March 27, 1966).
4. Preface to *The Lyrical Ballads 1798–1805* (London: Methuen, 1961), p. 26.
5. Craig Adcock, *James Turrell: The Art of Light and Space* (Berkeley, CA: University of California Press, 1990), p. 208.

Chapter 17: A Literature of Silence

1. This phrase was spoken by Lucky in *Waiting for Godot*, by Samuel Beckett (New York: Grove Press, 1954), p. 29.

Chapter 18: Boulders from Flatland

1. Edwin A. Abbott, *Flatland: A Romance of Many Dimensions* (New York: Dover Publications, Inc., 1952), p. 86.

Chapter 19: Box, Aspects of

1. "From my first affirmation of the space-idea in the *Realistic Manifesto*, 1920, I have not ceased to emphasize that in using the spatial element in sculpture, I do not intend to deny the other sculptural elements; that by

saying, 'We cannot measure or define space with solid masses, we can only define space by space,' I did not mean to say that massive volumes do not define anything at all, and are therefore useless for sculpture. On the contrary I have left volume to its own property to measure and define – masses," writes Naum Gabo. "Sculpture: Carving and Construction in Space" is reprinted in I. L. Martin, B. Nicholson, and N. Gabo, eds., *Circle: An International Survey of Constructivist Art* (London: Faber and Faber, Ltd., 1937; New York: Praeger, 1971), p. 107.

Although Gabo resists being associated with a transcendent concept of space, space *a priori* and necessary, which is assumed to be true by Kant, lends philosophical weight to this defining condition of sculpture.

2. Martin Heidegger, *Being and Time*, Sections 15 and 98, cited in Stephen Mulhall, *On Being in the World: Wittgenstein and Heidegger on Seeing Aspects* (London: Routledge, 1993), pp. 110–11.

3. See, for example, Kendall Walton, "Categories of Art," in Joseph Margolis, ed., *Philosophy Looks at the Arts* (Philadelphia, PA: Temple University Press, 1978), pp. 88–114.

4. For an opposing view of visual language, see Donald Kuspit, "Wittgensteinian Aspects of Minimal Art," *The Critic as Artist: The Intentionality of Art* (Ann Arbor, MI: UMI Research Press, 1984), pp. 243–52.

5. Discussion of designation, or fixing a reference through ostension and description – although not by identifying a mere bundle of properties – may be found in Saul A. Kripke's consideration of Russell and Wittgenstein in *Naming and Necessity* (Cambridge, MA: Harvard University Press, 1972, 1980).

6. Gabo's 1937 article "Sculpture: Carving and Construction in Space" is reprinted in his *Circle*, p. 109.

7. The tendency for language to dictate the sense we impute, then, to the artifacts, is, of course, the source for assumptions about conceptual frameworks and reasoning about the artifacts' ideological content.

8. Compatible with the notion of reduction that resulted when form developed through the elimination of material excess – a topos common enough in the history of ideas – form simplified to its essentials through the organic process of revision, is the idea of minimalism that the Russian emigré John Graham introduced to Americans in his *System and Dialectics of Art*, edited by Marcia Epstein Allentuck (Baltimore and London: Johns Hopkins University Press). To put it another way, we might say that the attainment of simplicity in Brancusi's carved cast sculptures, those comprising the Bird in Space (1923–28) group, is not at all identical to the simplicity of a modular plan executed in constructed sculpture that is ordered by Judd.

9. Xenophon, *Symposium*, chapter V, U. J. Todd, trans. (Cambridge, MA: Harvard Loeb Library, 1997), pp. 598–603.

10. Michael Podro, *The Critical Historians of Art* (New Haven, CT: Yale University Press, 1982), p. 45. Podro insists on the nonmaterial content upheld by Semperian functionalism – or rather, Podro shows his own idealist bias when saying of Semper that to call him a functionalist is to

ignore the importance given to transformation of materials. (See also Podro's initial discussion of reduction, in which he appeals to Hegel's definition of sculpture becoming inward – attaining to reduction – insofar as it passes over into painting [p. 22].)

11. Robert Furneaux-Jordan, *Victorian Architecture* (Harmondsworth, UK: Penguin Books Ltd., 1966), p. 131.

12. For the historically driven argument of creativity that challenged functionalism and utility, see Reyner Banham, *Theory and Design in the First Machine Age* (Cambridge, MA: MIT Press, 1980).

13. See, for instance, Gabo's statement in 1937: "The shapes we are creating are not abstract, they are absolute. They are released from any existent thing in nature and their content lies in themselves" (*Circle*, p. 109).

14. MOMA, *Naum Gabo Antoine Pevsner* (New York: Museum of Modern Art, 1948), p. 18.

15. Gabo, "The Constructive Idea in Art," *Circle*, p. 7.

16. For a discussion of transparency in the modern history of ideas, see Colin Rowe (with Robert Slutzky), "Transparency: Literal and Phenomenal," written in 1955–56 and published before being collected in Rowe's *Mathematics of the Ideal Villa and Other Essays* (Cambridge, MA: MIT Press, 1976; 1988), pp. 159–83. Parenthetically, a noteworthy current example of transparency exploited for the sake of phenomenal ambiguity may be found in the spatial construction installed on the roof of the Dia Foundation building in New York in 1981 by Dan Graham. It is typical of the artist's behavioral extrapolation of perception.

17. El Lissitzky and Ilya Ehrenberg, "The Blockade of Russia Is Coming to an End," *Veshch/Gegenstand/Objet* 1–2 (March–April 1922), p. 1. This editorial was reprinted in Stephen Bann, ed., *The Tradition of Constructivism* (New York: Viking, 1974; Da Capo, 1990), pp. 53–57.

18. Donald Judd, "It's Hard to Find a Good Lamp," in *Donald Judd Furniture* (Rotterdam: Museum Boymans–van Beuningen, 1993), p. 7.

19. In this regard, Judd's plywood boxes of the 1970s have something to say about how they discharge the role of industry and craft. Insofar as volume remains normative for modernity, then the box and its standardization offer an industrial alternative to, say, the improvised assemblage, with found – since disused – boxes attached. Rauschenberg's Cardboards from the early 1970s, if not flattened, then splayed and facing the wall to which they were attached, would pose the sort of readymade to which Judd's boxes would be the alternative – although in their immanent presence these cardboard and plywood artifacts share common ground. Judd's *a priori* rationalism and Rauschenberg's serendipitous bricolage register very different sets of beliefs and mentalities. Even so, in both instances, the box is a reality no less referenced for being a formal – and tectonic – commonplace. If volume is primary law, then perhaps the box may be seen to be a revernacularization of this law of volumetric space articulating the prototype – Colquhoun's term, in his "Vernacular Classicism," in *Modernity and the Classical Tradition: Architectural Essays 1980–1987* (Cambridge, MA: MIT Press, 1994), p. 30.

20. See Alan Colquhoun, "Postmodernism and Structuralism: A Retrospective Glance," *Modernity*, p. 248.

21. Ibid., pp. 246–7. Reviving the type as preexistent form may be said to lend itself to the structuralist method. Jack Burnham's application of the structuralist method to the analysis of modern cultural form is noteworthy here. See his *Structure of Art* (New York: George Braziller, Inc., 1971).

22. Robert Venturi, *Complexity and Contradiction in Architecture* (New York: Museum of Modern Art, 1966). For further discussion, see Joseph Masheck, "Tired Tropes: Cathedral versus Bicycle Shed; Duck" versus "Decorated Shed," in *Building-Art: Modern Architecture under Cultural Construction* (New York: Cambridge University Press, 1993), pp. 184–221. If Venturi disdains the functional "duck" to elaborate the aesthetic sign attached to the "decorated shed," Judd evidently resisted this conversion to postmodern aesthetics happening around him during the 1960s. His work evidences a determination to do ducks despite the shift in culture. The terms of his pursuit surely center on "box," and, having accommodated "frame," accommodate also "bin" and "shelf." Meanwhile, all these terms can be made accountable to the necessity of formalism, with its crucial term "volume" remaining intact.

23. Bruce Glaser, "Questions to Stella and Judd," in Gregory Battcock, ed., *Minimal Art* (New York: E. P. Dutton and Co., Inc., 1968), p. 156.

24. Colquhoun analyzes the interrelation of functionalism, formalism, and logical atomism – and the corresponding ideas in architectural design in his "Rationalism: A Philosophical Concept in Architecture," in *Modernity*.

Chapter 20: Quality Through Quantity

1. Robert Morris, "Notes on Sculpture"; Parts I and II were originally printed in *Artforum* 4 (February 1966), 42–4, and 5 (October 1966), 20–3. These essays were subsequently reprinted in Gregory Battcock, ed., *Minimal Art* (New York: E. P. Dutton, 1968), pp. 222–35.

2. Donald Judd's "Specific Objects" was originally published in *Art Yearbook* 8 (New York: Art Digest, 1965), pp. 74–82. "Specific Objects" appears in Donald Judd, *Complete Writings 1959–1975* (Halifax, Canada: The Press of Nova Scotia College of Art and Design; New York: New York University Press, 1975), pp. 181–9.

3. Judd, "Black, White and Gray," *Complete Writings*, pp. 117–18.

4. Ludwig Wittgenstein, *Philosophical Investigations* (New York: Macmillan, 1953), Part I, specifically Sections 1–10.

5. As for Judd, he assesses art for both directed strategy and tactics. Another way of interpreting Judd's remarks on Morris is to say that categorical thinking in artisans produces generic results. Objects rendered conceptually vague may be precise or diffuse relative to their cultural claims, and Judd certainly does not hesitate to discriminate among these when writing art criticism. Kind, yet disciplining Ronald Bladen for being general –

meaning vague – in adaptations of Neo-Plasticism, Judd is also annoyed with Burgoyne Diller, whose "mediocre show" in 1962 included a work that foundered because "[a]side from Albers' scheme, the two squares suggest a purposeful relationship, which is not present" (Judd, *Complete Writings*, p. 70).

Again, in Judd's view, if the principle of repetition were indifferent to substantive content, a composition of congruent squares, not to mention of modular elements, would be immune to considerations of merit. Yet refinement is not the antidote to generic form. Nor is tension or balance necessarily redemptive of geometry, although Frank Sibley's term "aesthetic qualities," which gives consideration to tension and balance, might suggest that once a work of art is in balance, it is resolved. "The more balance, the more success" would be the underlying assumption here, even though in consequence of this refinement, the art may be merely exquisite – or if conventional in its refinements, merely tasteful. As Frank Sibley employs it, the term "aesthetic qualities" will be easily confused with value and merit in most people's minds.

But I believe the nature of the charge by Judd against the mediocrity of Diller's show to be another matter. Deriving a form from one already sanctioned is no guarantee that the content of that form will be transmitted. Squares in congruence or in alignment may suggest intention, but that is all, and Judd has nailed Diller on the possibility that his intention may be pointless. The content of Neo-Plasticism or of Minimalism cannot be realized automatically or in ignorance of the aesthetic. Judd has detected in Diller an imitation of appearance, not principle.

＊

Perennially under discussion, the problem of quality in current art-critical discourse may be represented as a norm or a set of aesthetic values strategically pursued that attaches to modernity. If quality is the guiding principle in modernism, difference is the guiding issue in postmodernism, as Tom McEvilley argues in *Art and Otherness* (Kingston, NY: McPherson and Company, 1992). Yet with Minimalism, at any rate, some doubt arises whether the ideas of quality and difference can be disentangled so readily. With repetition crucial in ordering Minimalist structure, overlooking the semantic of deferral in linguistic relations is done only at one's peril. Beyond this, beyond the sense of merit that attaches to art-historically significant strategy, quality entails controlling cultural reference in forms and in their primary qualities. The point of all this is that the deconstruction of meaning onto nonvalued linguistic relations is itself a strategy for producing certain kinds of sense.

Among contemporary critics, meanwhile, Yve-Alain Bois defends the concept of quality. Less ideologically polarized than McEvilley, Bois in effect asks, "What does (semiotic) interpretation in art make possible?" A further question is suggested: "What conceptual frameworks are available in criticism today to advance strategic thought?" Essays in Bois's *Painting*

as Model (Cambridge, MA: MIT Press, 1990) include "Matisse and Arche-Drawing," in which Bois considers the "quantity–quality" systems that are Matisse's answer to divisionism.

Applying semiotic instrumentality to modern art, meanwhile, Richard Shiff studies how Cézanne represents originality of the medium in his art, and he weighs the signifying aspects of the repetition of an essence. (See Richard Shiff, *Cézanne and the End of Impressionism: A Study of the Theory, Technique and Critical Evaluation of Modern Art* [Chicago, IL: University of Chicago Press, 1984]. Addressing Cézanne's painting as though it were a thoroughgoing accrual of touch, Shiff subjects the concept of *petit sensation* to a postmodern interpretive scheme – this he does in the essay "Cézanne's Physicality: The Politics of Touch," in Salim Kemal and Ivan Gaskell, eds., *Language of Art* [Cambridge, MA: Cambridge University Press, 1991].)

Ultimately at stake is the philosophical realism that attaches to conceptual frameworks.

6. James Joyce, *A Portrait of the Artist as a Young Man* (New York: Viking, 1960), p. 212.

7. These primary visual resources available to Judd could be readily supplemented with images in the celebrated volume continually in print, Alfred Barr's *Cubism and Abstract Art* (New York: Museum of Modern Art, 1936). The truly cosmopolitan, intellectually progressive Barr had returned from his 1928–29 trip to Germany and Russia with many invaluable avant-garde (and specifically Constructivist) artifacts, artifacts that became the core of the collection of the museum when founded later in 1929.

8. Yve-Alain Bois, *Donald Judd* (Paris: Galerie Lelong, 1991), unpaginated.

9. Ibid.

10. Bois, "Strzemiński and Kobro: In Search of Motivation," *Painting as Model* (Cambridge, MA: MIT Press, 1995), pp. 123–35. (A different view may be sampled. The critic Marek Bartelik not only reviews Bois's essay – believing that Bois underemphasizes the politics of the artists – but he also reviews materials precipitating from a conference on Strzemiński in 1995 at Łódź, Poland. See Marek Bartelik's untitled review in *The Structurist* 35/36 (Saskatoon, Canada, 1995/96), pp. 132–6.

Recently translated into English is the 1928 manifesto by Władysław Strzemiński, *Unism in Painting*, "praesens" Library Warsaw No. 3 (Łódź, Poland: Museum Stzuki, 1994).

11. Reyner Banham, *Theory and Design in the First Machine Age* (Cambridge, MA: MIT Press, 1986), pp. 160–1. Although Banham's narrative mentions Russian Constructivism only in passing, it does note the cooperation of De Stijl and Constructivism, in that both van Doesburg and El Lissitsky signed the Foundation Manifesto for the Constructivist International. He writes, "This International is not the result of some humanitarian idealist or political sentiment, but that of amoral and elementary principles on which science and technology are based" (p. 187).

12. Strzemiński, "Notes on Russian Art" (1922), cited in Bois, "Strzemiński and Kobro," *Painting as Model*, p. 130.

13. Ibid. Strzemiński's polemic is directed against Rodchenko and Stepanova for doing supposedly new art – not "all the same," but worse – and for misunderstanding the strategic achievement of Cubism to which so much new art is indebted.

In modern art, merit is deemed to be a function of striving toward radical idea – but radical idea entailing art-historical necessity. 'What is innovation?' asks the social historian Arnold Hauser. Historical accident gives rise to necessity, insofar as "a completed action or achievement fulfilled gives rise to the impression that [something] is fixed and cannot be altered" (Arnold Hauser, *Philosophy of Art History* [Evanston, IL: Northwestern University Press, 1985], p. 190). Elsewhere, Hauser distinguishes contingent necessity from logical necessity (also necessity of the sort that precludes certain solutions at certain times under certain values).

14. Lancelot Law Whyte, ed., *Aspects of Form: A Symposium on Form in Nature and Art* (Bloomington: Indiana University Press, 1961). Even considering the perennial influence of science on art several times this century, one cannot overestimate the significance of the cultural rapprochement between art and science for the art theory of the 1950s, 1960s, and early 1970s. A symposium dedicated to the achievement of D'Arcy Wentworth Thompson, who published *Aspects of Form* on the mathematical structure governing biology in 1917, aspired to bring Thompson's achievements up to date. From Joseph Needham to Rudolf Arnheim, specialists delivered symposium papers that examined the universals of structure. Arnheim's consideration of perception subsequently brought gestalt psychology to a wide audience in the United States.

15. For a discussion of art seeking passage to pure syntax, see Mel Bochner's "Serial Art, Systems, and Solipsism," *Arts Magazine* 41 (Summer 1967), reprinted in Gregory Battcock, ed., *Minimal Art* (New York: E. P. Dutton, 1968), pp. 92–102.

16. A term from Tobias Dantzig, *Number: The Language of Science* (Garden City, NY: Doubleday & Co., 1956), p. 7.

17. Dantzig, *Number*. Chapter 9, "Filling the Gaps," discusses arithmetic continuity.

18. W. V. Quine, *Quiddities* (Cambridge, MA: Harvard University Press, 1987), p. 34.

19. See William James, *Essays in Radical Empiricism* (New York: Longman, Green & Co., 1912) and *A Pluralistic Universe* (New York: Longman, Green & Co., 1909, 1958).

20. James, *Essays*, p. 42.

21. James, *Essays*, p. 44. William S. Wilson meditates on the notion of "with" in "Eva Hesse: Alone and/or Only With," *Artspace* 16 (September/October 1992), pp. 36–41.

22. James, *Essays*, p. 45.

23. Speaking at "Judd Reconsidered," the symposium she moderated at the Whitney Museum of American Art on December 6, 1994, Roberta Smith

acknowledged that he had read Hume's philosophy together with that of Dewey. (Others participating in this symposium were Mel Bochner, Lucy Lippard, and Michael Grey.) Although *sentiment* may be taken to mean either sensation or judgment in the French, here it is meant to highlight the fact that even sensation in artifacts requires a critical spirit.

24. John Dewey, *Art as Experience* (New York: Capricorn, 1954), p. 192. Analytical and perceptual seamlessness occurs more readily in Judd's linear drawings thanks to the unifying capacity of line and also thanks to the perspective scheme originating from the center of the vertical stack, regardless of the gravitational orientation of the viewer.

25. Peter Caws, *The Philosophy of Science* (Princeton, NJ: D. Van Nostrand & Co., 1965), p. 145.

26. Ibid. Judd's shift in his choice of red – from the named view of cadmium red to names as specific yet in hue experientially "off" – also entails a shift in sense; initially a reference to Barnett Newman's opticality of surface (compounding Yves Klein's tactility), the red chosen thereafter is calculated to be elusive phenomenal namelessness, as Caws suggests here.

Note that in his criticism of others, Judd expects color to function "lucidly and rigorously," as Mel Bochner put it (in remarks on "the quality of color" in Judd's "Kandinsky in His Citadel," which was published originally in *Arts Magazine* in March 1963, in the symposium "Judd Reconsidered").

27. Banham, *Theory and Design*, pp. 188–9.

28. Bois, *Donald Judd* (unpaginated).

29. In 1951 the mathematician Hermann Weyl, lecturing on the idea of symmetry in art and science, remarked upon the neutrality with which nature treats left and right; despite what he had heard, Heinrich Wöfflin claimed for the left in art – with its sinister connotations. See Weyl, *Symmetry* (Princeton, NJ: Princeton University Press, 1989), pp. 23–4.

30. For a mention of recurrence as a kind a repetition, see Dantzig, *Number*, p. 71.

Throughout the first half of the twentieth century, it had been assumed that systematic investigation of structural orders lent fundamental profundity to a variety of individualistic expressions, with the seriality of Schönberg's music and of Gertrude Stein's distributed recurrent repetitions in verbal portraits of artists deriving the possibilities of repetitive organization from entirely different premises. Serial music lent systematic stratification to pitch in order to yield permutational order. Schönberg's notorious send-up of Stravinsky's orgiastic repetitions in "Dance Around the Golden Calf" from *Moses und Aron* illustrates the principled dispute over orthodox uses of repetition. As for Stein, the normative sentences that comprise the portraits allow her to assemble the behavioral evidence of, for instance, Picasso bit by bit. Behavioral rather than physiognomic, Stein's early sketches of artists disclose a pragmatic tendency that can be traced to her sleep research during her student days under the tutelage of William James. (In lectures at the School of Visual Arts [1987–90] that I

am completing for publication, I argue that Stein's early portrait of Picasso is behavioral rather than physiognomic.)

Chapter 21: Maquettes and Models

1. Wallace Stevens, "The Man with the Blue Guitar," *Collected Poems of Wallace Stevens* (New York: Alfred A. Knopf, 1964), pp. 165–7. Copyright 1954 by Wallace Stevens. Reprinted by permission of Alfred A. Knopf.
2. Unrecorded conversation with the artist.

Chapter 22: Ideas of Order

1. Walter McQuade, "Architect Louis Kahn and His Strong-Boned Structures," *Architectural Forum* (October 1957), p. 139.
2. Sol LeWitt, "Paragraphs on Conceptual Art," in Alicia Legg, ed., *Sol LeWitt* (New York: The Museum of Modern Art, 1978), p. 166. Reprinted from *Artforum* (June 1967), pp. 79–85.
3. Pierre Boulez, *Boulez on Music Today* (Paris: Editions Gurithier, 1963; Cambridge, MA: Harvard University Press, 1971).
4. Correspondence between Andrea Miller-Keller and Sol LeWitt, excerpted in Sol LeWitt, *Sol LeWitt Wall Drawings 1968–1984* (Amsterdam: Stedelijk Museum, 1984), p. 20. Rule-governed structure crucial to modern art antedates the twentieth century. Of special interest to LeWitt in the rules informing the poetry is the Symbolist Stéphane Mallarmé, whose work he read in Hans Rudolf Zeller's "Mallarmé and Serialist Thought," *die Reihe* 6 (Speech and Music) (Bryn Mawr, PA: Theodore Presser, 1960). Noteworthy is the conspicuous use to which Boulez has put Mallarmé.
5. Daniel Buren, "Beware!" in Ursula Mayer, ed., *Conceptual Art* (New York: E. P. Dutton, 1972), p. 61, reprinted from *Studio International* 920 (May 1970).
6. Erwin Panofsky, *Idea: A Concept in Art History* (New York: Harper & Row, 1968), p. 119.
7. Alpers mentions Aloïs Riegl's theory of the principle of coordination in Northern Renaissance space in her "Style Is What You Make It," which appeared in Berel Lang, ed., *The Concept of Style* (Ithaca, NY: Cornell University Press, 1987), p. 145.
8. Mondrian's grid informs De Stijl early on. Writing to J. J. P. Oud and his wife in 1919, Theo van Doesburg remarks that "[t]he division of the plane is a single module, which [is] therefore just ordinary rectangles of equal size." Van Doesburg's scheme of Mondrian's grid follows. See Allan Doig, *Theo van Doesburg: Painting into Architecture, Theory into Practice* (New York: Cambridge University Press, 1986), p. 25.
9. Van Doesburg aims for an architecture of "formless monumentality." He writes,

[I]t is *open*, bounded but not organically enclosed (*form architecture*). If the building achieves a *gestalt* arising out of the internal constructive divisions, then it also excludes form, the type, once and for all. Every plan that forms the bounding of a space has a continuing spatial extension, while overcoming the closed nature of organic form. This is *formless monumentality*. (Doig, *Theo van Doesburg: Painting into Architecture, Theory into Practice*, p. 135. Here, Doig is citing van Doesburg from a series of articles written in 1921 that was entitled, "The Significance of the Mechanical Aesthetic for Architecture and Other Professions," *Bouwkundig Weekblad* XLII, no. 25 [June 18, 1921], pp. 164–6, and no. 26 [July 9, 1921], pp. 179–83.)

10. Noted in architectural theory and practice, as well, by Alan Colquhoun in "Frames to Frameworks," *Essays in Architectural Criticism: Modern Architecture and Historical Change* (1977) (Cambridge, MA, and London: MIT Press, 1981; 1991), p. 120.
11. Lucy Lippard, "The Structures, The Structures and the Wall Drawings, The Structures and the Wall Drawings and the Books," in Legg, ed., *Sol LeWitt*, p. 30.
12. Donald Kuspit, "The Look of Thought," *Art in America* 63 (September–October 1975), pp. 43–9; Joseph Masheck, "Kuspit's LeWitt: Has He Got Style?" *Art in America* 64 (November–December 1976), pp. 107–11; Donald B. Kuspit, *Art in America* 65 (January–February 1977), pp. 5–6. Reprinted in Donald B. Kuspit, *Sol LeWitt: Critical Texts* (Rome, Italy: A.E.I.U.O., 1994).
13. The partial title of an extremely important book (*Dematerialization of the Art Object*) – itself assuming the form of an archival chronicle of the movements in the 1960s most given to this documentary approach. This book was edited and annotated by Lucy R. Lippard (New York: Praeger, 1973).
14. Rauschenberg had wished, however, for a reception that took note of differences within apparent similarity.
15. Lawrence Alloway, "Sol LeWitt: Modules, Walls, Books," *Artforum* (April 1975), p. 38.
16. Roger Shattuck, "The Tortoise and the Hare,"in *The Innocent Eye* (1965) (New York: Washington Square Press, 1984), p. 105.
17. Speaking of Valéry on da Vinci in connection with the rationalist predisposition of the Machine Age is Reyner Banham, *Theory and Design in the First Machine Age* (Cambridge, MA: MIT Press, 1986), p. 18.
18. Gertrude Stein, "Portraits and Repetition," *Lectures in America* (Boston: Beacon Press, 1985), pp. 170–1.
19. "Motor automatism" is a term Stein and Leon M. Solomons employed to describe their experiments in behavioral psychology. Mechanistic approaches to psychology typify the broad scientific positivism of the late nineteenth century that affected direct observation in Impressionism and the systematization of mediated observation in Post-Impressionism.
20. *October* 37 (Summer 1986).

21. Benjamin Buchloh, "The Primary Colors for the Second Time: A Paradigm Repetition of the Neo-avant-garde," in ibid., pp. 41–52.

22. Steven Z. Levine, "Monet's Series: Repetition, Obsession," in ibid., p. 73.

23. Sol LeWitt, "Sentences on Conceptual Art," *Sol LeWitt*, p. 168. First published in England in *Art-Language* 1 (May 1969), pp. 11–13.

24. Ibid.

Chapter 23: Contextualizing "The Open Work"

1. As a consequence of seeing this exhibition and of being introduced to Armajani's work through it, Carin Kuoni, then the director of the Swiss Institute, invited me to write a catalogue essay for the show she had been inspired to do. The result was *Common Houses: Siah Armajani and Hannes Brunner* at the Swiss Institute in New York (November 11, 1993, to January 8, 1994). (See Chapter 21, pp. 253–56, for the catalogue essay.)

Index